SHARP C

In love +

Peter

Wordsworth and Word-Preserving Arts

Wordsworth and Word-Preserving Arts

Typographic Inscription, Ekphrasis and Posterity in the Later Work

Peter Simonsen

© Peter Simonsen 2007

All rights reserved. No reproduction, copy or transmission of this
publication may be made without written permission.

No paragraph of this publication may be reproduced, copied or transmitted
save with written permission or in accordance with the provisions of the
Copyright, Designs and Patents Act 1988, or under the terms of any licence
permitting limited copying issued by the Copyright Licensing Agency,
90 Tottenham Court Road, London W1T 4LP.

Any person who does any unauthorized act in relation to this publication
may be liable to criminal prosecution and civil claims for damages.

The author has asserted his right to be identified
as the author of this work in accordance with the Copyright,
Designs and Patents Act 1988.

First published 2007 by
PALGRAVE MACMILLAN
Houndmills, Basingstoke, Hampshire RG21 6XS and
175 Fifth Avenue, New York, N.Y. 10010
Companies and representatives throughout the world

PALGRAVE MACMILLAN is the global academic imprint of the Palgrave
Macmillan division of St. Martin's Press, LLC and of Palgrave Macmillan Ltd.
Macmillan® is a registered trademark in the United States, United Kingdom
and other countries. Palgrave is a registered trademark in the European
Union and other countries.

ISBN-13: 978–0–230–52481–1 hardback
ISBN-10: 0–230–52481–8 hardback

This book is printed on paper suitable for recycling and made from fully
managed and sustained forest sources. Logging, pulping and manufacturing
processes are expected to conform to the environmental regulations of the
country of origin.

A catalogue record for this book is available from the British Library.

A catalog record for this book is available from the Library of Congress.

10 9 8 7 6 5 4 3 2 1
16 15 14 13 12 11 10 09 08 07

Printed and bound in Great Britain by
Antony Rowe Ltd, Chippenham and Eastbourne

To my parents,
Jens and Charlotte Simonsen

Yet in his page the records of that worth
Survive, uninjured;—glory then to words,
Honour to word-preserving Arts.

—Wordsworth, 'Musings Near Aquapendente'

Contents

List of Figures

Acknowledgements

Given its subject, a surprising number of people have shown interest in this book, and I gratefully acknowledge their help and kind encouragement. Claus Schatz-Jakobsen first mentioned the problem of late Wordsworth over a decade ago, and has since been a good friend and colleague at the University of Southern Denmark. Ken Daley, Bob DeMott and Bob Miklitsch were sources of inspiration at Ohio University. At the University of Copenhagen, Charles Lock was present at the right moments with tremendous amounts of enthusiasm and insightful attention to the minutest details. Without Charles' support and wealth of ideas this book would not have materialised. At Copenhagen, I was also fortunate to meet Frank Kjørup, Robert Rix, Christopher Prendergast and Lene Østermark-Johansen. Frances Ferguson and Neil Hertz gave time and encouragement at Johns Hopkins, and at various times and venues I have benefited from conversations with and critical readings by Jørn Erslev Andersen, Andrew Bennett, Anne Frey, Erik Granly, Jakob Stougaard Nielsen, Chris Rovee, Lars Ole Sauerberg, Gene Stelzig, Mads Rosendahl Thomsen and Per Øhrgaard. Last but not least, despite or perhaps because of an embarrassing first introduction, Peter Manning became a magnificent source of inspiration and help as well as a good, much-appreciated friend. My greatest thanks and debts are to my wife, Kirsten, and our daughter, Katrine.

Parts of this book have previously appeared elsewhere. A shorter version of Chapter 6 was published in *Angles on the English-Speaking World* 3 (2003). A few paragraphs of Chapter 2 were published in *Nineteenth-Century Studies in Lund and Copenhagen*, edited by Cecilia Wadso-Lecaros (Lund, 2005), and a shorter version of Chapter 4 is due to appear in *Studies in English Literature* (Autumn 2007). I am grateful for permission to reproduce this work.

List of Abbreviations

Bate & Engell	Samuel Taylor Coleridge, *Biographia Literaria or Biographical Sketches of My Literary Life and Opinions*, 2 vols, ed. Walter Jackson Bate and James Engell (Princeton: Princeton UP, 1983).
Brett & Jones	William Wordsworth and Samuel Taylor Coleridge, *Lyrical Ballads: The Text of the 1798 Edition with Additional 1800 Poems and the Prefaces*, ed. R. L. Brett and A. R. Jones (London: Routledge, 1991).
EY	*The Letters of William and Dorothy Wordsworth: The Early Years, 1787–1805*, ed. Ernest de Selincourt and Chester L. Shaver (Oxford: Clarendon P, 1967).
LY	*The Letters of William and Dorothy Wordsworth: The Later Years, 1821–1853*, 4 vols, ed. Ernest de Selincourt and Alan G. Hill (Oxford: Clarendon P, 1978–1993).
MY	*The Letters of William and Dorothy Wordsworth: The Middle Years, 1806–1820*, 2 vols, ed. Ernest de Selincourt, Mary Moorman and Alan G. Hill (Oxford: Clarendon P, 1969–1970).
Prelude	William Wordsworth, *The Prelude 1799, 1805, 1850*, ed. Jonathan Wordsworth, M. H. Abrams and Stephen Gill (New York: Norton, 1979).
PrW	William Wordsworth, *The Prose Works*, 3 vols, ed. W. J. B. Owen and Jane Worthington Smyser (Oxford: Clarendon P, 1974).
PW	William Wordsworth, *The Poetical Works*, 5 vols, ed. Ernest de Selincourt and Helen Darbishire (Oxford: Clarendon P, 1967–1972).
Reiman	Donald H. Reiman, *The Romantics Reviewed: Contemporary Reviews of British Romantic Writers. Part A. Volumes I & II* (New York and London: Garland Publishing, 1972).

Introduction

This book challenges the myth that in or around 1807 William Wordsworth suffered a sudden and irrevocable decline in his creative powers. The myth registers in speculations of what our sense of British Romanticism would be had its central poet died young, and in strong dismissals of the later work by some of the most influential critics.[1] The typical argument is that Wordsworth relatively quickly exhausted his main poetic resource—himself—and was left with nothing sufficiently compelling to write about. Combined with other explanations ranging from premature old age, the death of John Wordsworth in the wreck of the Abergavenny in 1805, the threat of going blind, the break with Coleridge and the alliance with Sir George Beaumont, frustrations over being unable to finish *The Recluse*, the defection from republicanism and profession of toryism and anglicanism, to Francis Jeffrey's hostile criticism in the *Edinburgh Review*, it has led to a framing of Wordsworth's career in terms of ten good years, the Great Decade worth our highest praise, and forty bad years, the great Anti-Climax worth our most ostracising criticism.[2]

Wordsworth and Word-Preserving Arts aims to nuance this representation of the career through a series of close textual analyses and contextual accounts of some of the new things Wordsworth actually said in and accomplished with his later poetry. In the four critically lost decades of more or less continuous poetic productivity that followed the composition of *Lyrical Ballads* (1798, 1800), *The Prelude* (1805) and the poetry of *Poems, In Two Volumes* (1807), Wordsworth typically averted his eyes from himself to consider and articulate the visible world of sense. Specifically, he began to write about the visual arts and to show an increased awareness of the visible appearance of his poetry in print. This book accounts for these new Wordsworthian preoccupations and aims

1

to explain their significance by arguing that they are necessary, if not sufficient, means to achieve a more full understanding and appreciation of Wordsworth.

A career that spanned six decades and was informed by a historical context which saw massive political, social, demographic and cultural upheavals seems bound to present problems for anyone setting out to understand it in terms of unity and coherence. Yet, the traditional approach to Wordsworth's work and Romantic period writings has been to reduce their internal conflicts and differences to construct a coherent and unified picture.[3] In more recent years, such constructions have been rendered problematic by a number of critics who, from across the methodological spectrum, have theorised what they perceive as the diversity and multiplicity characteristic of Romantic period writings as a strength rather than a weakness.[4] These new Romantic critics have revised our way of reading the canonical poets and pointed both to such familiar Romantic 'problems' as Jane Austen, George Crabbe, Robert Southey and to the many more recently recovered women poets, notably Charlotte Smith, Mary Robinson, Felicia Hemans and Letitia Elizabeth Landon, to substantiate the argument that insofar as categories such as 'period', 'movement', or 'career' presuppose and produce notions of unity and coherence—they are inadequate as instruments to account for the complexities involved in studying literary texts in relation to the various contexts within which they are produced and received. From within this enabling context in Romantic studies, this book presents Wordsworth's later poetry as a force that decentres and destabilises his earlier, canonical work, and by implication destabilises traditional accounts of Romanticism and impels their reconfiguration.

A number of critics, such as William Galperin, Peter Manning, Alison Hickey, John Wyatt and Sally Bushell, as well as Cornell editors, such as Jared Curtis and Geoffrey Jackson, have, in recent years, contributed to the understanding of late Wordsworth, and would agree with Geoffrey Hartman, Wordsworth's most important critic in the twentieth century, that 'There are ... strange happenings in the later poetry which has a precarious quality of its own.'[5] In a series of exemplary contextual close readings, Manning suggests that to reconstruct both the historical and bibliographical contexts of Wordsworth's later work is to recuperate its special significance.[6] Wyatt adopts a similar contextual approach in his consideration of the care Wordsworth took in arranging his poems of travel in longer sequences after 1819.[7] Hickey and Bushell both attend at book length to a poem only commented in passing in the present study, *The Excursion* (1814), which they argue constitutes 'a vast, unexplored

space that has yet to be granted its full complexity'.[8] These studies, including the present, are indebted to Galperin's argument that to fully understand the complexity of Wordsworth's career, he must be read 'as a poet whose early and late poetry, and ostensibly radical and conservative phases, are necessarily continuous'.[9] Yet, although one cannot be understood without the other, these 'phases' should not be taken to constitute a homogeneous continuum, but rather a conflictual field informed by a principle of revision whereby they destabilise and unsettle one another's authority to stand in for what is the 'essential' Wordsworth.

The importance traditionally assigned to the Great Decade poetry is based on the assumption that in works such as 'Tintern Abbey' and *The Prelude* Wordsworth 'began modern poetry, the poetry of the growing inner self'.[10] Duncan Wu has recently returned to Wordsworth's *juvenilia* and unpublished manuscripts to study this topic. According to Wu, Wordsworth's most characteristic poetry emerged in July 1787 when 'the delayed mourning' of his father carried out in *The Vale of Esthwaite* turned 'into a deeply personal investigation of grief, guilt and restitution. Without being fully aware of it, Wordsworth traced an emotional course that would compel him for the rest of his poetic career'; or at least as far as 1813, where Wu ends his investigation of the career that continued for more than thirty years.[11] Wu aligns himself with the dominant twentieth-century understanding of Wordsworth when he writes that 'the shift of gear detectable in Wordsworth's poetry from July 1787 was the result of a searching and poised act of self-examination' (15); and that 'Wordsworth is attempting to analyse his own habits of mind' (60) in his most typical poetry. As indicated by the many facsimiles of Wordsworth's near-illegible manuscript pages it reproduces, *Wordsworth: An Inner Life* aims to return us to origins and to transcend any material hindrance standing between us and the mind of the poet, who for Wu is 'pre-eminently the master of the immaterial' (x). The present study looks in the other direction and aims to supplement Wu's work by showing Wordsworth's aspiration to also master the material in work that largely saw print after 1813. This book's main premise is that the differences of the later Wordsworth deserve to be recognised and recuperated from the web of critical misconceptions that surrounds this figure in the critical tradition. These differences are seen in terms of how the later Wordsworth's more impersonal and formally self-conscious poetry, which is inspired by and represents various kinds of plastic art works and whose printed, material appearance matters, decentres and complicates the earlier more personal poetry of self and nature.

 To thus perform an analysis of the later work that reveals its aims, sources and resources as materially different from the earlier work is not only to reach a better understanding of both parts of the *oeuvre*, but also to get a better sense of the value of the whole. In a literary historical situation which still posits 'particularity, local difference, heterogeneity, fluctuation, discontinuity, and strife' as its 'preferred categories for understanding any moment of the past', any particularities that expose local differences in Wordsworth's *oeuvre* and reveal it as a heterogeneous, non-unifiable and non-totalisable entity may be positivised and seen to cast new light on the work as such.[12] Thus I agree with earlier critics who saw Wordsworth's *oeuvre* as a whole, but my approach to this wholeness differs inasmuch as I find the inconsistencies, the breaks, ruptures and internal differences and conflicts which keep the *oeuvre* from constituting a 'homogeneous' 'whole' to be the interesting object of study.[13] Hence the overall aim of *Wordsworth and Word-Preserving Arts* of promoting a renewed understanding and valuation of the complexity of Wordsworth's work. In this way, the rich diversities which contemporary Romanticists have shown to constitute the literature of the period may be brought further into the open, and seen more profitably as strengths rather than weaknesses.[14] Instead of imagining a British Romanticism without late Wordsworth, I suggest that we develop a sense of the period's literature that is flexible and open enough to encompass all of Wordsworth. Given the scope of the corpus thus opened up and the need to conduct the argument at the level of the particular, I have of necessity been selective in the choice of material for analysis. Yet, it is hoped that the examples singled out suffice to show that a critical examination of the later work on its own terms is rewarding for revealing Wordsworth as a much more interesting because much more varied, diverse and persistently active artist than has been common.

 The following chapters trace the special force of Wordsworth's later work in two of its especially characteristic poetic forms: *inscription* and *ekphrasis*. By *inscription* is meant poetry that is actually or supposedly inscribed and visually displayed upon a material surface to which the text stands in a significant relationship. According to Angus Easson, 'The Inscription is distinctive in being words deliberately displayed: the forms of language, hieroglyphs or ideograms or alphabetic characters, occupy physical space to which their meaning is significantly related.'[15] A number of critics have described and analysed Wordsworth's several conventional inscriptions and his more general and peculiar tendency towards the inscriptional and epitaphic.[16] However, few have considered the changes in this tendency within Wordsworth's career and no one has

extended the discussion of the inscriptional to encompass Wordsworth's concern with the printed layout of his works: the so-called *mise-èn-page* of the poetry. This approach has been made possible by the relatively new field of book history, material bibliography and new textual criticism as articulated in the work of Jerome McGann, D. F. McKenzie, Gérard Genette, Roger Chartier and others. For these critics, the book and the page always function as meaningful sites for the display of the text. As Chartier puts it, 'any comprehension of a text is necessarily dependent on a knowledge of the material forms it has taken'.[17]

The analysis of Wordsworth's inscriptional work, which is mostly carried out in Chapters 2 and 4, entails both an account of changes in the conventional inscriptions and an engagement with poetry where typography is used to accentuate the inscriptional and thereby expose the page as the place for what I call 'typographic inscription'. In the course of this analysis, a passage is charted in Wordsworth's career from understanding poetic inscription in its traditional sense to seeing it as an aspect of all printed poetry; from reading the earlier inscriptional poetry as *re*presenting actual inscriptions that presumably exist prior to the poem's notation, to reading the later work as consciously *pre*senting the inscription in its visual immediacy. This passage in which the monumental stone is replaced by the book as inscriptional site is one of the significant new turns that becomes evident only when we take the poetry and special concerns of the later phase of the career into consideration.

By *ekphrasis* is meant poetry which is about, on, or in various ways intended to imitate, resemble or otherwise utilise the techniques, ideals and materiality of works of plastic art.[18] One of Wordsworth's very last poems, composed in 1846 and published in 1850 as 'To Luca Giordano', is an example of ekphrasis.[19] This poem marks the end of what may be called his 'ekphrastic period', which was inaugurated in 1806 by the composition of 'Elegiac Stanzas Suggested by a Picture of Peele Castle in a Storm, Painted by Sir George Beaumont'; comprises a substantial number of ekphrastic texts; and reveals a frequent appearance and use of plastic artworks both as referential objects and as vehicles of metaphors in the later poetry.[20] Historically, the term has been used in a variety of senses ranging from its perhaps strictest definition of envoicing an art object, a usage which derives from the Greek etymological sense of *ekphrazein*, 'to speak out or to tell in full' and is related to the trope of prosopopoeia; to its more traditional definition of the imitation or reproduction in words of a spatial *objet d'art*; to its more inclusive, current definition of the verbal representation of visual representation;

and finally to its original sense of pure description (*hypotyposis*) aimed to generate in the mind of the recipient the kind of visualisation usually discussed with reference to the classical rhetorical term *enargeia*, and thus neither dependent on the described object being representational, nor an art object in any conventional sense, nor indeed an object. As Ruth Webb has shown, ekphrasis originally also implied the vivid description of actions.[21] Rather than use the term in a strictly defined manner that results from a choice among its several meanings and consequently excludes certain ekphrastic aspects from consideration, ekphrasis is approached in this study from an eclectic point of view that understands and uses it in a comprehensive and inclusive sense.[22] The dominant idea behind the examination of ekphrasis, mainly in Chapters 1, 3 and 5, is that we do not need to be able to define precisely and thus know exactly what it is in order to investigate its presence, use and function in a certain body of poetry. This eclecticism can be legitimated with reference to my primary aim, which is not to reach a better and more rigorous definition of ekphrasis, but to reach, from the perspective of the decentering ekphrastic tendency of Wordsworth's later poetry, a better and more nuanced understanding of his work in relation to British Romantic period writing.

Inscription and ekphrasis are significant late Wordsworthian kinds of poems because they are at once atypical of the Wordsworth to whom traditional literary history has accustomed us, but typical of the later work, especially in their visual emphases on exteriority. They force the reader, on the one hand, to see the text, to look at it on the page, and, on the other hand, to see through the text to visualise the artwork it references.[23] Much recent Romantic criticism has attempted to understand the Romantics' sense of the visible as something to be positively engaged and articulated. William Galperin's *The Return of the Visible in British Romanticism* (1993) marked a paradigm shift in Romantic studies in this context inasmuch as it was the first monograph-length study to revise traditional accounts of Romanticism's presumed univocal iconoclastic poetics by dominant twentieth-century Romanticists. Although he neglected the women poets, to whom Stuart Curran had already called attention to for their visual awareness, Galperin's broad treatment of writers such as Wordsworth, Lamb, Hazlitt, Coleridge, Byron, artists such as Constable and Friedrich, as well as cultural phenomena such as panorama and diorama, gave credence to his central contention 'that a visible world—accessible to the material, bodily condition of sight and thus prior to idealization—is manifest in certain texts, including verbal texts, of the British romantic period'.[24]

For Galperin the force of the exploration of this hitherto repressed visible world of Romantic writing was that it entailed 'a reversal of the imaginative iconoclasm—that is, the fear of both visual images and the material world such images admit—endemic to romantic poetics' (19). Galperin recuperated the visible to promote 'a romanticism beside itself' (24), where 'romanticism's unappreciated rejection of itself' (29) was its perhaps most significant feature. This was a new way of foregrounding 'the variousness and remarkable mobility of romanticism, both as movement against itself, or what we ordinarily consider the "romantic movement", as well as a counterculture that opposes both its typical mystification as revolution and its typical demystification as bourgeois humanism' (31). Galperin's intervention is inscribed in a long tradition in Romantic studies that values the diversity of Romanticism. His works were preceded most prominently in the twentieth century by A. O. Lovejoy's, 'On the Discrimination of Romanticisms' (1924), and Marilyn Butler and Jerome McGann's seminal works, *Romantics, Rebels and Reactionaries* (1981) and *The Romantic Ideology* (1983), both of which actualised Lovejoy's position and produced the currently predominant conception of Romantic period literature as something we must go 'beyond', to the 'limits' of, 're-vision' and 'question' to understand.[25] In showing us a Wordsworth 'beside himself' the inscriptional and ekphrastic work enables us to see him with new eyes in terms of what Galperin calls a Romanticism 'beside itself' whose 'informing feature is its productive decentredness' (32).

The inscriptional and ekphrastic poems lend themselves to being studied as parallel phenomena not only because they are signs of the unsettling return of the visible in the later Wordsworth, but because they may be understood in relation to one of his presiding ideas: that only posterity would qualify as the 'fit audience' for his work.[26] In the 'Essay, Supplementary to the Preface' (1815), Wordsworth famously said, 'Every Author, as far as he is great and at the same time *original*, has had the task of *creating* the taste by which he is to be enjoyed: so has it been, so will it continue to be' (*PrW* 3, 80). The origin of this idea is most often traced to a letter to Lady Beaumont, May 1807:

> every great and original writer, in proportion as he is great or original, must himself create the taste by which he is to be relished; ... this, in a certain degree, even to all persons, however wise and pure may be their lives, and however unvitiated their taste; but for those who dip into books in order to give an opinion of them, or talk about them to make up an opinion—for this multitude of unhappy, and

misguided, and misguiding beings, an entire regeneration must be produced; and if this be possible, it must be a work *of time*. (*MY* 1, 150)

This letter announced a radical revision of Wordsworth's poetics as presented in the 1800 Preface to *Lyrical Ballads* since it cast *all* readers, not just the 'unhappy, and misguided' ones, as incapable of understanding the poet immediately. Immediate and intuitive understanding was a fundamental presupposition of the Preface reflected by the idea of the poet as a 'man speaking to men'. To be a 'man speaking to men' is to imagine the audience as equals. Unlike this enunciatory situation, the 1807 letter and Wordsworth's later poetics presuppose a temporal distance between the production and the reception of a poetic utterance as the precondition for its appropriate understanding. There are of course degrees distinguishing sympathetic from unsympathetic readers, yet they are all of a kind in that *time* is required to ensure proper understanding. If we were to literally (over)hear Wordsworth uttering his poetry, if he were truly 'a man speaking to men' and we were his literal 'audience' (from Latin *audientia* 'a hearing'), we would by definition not comprehend it.

Wordsworth's letters after 1807 are littered with signs of his internalisation of a posterior audience. With reference to *The White Doe of Rylstone* he wrote Dorothy in March 1808, 'I do not think it likely that I shall publish it at all—indeed I am so thoroughly disgusted with the wretched and stupid Public, that though my wish to *write* for the sake of the People is not abated yet my loathing at the thought of publication is almost insupportable.'[27] In August 1816, after a series of failures culminating in the *Thanksgiving Ode*, he wrote to Henry Crabb Robinson, 'as to Publishing I shall give it up, as no-body will buy what I send forth: nor can I expect it seeing what stuff the public appetite is set upon' (*MY* 2, 334). When he had nevertheless published new work in 1820 and 1822, Dorothy wrote to Crabb Robinson, 'he will never, in his life-time— *publish* any more poems—for they hang on hand—never selling' (*LY* 1, 178). This internalisation was caused not only by hostile and often personal and politicised reviews and poor sales, but also by a fundamental alienation from the kind of familial, known and predictable audience earlier poets had known and exposure to an unknown, heterogeneous and more contentious mass of readers whose reading habits and skills were changing from slow and intensive to rapid and extensive; by fierce competition among authors on an increasingly commercialised market, which can be seen for instance in the burgeoning market for parodies of which Wordsworth would become a darling victim; and

finally, by a sense that too much printed material of too poor quality was being published in book and periodical form to render readers incapable of recognising real quality and forcing a poet like Wordsworth to bury his poetic treasure (like the Arab in the famous nightmare in Book Five of *The Prelude*) in the hope that a future audience might chance upon it.[28]

Due to the reconfiguration of addressee as posterity, the materiality of the media of writing and printing assumed new importance in Wordsworth's poetry and poetics. While it does not appear strange for someone who has defined his ideal addressee as his contemporaries to be posing as a classical *rhetor*, a 'man *speaking* to men', it would be strange not to reflect upon the need for a medium more durable, lasting and permanent than speech for someone who explicitly understands and presents himself to be addressing posterity. So it should come as no surprise, even though it has rarely been understood in quite these terms, that Wordsworth, after redefining his ideal addressee as posterity, should become ever more interested in and fascinated by the characteristics of writing which exceed its technical function as notification of speech and formulate his poetic in terms of epitaphic inscription in the *Essays upon Epitaphs* (c.1810). Because his ideal addressee had been reconfigured as posterity, Wordsworth was forced, even as his readers are forced, to attend to aspects of writing and printing such as the materiality of the typographical sign and the durability of its surface, the page and the book, the fixity of which must function to secure the permanence of the poetic utterance.

While the inscriptional poems aspire to give the impression that they have assimilated the surface and place of inscription, the ekphrastic poems aspire to give the illusion that they have absorbed the *objet d'art* they are about. Jean Hagstrum has noted Wordsworth's 'tendency to be inscriptive—to create the fiction of engraving his lines, as though in permanent form, on tombstone, tree trunk, bench, seat'.[29] For Susan Eilenberg, Wordsworth's inscriptional poetry similarly 'presents itself as somehow infused with the materiality of the objects it so ostentatiously depends upon ... [It appears] thinglike in its radical dumbness'.[30] Hagstrum linked the inscriptional and ekphrastic tendencies and saw them in terms of 'Wordsworth's need in poetry to achieve hard and changeless plastic form'.[31] The 'need' for this kind of formal permanence and stability is pointed out by most commentators on Wordsworth's relationship to the plastic arts when they explain his attraction to this 'other' of poetry. As Martha Hale Shackford puts it, 'Painting, Wordsworth thought, was one of man's inspired challenges to Mutability, giving concrete, silent, sustained existence to the impermanent.'[32]

Wordsworth tended to value the 'fixative' power of painting positively and to reveal as much as, if not actually more interest in, this capacity of art than in what a given work represented.[33] Wordsworth indeed craved what Murray Krieger calls 'the spatial fix'.[34] For Krieger, this 'fix' is symptomatic of what he terms 'the ekphrastic principle', one of whose manifestations is a desire of the 'verbal object [to] emulate the spatial character of painting or sculpture by trying to force its words, despite their normal way of functioning as empty signs, to take on substantive configuration' (9). One explanation of the later Wordsworth's valuation of the fixity of painting and his possible desire to emulate it in ekphrasis is that it allows poetry to attain the kind of permanence he aspired to confer upon his work in order to imagine its posterior reception.

Wordsworth's need for a durable and permanent work is reflected in his overall concern with 'word-preserving Arts' (*PW* 3, 209, l. 250) as he calls the arts of writing, printing and by extension painting in the late poem, 'Musings Near Aquapendente' (1837). Late Wordsworth consciously utilised these 'arts' to produce a poetic work that would survive and reach posterity. This kind of poetic work is reflected by his inscriptions and ekphrastic poems both of which articulate a desire to render the poetic work permanent. The master trope of Wordsworth's later work is thus the eminently ekphrastic *and* inscriptional idea of the poem as a 'speaking monument' (*PW* 3, 247) expressed in the third of *The River Duddon* sonnets (1820). This is also reflected in one of his most famous metaphors, which maps his *oeuvre* on to a gothic church in the Preface to *The Excursion*. Whatever else a gothic church is it is both a concrete place for inscription and a visual-material work of monumental art intended for posterity.

When we compare the earlier and the later Wordsworth, we will see him change, gradually and never completely, from writing one kind of poetry, which is private, personal and largely inspired by the interaction of self and nature, to another kind of poetry, which is public, impersonal and largely inspired by the interaction of self and artworks. By tracing this change from a 'nature poetry' addressed to and informed by a present listening audience to an 'art poetry' addressed to a future audience of readers, and by emphasising the differences, new aspects of the richly complex diversity of Wordsworth's work may be exposed. The following chapters aim to do so by describing, in a roughly chronological manner, Wordsworth's increasing immersion in aspects of the visual culture of British Romanticism by moving back and forth between dealing primarily with ekphrasis (Chapters 1, 3 and 5) and typographic inscription (Chapters 2 and 4) to conclude in Chapter 6 by

almost leaving words behind to concentrate on Wordsworth's graphic image as represented in the two frontispiece portraits he published in collected works editions in 1836 and 1845. I have chosen this format in order to present the two subjects as coterminous and to note that their strategies and concerns often interweave, especially as they relate to the awareness of posterity as audience. Thus, the chapters can be read both independently as examples of the central argument and consecutively as steps towards a final goal: the monumentalising efforts embodied in the late collected editions epitomised in the image of the poet in the frontispiece portraits.

1
The Return of the Visible and Romantic Ekphrasis: Wordsworth in the Visual Art Culture of Romanticism

Wordsworth is often identified with a deep iconoclastic scepticism regarding sight and visual phenomena. In *The Prelude*, he refers to the eye as 'The most despotic of our senses' and recalls a time when it had 'gained / Such strength in me as often held my mind / In absolute dominion' (1805, XI, ll. 171–176). As he continues by saying that he would 'Gladly' 'endeavour to unfold the means / Which Nature studiously employs to thwart / This tyranny' (ll. 176–180), Wordsworth encourages the identification enabling W. J. T. Mitchell, for instance, to state that 'the first lesson we give to students of romanticism is that, for Wordsworth…"imagination" is a power of consciousness that transcends mere visualization. We may even go on to note that pictures and vision frequently play a negative role in romantic poetic theory'.[1] One reason among many why the eye is a touchy subject in Wordsworth is no doubt that from January 1805 and for the rest of his life he suffered from attacks of severe inflammation of the eyelids that made him hypersensitive to light and inhibited poetic composition.[2] Yet, while his bad eyes thus put a strain on composition, they also undoubtedly caused Wordsworth to become increasingly aware and appreciative of the gift of seeing, and consequently contributed to the foregrounding of the visible and the turn to descriptive and ekphrastic writing in the later career: a turn that was coterminous with what Alan Liu calls the later Wordsworth's 'effort to criticize the flight of imagination' resulting in predominantly '*dis*imaginative work' that revises the early visual scepticism which informs much of the Great Decade poetry.[3]

Another contributing factor to the later Wordsworth's turn to ekphrasis and his increasingly positive sense of the visual was that the Romantic period saw an unprecedented interest in works of plastic art,

which translated into a widely held desire among leading poets to render them and their effects in the medium of language. As Herbert Lindenberger points out,

> The late eighteenth and early nineteenth centuries mark not only the first sustained attempt to theorize the arts as a whole but also a systematic effort, continuing to our day, to break down long-established borders between the various arts as well as borders between the individual genres constituting each art form.[4]

Excepting the problematic Blake, whose 'composite works' may best be characterised as media events rather than examples of ekphrasis, Keats is the best-known ekphrastic poet of the period and has been studied most closely as such.[5] In James Heffernan's *The Museum of Words*, Wordsworth, Shelley and Byron also garner attention as ekphrastic poets, and as criticism is beginning to recognise, the women poets of the age were often ekphrastically inclined.[6]

Among reasons to explain the increase in the number and popularity of ekphrastic poets and poems in the Romantic period should be counted the excavations of ancient works of art at Herculaneum (1738) and Pompeii (1748); the founding of the Royal Academy (1768) which in 1798 allowed artists exhibiting at the annual show to give quotations in the catalogue instead of, or in addition to, titles;[7] the appearance of the modern art museum (British Museum, 1759; Louvre, 1793; National Gallery, 1824), exhibition halls (e.g. British Institution, 1805) and auction houses (Southeby's, 1740; Christie's, 1762), where works hitherto kept in private collections were made increasingly available to the public; the cultivation of engraving as an art form that enabled more people to see and own reproductions of both classical and contemporary works (Boydell's Shakespeare Gallery was founded in 1789; in 1802 the Society of Engravers was founded); and (as noted by Lindenberger) the rise of the discourse of aesthetics that aimed to describe the nature and effect of art reflected for instance in the founding in 1817 of the first specialised art journal in Britain, *The Annals of the Fine Arts*, where Keats and Wordsworth's ekphrases were published along with critical essays on the sister arts.[8]

The Romantic period in other words saw the first signs of the democratisation of art and a number of efforts to make it public. This was noted by a contributor to the *Annals of the Fine Arts*, who in 1819–1820 recalled, in the context of the Academy's annual show, how

Some years ago...old pictures were cloistered up from the public gaze and the desiring eye of the painter, as though they had been forbidden ware...; it is upon conveying the memory back to those days that one feels a delight and a touch of gratitude at witnessing the happy change which has taken place in this respect. The most splendid collections of old original pictures of consummate excellence are now annually displayed before the public.[9]

Art was also becoming available in reproduced form in the phenomenally popular literary annuals that appeared from the early 1820s onwards. Published in time for the Christmas season, the annuals were luxuriously bound and profusely and lavishly illustrated books designed as parlour pieces for middle-class readers. As Eleanor Jamieson points out, due to the literary annuals, 'the *finest* art of the country could be reproduced at a reasonable price, and when such reproductions were diffused through the huge circulation of the annuals, they fostered in the general public an appreciation of painting never hitherto known'.[10] The annuals were hotbeds for the development of Romantic and later Victorian ekphrasis and more than the museum and other exhibitions of original art, they were both cause and effect of the dramatic upsurge in interest in visual art in the later Romantic period. In the introductory poem to one of the most popular annuals, *The Keepsake for 1828*, we see that these publications were highly conscious of their use of word–image constellations: 'Unto the beautiful is beauty due', the editor writes, addressing the female readers he was targeting,

> For thee the graver's art has multiplied
> The forms the painter's touch reveals to view,
> Array'd in warm imagination's pride
> Of loveliness (in this to thee allied).
> And well with these accord poetic lays
> (Two several streams from the same urn supplied);
> Each to the other lends a winning grace,
> As features speak the soul—the soul informs the face.[11]

Although word and image are presented as equals, in fact the image was superior in the medium. In responding to an environment increasingly saturated with works of plastic art, certain Romantic poets thus revised Gotthold Ephraim Lessing's influential division of the arts in *Laocoön: An Essay on the Limits of Painting and Poetry* (1766) according to whether their signs follow one another in time to better represent

actions unfolding in time, or whether they may be apprehended at once in a spatial configuration to better represent bodies in space; and they anticipated Richard Wagner's idea of the *Gesammtkunstwerk*, which he developed in *The Art Work of the Future* (1850).[12]

Yet, ekphrasis has been neglected in studies of Romanticism which have been dominated by an idealist understanding that concentrates on High Romanticism and finds it to aspire to emulate music rather than the visual arts. In the most influential study of High Romantic aesthetic theory in the twentieth century, M. H. Abrams' *The Mirror and the Lamp*, we read that 'In the place of painting, music becomes [for the Romantics] the art frequently pointed to as having a profound affinity with poetry. For if a picture seems the nearest thing to a mirror-image of the external world, music, of all the arts, is the most remote.'[13] In their quest for the abstract visionary, the Romantics are typically seen to eschew the concrete visible. In a lecture on *Romeo and Juliet* in 1811, Coleridge said that 'The power of genius [is] not shown in elaborating a picture of which many specimens [are] given in late poems where throughout so many minute touches [are] so dutchified that you ask why the poet did not refer to one to paint it.'[14] Instead, Coleridge said later, the 'power of genius' may be observed when the mind 'would describe what it cannot satisfy itself with the description of' (495). This struggle can lead to

> The grandest efforts of poetry ... where the imagination is called forth, not to produce a distinct form, but a strong working of the mind, still offering what is still repelled, and again creating what is again rejected; the result being what the poet wishes to impress, namely, the substitution of a sublime feeling of the unimaginable for a mere image. (496)

A poet's ability to thus articulate the sublime was for Coleridge a sign of his superiority, a sign of 'the narrow limit of painting, as compared with the boundless power of poetry: painting cannot go beyond a certain point; poetry rejects all control, all confinement' (496). For Coleridge as for Lessing (who Coleridge at one point claimed to be writing an extensive introduction to), poetry had little or nothing to gain from entering into a co-operative relationship with painting.

Geoffrey Hartman's interpretation of Wordsworth is similarly premised on the idea that 'When Wordsworth depicts an object he is also depicting himself or, rather, a truth about himself, a self-acquired revelation. There is very little "energetic" picture-making in him.'[15] As Hartman's note to Jean Hagstrum's discussion of *enargeia* in his classic

study of the *ut pictura poesis* tradition, *The Sister Arts*, that ends this quotation reveals, Wordsworth is for Hartman fundamentally anti-ekphrastic, and his Romantic resistance to the Neoclassical espousal of *ut pictura poesis* and *enargeia* partly define his originality. In a neglected article that extended *The Sister Arts* beyond the Neoclassical period with reference to Blake and Keats in particular, Hagstrum questioned the validity of what he calls 'the pre-emptive views that in the early nineteenth century *ut musica poesis* replaced the venerable *ut pictura poesis*'.[16] By presenting Wordsworth's later work as another example, my aim is not to deny that the Romantics often valued music over painting and aspired to eschew descriptive writing to better imitate the former art form in a sublime pursuit to describe what eludes description. Instead, it is to resist the theory of a sudden epistemic shift in aesthetics from idealising one art form to another and to argue that to neglect to consider the Romantic poets' use of painting and explain their strategic valuation of this 'other' of poetry, whether positive or negative, is to only partially understand the full complexity of their work.

 In valuing the 'visionary' and transcendental aspects of Wordsworth's work as absolutely central, the idealist tradition that runs from Coleridge to A. C. Bradley around 1900 and on to Hartman, Harold Bloom and beyond has rendered virtually meaningless or unreadable in positive terms the strong desire to describe and verbally render the visible that is also present in his work, where it constitutes a materialist, 'low' Romantic strand that counters and unsettles the High Romantic strand to the extent that it values the visible object not for what it is not or what it points to (i.e. the subjectivity and personality of the poet), but for what it is in itself. In certain texts and passages, Wordsworth describes external, physical nature less to find himself reflected than to render the seen world and the pleasures it gives as accurately as possible. This descriptive/ekphrastic aspect of his poetic practice should not be understood in terms of a failure to achieve 'vision' or as a mere first step in a dialectic leading beyond the visible, but as of value in itself. William Galperin in particular has begun the recuperation of this strand in terms of his idea of the 'return of the visible', and has suggested that it instances a Wordsworthian 'counteraesthetic'.[17]

 Some of the best evidence for this 'counteraesthetic' may be found in a text often neglected in accounts of Wordsworth that focus exclusively on his poetry, his prose masterpiece, the *Guide to the Lakes*, which Stephen Gill aptly characterises as 'a prose-poem about light, shapes, and textures, about movements and stillness'.[18] That Wordsworth did not see this prose work as opposed to his poetic concerns is indicated

by its inclusion in the *River Duddon* volume in 1820 as well as the inclusion in it of a number of poems and passages from poems. In a prefatorial note to its publication in the *River Duddon* volume, Wordsworth thus wrote, 'This Essay, which was published several years ago...is now, with emendations and additions, attached to these volumes; from a consciousness of its having been written in the same spirit which dictated several of the poems, and from a belief that it will tend materially to illustrate them.'[19]

While Wordsworth in 1820 presented the prose as an illustration of his own poems and as 'written in the same spirit', it not only predated the poems but had in fact first served as verbal illustration of visual images. The *Guide* was composed in 1809/1810 and published anonymously in monthly parts in 1810 as the verbal supplement to a series of forty-eight engravings from Rev. Joseph Wilkinson's pictures of the Lake District, *Select Views in Cumberland, Westmoreland, and Lancashire*. It is an example of a text which was generated by visual art: where images dictate text. The work was commissioned by Wilkinson and stipulated that Wordsworth should follow a visual original and merely provide copytext. Wordsworth had grave difficulties thus being in a submissive position *vis-à-vis* a graphic artist where he had to write at a predetermined length and according to the order set by the engravings, and he only seems to have participated in the project to make money. In July 1810, he wrote Mary that '[Dorothy] has been so good as to abridge the sheets I wrote for Wilkinson', continuing, 'for my own part I have no longer any interest in the thing; so he must make what he can of them; as I can not do the thing in my own way I shall merely task myself with getting through it with the least trouble'.[20] Later in the year, he in fact made Dorothy compose some of the last descriptions, as she wrote to Catherine Clarkson 12 November 1810, '[William] employed me to compose a description or two for the finishing of his work for Wilkinson. It is a most irksome task to him, not being permitted to follow his own course, and I daresay you will find this latter part very flat' (*MY* 1, 449).

The *Guide* has a highly complex textual history: it was as mentioned republished in revised form in 1820 along with the *River Duddon* volume as *Topographical Description of the Country of the Lakes in the North of England*. In 1822 and 1823, it was published separately and again in revised form as *A Description of the Scenery of the Lakes in the North of England*. In 1835, it found its final form and was published, again revised, as *A Guide through the District of the Lakes in the North of England*. This protracted publication history shows that the *Guide* was among the most

popular of Wordsworth's works during his lifetime. As Gill writes, 'It is by far Wordsworth's most attractive and accessible prose and were it not for the utilitarian connotations of "guide" it would be recognized more freely for what it is, a gem of Romantic writing.'[21] Despite recent efforts, it is fair to say that the *Guide* remains neglected in the critical tradition.[22] The reasons for this include that it was written for money, that Wordsworth at first distanced himself from authorship through anonymity, that it is in prose, and no doubt that it is descriptive and signals the return of the visible. This return, however, also indicates its centrality and strength as it shows Wordsworth's participation in the visual art culture of Romanticism.

One crucial thing not made an issue in recent reappraisals of the *Guide* is that in all republications after 1810, where it continued to grow as more and more text was added, the engraved 'views' were left out and all reference to them suppressed. While probably made impossible due to technical problems involved in the process of reproduction, this is also a clear sign of Wordsworth's High Romantic iconoclastic scepticism regarding illustration and the visual noted by most critics, who align him with Coleridge and Charles Lamb on this issue.[23] Coleridge's above-mentioned antipathy to description and the visible in the lecture on *Romeo and Juliet* was articulated in the context of a harangue against graphic illustrators of Milton's Death in *Paradise Lost*. For Coleridge,

> the passage from Milton might be quoted as exhibiting a certain limit between the Poet & the Painter—Sundry painters had not so thought and had made pictures of the meeting between Satan & Death at Hell gate and how was the latter represented? By the most defined thing that could be conceived in nature—A Skeleton perhaps the dryest image that could be discovered which reduced the mind to a mere state of inactivity & passivity & compared with a Square or a triangle was a luxuriant fancy.[24]

Coleridge's criticism is not just directed against particularly bad and incompetent illustrators but against the visual medium as such, which renders the mind of the recipient passive and disenchants Milton's words.

Coleridge responded to what Martin Meisel calls the 'new age of illustration' that was 'launched with much fanfare just before the French Revolution by Alderman Boydell's grandly conceived Shakespeare Gallery and Thomas Macklin's rival Poet's Gallery'.[25] These galleries

exhibited paintings inspired by the works of Shakespeare and Milton in particular, which the audience could order engravings from to be made on demand. As Marilyn Gaull points out, 'The galleries themselves had only limited success but the promise of catalogues based on them stimulated engraving as an art form, the engravings often surpassing the originals in quality and detail.'[26] Boydell's gallery collapsed because the engravers could not deliver their works quickly enough, yet the fact that it faltered on a failure to answer demand is a significant sign of the burgeoning popular visual culture. Charles Lamb resisted this culture and said in an 1834 letter, 'I am jealous of the combination of the sister arts. Let them sparkle apart. What injury (short of the theatres) did not Boydell's Shakespeare Gallery do me with Shakespeare?... to be tied down to an authentic face of Juliet; to have Imogen's portrait; to confine the illimitable!'[27] Lamb and Coleridge's deep scepticism regarding illustration is typical of High Romanticism's privileging of the ear over the eye, the transcendent over the material, the general over the particular, the mind over the body, the visionary over the visible, and may explain the lack of critical interest in exploring the presence of illustration in Wordsworth's text.

Yet, the ghostly presence of the suppressed illustrations may be seen to inform the *Guide* and exert positive influence on Wordsworth's textual supplements. Indeed, the original assignment of providing copytext for the illustrations, which Wordsworth found 'irksome' and that for Dorothy resulted in 'flat' writing can be said to have determined the nature of the important textual additions in later versions of the *Guide*: additions which are among the most powerful parts of the work and more than anything signal Wordsworth's desire to grasp the visual through language in a manner that emulates that of the graphic artist. Having to write in illustration of pictures seems to have caused Wordsworth to think more seriously of ways of finding pleasure in visual representation and to cultivate his powers of description, especially once the illustrations were removed and there was no anxiety of competition from the painter's art. Judging from the nature of the later additions, the removal of the pictures and the assertion of verbal primacy gave Wordsworth a sense of empowerment and liberation that he converted into descriptive strength, thereby foregrounding the materially visible through *enargeia*.

The opening paragraphs to the first section, 'Description of the Scenery of the Lakes', show Wordsworth to be verbally complementing and assimilating a visual mode of representation (unless otherwise noted quotations are from the fifth 1835 edition):

At Lucerne, in Switzerland, is shewn a Model of the Alpine country which encompasses the Lake of the four Cantons. The Spectator ascends a little platform, and sees mountains, lakes, glaciers, rivers, woods, waterfalls, and vallies, with their cottages, and every other object contained in them, lying at his feet; all things being represented in their appropriate colours. It may be easily conceived that this exhibition affords an exquisite delight to the imagination, tempting it to wander at will from valley to valley, from mountain to mountain, through the deepest recesses of the Alps. But it supplies also a more substantial pleasure: for the sublime and beautiful region, with all its hidden treasures, and their bearings and relations to each other, is thereby comprehended and understood at once.

Something of this kind, without touching upon minute details and individualities which would only confuse and embarrass, will here be attempted, in respect to the Lakes in the North of England, and the vales and mountains enclosing and surrounding them. The delineation, if tolerably executed, will, in some instances, communicate to the traveller, who has already seen the objects, new information; and will assist in giving to his recollections a more orderly arrangement than his own opportunities of observing may have permitted him to make; while it will be still more useful to the future traveller, by directing his attention at once to distinctions in things which, without such previous aid, a length of time only could enable him to discover. It is hoped, also, that this Essay may become generally serviceable, by leading to habits of more exact and considerate observation than, as far as the writer knows, have hitherto been applied to local scenery. (*PrW* 2, 170–171)

Wordsworth had first seen this simulacrum of the Alps on his tour with Jones in 1791 and in 1822 he had revisited it. The model is invested with substantial value: it 'affords an exquisite delight to the imagination' and it enables the spectator to comprehend and understand 'the sublime and beautiful region, with all its hidden treasures' 'at once'. The model makes visible for the bodily eye what in the original is hidden from sight. For Coleridge, as we saw above, the visible negated the sublime, which for the (male) High Romantics typically instanced the most ambitious aesthetic goal.[28] To the contrary, for Wordsworth the sublime as well as the beautiful could be rendered visible and subjected to an act of comprehension and understanding that for Coleridge was incommensurate with the sublime. This made Wordsworth less categorically sceptical of the visual and allowed him to invoke it as his model for

verbal description in the *Guide* with the aim of ordering memory and giving a firm ground for new observations.

In the 1810 version that accompanied the engraved images, the second paragraph given above was substantially different:

> Something of this kind (as far as can be performed by words which must needs be most inadequately) will be attempted in the following introductory pages, with reference to the country which has furnished the subjects of the Drawings now offered to the public, adding to a verbal representation of its permanent features such appearances as are transitory from their dependence upon accidents of season and weather. This, if tolerably executed, will in some instances communicate to the traveller, who has already seen the objects, new information; and will assist him to give his recollections a more orderly arrangement than his own opportunities of observing may have permitted him to do; while it will be still more useful to the future traveller by directing his attention at once to distinctions in things which, without such previous aid, a length of time only could enable him to discover. And, as must be obvious, this general introduction will combine with the Etchings certain notices of things which, though they may not lie within the province of the pencil, cannot but tend to render its productions more interesting. (*PrW* 2, 170–171 *app. crit.*)

The first substantial change is from parenthetically mentioning in 1810 the inadequacy of words compared to the visual model to later pointing to the fact that 'minute details and individualities' will be left out of the description. This revision makes a significant difference in how the verbal medium is introduced in the *Guide* as such: while it suggests that words are inferior to and need the visual media of the model and the graphic illustrations in the early version, in later versions Wordsworth says that words are their equals and can substitute adequately for them even though it would make for awkward reading.

The next two substantial differences are the removals of references to the 'etchings'. In both cases, Wordsworth remarks on the different effects and capacities of the visual and the verbal media. The first states that Wordsworth's words will add to the drawings, which represent the 'permanent features' of the scenery, 'such appearances as are transitory from their dependence upon accidents of season and weather'. Although the syntax is problematic, Wordsworth here seems to align the visual with the permanent (space) and the verbal with the transitory (time).

Words can seemingly render the seasonal changeability of nature in a manner that pictures for Wordsworth cannot. This Lessingesque sense that the different media can render different things is elaborated in the last excised passage: 'this general introduction will combine with the Etchings certain notices of things which, though they may not lie within the province of the pencil, cannot but tend to render its productions more interesting'. The paragraph that had begun by stating the inadequacy of words ends by saying that the verbal supplement to the pictures will reveal certain things, which are not in these specific etchings, and perhaps not 'within the province of the pencil, [but which] cannot but tend to render its productions more interesting'.

The sense of verbal superiority Wordsworth almost cannot keep himself from expressing, and his typically High Romantic dislike of working as a secondary illustrator of primary pictures, was expressed in 1810 in the section, 'Of the Best Time for Visiting the Lakes' (in later editions called 'Miscellaneous Observations'):

> In the Introduction to this Work a survey has been given of the face of the country.... I will now address myself more particularly to the Stranger and the Traveller; and, without attempting to give a formal Tour through the country, and without binding myself servilely to accompany Etchings, I will attach to the Work such directions, descriptions, and remarks, as I hope will confer an additional interest upon the Views. (*PrW* 2, 226 *app. crit.*)

Having to follow Wilkinson's pictures made Wordsworth feel like a slave subjected to the 'despotic' 'tyranny' of the bodily eye. This sense of inhibition reflects Coleridge and Lamb's view of the word–image relationship and is in line with traditional accounts of High Romanticism's devaluation of ekphrasis that would make the matter of the text being illustrated unimportant.

Wordsworth sought to 'rebel' against his sense of being bound in a servile manner to the visual images in several ways, which paradoxically seem to have been profitable for the later work on the *Guide*, and by implication the turn to ekphrasis. His rebellion came most directly in the form of a denunciation of the quality of the engravings in a letter to Lady Beaumont, 10 May 1810,

> I am very happy that you have read the Introduction with so much pleasure.... The drawings, or Etchings, or whatever they may be called, are, I know, such as to you and Sir George must be intolerable.

You will receive from them that sort of disgust which I do from bad Poetry, a disgust which can never be felt in its full strength, but by those who are practiced in an art, as well as Amateurs of it.... They will please many who in all the arts are most taken with what is most worthless. I do not mean that there is not in simple and unadulterated minds a sense of the beautiful and sublime in art; but into the hands of few such do prints or picture fall. (*MY* 1, 404–405)

Yet, we should note that Wordsworth denounces the quality of these specific examples as 'intolerable', not the idea and practice of such illustrated books the way Lamb and Coleridge were more inclined to do. He for instance praised his friend William Green's engraved views of the Lake District, published in 1819 as *The Tourist's New Guide to the Lakes*, and was hesitant to agree to help Wilkinson in order not to compete with Green's work (*PrW* 2, 124–125).[29]

Wordsworth rebelled against the engravings in a more indirect manner in the original 1810 version. First of all, in his introductory description of the Lakes modelled on the Alpine simulacrum where he introduced the figure of a wheel with eight spokes to visualise the eight valleys of the Lake District perhaps in verbal competition with and under stimulating inspiration from the idea of graphic illustration. Secondly, in his own word-paintings exemplified for instance at the end of Section Two (Section Three in later editions) where he gives advice on the proper way of planting trees so as not to disfigure the natural scenery:

As to the management of planting with reasonable attention to ornament, let the images of nature be your guide, and the whole secret lurks in a few words; thickets or underwoods—single trees—trees clustered or in groups—groves—unbroken woods, but with varied masses of foliage—glades—invisible or winding boundaries—in rocky districts, a seemly proportion of rock left wholly bare, and other parts half hidden—disagreeable objects concealed, and formal lines broken—trees climbing up to the horizon, and, in some places, ascending from its sharp edge, in which they are rooted, with the whole body of the tree appearing to stand in the clear sky—in other parts, woods surmounted by rocks utterly bare and naked, which add the sense of height, as if vegetation could not thither be carried, and impress a feeling of duration, power of resistance, and security from change! (*PrW* 2, 223)

This 'picture' is an extreme instance of Wordsworthian '*matter-of-factness*' in its enumeration and accumulation of detail. Wordsworth's peculiar '*matter-of-factness*' has often been the object of critical despair. In the *Biographia Literaria*, Coleridge said it contravened 'the very essence of poetry' (Bate & Engell 2, 127) because it was superfluous and could be replaced by a graphic illustration ('what a draughtsman could present to the eye with incomparably greater satisfaction by half a dozen strokes of his pencil, or the painter with as many touches of his brush'). According to William Hazlitt, already in 1798 Coleridge had 'lamented...that there was a something corporeal, a *matter-of-fact-ness*, a clinging to the palpable, or often to the petty, in [Wordsworth's] poetry', at least in the 'descriptive pieces' compared to the 'philosophical' poetry that Coleridge preferred.[30] According to Galperin, the resistance to '*matter-of-factness*' in Wordsworth is due to a fear of 'what the world, either viewed or accidentally admitted, might do to [his] poetry'.[31] The visible world threatens to evacuate the mind from the work which then only aspires to the condition of a mute and 'palpable' thing. This may be observed in the extreme '*matter-of-fact*' passage from the *Guide* where Wordsworth uses words and typographic dashes as a kind of painterly lines to compose an ideal landscape, which is meant to 'impress a feeling of duration, power of resistance, and security from change!' in a manner similar to how he typically saw and valued works of art as permanent and unchangeable.

Wordsworth rebelled against the idea and presumed need for graphic illustration in a less indirect manner when in the third unillustrated and first independently published edition in 1822 he added a passage dealing with 'fleecy clouds resting upon the hill-tops' towards the end of the first section; such clouds, says Wordsworth,

> are not easily managed in picture, with their accompaniments of blue sky; but how glorious are they in nature! how pregnant with imagination for the poet! and the height of the Cumbrian mountains is sufficient to exhibit daily and hourly instances of those mysterious attachments. Such clouds, cleaving to their stations, or lifting up suddenly their glittering heads from behind rocky barriers, or hurrying out of sight with speed of the sharpest edge—will often tempt an inhabitant to congratulate himself on belonging to a country of mists and clouds and storms, and make him think of the blank sky of Egypt, and of the cerulean vacancy of Italy, as an unanimated and even sad spectacle. (*PrW* 2, 191)

Painting is denigrated as mechanical (something 'managed') and the poet's imagination is being upgraded as organic. This is illustrated as Wordsworth presents a verbal rendition of three variations of a cloud formation and its movement ('cleaving to their stations, or lifting up suddenly their glittering heads from behind rocky barriers, or hurrying out of sight with speed of the sharpest edge'). In Wordsworth's paratactic sentence, the three cloud images connected by 'or' are presented as if in simultaneity even though they negate one another in being fixed, moving and disappearing at once. Such an image, he implies, could not be 'managed' in a picture which for Wordsworth should only represent one moment.

This verbal representation of the moving 'spectacle' of various cloud formations sets the stage for the most interesting addition to the fourth edition in 1823, a stunning 'painting' in words that gives closure to the first section and performs with words both what the absent visual representations could perhaps have accomplished if their quality had been sufficiently high, and something more, as Wordsworth expands 'the province of the pencil' and inscribes time and movement into his verbal 'painting'. Yet, he begins by suspending chronological time and invoking the stasis of a moment or 'spot of time' especially 'pregnant with imagination for the poet':

It has been said that in human life there are moments worth ages. In a more subdued tone of sympathy may we affirm, that in the climate of England there are, for the lover of nature, days which are worth whole months,—I might say—even years.... [I]t is in autumn that days of such affecting influence most frequently intervene,—the atmosphere seems refined, and the sky rendered more crystalline, as the vivifying heart of the year abates; the lights and shadows are more delicate; the colouring is richer and more finely harmonized; and, in this season of stillness, the ear being unoccupied, or only gently excited, the sense of vision becomes more susceptible of its appropriate enjoyments. A resident in a country like this which we are treating of, will agree with me, that the presence of a lake is indispensable to exhibit in perfection the beauty of one of these days; and he must have experienced, while looking on the unruffled waters, that the imagination, by their aid, is carried into recesses of feeling otherwise impenetrable. The reason of this is, that the heavens are not only brought down into the bosom of the earth, but that the earth is mainly looked at, and thought of, through the medium of a purer element. The happiest time is when the equinoxial gales are departed; but their fury may probably

be called to mind by the sight of a few scattered boughs, whose leaves do not differ in colour from the faded foliage of the stately oaks from which these relics of the storm depend: all else speaks of tranquillity;—not a breath of air, no restlessness of insects, and not a moving object perceptible—except the clouds gliding in the depth of the lake, or the traveller passing along, an inverted image, whose motion seems governed by the quiet of a time, to which its archetype, the living person, is, perhaps, insensible:—or it may happen, that the figure of one of the larger birds, a raven or a heron, is crossing silently among the reflected clouds, while the voice of the real bird, from the element aloft, gently awakens in the spectator the recollection of appetites and instincts, pursuits and occupations, that deform and agitate the world,—yet have no power to prevent nature from putting on an aspect capable of satisfying the most intense cravings for the tranquil, the lovely, and the perfect, to which man, the noblest of her creatures, is subject. (*PrW* 2, 191–192)

This passage, which Ernest de Selincourt calls 'perhaps the subtlest and most finely wrought passage in the book' (*PrW* 2, 400n), utilises the ancient trope of *enargeia* and seems to emulate and wish to surpass the effect of graphic illustration. It makes us see what is neglected in accounts of Wordsworth that centre on his early iconoclasm and sense of the 'tyranny' of the eye; that in a 'season of stillness, the ear being unoccupied...', the sense of vision becomes more susceptible of its appropriate enjoyments'. If the painter's canvas tended to be a poor surface for the reflection of moving clouds, the mirror of a lake is ideal. This mirroring effect is reflected in Wordsworth's equally gliding prose which duplicates the three-part paratactic or-construction noted above as it references clouds, a traveller, and, in an especially pregnant moment, the spectacle of 'the figure of one of the larger birds... crossing silently among the reflected clouds'. This double image of an image of a bird 'crossing silently' the images of moving clouds—'crossing' suggesting both a kind of blending and marking—leads Wordsworth to state, as succinctly as anywhere in his work, the function and value of visual representation for him: it can satisfy 'the most intense cravings for the tranquil, the lovely, and the perfect, to which man... is subject'.

 Paradoxically, the visual here performs exactly the kind of subjection of the human that Wordsworth would resist according to Geoffrey Hartman. For Hartman, there is in Wordsworth a 'constant concern with denudation, stemming from both a fear of visual reality and a desire for physical indestructibility'; there is, Hartman continues, a 'vast

identity established throughout the poems of Wordsworth, an identity against sight, its fever and triviality, and making all things tend to the sound of universal waters; subduing the eyes by a power of harmony'.[32] For Hartman, Wordsworth's poetry is ultimately hostile to sensuous nature and concerned with the possibility for consciousness to transcend the natural-corporeal world of mutability and death. Hartman has surely located the central current in Wordsworth's Great Decade poetry and identified it as a 'fear of visual reality'. In a key passage in *The Prelude*, for instance, Wordsworth describes a privileged moment in which he 'felt what'er there is of power in sound / To breathe an elevated mood, by form / Or image unprofaned' (1805, II, ll. 321–326), which made him forget that he had 'bodily eyes' (l. 369). As much motivated and energised by attacks on Neoclassical descriptive poetry and the popular, profoundly visually oriented gothic genre, as by the political ideals espoused by the iconoclastic French Revolution, this resistance to the visual came to represent, for Hartman and a number of other Romanticists, what was most authentically Wordsworthian about Wordsworth.[33] Indeed, for Harold Bloom, it signified what was Romantic about Romanticism and what defined the originality of the movement. As Bloom writes, 'The burden of Romantic poetry is absolute freedom, including freedom from the tyranny of the bodily eye, and this freedom appears to have resulted in part from the specifically Protestant influence that made modern poetry possible.'[34] However, this interpretation of Wordsworth typically fails to account for the later work except in terms of a decline into weakness and a failure to maintain imaginative vision. It consequently blinds us to the strength of a new current in the later work which tends towards the visual and towards a positive valorisation of sight as seen when the 'fear of visual reality' and 'identity against sight, its fever and triviality' is replaced in the *Guide* by a need for the clear sight of watery reflections that are indeed seen to reflect and satisfy what Hartman calls Wordsworth's 'desire for physical indestructibility'.

When we read Wordsworth's relationship with visual phenomena in dialectical terms of interchange and cross-fertilisation rather than of silent repression or violent denial, we begin to see that such phenomena as the Alpine model, the wheel metaphor or illustrations present and absent inspire some of the most characteristic and most forceful texts and passages in the later work, such as the 1823 addition to the *Guide*. The return of the visible in the later work, of the capacity to take almost endless pleasure in the reception and production of the illusions of visual representation, does not usurp what Hartman calls the

'identity against sight' that according to him permeates Wordsworth's work; it disrupts it and makes us question whether there is not more than one 'identity' in the *oeuvre*. Having to a large extent overcome his 'fear of visual reality' and learnt how to take pleasure in the sights given in many of the later works, which tend to consist of reports made by a sight-seeing tourist writing primarily to render, not the seeing subject, but the seen world visible through language, Wordsworth saw in the visible the possibility for a fulfilment of what Hartman describes as his 'desire for physical indestructibility' that underpins his creative activity, especially after the orientation towards a posterior reception.

Despite frequent celebrations of the painter's and sculptor's crafts as well as attempts at emulation through ekphrasis and *enargeia*, Wordsworth valued poetry over painting and other products of the visual arts. Yet, his understanding of their relationship is more complex than it is often made out to be. In the Fenwick Note to the 1835 sonnet, 'Composed in Roslin Chapel, During a Storm' (*PW* 3, 266), Wordsworth provided a characteristic comparison of the painter and the poet when he told Isabella Fenwick that

> the movements of the mind must be more free while dealing with words than with lines and colours; such at least ... has been *on many occasions* my belief, and, as it is allotted to few to follow both arts with success, I am grateful to my own calling for this and a thousand other recommendations which are denied to that of the Painter. (*PW* 3, 528; emphasis added)

According to Wordsworth, the painter cannot like the poet evoke the impact of an outside and hence invisible storm on someone inside the church: the painter cannot represent the roof as a space for sublime sounding and resounding the way the poet can and does in the mono-syllabic rhyme-words of the sonnet's octave. Especially the *a*-rhymes (*clank, sank, blank, bank*) give the impression of a cacophony of 'harsh' sounds, which a storm may be imagined to make to someone inside a church building. At least, the rhymes reinforce the poem's subject, which is the 'music' made by the storm on the 'organ' of the church building. Although we must temper it with Wordsworth's own qualific-ation ('on many occasions'), he would typically 'not allow the plastic artist of any kind to place himself by the side of the poet as his equal', as his friend and travelling companion, Henry Crabb Robinson, reported in a letter to Barron Field after the tour to Italy in 1837.[35]

Already in 1820, Crabb Robinson had noted an impression of Wordsworth's understanding of the hierarchy between poetry and the plastic arts during a visit to the British Museum:

> I did not perceive that Wordsworth enjoyed much the Elgin Marbles, but he is a still man when he does enjoy himself and by no means ready to talk of his pleasure except to Miss Wordsworth. But we could hardly see the statues. The Memnon, however, seemed to interest him very much. I have thought that Wordsworth's enjoyment of works of art is very much in proportion to their subserviency to poetical illustration. I doubt whether he feels the beauty of mere form.[36]

Wordsworth's apparent lack of response to the Elgin Marbles may have been due simply to poor viewing conditions either because of darkness or the crowd that would be present in the temporary gallery, which had opened in 1817 (in use until 1831). Or perhaps Wordsworth just had a problem with sculpture. As Crabb Robinson told Barron Field in 1837, 'His eye for colour seems more cultivated than his sense of form: at least the picture galleries were more attractive to him than the museums of sculpture.'[37] His taste for sculpture may also simply have been more eclectic and less highbrow than that of Crabb Robinson's and other connoisseurs at the time, who had learned to praise the classical, Hellenistic Elgin Marbles as the epitome of 'fine art'.[38] Hence his interest in the Egyptian Memnon (actually the head of Ramses II), which had been brought to the Museum in 1817 by Giovanni Belzoni.[39] Many did not consider the Egyptian works fine art and Wordsworth's 'interest' in them (as objects of curiosity rather than forms of beauty) may explain Crabb Robinson's sense that Wordsworth was incapable of 'feeling the beauty of mere form'. Yet, another explanation may simply be that he had already seen and praised the Elgin Marbles and was more interested in the Egyptian novelty. In December 1815, he had written to the first and most ardent supporter of the Elgin Marbles, the history painter Benjamin Robert Haydon, 'I am not surprised that Canova expressed himself so highly pleased with the Elgin Marbles. A Man must be senseless as a clod, or perverse as a Fiend, not to be enraptured with them' (*MY* 2, 257–258).

As the letter to Haydon indicates, in his later years Wordsworth was immersed in the visual art culture of Romanticism and had learned to value the plastic arts very highly. Indeed, he was actively seeking to integrate them into his poetic works even if they were to take up a subservient, servile position. In October 1836, referring to the revised

multivolume collected works edition being published by Edward Moxon, Wordsworth wrote to the artist, Thomas James Judkin, 'I am truly sensible to your kind offer to assist in illustrating my Poems It is now too late for the present Edition, but I shall nourish the hope that at some future time our labours may be united in a manner so agreeable to my feelings' (*LY* 3, 306). Later he wrote to Moxon and suggested that in future editions they might 'try [their] fortune with illustrations. Both Mr [Frank] Stone and Mr Judkin have [offered?] drawings gratis—an artist whom I met with the other day promised to send me a finished drawing from a sketch which he had made of the Valley in which I have placed the Solitary and which would be an appropriate ornament for the Excursion' (*LY* 3, 318). This typical Wordsworthian desire to reduce costs by getting illustrations for nothing hides a less typical positive espousal of the presence of visual images in his books. The hierarchy and production sequence is clearly in favour of the word over the image, of the poet inspiring and controlling the painter in an inversion of how the *Guide* was produced. In the letter to Judkin, Wordsworth was writing to acknowledge the receipt of a painting which it appears he had a hand in designing, 'Your Picture was very welcome, I think it decidedly improved by the suggestions you were kind enough to work upon, and by the additional figure' (*LY* 3, 306). Yet, Wordsworth's espousal of illustration and his sense that his and Judkin's 'labours may be united in a manner so agreeable to my feelings' still problematises the usual understanding of Wordsworth's view of illustrated books.

Wordsworth's wish for an illustrated edition may be contrasted to a letter he had written to Moxon in May 1833, where he said that 'It is a disgrace to the age that Poetry wont sell without prints', and continued: 'I am a little too proud to let my Ship sail in the wake of the Engravers and the drawing-mongers' (*LY* 2, 617). This letter is in tune with the typical account of Wordsworth on illustration which is based on a late sonnet, 'Illustrated Books and Newspapers' (1846):

> Now prose and verse sunk into disrepute
> Must lacquey a dumb Art that best can suit
> The taste of this once-intellectual Land.
>
> Avaunt this vile abuse of pictured page!
> Must eyes be all in all, the tongue and ear
> Nothing? Heaven keep us from a lower stage!

> (*PW* 4, 75)

Despite this animosity (which registers, for example, in the '*dumb* Art' as a derogatory variation on mute), the subject of illustration was evidently one that Wordsworth was also positively attracted to. Wordsworth did not, in a reactionary manner, condemn and wish to ban illustration *per se*. He may have taken offence over certain examples in the ephemeral press. Not until the mid-1830s did newspapers regularly provide illustrations of the events they reported. In 1840, the *Penny Sunday Times*, as Richard Altick points out, 'pleased its semiliterate public with crude illustrations depicting the murders, child kidnappings, armed robberies, and other violent occurrences with which its columns were filled. But the sixpenny *Illustrated London News*, begun two years later, was the first to make a policy of subordinating text to pictures'.[40] But primarily he worried that the eye might become more important than the ear and render it superfluous as an organ of sense. 'Must eyes be *all in all*' is no longer a simple reflection of the 'tyranny' of the eye. It is a recognition that the eye is vital, but that the eye and the ear must co-operate rather than compete.[41] Gillen D'Arcy Wood presents a too simple view of Wordsworth's complex relation to graphic illustration when he sides Wordsworth with Coleridge and Lamb and claims, merely on the basis of 'Illustrated Books and Newspapers', that

> as late as the 1840s, the literary elite continued to actively resist the cultural influence of new visual media. Like the public spectacles of the theater and the panorama, the increasingly popular illustrated book engaged the eye rather than the mind and imagination. For Romantic writers, it symbolized the spread of an infantilizing visual medium to the domestic sphere and, more seriously still, the encroachment of the visual arts onto literature's sovereign domain, the printed book.[42]

Wordsworth actively resisted being dictated by visual art of poor quality, yet he did not unequivocally resist illustration or visual media just because they were visual.

Crabb Robinson registered the later Wordsworth's enhanced understanding of the plastic arts when he reported from an 1828 visit first to the National Gallery and next to the British Institution: 'A long lounge over the pictures. Wordsworth is a fine judge of paintings and his remarks are full of feeling and truth. We afterwards went to the British Institution, where we also lounged a long time over a glorious collection of the Old Masters—a very fine collection.'[43] According to Robert P. Graves, Wordsworth at one point said that

there were three callings, for success in which Nature had furnished him with qualifications—the callings of poet, landscape-gardener, and critic of pictures and works of art.... As to works of art, his criticism was not that of one versed in the 'prima philosophia', as he called it; and it was, as it appeared to me, of the highest order.[44]

This art critical interest and talent was registered by William Hazlitt in *The Spirit of the Age*: 'We have known him to enlarge with a noble intelligence and enthusiasm on Nicolas Poussin's fine landscape-compositions, pointing out the unity of design that pervades them, the superintending mind, the imaginative principle that brings all to bear on the same end',

> His eye also does justice to Rembrandt's fine and masterly effects. In the way in which that artist works something out of nothing, and transforms the stump of a tree, a common figure into an *ideal* object, by the gorgeous light and shade thrown upon it, he perceives an analogy to his own mode of investing the minute details of nature with an atmosphere of sentiment; and in pronouncing Rembrandt to be a man of genius, feels that he strengthens his own claim to the title.[45]

Wordsworth, in other words, at times did not insist on the inferiority of 'the plastic artist' or always hold that pictures must be subsumed by poetry and serve only as secondary illustration. Instead of insisting on *ut musica poesis* he sometimes openly engaged in the game of *ut pictura poesis* wherein he identified with certain painters both in terms of technique and in terms of possessing genius. In the sonnet he wrote to Haydon in 1815 and included in the letter that mentioned the Elgin Marbles, Wordsworth saw the two kinds of artists as equals even if their means or 'instruments' of expression differ:

> High is our calling, Friend!—Creative Art
> (Whether the instrument of words she use,
> Or pencil pregnant with ethereal hues,)
> Demands the service of a mind and heart,
> Though sensitive, yet, in their weakest part,
> Heroically fashioned—to infuse
> Faith in the whispers of the lonely Muse,
> While the whole world seems adverse to desert.
>
> (*PW* 3, 21)

Haydon naturally took delight in this sonnet and in what Robert Woof has described as Wordsworth's 'bracketing together [of] poet and painter as creatures equal in high creative impulse'.[46] As he wrote to Wordsworth in December 1815, 'every other poet has shown a thorough ignorance of its nature before—seeming not to know that the mind was the source the means only different—if for this only, you will have the gratitude of every painter'.[47] As Haydon said of Wordsworth in 1842, 'His knowledge of Art is extraordinary, he detects errors in hands like a connoisseur or artist.'[48]

Wordsworth's acquired knowledge of art was also demonstrated in his 1826 poem, 'The Pillar of Trajan' (*PW* 3, 229–231). It is an ekphrasis of the impressive thirty-metre tall Pillar of Trajan, which still stands in Rome where it was first erected in the early second century (AD 107–113). The poem was first published in 1827 among the 'Poems of Sentiment and Reflection', and in 1845 it was reclassified and printed in the important position as concluding poem in the *Memorials of a Tour in Italy, 1837*, which were first published in 1842 among the *Poems, Chiefly of Early and Late Years*. Wordsworth had not seen the Pillar of Trajan in 1826 and based his account on written evidence and possibly engraved reproductions that proliferated; but in 1845, after visiting it with Crabb Robinson, he saw that it suited the touristic and visually overdetermined sequence of Italian poems.

'The Pillar of Trajan' reads like Wordsworth's version of Keats's 'Ode on a Grecian Urn'. The urn's 'leaf-fringed legend' haunting about its shape is typically taken to mean that Keats sees the urn as inscribed with ornamental letters formed like leaves. Keats's use of Nature as a metaphor for Art is then read as characteristically late Romantic, as inspired by his immersion in contemporary art and museum culture, and as a departure from Wordsworth's first-hand use of nature.[49] Yet, we can observe the same thing in 'The Pillar of Trajan':

> Historic figures round the shaft embost
> Ascend, with lineaments in air not lost:
> Still as he turns, the charmed spectator sees
> Group winding after group with dream-like ease;
> Triumphs in sun-bright gratitude displayed,
> Or stealing into modest shade.
> —So, pleased with purple clusters to entwine
> Some lofty elm-tree, mounts the daring vine;
> The wood-bine so, with spiral grace, and breathes
> Wide-spreading odours from her flowery wreaths.

<div align="right">(ll. 13–22)</div>

The Pillar is famous for its row of numerous images which spiral upwards in a helix depicting the Emperor Trajan's campaigns and victories ending with a statue to crown it. Two natural phenomena, vine and woodbine, are used by Wordsworth as metaphors to describe the way in which the images thus wind themselves around the pillar. This is an instance of a chiasmic reversal in the transition from earlier to later Wordsworth whereby the hierarchy of nature and art seems to be reversed, and art takes up a position over nature. As Peter Manning points out, in his later phase Wordsworth 'became increasingly concerned with problems of representation and cultural transmission, [and] ekphrastic poems, rare at the outset of his career, crop up with some frequency. Meanings once inscribed on the natural landscape . . . now shelter in art'.[50]

'The Pillar of Trajan' is composed in the heroic couplet. The prosaic explanation is that Wordsworth wrote it as an example of a poem that might have competed for the so-called Newdigate Prize, a competition instituted in 1806 at Oxford for students to write the best poem on a classical Greek or Roman work of art or architecture.[51] Wordsworth of course did not participate in the competition and merely wrote the poem to show his twenty-two-year-old son, John, then at Oxford, how such a thing might be done. With one exception, the couplets in 'The Pillar of Trajan' are closed. They are not as closed as they tend to be in Dryden or Pope, as signalled by the fact that the very first line runs over ('Where towers are crushed, and unforbidden weeds / O'er mutilated arches shed their seeds'). But they are not as open as in Keats, who famously enjambs a series of couplets in opening *Endymion* (1818) in imitation of earlier romance poets' use of the so-called 'romance couplet'. In an 1819 letter, Wordsworth expressed his 'detestation of couplets running into each other, merely because it is convenient to the writer;—or from affected imitation of our elder poets. Reading such verse produces in me', he says, 'a sensation like that of toiling in a dream, under the night-mare. The Couplet promises rest at agreeable intervals; but here it is never attained—you are mocked and disappointed from paragraph to paragraph' (*MY* 2, 547). Often, the first line of a couplet in 'The Pillar of Trajan' is run over without punctuation, yet with almost no exception the second line is terminated either with a full stop or a semicolon. The closed nature of Wordsworth's couplets suggests the classical Augustan virtues of control and restraint and may thus be said to match the 'classical' work of art they represent and build up.

Just as the Pillar ends with something special, the statue of Trajan (in fact substituted in 1587 by one of St Peter), so the poem ends with something special in the form of a remarkable variation on what has

by then become an almost unbearably regular couplet pace: the second line of the penultimate couplet is run over, the only of its kind in the entire poem:

> Still are we present with the imperial Chief,
> Nor cease to gaze upon the bold Relief
> Till Rome, to silent marble unconfined,
> Becomes with all her years a vision of the Mind.

> (ll. 70–73)

Far from a result of what Wordsworth would call a writer's 'convenience', this perfectly timed enjambment of two couplets—which disrupts our expectation of 'rest at agreeable intervals'—gives a colossal sense of release, openness and liberation, which the poem calls 'unconfinement'. This release is captured in the pun on 'relief' and enacted metrically by the use of an alexandrine as closing line, which inscribes an extra foot to both contain and release, in a word, to 'unconfine' the most important thing in the poem and in normative High Romanticism: 'the Mind'. Yet, now 'vision' and 'Mind' have been solidly anchored and externalised in the material and visible world of art.

Due to its placement between two libraries from where spectators could view its upper images, the Pillar is usually taken to imitate a partly unrolled scroll. The Pillar is a kind of poem, a visual epic that relates Trajan's history. In the book Wordsworth used as his main source, Joseph Forsyth's *Remarks on Antiquities, Arts, and Letters, during an Excursion in Italy in 1802–3* (1813), it is said that the Pillar should be 'considered as a long historical record to be read round and round a long convex surface'.[52] Just as the monumental Pillar is like a text, so the text about the Pillar assumes monumental and sculptural contours. In ekphrastic poems, the verbal representation of the act of seeing a visual representation may cause the reader to begin to look at the words of the poem and to attend to them as if they were of the same ontological nature as the represented art object. We are encouraged to do so by the fact that the poem refers to its art object not only as a 'pillar' in the title and in line 35, but also as a 'Column' (l. 6). If we activate the pun, we get the sense in which a two-dimensional printed column on the page may iconically imitate a three-dimensional free-standing column. That Wordsworth calls the object one thing in the title and another in the poem merely reflects general practice, which too reveals confusion whether to call it a pillar or a column. Yet, a poem is of course

not ordinary speech, in which verbal confusion may be just that; in a poem, such apparent confusion often contains vital leads to the poem's significance. In 'The Pillar of Trajan', the art object described is surely called both a column and a pillar to suggest the textuality of the pillar and the spatiality of the poem's column.

What Wordsworth values about the Pillar is its permanence and capacity to remain after the death of speech. Towards the end of the poem Wordsworth asks: 'Where now the haughty Empire that was spread / With such fond hope? her very speech is dead' (ll. 65–66). The Empire's fall is illustrated by the fact that Rome's 'very speech is dead'. While it obviously refers to Latin as a dead language that does not live in speech but only remains as written text, it has a certain resonance for the poet who had fashioned himself as a 'man speaking to men'. After the death of speech, the statue representing the quintessential Romantic type of the overreacher remains: 'Yet glorious Art the power of Time defies, / And Trajan still, through various enterprise, / Mounts, in this fine illusion, toward the skies' (ll. 67–69). In an analysis of the 'Ode on a Grecian Urn', A. W. Phinney points out that Keats 'countered his failure to find a large contemporary public by placing his hopes in poetic immortality', and that 'A confrontation with the art of the past ... represented a confrontation with the destiny he had willed for himself.' As Phinney continues, 'Looking at an image of the past, the poet who aspires to immortality cannot help but see his own future image. Thus the "Ode on a Grecian Urn" looks not only toward the past but toward the future as well, encoding in itself an allegory of its reading.'[53] In the permanent Pillar, which is presented as a visual text and subjected to reading (l. 15), Wordsworth similarly perceived a model for a poetry written for posterity which he aimed to absorb and assimilate through ekphrasis. The artwork offers what the verbally mediated images of nature offer in the *Guide*: permanence, stability and an idea of indestructibility which Wordsworth wished to confer upon his own work in the interest of securing its posterior survival.

In another characteristic late touristic poem, the sonnet 'Brugès' from the *Memorials of a Tour on the Continent, 1820*, Wordsworth writes:

> The Spirit of Antiquity—enshrined
> In sumptuous buildings, vocal in sweet song,
> In picture, speaking with heroic tongue,
> And with devout solemnities entwined—
> Mounts to the seat of grace within the mind

(PW 3, 165)

Buildings, paintings and monumental sculpture evidently spoke to and inspired the later Wordsworth. Their materiality gave them a permanence that enabled them to transcend the moment of production and promised the survival of the 'spirit' of the past. Wordsworth's historical consciousness undoubtedly led him to draw a parallel between this articulate sense of the presence of the past in material objects and the possibility of securing the presence of 'himself' in a similar future situation. Wordsworth's attraction to the visual was an attraction to the materially permanent, and it was both spurred by and in turn spurred his desire to produce an equally permanent ekphrastic work that might endure beyond himself; that might be an extension of himself beyond himself in the doubling of the statue that remains, like a written and printed text, after the death of the speaker.

2
Typographic Inscription: The Art of 'Word-Preserving' in Wordsworth's Later Inscriptions

One of the most interesting and productive paradoxes in Wordsworth is that he was, on the one hand, a self-proclaimed 'man speaking to men', who seems to have abhorred the physical act of writing and in 'The Tables Turned' (1798) biblioclastically associated books with 'a dull and endless strife' (Brett & Jones, 105). And yet, on the other hand, he was deeply fascinated by the visible, tactile and permanent language of material inscriptions and epitaphs, and in 'Personal Talk' (1807) impersonated the bibliolater:

> books, we know,
> Are a substantial world, both pure and good:
> Round these, with tendrils strong as flesh and blood,
> Our pastime and our happiness will grow.

> *(PW* 4, 74)

A rich critical tradition has established Wordsworth's epitaphic and inscriptional tendency (if not his related bibliophily) as one of the most fascinating aspects of his work.[1] Yet, the significance of this peculiar tendency, which decentres the more well-known tendency towards orality and offers a sense of Wordsworth's real complexity, has not been fully accounted for because it has not been seen in terms of self-revisionary changes in the career. Geoffery Hartman emphasised the earliest inscriptions and described how they facilitated Wordsworth's more mature lyrics, while Ernest Bernhardt-Kabish undertook an examination of the inscriptional or 'monumental' tendency in relation to the career, but concluded that the earlier and the later parts were 'fused in an overriding unity' by this tendency.[2] Given the general neglect of

the later Wordsworth, no critic has looked for changes and new depar-
tures in the later inscriptions. However, when studied in the light of the
recognition that he was writing for posterity, certain differences can be
identified between the earlier and the later inscriptions as well as in the
use and understanding of the book rather than the monumental stone
as the ideal medium for the inscriptional and epitaphic poetry.

As he internalised posterity as audience, Wordsworth increasingly
began to envision poetic composition also in terms of writing rather
than solely speaking. This tendency culminated in the three *Essays upon
Epitaphs* composed around 1810 and published partly in Coleridge's
The Friend and as a note to *The Excursion*. Along with the *Guide to
the Lakes*, these essays signal certain changes and new departures in
Wordsworth's aesthetics. Yet, to preclude the false notion of a sudden
rupture in Wordsworth's poetic thinking due to the conscious reorienta-
tion towards posterity, we may begin by considering how two fragments
relating to *The Prelude* (c.1799) problematise the idea of a spontan-
eous and vocal outpouring as a sufficient model for poetic composition,
and propose a supplementary form of poetic productivity suggestive of
inscription:

> nor had my voice
> Been silent—often times had I burst forth
> In verse which with a strong and random light
> Touching an object in its prominent parts
> Created a memorial which to me
> Was all sufficient, and, to my own mind
> Recalling the whole picture, seemed to speak
> An universal language. Scattering thus
> In passion many a desultory sound,
> I deemed that I had adequately clothed
> Meanings at which I hardly hinted, thoughts
> And forms of which I scarcely had produced
> A monument and arbitrary sign.
>
> In that considerate and laborious work,
> That patience which, admitting no neglect,
> [By?] slow creation doth impart to speach
> Outline and substance, even till it has given
> A function kindred to organic power—
> The vital spirit of a perfect form

> (*Prelude*, 495)

The latter fragment prefigures the poetics of the epitaph as formulated in the *Essays upon Epitaphs*, where the inscriptional poetic of the later Wordsworth was laid out. The 'considerate', 'laborious', 'patien[t]' and 'slow' work of 'creation' may in other words be read as the work of engraving Wordsworth described in the first *Essay upon Epitaphs*, where he attended to the way in which writing surface and text ideally reflect one another and indicate the 'slow and laborious hand' of the engraver:

> The very form and substance of the monument which has received the inscription, and the appearance of the letters, testifying with what a slow and laborious hand they must have been engraven, might seem to reproach the author who had given way upon this occasion to transports of mind, or to quick turns of conflicting passions. (*PrW* 2, 59–60)

This work of material inscription can be seen as equivalent to the 'laborious work', which '*doth* impart to speach / Outline and substance'.[3] For Wordsworth, inscription enshrines speech, consummates it for future use and produces a 'perfect form' that may survive. Poetry grounded on such poetological considerations, as J. Douglas Kneale puts it, 'acknowledges the passing from living voice to the dead letter but seeks to outlive this death through the epitaphic permanence of writing that aspires to the phonocentric immediacy of speech'.[4] This epitaphic, written voice is divorced from the poet's body (note the absence of the 'I' and other personal pronouns in the second fragment, a remarkable absence compared to the no less than eight self-references in the first fragment) and wedded to the more permanent surface of monumental stone.

Writing outlines speech, it fixes, externalises and visualises it in poetic lines, which have a substantiality not inherent to speech, but which for Wordsworth was not alien to speech either. In a November 1811 letter to George Beaumont, who had asked Wordsworth to write an inscription in Beaumont's name to commemorate Sir Joshua Reynolds, Wordsworth legitimised such authorial subterfuge. 'It did always appear to me', said Wordsworth,

> that inscriptions, particularly in Verse or in a dead language, were never supposed *necessarily* to be the composition of those in whose name they appeared. If a more striking or more dramatic effect could be produced, I have always thought that in an epitaph or memorial of any kind a Father or a Husband etc., might be introduced speaking,

without any absolute deception being intended: that is, the Reader is understood to be at Liberty to say to himself; these Verses, or this Latin, may be the composition of some unknown Person, and not that of the Father, Widow, or Friend, from whose hand or voice they profess to proceed. If the composition be natural, affecting or beautiful, it is all that is required. (*MY* 1, 516)

Of even more interest than Wordsworth's legitimisation of the unRomantic practice of ghost-writing and the extinction, as opposed to the expression, of authorial personality it entails (something Wordsworth seems to have had less trouble with at this stage in his career), is surely the conflation, 'hand or voice'. Hand (a metonymy for writing) and voice (a metonymy for speech) were ultimately equivalent to Wordsworth: they are indexical signs based on physical contiguity and direct cause and effect of the presence of the author; they are adequate substitutes for the author, who may be entirely different from the 'persona' who is 'introduced speaking'. This is not to say that Wordsworth would wish to regressively substitute a chirographic and assumedly personal manuscript for a technologically reproduced and assumedly impersonal printed copy, at least judging from a letter he wrote in 1816, where he recognised that 'Poetry reads so much better in Print than in MSS' (*MY* 2, 287). According to Wordsworth, the qualities of the inscribing and engraving 'hand' were translatable into print.

The production of this 'monumental writing' (*Prelude*, 1805, XI, l. 295) which arrests presence and enshrines voice is predicated on the writer's mind being composed and not subject to waywardness and whimsical movements of thought and emotion. No 'transports of mind' or 'quick turns of passion' are allowed in epitaphic writing. As Wordsworth said in the third *Essay upon Epitaphs*, 'in a permanent Inscription' one should only admit 'things...that have an enduring place in the mind' (*PrW* 2, 88). When we intend 'to raise a monument', it must be remembered that it

is a sober and reflective act; that the inscription which it bears is intended to be permanent, and for universal perusal; and that, for this reason, the thoughts and feelings expressed should be permanent also—liberated from the weakness and anguish of sorrow which is in nature transitory.... The passions should be subdued, the emotions controlled; strong, indeed, but nothing ungovernable or wholly involuntary. (*PrW* 2, 59–60)

Writing surface and the materiality of the inscription are both permanent and publicly available for visual reading. Because of this permanence and universal availability, the 'content' of the inscription is also called upon to be permanent. Writing surface, mode of inscription and intended audience can almost be seen to generate what may be said in an epitaph and how it may be said. This passage spells out a poetic almost symmetrically opposed to one of 'spontaneous overflow' and the pouring out of subjective emotion and reflects David Simpson's sense that 'Much of [Wordsworth's] later writing seems to articulate a rhetoric of stability.'[5] To the extent that the master trope of the later Wordsworth is the poem as a 'speaking monument', this is a self-characterisation of the poet as an ageing person who has left behind the ambition of being a 'man speaking to men' in a direct and unmediated manner. The future role of the unknown and anonymous reader *as reader*, the fact that the inscription will be for 'universal perusal', plays an important role in the formulation of this impersonality theory of poetry, which combats a subjectivist theory of pure, self-expressivist aeolianism.[6] In the *Essays upon Epitaphs*, we see the later Wordsworth as a 'man writing to posterity' intensely conscious of the need to integrate writing surface, writing and meaning around the central quality of permanence in the interest of a future audience of silent readers envisioned as gazing at and not just listening to the poem on the page.

A blank verse poem composed in 1826 articulates Wordsworth's later poetic of writing to posterity and positions the reader within the poetic text as its reason for being and condition for remaining. It opens with a comparison between roads left behind in Britain by the Roman Empire and a path left behind on a mountain side by the 'speaker' of the poem:

> THE massy Ways, carried across these heights
> By Roman perseverance, are destroyed,
> Or hidden under ground, like sleeping worms.
> How venture then to hope that Time will spare
> This humble Walk?

> (*PW* 4, 201, ll. 1–5)

Although an expectation has been raised, the following lines do not present an explanation of why the fate of the walk may be different from the fate of the Roman ways. Instead, they merely give an account

of its origin in which it is implied that the reason why the walk will survive is that it was first shaped by a poet's hand in unstated contrast to the hand that shaped the Roman ways:

> Yet on the mountain's side
> A POET'S hand first shaped it; and the steps
> Of that same Bard—repeated to and fro
> At morn, at noon, and under moonlight skies
> Through the vicissitudes of many a year—
> Forbade the weeds to creep o'er its grey line.

> (ll. 5–10)

This initial 'yet' suggests but does not state that the walk deserves to be spared by time because it was fashioned by a poet rather than a foreign invading military force. The poem goes on to declare that in the future the poet will no longer be present to forbid 'the weeds to creep o'er [the] grey line' of the walk; the poet will no longer compose as he walks 'to and fro', 'No longer, scattering to the heedless winds / The vocal raptures of fresh poesy / Shall he frequent these precincts' (ll. 11–13). And the concluding lines 'consign / This Walk, his loved possession, to the care / Of those pure Minds that reverence the Muse' (ll. 20–22). These 'pure Minds' will ideally keep the walk from sharing the fate of the Roman roads.

When it was first published in *Yarrow Revisited* (1835), the poem was entitled 'Inscription', but in later collected editions it appeared untitled. The reason for this may be that in the later editions it was placed among the class of Inscriptions which was introduced in the edition of 1815, and that Wordsworth simply wanted to avoid using the same title to denote a class and an individual poem. The titles to Wordsworth's inscriptions are usually characterised by the elaborateness with which they gesture towards the inscriptional site and detail the surface and tool of writing. An extreme example is 'Lines. Written with a Slate-pencil upon a Stone, the largest of a heap lying near a deserted Quarry, upon one of the Islands at Rydale' from *Lyrical Ballads* (1800). As J. Hillis Miller notes, these 'titles, almost longer than the poems they name, are striking in the extreme circumstantiality of detail with which they identify the act whereby the poem was given physical existence.... This precision suggests that the most important aspect of these particular poems may be the act of writing them.'[7] If these long, circumstantial titles are closer to the Wordsworthian as well as generic norm, a basic, rudimentary title such as 'Inscription', which appears to simply call attention to the

poem's genre or class, begins to have a disruptive function.[8] The title 'Inscription', more than the longer title, alerts us to the possibility that this is a poem as much *about* inscription as such as it is an instance *of* an inscription.

The poem is about the silencing of poetic speech ('No longer, scattering to the heedless winds / The vocal raptures of fresh poesy') and its more or less accidental transformation into a kind of inscriptional writing. The poem is about even as it is also an example of the trace, which is the unintended effect of Wordsworth's compositional technique of walking 'to and fro' while speaking out loud.[9] In typical Romantic fashion, process and product fuse through the semantic ambivalence of 'walk': its meaning as an intransitive verb signifying the process of walking (to walk) is also its meaning as a noun (a walk), which names the substantial product of the act of walking. The basic trope of the poem implies that unlike the roads left behind by the Roman Empire, which have been destroyed or buried in intervening years and thus lost their use value, the path which the poet's hand has traced upon the mountain side will survive and continue to be of use given the presence of what the poem calls 'those pure Minds that reverence the Muse'. Those 'pure Minds', however, should not merely revere this walk because it is the place where the poet composed his poetry and because the walk provided him with the inspiration to do so enabling them to follow in his footsteps. They should revere the walk because it *is* what remains after the poet has spontaneously overflown in 'vocal raptures of fresh poesy', that is, after he has orally created and performed poetry which, however, nobody hears—this poet composes in his own company. Afterwards, there is nothing but the 'grey line' 'shaped' by 'A POET's hand'; there is the trace of speech—text.

Wordsworth surely puns on 'line' to suggest and establish a certain similarity between a written line of poetry and 'This humble Walk': between the 'grey line' shaped in nature by his hands and feet and the lines of the inscription. The place of intersection between these two kinds of lines is when the dash that ends line 9 is immediately followed by the line that is ended by the word 'line': in other words, when the word 'line' is placed in a rhyming position with its equivalent punctuation mark to suggest that we are meant to be as much looking at *these* lines—as lines—as we are meant to be listening for the oral antecedent, the poet's 'vocal raptures'. This dash was inserted in the 1836 revisions along with five additional dashes. Looking at the already printed poem, Wordsworth underlined the poem's visual appeal on the page.[10] Blank verse—this inscription's metre—surely is not meant

to rhyme, yet Wordsworth silently reminds us of one of the senses in which blank verse, as Dr Johnson said of Milton, is 'verse only to the eye'.

The implied context of 'Inscription' is that just as the Romans eventually were forced to leave Britain, so Wordsworth (speaking biographically) had to leave the place where he had traced this 'grey line' and inscribed himself in nature. This was his motive for composing the inscription. The inscription, we are informed by pre-textual material in the form of an MS note, was 'Intended to be placed on the door of the further Gravel Terrace if we had quitted Rydal Mount' (*PW* 4, 201). We may safely assume that Wordsworth in 1826 had this specific inscriptional surface in mind.[11] However, the poem never reached its destination because the Wordsworths were not obliged to 'quit' Rydal Mount in 1826, though there had been a fall-out with the landlord, Lady Fleming.[12] Instead of being inscribed on the door in 1826, it was inscribed on the page of *Yarrow Revisited* in 1835. Yet, because it does not—surprisingly—bear a circumstantial title designating its intended inscriptional site (e.g. by using the MS note as title), the inscription assumes new significance on the page, where (in a manner similar to 'The Pillar of Trajan') it writes an allegory of late Wordsworth's understanding of poetic production, transmission and reception and in fact opens itself to a more complex reading, which substantiates what the poem itself tells us: that the poem is the walk and the book the mountain, whose 'side' is the surface of the page. *Because* we meet the inscription in the context of a printed collection of poetry and not where it was 'intended' to be placed—because not least of the pun on 'line'—the situational deictic 'this' (in 'this Walk, his loved possession') changes its point of reference from the intended surface of the door to the page. The walk in other words takes on metaphorical significance as the poem and the 'pure Minds that reverence the Muse' become a figuration of posterity, not of the accidental tourist-pilgrim going to the Lake District in search of traces of the famous poet.

Although its visual, silent materiality is crucial to its meaning, we are surely meant to vocalise 'Inscription' in the manner Wordsworth tells us to vocalise another inscription, 'Inscribed Upon a Rock' (1820), which begins:

> PAUSE, Traveller! Whosoe'er thou be
> Whom chance may lead to this retreat,

> Where silence yields reluctantly
> Even to the fleecy straggler's bleat;
>
> Give voice to what my hand shall trace,
> And fear not lest an idle sound
> Of words unsuited to the place
> Disturb its solitude profound.

<div align="center">(PW 4, 204)</div>

This is the second of a series of five 'Inscriptions Supposed to be Found in and Near a Hermit's Cell', which follows 'Inscription' in the class of Inscriptions in the collected works. In this context, and due to the similar emphasis on the writing hand, it reads as a reflection upon the preceding inscription. In 'Inscribed Upon a Rock', inscription and reception are brought into the closest possible proximity in the use of the auxiliary in '*shall* trace': reading something which we have already been told is an inscription (twice, in both titles), and which indeed *is* an inscription, we are told to vocalise an inscription that has not yet been traced, but which will be traced before our eyes as we read. Reading becomes almost a kind of writing, at once a visual and an aural experience. The first two stanzas are not part of the inscription 'proper', which follows in stanzas 3–6. However, before we realise that we are not reading the inscription 'proper' (stanzas 3–6), we cannot but read Wordsworth's poem (stanzas 1–6) itself as an inscription. We do so not only because of the title, but because of the use of the epitaph-inscriptional convention *par excellence*, the call to the unknown reader to stop and read, 'Pause, Traveller!' (*siste viator*).

The traveller through Wordsworth's text is told to stop and read aloud an inscription that is about to be traced before his or her very eyes even as he or she is already looking at Wordsworth's inscription. From one point of view, this Chinese-box structure may be read as a kind of denial or repression of the writtenness of Wordsworth's poem compared to the inscription he is about to 'trace'; yet from another point of view, one that takes its cue from the 'supposed' in the title to the series, it may be read as a recognition that Wordsworth's poem itself is an inscription whose call to vocalise is decoded in silence: even if this act of silent reading, if we follow the call of the text, will lead to a vocalisation of the inscription 'proper'. In other words, Wordsworth both endorses and resists silent reading by recognising that, for the call for vocalisation to have any effect upon 'posterity', it must occur in a writing whose mode of reception is silent and visual and precedes vocalisation. Wordsworth's poetry may be

intended for oral delivery and vocalisation, but vocalisation depends on a material inscription that precedes speech.

Wordsworth's later inscriptions can be distinguished from the earlier inscriptions by their increased use and awareness of the page as writing surface and printing as the actual tool of 'inscription'. This is seen implicitly in 'Inscription' and more explicitly in the strange doubleness of 'Inscribed Upon a Rock'. The distinction also obtains in the fact that the later inscriptions emphasise the paradoxical survival of the inscription despite the inevitable temporal fate of the surface, its title may inform us, it is supposed to be inscribed upon. The earlier inscriptions, as Cynthia Chase and Linda Brigham have suggested, tend by contrast to be more directly dependent upon and determined by the ruinous mutability of their inscriptional surface.[13] The difference which results from imagining the poem as inscribed either on a natural object such as a stone or on the page in a book is the difference between imagining a writing which is ideally co-extensive with nature and therefore subject to the same kinds of accidents that natural objects are (the path in 'Inscription' will be overgrown), and a writing which is ideally (but of course never completely) exempt from such accidents. Once fixed in print, as Jane Tompkins points out, 'The literary work becomes endlessly reproducible, available to anyone who can read. Hence, the possible distance in time and space between the originator of the work and its readers becomes virtually limitless.'[14]

A comparison of the early 'Lines. Written with a Slate-pencil upon a Stone, the largest of a heap lying near a deserted Quarry, upon one of the Islands at Rydale', composed in 1800 and first published in the second edition of the *Lyrical Ballads*, and 'For a Seat in the Groves of Coleorton', composed in 1811 and first published in 1815, illustrates this difference even as it also accentuates the line of continuity in Wordsworth's career which Bernhardt-Kabisch emphasised. This continuity is evident in the persistent interest in the inscriptional as a special form of poetry which includes a formal 'device' usually left unmarked in poetic discourse, but which is exploited to great effect in these poems: the non-verbal surface of inscription. Angus Easson has called attention to this 'device', yet he rules out of consideration the most obvious inscriptional surface during the age of the book: the page.[15] For Easson, 'unlike other poems, epitaphs and inscriptions are meant (or feigned) to be read in their context—in the hermitage or the island hut or on the chiselled stone: they are not meant for books.... In an important sense, inscriptions are not detachable from their context: when they are printed, the title, sometimes at great length, has to provide information about their place

and purpose.'[16] Yet why Easson feels compelled to exclude the page as inscriptional surface and context for reading remains unexplained. The fact that we should not exclude the page as context is brought out when we look more closely at what Easson points to: an inscription's title, which also should make one wonder what Easson would do with a decontextualised inscription like 'Inscription', given his premise that an inscription's title '*has* to provide information about [the inscription's] place and purpose'.

The title to a (Wordsworthian) inscription is, in a fundamental sense, redundant and ought to render itself transparent in fulfilling its intention of pointing to the place where the inscription is supposedly inscribed (this is what happens when 'Inscription' gets republished without its original title). Yet by its sheer presence the title points to an unfulfilled intention stating that the text is not in fact inscribed where it purports to be inscribed. The title becomes a sign that the inscription is not (no longer, not yet or not exclusively) inscribed on its intended object, but instead fixed on the page in the book, which functions as a substitute for the intended inscriptional surface. The difference between early and late Wordsworth, from the point of view of his inscriptions, may be found by looking at the way in which he imagines the relation between the intended and the actual surface of inscription and the inscription itself. This is signalled in the titles given to the inscriptional poems.

The earlier inscription among the two singled out for comparison is entitled 'Written with a Slate-pencil *upon* a Stone...', whereas the later is entitled '*For* a Seat...'. The former inscription unambiguously signals that it is to be imagined as already inscribed upon its intended object, whereas the latter signals either that it has not yet been inscribed upon its object or that it may be both inscribed upon the object (seat) and present on the page (where it is the intention of something that may have been fulfilled, but still has the form of an intention). The difference between these two prepositions ('upon' and 'for') frames the difference between the earlier and the later Wordsworthian inscriptional practice in terms of an increasing consciousness of the change from using natural objects as writing surfaces, to using the page and the book as writing/printing surfaces. Thus, the five inscriptions composed in 1818 and published in 1820 under the collective title, 'Inscriptions *Supposed* to be Found In and Near a Hermit's Cell', are typical in no longer feigning to be inscribed anywhere else than on the page in the book—a difference reflected by 'Inscribed Upon a Rock', which oscillates between print and material inscription, the page and the rock as its

inscriptional site, and presents the page as proper inscriptional site by deploying the epitaph-inscriptional trope (*sistae viator*) in the part not explicitly inscribed.

'Lines. Written with a Slate-pencil upon a Stone...' uses a word ('pile', l. 16) that becomes important in the later inscription, which arguably performs a revisionary reading of the earlier inscription by changing the reference of 'pile' from a pile of stone to the poem itself. The early inscription is about and is said to be literally written upon an aborted building project. One Sir William had decided to build a pleasure house on the island at Rydal, but having learnt that it could be reached by a full-grown man wading across shallow water, he abandoned the project. The quarry and the heap of stones that remained to catch the poet's interest, then, 'Are monuments of his unfinish'd task' (Brett & Jones, 189, l. 13). 'The block on which these lines are trac'd, perhaps,' the poem goes on,

> Was once selected as the corner-stone
> Of that intended pile, which would have been
> Some quaint odd play-thing of elaborate skill,
> So that, I guess, the linnet and the thrush,
> And other little builders who dwell here,
> Had wonder'd at the work.
>
> (ll. 14–20)

The message of the poem is essentially that it was a good thing that Sir William aborted his building project, because such a pleasure house would have disfigured nature in the manner of those settling in the Lake District who, according to the *Guide to the Lakes*, disfigured the countryside by whitewashing their houses and thus failed to integrate them into their context in the manner of such natural builders as the linnet and the thrush (*PrW* 2, 216–217). More interestingly, the poem feigns to be inscribed upon an unfulfilled intention ('that intended pile' and 'monuments of his unfinished task') and thus itself to signal fragmentation, decay and ruinous dissolution (something also underlined by its being written with a slate-pencil and thus not as permanent as if it had been cut with a chisel). This is interesting because such a manner of producing significance—where the words of the poem are imagined as reflecting and participating in the fragmentation and dissolution of the inscriptional surface—is what the later Wordsworth aspired to go

beyond, though not by denying the need to incorporate poem and context, but by changing the context from nature to the book.

The later Wordsworth struggled to forget that the 'intended pile' would always be open both to natural decay and to human occupation; that it belongs both to the world of death, dissolution and decay and of impure and unfulfilled intentions. In 'For a Seat in the Groves of Coleorton', written a decade later with the knowledge that it would be cut in stone, Wordsworth imagined a pile that belongs to an altogether different order, the order of that which does not decay because it has been fully realised as intention:

> BENEATH yon eastern ridge, the craggy bound,
> Rugged and high, of Charnwood's forest ground,
> Stand yet, but, Stranger! hidden from thy view,
> The ivied Ruins of forlorn GRACE DIEU;
> Erst a religious House, which day and night
> With hymns resounded, and the chanted rite:
> And when those rites had ceased, the Spot gave birth
> To honourable Men of various worth:
> There, on the margin of a streamlet wild,
> Did Francis Beaumont sport, an eager child;
> There, under shadow of the neighbouring rocks,
> Sang youthful tales of shepherds and their flocks;
> Unconscious prelude to heroic themes,
> Heart-breaking tears, and melancholy dreams
> Of slighted love, and scorn, and jealous rage,
> With which his genius shook the buskined stage.
> Communities are lost, and Empires die,
> And things of holy use unhallowed lie;
> They perish;—but the Intellect can raise,
> From airy words alone, a Pile that ne'er decays.

(PW 4, 197)

The basic conceit of the poem is a comparison between buildings made of stone and buildings made of words. Buildings made of stone change their function over time, for example from being a 'religious House' to being an 'ivied Ruin'. This propensity to change meaning over time reflects the fact that they partake of the order of what perishes and decays. Buildings made of words, on the other hand, partake of the order of what 'ne'er decays' because, so the poem wishes to convince us, they

are ultimately not dependent upon a material and perishable founda-
tion. This Horatian conceit of comparing in order to contrast architec-
tural constructions to constructions of the intellect such as poems to
assert the durability of the latter against the mutability of the former is
one around which many of Wordsworth's poems revolve, yet it is rarely
as explicitly articulated as here.

As mentioned, 'For a Seat...' suggests that this poem does not feign
to be actually inscribed *upon* the seat, although a version of the poem
was in fact inscribed there.[17] The seat and other material phenomena
mentioned in the poem 'perish' (l. 19) because they partake in the
economy of what 'decays' (l. 20). The early inscription, which was
'trac'd' upon a block of stone that was a part of 'that intended pile',
also explicitly partakes in this economy as does the ice which melts and
dissolves in 'Inscribed Upon a Rock'. However, the poem *intended for* an
actual material surface, yet not in fact inscribed upon it, raises 'From
airy words alone, a Pile that ne'er decays' (l. 20). This poem, which
dwells in the *Poems* of 1815 from where it may be vocalised by future
generations of readers as Wordsworth has vocalised the work of Francis
Beaumont, may survive. Paradoxically, it is the ultimate uninscribed-
ness (in nature) of this inscription that secures its posterior survival as
typographic inscription (on the page). This inscription transcends its
intended context of inscription; or rather, it incorporates and absorbs
it to re-seat the inscription upon a surface that promises, if not immor-
tality, then something close.

Three inscriptions out of the four Wordsworth composed for Sir
George Beaumont's garden at Coleorton were actually inscribed where
they were supposed to be inscribed. By 1887 they were variously
decayed, as William Knight noted, 'The memorial stone remains, some-
what injured, and the inscription is more than half obliterated.... The
last of the inscriptions set up at Coleorton...was cut in stone at the end
of a terrace walk, at right angles to the avenue of limetrees, overlooking
the garden, where it is still to be seen, lichen-covered and weather-
worn.'[18] We may distinguish between the inscription on the page and
in the garden in terms of an allographic product versus an autographic
product.[19] The allographic product can ideally be reproduced without
loss of value and meaning whereas the autographic product is unique
and cannot be reproduced without losing value and meaning. Prob-
lems quickly multiply when we attempt to do so, however. We may
simply note, for instance, that the material inscription on the page is
not identical in various editions of Wordsworth's poems: the central
word 'pile' was not capitalised on its first appearance in 'Lines Written

with a Slate-pencil...' in 1800, whereas when the poem was reprinted in 1815, it was capitalised; perhaps to signal the relationship to the later inscription and the fact that the early inscription had now changed its status from something in nature to something in a book: it had survived and become a 'Pile that ne'er decays' (but has then changed its meaning over time like the decaying buildings in 'For a Seat...'!). The statement that the 'Intellect can raise / From airy words alone, a Pile that ne'er decays' means something radically different whether read in the context of a garden where it is 'lichen-covered and weather-worn' and thus difficult to vocalise and release into 'airy words', or whether it is read in the context of the book where we have little difficulty in reading it out loud to realise its intention in oral performance. A half-worn text can surely be orally performed, yet this performance gives an ironic twist to and undercuts the semantic meaning of the last line, whereas the performance of a pristinely printed text clearly instances the meaning of the last phrase.

A number of Wordsworth's critics have dealt with the emphasis on the materiality of the sign and the tendency to reify the poem in Wordsworth's poetic thinking in relation to his writing of epitaphs and inscriptions and his general interest in epigrammatic lettering.[20] However, printing and the book are rarely considered among the means Wordsworth employed to render words as things even though this technology and its primary product represent a progression (of degree rather than of kind) beyond writing and speaking in the capacity to permanently render words as things.[21] As Walter J. Ong notes, 'Writing makes "words" appear similar to things because we think of words as the visible marks signalling words to decoders: we can see and touch such inscribed "words" in texts and books. Written words are residue. Oral tradition has no such residue or deposit.'[22] Yet as Ong points out, 'Print suggests that words are things far more than writing ever did.... It was print, not writing, that effectively reified the word.... Print situates words in space more relentlessly than writing ever did. Writing moves words from the sound world to a world of visual space, but print locks words into position in this space' (118–121). Wordsworth's success in writing to posterity in fact depended on and was conditioned by this aspect of the print medium.

The Romantic poets were the first to fully experience and exploit the fact that literature had assumed the fixed condition often associated with print. With the coming of Romanticism, England had emerged as a full-fledged print society and print had lost what remained of its 'stigma', the aristocratic and gentlemanly ideas of earlier ages about

print as a less prestigious medium for poetry exemplified in the anti-
pathy to the medium in poets such as Wyatt, Surrey, Sidney, Raleigh,
Donne, Herbert, Suckling and Lovelace.[23] The Romantics came to accept
print as a proper medium for poets aiming to achieve secular immor-
tality and posterior recognition. Print did constitute a threat of the kind
Wordsworth registered in the Preface to *Lyrical Ballads* where he feared
an inundation of texts in the form of 'frantic novels, sickly and stupid
German Tragedies, and deluges of idle and extravagant stories in verse'
(Brett & Jones, 249). And Wordsworth did at times feel that a printed
book was merely a 'shrine so frail', a 'Poor earthly casket' as in Book
Five of *The Prelude* (1805, ll. 48, 164) or a 'lifeless' thing in Book Eight
(l. 727). Still, the full potential of print as a medium for poetry was
realised in the Romantic period when poets like Wordsworth became
convinced that their work would not be properly appreciated until after
their death, and therefore stood in dire need of the promise of the kind
of durability and permanence that was elusively and tantalisingly held
forth by what has been called 'typographical fixity'.[24]

In a footnote to his essay, 'Oxford in the Vacation' (1820), Charles
Lamb provided an example of the kind of understanding and valuation
of print that is typically Romantic and ultimately Wordsworthian. Lamb
described a shocking confrontation with Milton's manuscript to *Lycidas*
(1638):

> There is something to me repugnant at any time in written hand. The
> text never seems determinate. Print settles it. I had thought of the
> Lycidas as of a full-grown beauty—as springing up with all its parts
> absolute—till, in an evil hour, I was shown the original copy of it....
> How it staggered me to see the fine things in their ore! interlined,
> corrected! as if their words were mortal, alterable, displaceable at
> pleasure! as if they might have been otherwise, and just as good! as if
> inspiration were made up of parts, and these fluctuating, successive,
> indifferent![25]

Lamb potentially deconstructs the Romantic myth of the Poet as an
autonomous, creative genius who is capable of generating beautiful
works of art on his own. To Lamb, the impersonal technology of printing
is required to give birth to the poem as a beautiful work of art; the
poem requires the external intervention of printers and publishers in
order to reach perfection. Not until it exists as a printed object does
Lycidas become a 'full-grown beauty'. Printing and publication not only
determine and beautify the manuscript, thus rendering it a true work of

art; by implication, these processes and the products they lead to also invert the mutable status of words found in manuscript. In a manuscript, words are 'mortal, alterable, displaceable at pleasure! as if they might have been otherwise, and just as good'. After printing and publication, according to Lamb, words are immortal, unalterable and fixed without variants.

Lamb's confidence in the stability and durability of printed matter, even if informed by a certain amount of irony (he was articulating it in a footnote in an ephemeral magazine), reflects the naturalisation of the idea of print as something fixed and as a stable bearer of cultural traditions. Historically, this idea was established in the century that led up to Lamb's essay when, as Alvin B. Kernan puts it, print's 'simple usefulness acquired an aura of authority as, for example, permanent records began to be printed, accurate information conveyed in newspapers, and the society's privileged texts—legal, sacred, instructional—stabilized and stored in print'.[26] Kernan goes on to summarise Marshall McLuhan's idea that because a transition is made from circulating poems in manuscript to printing and publishing them, a certain stabilisation occurs which is the condition of possibility for what we today call *literature*: 'Print...makes poems into literary works of art and encourages thereby "a new hypnotic superstition of the book as independent of and uncontaminated by human agency".'[27] This is the 'hypnotic superstition' articulated by Lamb, which points to the later nineteenth-century idea of the full autonomy of literary works that culminated at the turn of the century with A. C. Bradley. According to Bradley, the 'nature' of poetry 'is to be not a part, nor yet a copy, of the real world (as we commonly understand that phrase) but to be a world by itself, independent, complete, autonomous'.[28] This idea, along with the material conditions that prompted its formulation, is the larger context within which to understand Wordsworth's change of addressee and his consequent figuration of the poetic work as a spatial structure made to endure, a 'Pile' that 'ne'er decays'.

Wordsworth not only made constructive use of print by utilising its promise of permanence, he also adopted it for purposes of expression seemingly agreeing with Lamb that typography may confer aesthetic value on a text. According to Ong, 'typography was interiorized in the Western psyche definitively at the moment in Western history known as the Romantic Movement'.[29] The Romantic period in fact witnessed a 'general rage for splendid typography', as David Rivers noted in 1798; in the words of the contemporary printer and literary chronicler, John Nichols, the late eighteenth century was 'an age of luxurious printing

and high prices'.[30] Although many were disappointed and came to see print as a commercially compromised medium and like Coleridge valued manuscript circulation as a mode of dissemination, the Romantics were the first poets who could reasonably hope to make a living from print publication. This was due to the explosive growth of an increasingly diverse and affluent reading public, which supplanted the role of the patron and revealed a voracious desire for printed material that could be processed through newly acquired skills of rapid reading. Elizabeth Barrett registered a consolidated culture of print when she reviewed Wordsworth's *Poems, Chiefly of Early and Late Years* (1842) and casually referred to 'these printing days when our very morning-talk seems to fall naturally into pica type'.[31] Insofar as printing, as Bertrand Bronson notes, 'is so obviously not only the conveyor of information but also in itself a valid form of artistic expression', and insofar as print had become ubiquitous for the Romantics, we should expect to find them articulating and exemplifying a new view and valuation of the art of printing as the inevitable and not necessarily stigmatised means to artistic expression as well as to reaching an audience and thereby earning a living.[32] We should in other words expect to register the emergence of two things that are more often identified with literary Modernism: an awareness of the page as a space where meanings that are incommunicable in speech may be made and displayed, and an awareness of the importance of the physical eye and of visual perception for the act of reading.

However, with the notable exception of Blake, the notion that the Romantic poets were positively concerned with how their poetry appeared on the page, and that they consequently employed the typographical sign to instance a poem's meaning, has not been generally recognised by critics of the period or by new textual critics more generally, who have focused on the eighteenth century (Pope and Sterne) or the later nineteenth century (D. G. Rossetti and William Morris).[33] Mario Praz expressed the typical twentieth-century view of the matter when he claimed that 'The Romantic exalts the artist who does not give a material form to his dreams—the poet ecstatic in front of a forever blank page.... It is romantic to consider concrete expression as a decadence, a contamination.'[34] This idea has more recently and surprisingly been restated by W. J. T. Mitchell, who was one of the first modern critics to stress the role of typography and layout in literary expression and experience.[35] However, in Mitchell's own practice the visible language of writing and print seems to be relevant only to understanding Blake among the canonical Romantics. Discussing Blake, Mitchell points out

that 'images, pictures, and visual perception were highly problematic issues for many romantic writers', and argues that

> if writing transforms invisible sounds into a visible language, then it is bound to be a problem for writers who want to be imaginative iconoclasts, who want images that are not pictorial, visions that are not visual, and poetry that need not be written down. Wordsworth's claim that a poet is a man 'speaking' (not writing) to men is no casual expression, but a symptom of what Derrida would call the 'phono-centric' tendency of romantic poetics. The projects for recovering or impersonating oral, folk traditions in poetry, the regular comparison of poetry with music, and the consistent distaste of the romantic poets for the vulgar necessity of submitting their words to material, printed form—all these patterns of thought reflect a common body of assumptions about the superiority of word to image, ear to eye, and voice to print.[36]

Mitchell's urgent need to frame Wordsworth in unified, coherent terms blinds him to the fact that Wordsworth in the course of his career gradually came to treat writing and print, the page and the book, less as necessary evils than as indispensable communicative tools, whose visual properties might in certain instances be utilised to achieve special effects of meaning. In the meeting of poetic word and the materialities of the medium, Wordsworth and his age came to recognise, new communicative and aesthetic possibilities are released even as this presupposes a more than linguistic understanding of what constitutes 'the poem' or 'poetry'.

Although he said in the note to 'The Thorn' that 'Words, a Poet's words more particularly, ought to be weighed in the balance of feeling, and not measured by the space which they occupy upon paper' (Brett & Jones, 288), Wordsworth revealed a certain concern with matters of layout and typography from the very outset of his career. In 1798, he and Coleridge wrote to their publisher, Joseph Cottle:

> I [Coleridge] meant to have written you an Essay on the Metaphysics of Typography; but I have not time.—Take a few hints without the abstruse reasons for them with which I mean to favour you—18 lines in a page, the lines closely printed, certainly more closely than those of the Joan (Oh by all means closer! W. Wordsworth), equal ink; & large margins. That is beauty—it may even under your immediate care mingle the sublime![37]

Both poets were intensely aware of the bibliographic codes of printed poetry and of the significance of what John Hollander calls 'the poem in the eye'.[38] Wordsworth seems to have been aware of both the purely visual impression of the page and of the ways in which book format, page size, paper quality, number and length of lines per page, as well as typeface may at once obstruct and interfere with aesthetic and formal intentions, and thus, by the same token, cooperate as necessary components in realising these intentions. And he was prepared to convert this knowledge into poetic acts on the page, which became more sophisticated as his career progressed and his knowledge of the technologies of the trade increased.

In 1835, *Yarrow Revisited* was printed in a relatively small type (*MY* 3, 190) that made it 'so ugly a book' (*MY* 3, 233) as Wordsworth confessed to his family in the same breath that he mentioned plans to have his collected works reset. Wordsworth's attention to typeface may also be seen in a letter he wrote in early 1837 to Moxon concerning the multivolume edition, where he complained that the popular prose memoir of the Rev. Robert Walker 'was not printed in a larger type, the same as the Essay on Epitaphs' (*MY* 3, 352). The cause for this, Wordsworth acknowledged, was that he had not given the printer directions to that effect. This shows his concern with the particulars of his texts both for aesthetic and communicative reasons. This concern was also indicated in a note to the printers of the 1807 *Poems*, where Wordsworth prohibited them from breaking a stanza in two, and revealed that he knew it was important to have the layout of one book match another to fabricate his own 'look': 'These two volumes are to be printed uniform with the *Lyrical Ballads*, in a stanza of four lines, four stanzas a page; the first page of each Poem only printing 2 or 3 stanzas according to the length of the Title.... This will imply that the stanzas must never be broken into different Pages.'[39] Wordsworth revealed a constant concern with ensuring the integrity of the stanza against the arbitrary intervention of the printer and the contingencies of something like the size of the page. Thus, as late as 1845 he wrote to Moxon, who was preparing a single-volume edition of the collected poems, 'I enclose a note...showing how much importance...I attach to the Stanzas not being broken. Do prevail upon the Printer to meet [my] wishes in this particular. They seem to have no notion of this subject' (*LY* 4, 676). This note is probably substantially the same that was used in 1807. It reveals that Wordsworth knew that the poem's *mise-èn-page* makes a difference to how we read it, and that control of the printer was needed to carry out his formal intentions. This was further underlined in a note

to the fair copy manuscript for the Intimations Ode, which reads, 'Let the Printer observe that the short lines of the following part of this Mss are written too far in; let them stand in the middle of the page.'[40] Wordsworth indeed struggled to control the most minute details of the layout and composition of his books, as we see from a letter written to the printer engaged on the multivolume Moxon edition published from 1836, Frederick Evans. 'Finding that the 2d vol is considerably short of matter', Wordsworth writes,

> I have sent another Poem ['Vernal Ode'] which can be spared from the 5th vol. I wish it to come in before the Devotional Incitements [thus moving it from the class of 'Poems of Sentiment and Reflection' to 'Poems of the Imagination'] and in printing it I am anxious that it may be so arranged, as for the conclusion of the 4th Stanza to appear upon the same page with the line immediately preceding, and with which it is connected by the rhymes. (*MY* 3, 349)

A review of *Poems, In Two Volumes* in the *Satirist* points to the high degree of awareness in the period of the communicative signals encoded by typography and other non-linguistic bibliographical signs such as bindings and illustrations (and the *kind* of illustration, e.g. copper engraving or woodcut). The reviewer notes a potential discrepancy between Wordsworth's poetics of simplicity and rusticity, which might be taken to signify low, vulgar 'popular' print culture, and the material impression of his book, which signified high, refined print culture: 'instead of occupying two duodecimo volumes of wire-wove and hotpressed paper, with a beautiful type and a large margin, the poems would have been more appropriately invested with a fine gilt wrapping, adorned with wooden cuts, and printed and bound uniformly in all respects with Mother Bunch's tales and Mother Goose's melodies' (Reiman, Vol. II, p. 845). The reviewer seems to be intentionally misunderstanding Wordsworth's idealisation of the low and the common by pointing to the potential contradictions entailed by the apparent misfit between layout, subject matter and audience. Yet the review is also getting Wordsworth entirely right. Wordsworth's project at this point was to raise the status of the 'common and the low', and one way of doing so was to use a kind of typography and book binding that would signal one kind of poetry, and then write a different kind of poetry that apparently did not fulfil the expectations raised by its covers. Wordsworth, in 1807, may have used typography as one of the means with which to break

the 'contract' with the kinds of poetry readers who judge a book by its covers.

Wordsworth's pleasure in a well-printed and proportioned page, which for him meant wide margins and closely printed, unbroken lines, was given most explicit articulation in an 1838 letter concerning plans to publish his collected works in a single, double-columned volume. Wordsworth responded to a sample page and commented on his aversion to the practice of breaking off the end of a line in double-columned publications and 'wrapping' the last words, a practice dictated by the narrowness of the page:

> on account of the overflowing lines, I could myself have no pleasure in looking at either the one page or the other. In the...pages sent me as specimens there are nine in one and 11 in the other; which both disfigures the book very much, and occupies so much space.... Could not the book be printed on paper sufficiently wide to allow of a ten-syllable verse being uniformly included in one line, as something very considerable would be saved in space. This would lessen the cost which wider paper would require. I repeat that I have an insurmountable aversion to overflowing lines, except where they cannot be avoided. On this subject however, as a mere suggestion for Printers, I would ask, whether the overflowing word would not be better placed, as formerly, near the end of the verse it belongs to, than so near the beginning of that line and of the next. (*LY* 4, 647)

The concern with amending the appearance in order to increase the visual 'pleasure in looking at either the one page or the other' by eliminating elements that 'disfigure the book' certainly reveals that the page was more than a 'word-preserving' entity to Wordsworth; that it was also a surface for aesthetic expression which was an integral part of a poem's total effect. Wordsworth knew that 'The perceptual features of text are as apt for expressive purposes as the semantic, syntactic, and rhetorical features.'[41]

I here wish to discuss two instances of Wordsworth's use of black letter or 'gothic' type for special expressive purposes. He does so in several places within his poetic texts: *The Excursion* (1814, VII, l. 971), *The White Doe of Rylstone* (1815), 'The Force of Prayer' published along with *The White Doe*, 'St. Catherine of Ledbury' (1836), and in the publication in 1836 of a revised version of 'Ellen Irwin, or the Braes of Kirtle'. When first published in the *Lyrical Ballads* in 1800, the final words of 'Ellen Irwin', 'Hic jacet', represented as an epitaphic inscription, were printed

in a roman type no different from the rest of the poem (Brett & Jones, 152). Already in 1802, 'His jacet' was re-set in small capitals, yet the most startling typographic revision was made for the Moxon collected works edition of 1836, where Wordsworth had the words reset in black letter type.

Used in Gutenberg's 42-line Bible printed in 1456, at the origins of the history of printing, when printed books were made to imitate hand-written manuscripts, black letter type was the norm and roman and italic were deviations used as distinguishing typefaces. Yet, black letter type was abandoned in England at the end of the sixteenth and the beginning of the seventeenth century, except in Bibles, prayer books and law books, where it survived into the seventeenth and eighteenth centuries, or as a distinguishing font in titles. The English move away from black letter type was epitomised in John Baskerville, who never cut a specimen. According to Sigfrid Steinberg, Baskerville's types 'possess the great virtue of unobtrusiveness combined with graceful readability. They never seem to come between reader and author.'[42] After the eighteenth-century's typographical revolution, in which the page was purified, regularised and standardised to finally look like something printed rather than scripted, industrially designed rather than hand-crafted, any use of black letter type was bound to come between the author and the reader, and to cause the reader to become conscious of the poem as a material object on the page rather than a transparent transcription of speech or a direct emanation of consciousness; as something to be looked *at* and not just looked *through*.[43] After Baskerville, no poet in the British tradition spontaneously overflowed in black letter type. A text in English using black letter type after Baskerville would do so to signify something archaic, antiquated, medieval; something relating to church scripture or law books and connoting 'tradition'. Or, it would do so to suggest something manually written rather than printed. When Wordsworth had the final epitaphic inscription of 'Ellen Irwin' printed in black letter types, he paradoxically used the medium of print to call attention to the inscribed and engraved—the *written* nature of the last words. That Wordsworth engaged in such a process whereby the older technology of manual writing was remediated by the younger technology of printing indicates that he thought of the page as a visual surface for 'typographic inscription'. When we attend to its publication history and consider the poem as being in a constant process of creation and re-creation over a thirty-six year period, it gains in value and complexity of expression.

The use of black letter type in *The White Doe of Rylstone; Or the Fate of the Nortons* is both representative of Wordsworth's other usages and possibly the most interesting instance, because it occurs in relation to one of his master themes: a person's individuation through loss, crisis and recovery. *The White Doe* was composed between 1807 and 1808, but not published until 1815. At Wordsworth's insistence, the poem which he at one point did not want to make public and whose manuscript he did not want to even show to his publisher was printed in an expensive and luxurious quarto edition with an engraved frontispiece illustration from a painting by Beaumont in order, as he said to Humphrey Davy in 1820, 'To express [his] own opinion of it'.[44] Wordsworth may have been inspired by Lamb to thus give special attention to the layout of the *White Doe*, because in 1815 Lamb wrote to Wordsworth that 'No alderman ever longed after a haunch of buck venison more than I for a spiritual taste of that "White Doe" you promise. I am sure it is superlative, or will be when *drest, i.e.* printed. All things read raw to me in MS.'[45] Generally neglected by the critical tradition, attention to the way in which *The White Doe of Rylstone* foregrounds textual materiality may reveal it as much more appetising than has often been the case.[46]

Set in the late 1560s, the poem tells the story of the Northern Catholic rise against the Reformation by focusing on the 'fate' of the Norton family. All the male members are killed by the Protestants and the family's sole survivor is the Protestant daughter Emily. The poem's primary theme concerns Emily's maturing experience of overcoming the grief caused by the death of her family for a cause she does not believe in; especially her grief at the death of her older brother Francis, who was also Protestant, but whose attachment to the Catholic father in the end caused his death at Protestant hands. What enables Emily to overcome her grief and transform what the poem calls a 'stern and rigorous, melancholy' (*PW* 3, 332, l. 1598) into what it calls a 'Mild, and grateful, melancholy' (*PW* 3, 336, l. 1758) is the intervention of a beneficent and sympathetic Nature in the form of the White Doe from which the poem takes its title. This theme and its resolution make it a typical Wordsworthian poem, and as John Williams has shown, Emily may be seen as a displaced version of Dorothy as she appears at the end of 'Tintern Abbey'.[47] *The White Doe* thus stages as an actual experience what was only a promise to Dorothy in 'Tintern Abbey', that she would be capable of overcoming any grief due to the combined influence of Nature and Wordsworth's poetry.

Towards the end of the poem, Wordsworth accounts for Emily's maturation process by juxtaposing two stages of her development, early

childhood and present maturity, with reference to a single perception of ringing bells. On a revisit to her family's seat after time has passed and she has overcome her grief, Emily hears again the bells she heard when she was a child; but the sound no longer carries the same meaning. The difference in meaning indicates the change she has experienced as the effect of death and sorrow. The use of sound may seem to go against the notion that the later Wordsworth increasingly tends towards the visual, and might be used to substantiate his more typical presentation as an iconoclastic and phonocentric conservative who, according to Mitchell, 'sought an escape from...print culture in the traditionalism of oral, rural culture'.[48] However, this does not explain why Wordsworth chose to present the meaning of the sound heard by Emily in black letter type, not just once, but twice, thus enacting visually on the page both the continued ringing of church bells and the fact that we are dealing with an identical sound that is twice perceived at different periods in a person's life (see Figure 1).

Even though these black letter words are supposedly heard by Emily, their deviant typography causes us to change our view of *The White Doe* from being a transcription of speech to being a composed text at several removes from speech; a remove that allows a certain manipulation of the typographic sign and creates a statement that cannot be rendered in spoken language. This is a visible 'speech' which we are meant to hear with our eyes as much as with our ears, and it again indicates that Wordsworth made use of the print medium to achieve certain effects that we miss when we read him simply as a phonocentric 'man speaking to men'.

While we hear with our eyes in this synaesthetic textual scenario, Emily sees with her ears as the sound of ringing bells calls forth the look of the words inscribed on the bell she saw as a child and whose meaning she can now understand. Emily's growth is illustrated as the emergence of a hermeneutic: to grow and mature is to learn to read beyond the level of the letter to where the spirit is, yet to do so without 'slighting' the letter. The young Emily perceives the writing on the bell without having experienced loss and absence, and thus without having been in need of God's 'aid'; she therefore 'slights' the writing. It does not mean anything, it just is. The older Emily has realised the importance of this writing as a principle of stability in a changing world, as something that gives a sense of continuity and purpose to life and connects her to her ancestors, who seem to be telling her that they have been aided by God after all. She has realised the inscription's physical being as reflective of, indeed an instance of its meaning. Inscriptional writing

When the Bells of Rylstone played
Their Sabbath music—" 𝔊𝔬𝔡 𝔲𝔰 𝔞𝔶𝔡𝔢!"
That was the sound they seemed to speak;
Inscriptive legend, which I ween
May on those holy Bells be seen,
That legend and her Grandsire's name;
And oftentimes the Lady meek
Had in her Childhood read the same,
Words which she slighted at that day;
But now, when such sad change was wrought,
And of that lonely name she thought,
The Bells of Rylstone seemed to say,
While she sate listening in the shade,
With vocal music, " 𝔊𝔬𝔡 𝔲𝔰 𝔞𝔶𝔡𝔢!"
And all the Hills were glad to bear
Their part in this effectual prayer.

Nor lacked she Reason's firmest power;
But with the White Doe at her side

Figure 1 Black letter typography from William Wordsworth, *The White Doe of Rylstone* (Longman: London, 1815). Private copy

represented as such by means of printing—typographic inscription—functions like the stabilising and soothing memory image of the Wye valley in 'Tintern Abbey'. Nature's and Wordsworth's 'language of the sense' that is perceived and imprinted on Dorothy's mind in 'Tintern Abbey' has been literalised on the page in *The White Doe*.

The White Doe insists on calling to our attention that we are *seeing* objects in the world: most prominently the two major symbols in the poem, the White Doe and the banner under which the Catholics rebel. The poem's pervasive visual tendency is most evident in the fact that as frontispiece it featured an illustration engraved by J. C. Bromley from a picture painted by Sir George Beaumont, which Wordsworth had all but commissioned in 1808. After finishing the first draft of the poem, Wordsworth wrote to Beaumont, 'In the Poem I have just written you will find one situation which, if the work should ever become familiarly known, would furnish as fine a subject for a picture as anything I remember in poetry, ancient or modern' (*MY* 1, 196). The 'situation' is part of the poem's opening description of the Doe, and Beaumont of course did as he was indirectly asked and provided the picture that was engraved and published in 1815:

Figure 2 Frontispiece to *The White Doe of Rylstone* (Longman: London, 1815). Painting by Sir George Beaumont, engraved by J. C. Bromley. Private copy

The ruined remains of gothic architecture in the background of the picture of the Doe used as illustration, the still standing arch of Bolton Priory, resonate visually with the 'gothic' typography at the end of the text. *The White Doe* thus begins and ends with significant visualisations which in various ways concretise its central referents, Nature and God, both of which are seen as helpful agents of its real subject: the humanisation and individuation of Emily through a process of loss and compensation.

Wordsworth's use of typography for expressive purposes and to meet special representational ends was never obtrusive or particularly sumptuous; yet he was certainly aware of and prepared to exploit its potential. The effect achieved by typographic foregrounding in Wordsworth is less one of readerly alienation and sense distortion of the kind we might expect from a Modernist, and more one that aims to increase the text's transparency and enhance its reality-effect. This may be observed in the endnote to the lines from *The White Doe* that use black letter, where this deviant typography is said to reflect an actual inscription on a bell and thus be grounded in fact. In a different way, this is also the case in the appended poem, 'The Force of Prayer' (see Figure 3).

THE

FORCE OF PRAYER;

OR

THE FOUNDING OF BOLTON PRIORY.

A TRADITION.

What is good for a bootless bene?
With these dark words begins my Tale,
And their meaning is, whence can comfort spring
When prayer is of no avail?

Figure 3 Black letter typography from 'The Force of Prayer', *The White Doe of Rylstone* (Longman: London, 1815). Private copy

The enigmatic expression that opens the poem, 'What is good for a bootless bene?', is set in black letters and referred to as 'dark words' in the sense of being unintelligible even as the poem goes on to explain that 'their meaning is whence can comfort spring / When prayer is of no avail?'. The 'dark' meaning of the words is mirrored in their dark typography, which to English eyes was becoming increasingly opaque and unreadable.

The later Wordsworth's (typo)graphocentrism should be seen in relation to his increasing presupposition of readerly visualisation and desire to produce *enargeia*. As discussed in Chapter 1, he expresses this in a number of places, for instance in *The Excursion*, where the Poet describes the effect of the Solitary's discourse by saying, 'the things of which he spake / Seemed present' (*PW* 4, 262, ll. 614–618). The desire to make 'things' 'present' for the physical eye—to transform words into things in a palpable vision—underwrites Wordsworth's use of black letter typography and his later work as such. At the height of his Great Decade years, Wordsworth may have called the eye the 'most despotic of our senses'; yet, the older Wordsworth came to espouse a visual aesthetic which presupposed a silent reader prepared to look at the poem's material signs, and he was not adverse to enlisting the services of the painter, engraver and printer to add the final touches in transforming a mutable manuscript text into a more permanent printed work for eye and ear alike.

The clearest example of Wordsworth's awareness of the difference between stone and book as inscriptional sites and of the need to utilise the page as inscriptional surface in order to reach posterity can be found in 'Musings Near Aquapendente', first published in *Memorials of a Tour in Italy, 1837* (1842). Wordsworth describes how, during the Italian Tour of 1837, he went in search of material evidence of the persons whom Italian poet Gabrielle Chiabrera commemorated in his famous epitaphs, which Wordsworth had translated in 1809; however, the search is in vain. The names and memorial tributes preserved in Chiabrera's epitaphs have disappeared from their original sites of inscription (*PW* 3, 209, ll. 236–242). Yet, despite the effacement of both the historical referents and any original inscriptions commemorating them, Chiabrera's 'sepulchral verse' (l. 241) has remained because unlike the traces Wordsworth searched for in vain, its survival was never fully dependent upon the contiguity of the material inscriptional base of the tombstone. Rather, it has remained in, and been transmitted to posterity through the medium of the book:

> Yet in his page the records of that worth
> Survive, uninjured;—glory then to words,
> Honour to word-preserving Arts.

<div align="center">(PW 3, 209, ll. 247–250)</div>

The 'word-preserving Arts' Wordsworth has in mind here are writing and especially printing as well as the art of making books with pages. Wordsworth goes on to invoke Horace, whose name is of course forever identified with the boast that his poetry, due to the combined forces of his genius, the political and military force of the Emperor Augustus and not least the relatively recently internalised medium of writing, constitutes a verbal monument that will outlive the kinds of 'actual' monuments he compares to his figurative monument, to end with a tribute to Virgil's 'never-dying verse' (l. 266). Due to the 'word-preserving' art of printing rather than the art of material inscription, which is tied to its singular spot in time and space, Chiabrera, Horace and Virgil have remained and have assumed the status of immortal classics. In like manner, through the use of the printed medium of the book, the later Wordsworth struggled to secure his own remaining beyond the limited durability of both spoken discourse (tied to the body) and material inscription (tied to stone).

A book's primary virtue in comparison to an inscription on a stone is that as an allographic object it can more easily be reproduced and distributed in multiple copies, which through translations like Wordsworth's may reach a global audience whose continued acts of reading may preserve it. Historically, this idea as mentioned emerged in the course of the eighteenth century to find its most consummate articulation in lines from 'Illustrated Books and Newspapers' (1846), which Steinberg used as epigraph to *Five Hundred Years of Printing*:

> Discourse was deemed Man's noblest attribute,
> And written words the glory of his hand;
> Then followed Printing with enlarged command
> For thought—dominion vast and absolute
> For spreading truth, and making love expand.

<div align="center">(PW 4, 75)</div>

According to Andrew Bennett, creative behaviour in the West is inevitably 'bound up with a certain survivalism'.[49] Allen Grossman provides

an unorthodox but compelling presentation of this urge for artistic immortality. With reference to Otto Rank, Ernest Becker and Hannah Arendt, Grossman states that 'The kind of success which poetry facilitates is called "immortality".'[50] For Grossman, 'Poetry functions as a machine for producing immortality in the form of a convergence of meaning and being in presence' (212). This convergence is most explicit in the name: 'A poem facilitates immortality by the conservation of names' (212), which Grossman sees as the traditional function of poetry. An explicit illustration of this idea comes in the four sonnets published as 'Personal Talk', mentioned at the beginning of this chapter. The fourth of these ends with a blessing and a wish in its sestet:

> Blessings be with them—and eternal praise,
> Who gave us nobler loves, and nobler cares—
> The Poets, who on earth have made us heirs
> Of truth and pure delight by heavenly lays!
> Oh! might my name be numbered among theirs,
> Then gladly would I end my mortal days.

<div align="right">(PW 4, 75)</div>

In the preceding three sonnets, Wordsworth alludes specifically to Spenser and Shakespeare. However, in comparison with these Renaissance authors' poetics of survival Romanticism spells an important difference. In the Romantic period, as Bennett points out, 'the literary convention that the subject of the verse will survive develops into the convention that the subject who writes will'.[51] In 'Musings Near Aquapendente', Wordsworth came as close as ever to punning on his own name when he placed 'words' and 'worth' in the important position at the end of the line thus suggesting a kind of 'visual rhyme' in the otherwise unrhymed blank verse lines. Such a visual eye-rhyme—or, as it were, I-rhyme—is only perceptible in the medium of writing. Because of writing, we can read 'backwards', against the flow of the imaginary speaking voice following which we read worth-words. Further, it only becomes really comprehensible in the medium of print, which held the promise that Wordsworth's name might eventually be 'numbered' among, and thus be received by posterity as of the same stature as Horace, Virgil, Spenser and Shakespeare: as a true classic.

3

'If Mine Had Been the Painter's Hand': Wordsworth's Collaboration with Sir George Beaumont

William Hazlitt first noted Wordsworth's visual turn to ekphrasis. Hazlitt's criticism of Wordsworth is justly famous for the strong correlation he made between the poetic principles of the Lake School poets and the French Revolution when he suggested in *Lectures on the Living Poets* that they 'went hand in hand'.[1] In *The Spirit of the Age*, Hazlitt repeated his well-known characterisation of the levelling tendencies of Wordsworth's early poetry and said that his revolutionary 'first' poetic principles generated a nature poetry, wherein objects were described 'in a way and with an intensity of feeling that no one else had done before him'. This made Wordsworth 'the most original poet now living, and the one whose writings could the least be spared: for they have no substitute elsewhere'.[2] What is rarely mentioned in the discussion of Hazlitt's reception of Wordsworth is that he registered a change in Wordsworth, and that the change and the duplicities it entailed may in fact be what Hazlitt means by the problematic phrase, 'the spirit of the age'.

Having presented the 'levelling' Wordsworth, Hazlitt noted a reversal in his poetic principles and actual poetry:

[Wordsworth's] later philosophic productions have a somewhat different character. They are a departure from, a dereliction of his first principles. They are classical and courtly. They are polished in style, without being gaudy; dignified in subject, without affectation. They seem to have been composed not in a cottage at Grasmere, but among the half-inspired groves and stately recollections of Cole-Orton. We might allude in particular, for examples of what we mean, to the lines on a Picture by Claude Lorraine, and to the exquisite poem, entitled Laodamia. The last of these breathes the

pure spirit of the finest fragments of antiquity—the sweetness, the gravity, the strength, the beauty and the languor of death—

'Calm contemplation and majestic pains'.

Its glossy brilliancy arises from the perfection of the finishing, like that of careful sculpture, not from gaudy colouring—the texture of the thoughts has the smoothness and solidity of marble. (90)

Hazlitt compares Wordsworth's later poetry to 'careful sculpture', expressing thoughts that have 'the smoothness and solidity of marble', and accordingly he singles out certain stylistic qualities and thematic characteristics of the later poetry: it is 'classical and courtly', 'polished in style', 'dignified in subject', 'breathes the pure spirit of the finest fragments of antiquity' and has a 'glossy brilliancy [which] arises from the perfection of the finishing'. This description and characterisation of the late style as sculptural is mirrored in the examples Hazlitt singles out. In particular, it is interesting to find him pointing to a new kind of poetry that the later poet had begun to write: poems about visual artworks, specifically one on a painting by Claude Lorraine, and poems that aspire to the condition of sculpture in the manner of 'The Pillar of Trajan'. As far as I can tell, Wordsworth never actually wrote a poem on a picture by Claude; yet Wordsworth's friend, patron and guide in all things concerning art, Sir George Beaumont (1753–1827), among whose 'half-inspired groves' at Coleorton the later Wordsworth often composed, owned four works by Claude, any of which Hazlitt may have recognised in a poem even if it was not explicitly referred to.[3] What is important to note is that Hazlitt sees the ekphrastic nature of the later work in terms of a departure from the earlier work and that he links this to Wordsworth's, for Hazlitt, problematic affiliation with the conservative, non-levelling, Burkean politics of Coleorton and Beaumont.

Hazlitt subtly frames the duplicities, contradictions and para-doxes that underlie Wordsworth's *oeuvre*. Paradoxically, even though Wordsworth's later principles for Hazlitt are a 'dereliction' or a ruina-tion of his earlier principles, they produce something not in the least derelict or ruined, but rather polished and finished, classical and courtly, indeed, virtually the kind of productions Wordsworth's first principles were formulated to level and destroy. This dual movement of vision and revision, action and reaction, creation and destruction, where creation can mean destruction and destruction creation, is in fact the 'spirit of the age', which Wordsworth's 'genius emanates', according to Hazlitt.

The 'spirit of the age', according to Hazlitt, is the spirit of irresolvable contradiction and opposition.[4] To consider Hazlitt's identification of ekphrasis in his analysis of Wordsworth in terms of his idea of the 'spirit of the age' is to begin to suggest the critical value, which the recuperation of ekphrasis in Wordsworth's later poetry may have for a renewed understanding of the diversity and complexity of a Romantic period literature 'beside itself'.

Wordsworth's ekphrastic turn must be understood, as Hazlitt also intimates, through his relationship with George Beaumont and Coleorton. The turn to write ekphrastic poetry dates to the composition of 'Elegiac Stanzas, Suggested by a Picture of Peele Castle, in a Storm, Painted by Sir George Beaumont' in the summer of 1806, towards the end of the Great Decade. With its central reference to 'A power [that] is gone, which nothing can restore' (*PW* 4, 259, l. 35), this poem lends itself to being read as a valediction to 'the power to write poetry' and to mark 'the end of Wordsworth's poetic life'.[5] However, a more fruitful approach to Wordsworth's career reads 'Peele Castle' as marking a dramatic change in his creativity and as constituting a new beginning insofar as it issued in the writing of the substantial corpus of ekphrastic poetry which is the most significant innovation in his later work. 'Peele Castle' revealed the first public signs of the later Wordsworth's crucial but critically neglected artistic collaboration with Beaumont, who was the most important new figure in Wordsworth's later phase, less for his financial and in other ways material help (the social class status his name and friendship conferred upon Wordsworth's work), than for introducing him to the world of visual art as well as providing the terms by which Wordsworth would apprehend and represent works of plastic art.[6]

Connoisseur, patron of art and amateur landscape painter, Beaumont entered the Wordsworth circle after 1803. The friendship, which Stephen Gill describes as 'one of the most important . . . of Wordsworth's life',[7] began in the summer of 1803 when George and Lady Beaumont travelled to Keswick eagerly wishing to see Wordsworth whom they admired from reading the *Lyrical Ballads*. The Beaumonts stayed at Greta Hall in July and August, and before they left Keswick, Beaumont had presented Wordsworth with the deeds to a farmstead at Applethwaite, under Skiddaw, less than two miles north of Greta Hall. Wordsworth accepted the gift but declined Beaumont's offer to build a house for him on the property, and instead suggested that he might serve as a 'Steward of the land' (*EY*, 408). This gift meant a dramatic shift in Wordsworth's class status. Thus, Beaumont gave Wordsworth 'two elegant drawings' in

exchange for which Wordsworth gave Beaumont three sonnets as well as the right to circulate two of them 'in any way you like' (*EY*, 410–411). In giving Wordsworth the farmstead, Beaumont gave him the right to vote which was dependent on being a freeholder of Cumberland. This was a matter of some import to Wordsworth as can be gathered from a letter dated 12 December 1803 to his brother Richard. Although Wordsworth had declined to have built for him, Beaumont, writes Wordsworth, 'insists on [his] keeping the land, so you see I am a freeholder of the County of Cumberland' (*EY*, 427). These few well-known biographical facts suggest the kind of interests and exchanges that informed the friendship from the beginning: poetry flowing in one direction, painting and property in the other; Wordsworth yielding independence by accepting Beaumont's gift of patronage, even as Wordsworth also gained a new form of independence by becoming a freeholder through acceptance of the gift on his own conditions.

Beaumont's aim with the gift of land was to promote artistic collaboration by bringing Coleridge and Wordsworth closer together (see *EY*, 406). Yet, the gift turned out instead to mark the end for that creative couple and the beginning of a new creative coupling, which was to span a period of some twenty five years from the first contact to Beaumont's death in February 1827. This death resulted, in November 1830, four months after he had told Samuel Rogers 'that the Muses and I have parted company' (*LY 2*, 309), in the re-awakening of Wordsworth's poetic nerve in the composition of one of the remarkable poems of his later years, 'Elegiac Musings in the Grounds of Coleorton Hall, the Seat of the Late Sir G. H. Beaumont, Bart.':

> Gone from this world of earth, air, sea, and sky,
> From all its spirit-moving imagery,
> Intensely studied with a painter's eye,
> A poet's heart; and, for congenial view,
> Portrayed with happiest pencil, not untrue
> To common recognitions while the line
> Flowed in a course of sympathy divine;—
>
> (*PW* 4, 271, ll. 19–25)

These lines are typical of the poetry relating to Beaumont which tended to blend the two art forms in an exploration of their common ground. Like Beaumont, the later Wordsworth often combined 'a poet's heart' with 'a painter's eye'.

In a letter, Wordsworth described their friendship as an 'interchange of knowledge and delight' (*MY* 1, 92). This phrase was included in an 1808 inscription, 'In the Grounds of Coleorton, the Seat of Sir George Beaumont, Bart., Leicestershire', which eloquently articulates the nature of their friendship:

> The embowering rose, the acacia, and the pine,
> Will not unwillingly their place resign;
> If but the Cedar thrive that near them stands,
> Planted by Beaumont's and by Wordsworth's hands.
> One wooed the silent Art with studious pains:
> These groves have heard the Other's pensive strains;
> Devoted thus, their spirits did unite
> By interchange of knowledge and delight.
>
> (*PW* 4, 195, ll. 1–8)

Theirs was a friendship that united the two arts of poetry and painting and enabled them to collaborate on a common project of creation, which is here symbolised by the joining of hands in the planting of a cedar tree, chosen perhaps to suggest durability and because it is an evergreen.

Formally, the poet–painter 'coupling' is fittingly articulated by means of the heroic couplet—rhyming 'unite' with 'delight'. Wordsworth's turn to the couplet in the four inscriptions relating to Beaumont and Coleorton, whose garden Wordsworth designed, may have to do with his search for a poetic form to articulate the nature of his friendship with Beaumont as well as the interart relationship.[8] As J. Paul Hunter has said, 'Because by definition they comprise two lines of equal length held together by (among other things) chiming endings, couplets are usually well positioned to exploit comparisons and contrasts, and it is not surprising that opposites are repeatedly set against one another in the paired lines or (almost as often) in the two halves of a single line divided by a caesura.'[9] The couplet signals a partnership between different but equal beings, rather than the kind of symbiotic 'blending' that would be signalled by blank verse; the couplet represents the two as parallel yet autonomous beings.[10]

Consider first the use of ellipsis in line 4 above, 'Planted by Beaumont's [hands] and by Wordsworth's hands'. Although of course legitimate from a grammatical point of view, it suggests, at the substantial level of referent, that the two pairs of hands are essentially the same, because

one pair of hands may substitute for another. This line sets Beaumont against Wordsworth in order to compare them; the absence of mid-line caesura or any other internal pause in the line, and the presence of the conjunction 'and' suggests similarity rather than the kind of antithetical 'contradistinction' that was more typical of normative eighteenth-century couplet verse. The binary, antithetical thrust of normative couplet poetry, however, is exploited in lines 5 and 6, 'One wooed the silent Art with studious pains:/These groves have heard the Other's pensive strains'. These lines parallelise and compare in order to contrast the two friends in terms of their different arts. Divided by the second-heaviest stop, the colon, which is often as here used to mark antitheses, and united by the end-rhyme, there is at least as much to suggest difference between them than to suggest similarity. This is also brought out in the chiasmic inversion in '*studious pains*' ⇔ '*pensive strains*'. The next couplet contrasts strongly with the preceding and refers back to the identity posited in line 4 as it compares the friends in terms of their 'spirits': 'Devoted thus, their spirits did unite / By interchange of knowledge and delight'. With no punctuation to keep the two parts of the couplet apart, and almost enacting the unification and interchange of 'spirits' through the rhyme of 'unite-delight', this enjambed couplet differs markedly from the preceding; together the two couplets present the relationship between Wordsworth and Beaumont and between poetry and painting as a complex relationship informed by difference and similarity to articulate which the heroic couplet presents itself as the perfect formal vehicle.

The turn to the couplet in the inscriptions relating to Beaumont may be said to be reflected in the choice of inscriptional surface. While the early Wordsworth was attracted to the ruined, rough and unhewn matter on which his early inscriptions from *Lyrical Ballads* purport to be inscribed, the later Wordsworth was also attracted to the polished and ordered 'classic grounds of Coleorton' (as he called it in the Dedication of 1815 discussed below) to which the couplet binds the poem. An unrhymed, stichic inscription without a predetermined end to signal that it is not fragmentary may be the proper decoration of some rough-hewn stone found on a deserted island, but not an adequate match for Coleorton. In this way, poetic form and inscriptional surface combine to suggest classical virtues of permanence and stability, which are also the subject matter of these inscriptions, all of which emphasise continuity despite change, survival despite mutability, in a word: tradition as what exceeds and transcends the individual 'transitory being'.

Tradition is thematically articulated when Wordsworth alludes to both John and Francis Beaumont in the second half of 'In the Grounds of Coleorton...':

> May Nature's kindliest powers sustain the Tree,
> And love protect it from all injury!
> And when its potent branches, wide out-thrown,
> Darken the brow of this memorial Stone,
> Here may some Painter sit in future days,
> Some future Poet meditate his lays;
> Not mindless of that distant age renowned
> When Inspiration hovered o'er this ground,
> The haunt of him who sang how spear and shield
> In civil conflict met on Bosworth-field;
> And of that famous Youth, full soon removed
> From earth, perhaps by Shakespeare's self approved,
> Fletcher's Associate, Jonson's Friend beloved.
>
> (*PW* 4, 195, ll. 9–21)

The Beaumont brothers become historic parallels to George Beaumont and Wordsworth, and serve to ground a projection forward in time whereby a future cultural production is anticipated and a continuous tradition is constructed. This historical projection is indicated by the subtle use of a triplet to achieve closure and metrical variety. Even as it signals continuity between past, present and future it also signals growth by using an alexandrine as final line. The triplet that ends in an alexandrine sends an echo back to John Dryden, who tended to end his triplets with an alexandrine to 'bound the sense', as he put it in the Dedication to *Aeneis*.[11] Likewise, Wordsworth 'binds' his poem to the 'classic ground' through the couplet, and the turn to the couplet becomes a turn to recuperate a more impersonal tradition which takes precedence over the individual, and whose preservation and transmission assumes priority. Such a conservative and conservationist poetics could not be articulated in blank verse in the early nineteenth century, whereas an allusive return to the couplet, even in a modified and loosened form, articulates this stance. The couplet here connotes a certain sense of permanence and stability which a poet writing to posterity may tend to value and wish to infuse into his poetic work.

Heroic couplets have been a stumbling block for readers of the later Wordsworth. Referring to the 1811 'Epistle to Sir George Howland

Beaumont, Bart. From the South-west Coast of Cumberland', Wordsworth's first modern biographer, George McLean Harper, wrote that it 'falls below mediocrity, and is the first downright poor piece encountered by one who reads his collected works in chronological order'; and he continues, 'There is a fine propriety in the fact that this, like other uninspired productions of his later life, is in the Popeian couplet, and has many of the pompous little affectations which Wordsworth's own precepts and poems had already taught the world to find ridiculous.'[12] Harper could find nothing of value in Wordsworth's development and apparent turn against himself, 'It is as if he wished to throw away his hard-earned gains' (198). As is so often the case, the earlier Wordsworth is the later Wordsworth's own worst enemy. Yet, the epistle is important in mapping the visual turn and Beaumont's role in this turn.

Where Coleridge stimulated Wordsworth's idealistic iconoclasm and provided Kantian rationale for despising the 'despotic' power of the 'bodily eye', one of the reasons Wordsworth revised this complex of ideas seems to have been his friendship with Beaumont. The later Wordsworth's more positive valorisation of the 'bodily eye' and its relation to Beaumont is articulated in the 'Epistle'. It opens with Wordsworth being locked up in a cottage due to bad weather, regretting that he can neither play music nor paint, and feeling 'Tired of my books, a scanty company! / And tired of listening to the boisterous sea' (ll. 32–33). To kill time, he paces

> [B]etween door and window muttering rhyme,
> An old resource to cheat a froward time!
> Though these dull hours (mine is it, or their shame?)
> Would tempt me to renounce that humble aim.
>
> (*PW* 4, 143, ll. 34–37)

Wordsworth's method of oral composition by walking 'to and fro', however, is no use in mastering time. He cannot any longer convert the 'cheerless place' (l. 27) where he stays into a place of joy by the sheer power of 'himself', that is, his restorative memory and creative imagination. The exterior storm, which in earlier days broke up the 'long-continued frost' and brought 'with it vernal promises' 'The holy life of music and of verse' (*Prelude*, 1805, I, ll. 48–54), as we hear in the preamble to *The Prelude*, is no longer a potential co-creative agent or 'corresponding mild creative breeze'. Wordsworth consequently

recognises that he now needs something else to help him with his poetry and he asks for the Muse's help:

> —But if there be a Muse who, free to take
> Her seat upon Olympus, doth forsake
> Those heights...
> And in disguise, a Milkmaid with her pail
> Trips down the pathways of some winding dale;
>
> If such a Visitant of Earth there be
> And she would deign this day to smile on me
> And aid my verse, content with local bounds
> Of natural beauty and life's daily rounds,
> Thoughts, chances, sights, or doings, which we tell
> Without reserve to those whom we love well—
> Then haply, Beaumont! words in current clear
> Will flow, and on a welcome page appear
> Duly before thy sight, unless they perish here.
>
> (*PW* 4, 143–144, ll. 38–58)

From here follows an account of exactly what is promised, the quotidian 'local' things to do with 'natural beauty and life's daily rounds' consisting of the absence of news from the neighbourhood, a longer account of a travel, and a description of a meal.

Except for a shorter passage that leads to a brief quasi-visionary moment when Wordsworth 'sees' beyond the visible given (ll. 189–199), what is most conspicuously absent from this poem is 'Wordsworth'; instead, we get a relatively objective report by 'the pen' (ll. 89, 270). This poem relinquishes the category of the boundless sublime as it appropriates the beautiful and eschews subjective self-expression in favour of objective reportage. It is explicitly meant for the eyes: its words 'Will flow, and on a welcome page appear/Duly before [our] sight, unless they perish here'. When we read the epistle to Beaumont in the light not only of the return of the visible in Wordsworth but also in terms of the turn to posterity and his increased awareness of poetic transmission and textual preservation, the fact that it thematises its own status as a piece of writing and consequently positions its addressee as an absent reader, who will experience the poem on the page rather than in a live performance, gives the poem a new significance and places it at the centre of new developments in the later period. The epistle, which Wordsworth

claims Beaumont never saw, reflects the position from which the later Wordsworth 'speaks', it articulates his new concerns; this perhaps makes it the more appropriate that it was not published until 1842, when it appeared in *Poems, Chiefly of Early and Late Years* along with a later reflection, 'Upon Perusing the Foregoing Epistle Thirty Years After its Composition' ('Thanks to the moth that spared it for our eyes; / And Strangers even the slighted Scroll may prize' [*PW* 4, 151, ll. 5–6]). The epistle's delayed publication, its perhaps surprising survival and appearance, and the idea that it may have value for someone else than its original intended reader, can be understood as indications of a poetics of posterior reception in the form of visual reading.

The epistle reflects a conscious lowering of poetic ambition, a turn from a visionary High Romanticism to a visual low Romanticism, to practise which Wordsworth asks the help of a more 'pedestrian' muse. It articulates and maps a significant transition in Wordsworth's poetry both in terms of theme (from high to low, from invisible to visible, from sublime to beautiful, from the lamp to the mirror) and in terms of the communicative situation of the poem (from speaking to writing, from listening to reading). It is of interest both in itself and for the complexity it exposes in Wordsworth's *oeuvre*. It is interesting in itself because it demonstrates that Wordsworth was capable of producing the 'quotidian' verse which has increasingly been canonised in terms of a feminine component in Romantic poetry.[13] It is interesting in terms of his *oeuvre*, because it turns so decisively against and thus problematises and decentres the means and ends of, for instance, 'Tintern Abbey' and *The Prelude*: from ode and personal epic in Miltonic blank verse to that most Augustan of Neoclassical genres, the verse epistle in heroic couplets which Pope perfected; from aspiring to grasp the invisible sublimities of 'something far more deeply interfused' or 'something evermore about to be' to seeing and accurately describing the visible beauty that appears 'When Nature's self... seems / To render visible her own soft dreams' (ll. 185–186) in the reflection of a landscape in a pool of water akin to those dealt with in Chapter 1 in relation to the *Guide to the Lakes*. These turns are not to be explained only by the intervention of Beaumont, but his presence as the poem's addressee certainly precipitates them. Surely it is no accident that Wordsworth emphasised the visual and rendered actual sights in writing to his painter-friend.

As the verse epistle makes evident, Wordsworth's poetry tends to be composed with a certain audience in mind, which in various ways influences its form and content. As we move away from the Great Decade and enter the later work, the private and ideally self-present listening

addressee found in much of the early conversational work (e.g. Dorothy in 'Tintern Abbey' and Coleridge in *The Prelude*) gets replaced not only by the more general addressee of an absent posterity, but also by repeated acts of public dedication of various volumes, sequences and memorials to named individuals among Wordsworth's expanding circle of friends and family members. In early Wordsworth, the poet speaks his poem directly to the dedicatee, who is a part of the poem and also in the position of an intimate addressee. In late Wordsworth, the dedicatee is singled out as a kind of ideal reader of the poem and thus not necessarily imagined as a listener present in the same communicative space as the poet-speaker uttering the poem; indeed, the dedicatee becomes a figure of the posterior recipient as *reader* rather than listener. The dedicatees are: Lord Lonsdale in *The Excursion* (1814), Mary Wordsworth in *The White Doe of Rylstone* (1815), Robert Southey in *Peter Bell* (1819), Charles Lamb in *Benjamin The Waggoner* (1819), Christopher Wordsworth in *Duddon Sonnets* (1820), Samuel Rogers in *Yarrow Revisited* (1835) and Henry Crabb Robinson in *Memorials of a Tour in Italy* (1842). Most importantly, Wordsworth dedicated his two volumes of *Poems* (1815) and all subsequent collected works editions to Beaumont. This dedication subsumes all other dedications of individual volumes and sequences which figure within the collected works.

The 1815 dedication to Beaumont sounds as follows:

My Dear Sir George,

Accept my thanks for the permission given me to dedicate these Volumes to you. In addition to a lively pleasure derived from general considerations, I feel particular satisfaction; for, by inscribing these Poems with your Name, I seem myself in some degree to repay, by an appropriate honour, the great obligation which I owe to one part of the Collection—as having been the means of first making us person-ally known to each other [i.e. *Lyrical Ballads*]. Upon much of the remainder, also, you have a peculiar claim,—for some of the best pieces were composed under the shades of your own groves, upon the classic ground of Coleorton; where I was animated by the recol-lection of those illustrious Poets of your name and family, who were born in that neighbourhood; and, we may be assured, did not wander with indifference by the dashing stream of Grace Dieu, and among the rocks that diversify the forest of Charnwood.—Nor is there any one to whom such parts of this Collection as have been inspired or coloured by the beautiful Country from which I now address

you, could be presented with more propriety than to yourself—to whom it has suggested so many admirable pictures. Early in life, the sublimity and beauty of this region excited your admiration; and I know that you are bound to it in mind by a still strengthening attachment.

Wishing and hoping that this Work, with the embellishments it has received from your pencil, may survive as a lasting memorial of a friendship, which I reckon among the blessings of my life,

> I have the honour to be,
> My dear Sir George,
> Yours most affectionately and faithfully,
> William Wordsworth.

Rydal Mount, Westmoreland,
 February 1, 1815

This dedication raises the problematic question of patronage and its persistence in a reformulated shape during the Romantic period. According to central tenets of the Romantic ideology, a poet's dependence on another is seen as demeaning while artistic independence is seen as an absolute good. The traditional account of the move from patronage to the free market is an emancipatory narrative that writes a crucial chapter in the story of the development of modern individualism.[14] Because the rhetoric of patronage is writ large in dedications, Wordsworth's apparently anachronistic specimen of the form may all too easily be dismissed as a piece of embarrassing evidence of late Wordsworth caught in the act of compromising his artistic independence and integrity.[15] The modern editors of Wordsworth's prose for instance dismiss it as 'of small literary interest' and claim that it is only of interest for being 'Wordsworth's formal acknowledgment of his long-standing friendship with' Beaumont (*PrW* 3, 15). However, the ways in which this friendship impacted on Wordsworth's art is also brought out in the dedication, which is one reason why we should attend to it with as much care as we attend to Wordsworth's other texts in prose.

Beaumont was one of the most important patrons of the arts during the Romantic period as we see for instance in his spontaneous gift of land to Wordsworth. According to William Knight, 'the Mæcenas of Coleorton...had the happiness of attaching *many* friends to himself by disinterested ties, and of thereby multiplying his own pleasures, and

adding to his culture. He always thought that he received more than he gave, in the interchange of friendship. He certainly had the gift of calling out whatever was best in his friends.'[16] What needs to be emphasised is that with Beaumont and other Romantic patrons of the arts, the nature of patronage changed. As Norma Davis points out, 'Tradition-ally patronage was the duty of the aristocracy and consisted chiefly of important commissions and of financial support for a few chosen artists.' However, Beaumont's wealth was not sufficient to fulfil this traditional role. Although he certainly made commissions and provided financial support for artists in other ways, 'there is abundant evidence that the major thrust of his patronage consisted of educating, recog-nizing, and encouraging artists and was pursued consciously but inform-ally on the basis of friendship'.[17] Beaumont also seems to have been one of the first patrons to aim to benefit the general public through his patronage. Besides his affiliation with Wordsworth, Beaumont's most significant legacy is that he promoted the idea of and helped estab-lish the National Gallery in 1824, to which in 1826 he donated his collection of sixteen masterpieces by Claude, Rembrandt, Rubens and Canaletto—works which had been enjoyed under private circumstances by Wordsworth and a number of other Romantic authors and artists such as William Lisle Bowles, Coleridge, Haydon, David Wilkie and Constable in Beaumont's homes, the country estate at Coleorton and the town house in London's Grosvenor Square.[18] Haydon for instance described a stay with Wilkie at Coleorton where they 'dined with the Claude and Rembrandt before us, breakfasted with the Rubens landscape, and did nothing, morning, noon or night, but think of painting, talk of painting, dream of painting, and wake to paint again'.[19] An introduction to the world of the fine arts, like the one Beaumont facilitated, in late eighteenth- and early nineteenth-century England could barely occur without access to wealthy landowning aristocratic circles into which few poets were born. Because he gave direct access to one private collection and indirectly to a number of others through letters of commenda-tion etc., we may understand the relationship between Beaumont and Wordsworth as one of patron and client, keeping in mind, as Dustin Griffin points out, that 'patronage is not simply money and housing in exchange for printed dedications', but 'that what is ultimately at stake is the control of high literary culture'.[20]

Wordsworth was not economically dependent upon Beaumont, espe-cially after 1803 when the inheritance from Lord Lowther had been settled. Yet, he owed many things besides money to the Beaumonts—who had made Wordsworth a freeholder with the right to vote; who

allowed the Wordsworth circle to stay at Coleorton when it had grown too large to be comfortably accommodated at Dove Cottage; who served as Wordsworth's entry into the world of the fine arts; who provided a garden for Wordsworth to exercise one of his great interests, horticulture; and who were the perfectly sympathetic, uncritical and impressionable readers that Wordsworth seems to have needed.[21] In exchange for this, Wordsworth dedicated his *Poems* to Beaumont and, as Henry Crabb Robinson put it in commenting on receiving Wordsworth's dedication of the *Memorials of a Tour in Italy, 1837*, provided the dedicatee with 'a sort of *vicarious* immortality. It is well', said Crabb Robinson, 'if a man can *do* nothing to stamp his name, that the friendship of a great poet should *fix* it'.[22] With the dedication, Wordsworth was repaying patron's gifts; he was returning the interest that had accrued from the cultural capital Beaumont had been investing in Wordsworth for over ten years. In return, Beaumont found his name immortalised in print. Writing to Wordsworth, Beaumont thanked him for 'the affectionate manner in which you have dedicated the work to me—I dread a compliment from most people, it rarely fails to make me hang my head and blush— seriously I feel the honour done me, and the thought of descending to posterity as the friend of Wordsworth delights my imagination and warms my heart'.[23]

The dedication to Beaumont belongs among those textual items analysed by Gérard Genette in terms of *paratext*: 'productions, such as author's name, a title, a preface' that 'enable a text to become a book and to be offered as such to its readers'.[24] The dedication, which 'prefaced all subsequent collected editions until 1845 when it was transferred to the last pages of the volume (*PrW* 3, 15), may indeed be considered among the most important paratextual documents in Wordsworth's later period. 'The convention of the dedication', as Genette points out, 'is that the work was written for its dedicatee, or at least that the dedication became imperative as soon as the writing was done' (128). During the Romantic period, the circumstances of dedication change. Earlier, this specific paratext had been the place where an author in exchange for a laudatory dedication would be remunerated 'either by protection of the feudal type or by more bourgeois (or proletarian) coin of the realm' (119). However, at the beginning of the nineteenth century with the changes in the patronage system that Beaumont was part of, the classical dedicatory epistle began to include 'information about the sources and creation of the work, or comments on the work's form and meaning—messages by which the function of the dedication clearly encroaches on that of the preface' (123–124). The chief function of a preface is '*to ensure that the*

text is read properly' (197). It often figures a book's intended readership and projected aesthetic impact by offering guidelines extracted from the poems' source of inspiration, mode and circumstances of production and thematic concerns regarding the intended effects of and thus the proper reading of a text. The dedication to Beaumont in fact reveals statements and hints that inform this traditional repertoire of a preface. This is reflected by the fact that in the Romantic period the dedicatee would be 'more apt to be a colleague or a mentor capable of appreciating its message', as Genette points out (125). The main purpose of Wordsworth's 1815 dedication was to characterise aspects of the work being dedicated while its secondary motivation was to characterise Beaumont as a colleague and mentor who was especially well disposed to receive the work; thus, implicitly it projected its ideal reader in the image of someone like Beaumont, with Beaumont's aesthetic norms, values, interests and tastes.

The dedication reveals that Beaumont was part cause and part condition of possibility for Wordsworth's turn to writing inscriptional and in particular ekphrastic poetry after the Great Decade. The dedication singles out most prominently a certain corpus of poems associated with 'the classic ground of Coleorton', which the Wordsworths occupied from November 1806 to July 1807: the four inscriptions commented upon above and in the previous chapter, all but one of which were composed and presented in a series of letters to the Beaumonts in 1811 and first published in 1815. By providing an ideal writing surface in the form of his winter garden at Coleorton, Beaumont enabled Wordsworth's continued cultivation and refinement of this poetic mode.

More importantly, the dedication is an indication of Wordsworth's pictorial turn to the visual, plastic arts evidenced by the ekphrastic poems, 'Elegiac Stanzas, Suggested by a Picture of Peele Castle, in a Storm, Painted by Sir George Beaumont' and 'Upon the Sight of a Beautiful Picture, Painted by Sir G. H. Beaumont, Bart.', which are the direct result of Beaumont's impact and are put in focus by the dedication. In the dedication, Wordsworth presents his poems (those inspired directly by the Lake District at least) as a kind of parallel or complement to Beaumont's paintings of the same scenery. When Wordsworth writes, 'Nor is there any one to whom such parts of this Collection as have been *inspired or coloured* by the beautiful Country from which I now address you, could be presented with more propriety than to yourself—to whom it has *suggested* so many admirable pictures', he writes that his ideal or model reader is a painter and that his own poetic productions may be

comparable to painting. Beaumont's paintings have been 'suggested' by certain scenes in the same manner that Wordsworth's 'Peele Castle', for instance, was 'suggested' by one of Beaumont's paintings. Wordsworth presents the inspirational sources of the two art forms as identical and interchangeable and points to the nature of the collaborative work, which proceeds by way of 'suggestion' and indirect influence rather than a more programmatic and systematic division of labours like the one Coleridge in the *Biographia* implies informed the two poets' collaboration on the *Lyrical Ballads*.

That Beaumont reflects Wordsworth's more general pictorial and ekphrastic turn is finally seen by the fact that the 1815 *Poems* carried two engraved frontispiece illustrations from paintings by Beaumont: for Volume One a view illustrating the fourth stanza of 'Lucy Gray', engraved by J. C. Bromley from a picture by Beaumont inspired by the poem; for Volume Two, an engraving by S. W. Reynolds of Beaumont's *Peele Castle in a Storm*, which inspired (i.e. 'suggested') Wordsworth's poem (see Figure 4). A poem produces a picture just as a picture

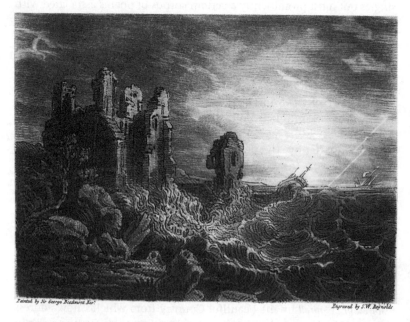

Painted by Sir George Beaumont Bar. *Engraved by S.W. Reynolds*

Figure 4 Frontispiece to William Wordsworth, *Poems* (Longman: London, 1815) of *Peel Castle in a Storm*, Painted by George Beaumont, engraved by S. W. Reynolds. Reproduced by permission. British Library shelf mark C.95.d.2 (Vol. 2)

produces a poem all of which are part of the same physical book as a composite artwork. In this way, a certain principle of interchangeability and equality—indeed co-authorship—may be signalled. 'Certainly, if nowadays the dedication's directly economic function has disappeared', writes Genette, 'one cannot mention a person or a thing as a privileged addressee without invoking... and therefore implicating the person or thing as a kind of ideal inspirer. "For So-and-So" always involves some element of "By So-and-So". The dedicatee is always in some way respons-ible for the work that is dedicated to him and to which he brings, willy-nilly, a little of his support and therefore participation' (136).

When Wordsworth sends his book off 'Wishing and hoping that this Work, with the embellishments it has received from [Beaumont's] pencil, may survive as a lasting memorial of a friendship, which I reckon among the blessings of my life', it expresses his characteristic desire for his poems to partake in the permanence that the Romantics were the first to invest in actual works of plastic art. This wish is ultimately the most important message encoded in the dedication to Beaumont: together, word and image constitute a 'Work' that may survive and reach Wordsworth's ideal addressee, posterity. When we see that Beaumont participates in the authoring of the 1815 *Poems* as source of inspira-tion, immediate audience and artistic collaborator, we understand the author no longer in the old role as proudly independent solitary genius, but in a new role as partly dependent and determined partaker in a collaborative production. The dedication points in two directions and functions as a kind of interface that integrates the frontispiece illustra-tions and the poetry, its most important statement being the wish that together image and word will compose a 'Work' that 'may survive as a lasting memorial'. The dedication presents the two volumes as one book and this book as a spatial form, a 'memorial' for posterity that consists of both word and image produced collaboratively by Wordsworth and Beaumont.

Beaumont paradoxically prompted the ekphrastic turn in Wordsworth's writing when he deliberately did not show Wordsworth his painting of *Peele Castle in a Storm* during the poet's visit to London in the late spring of 1806; an act that led to the composition of 'Elegiac Stanzas, Suggested by a Picture of Peele Castle, in a Storm, Painted by Sir George Beaumont'. To understand this poem and Beaumont's role as to some extent its co-author as well as source of inspiration and immediate audience, we need to examine a neglected aspect of its generative context, Sir Joshua Reynolds' *Discourses on Art*, which

Wordsworth and Beaumont had been discussing prior to their decisive meeting in 1806.

The use of ellipsis in the line, 'Planted by Beaumont's and by Wordsworth's hands', suggests as mentioned that the two pairs of hands are essentially the same. This emphasis on hands sends echoes back to a famous passage in 'Peele Castle', where Wordsworth speaks of painting in terms of planting and wishes his hand could perform both acts:

> Ah! THEN, if mine had been the Painter's hand,
> To express what then I saw; and add the gleam,
> The light that never was, on sea or land,
> The consecration and the Poet's dream;
>
> I would have planted thee, thou hoary Pile
> Amid a world how different from this!

> (*PW* 4, 259, ll. 13–18)

These lines refer to the picture Wordsworth would have painted had he had 'the Painter's hand' at the time when he was 'neighbour' (l. 1) to the actual Peele Castle in the summer of 1794. Because Wordsworth's is not 'the Painter's hand' in 1806 when he composed the poem, he 'commend[s]' (l. 43) the work of an actual 'Painter's hand', Beaumont's 'passionate Work' (l. 45). As he 'commend[s]' the painting, Wordsworth also releases the ekphrastic pun on 'comment' to signal the act of grafting his words onto the artwork. The poem says 'farewell' to 'the heart that lives alone, / Housed in a dream, at distance from the Kind!' (ll. 53–54) in order to say 'welcome' to 'fortitude, and patient cheer, / And frequent sights of what is to be borne!' (ll. 57–58). In welcoming 'sight', the poem articulates and reflects, perhaps even decisively inaugurates, the return of the visible in the later Wordsworth. In saying farewell to 'the heart that lives alone', the poem prepares for the significant and twice mentioned collective 'we' in the final line: 'Not without hope we suffer and we mourn'. Wordsworth's wish, 'if mine had been the Painter's hand', is a wish to be an autonomous, sovereign and fully independent artist in command of word as well as image, capable of producing a substantial artwork, a 'memorial', to house the poet's dream. The recognition with which the poem ends, the effect of commending Beaumont's work, is that by relinquishing this wish to be both a poet and a painter, and consequently by realising a degree of dependence upon the work of a fellow artist, the poet and the painter become a 'we' united in a struggle against time and mutability. Beaumont's work is seen as a symbol of something that 'braves' (l. 50) the natural forces

of destruction, and as such reveals and conceals the fate shared by all humans in their struggle against a death that is both represented in the picture (in its motif of shipwreck) and cushioned and deflected by what Wordsworth singles out as the central quality of the picture, its permanence and stability.

As critics have pointed out, 'Peele Castle' consists of three ontologically different pictures: (1) lines 1–12: Wordsworth's representation of his memory image of Peele Castle as a 'Form...sleeping on a glassy sea' (l. 4); (2) lines 13–40: The representation of the painting Wordsworth would have liked to paint 'if mine had been the Painter's hand' (l. 13); and (3) lines 41–60: Wordsworth's representation of Beaumont's actual painting of Peele Castle in a storm. As L. J. Swingle points out, these different verbal 'pictures' 'are static extremes, abstractions from the shifting nature of the world they pretend to portray'.[25] All three are dominated by and value positively qualities of stability, permanence and durability: the memory image 'sleeping on a glassy sea' 'trembled, but it *never passed away*' (l. 8); the projected painting should have been 'a treasure-house divine / Of peaceful years' (ll. 21–22), 'A Picture had it been *of lasting ease*' (l. 25) and of '*steadfast* peace' (l. 32); lastly, Beaumont's actual painting 'braves' (l. 50) the elements, it is 'Cased in the unfeeling *armour* of old time' (l. 51).

Wordsworth may have been inspired to see and to value art in these defensive, protective terms of stability and endurance by his reading of Reynolds' *Discourses*. Wordsworth had been given the *Discourses* by the Beaumonts in 1804, and had been reading them prior to the writing of 'Peele Castle' with the express purpose of appropriating a vocabulary to grasp and conceptualise painting. On 20 July 1804, Wordsworth wrote to thank the Beaumonts for the gift:

> Several of the Discourses I had read before, though never regularly together: they have very much added to the high opinion which I before entertained of Sir Joshua Reynolds. Of a great part of them, never having had an opportunity of *studying* any pictures whatsoever, I can be but a very inadequate judge; but of such parts of the Discourses as relate to general philosophy, I may be entitled to speak with more confidence.... The sound judgment universally displayed in these Discourses is truly admirable,—I mean the deep conviction of the necessity of unwearied labour and diligence.... It is such an animating sight to see a man of genius, regardless of temporary gains, whether of money or praise, fixing his attention solely upon what is intrinsically interesting and permanent. (*EY*, 490–491)

Two things are of interest here: Wordsworth's profession of a lack of knowledge of actual paintings, and his sympathetic response to Reynolds' 'general philosophy'; that is, to Reynolds' promotion of disinterested artistic 'labour' solely directed towards the creation of lasting works of art.

Wordsworth's sense of the permanence of the plastic arts, as revealed in the images of 'Peele Castle' and elsewhere in his ekphrastic production, seems to derive to some extent from one of the cardinal values in Reynolds' 'general philosophy' of art: tradition. The importance of the *Discourses* for the Romantics, in particular the service they paid as a point of negative identification for Blake and Hazlitt, has been dealt with by others, but the potentially crucial and rather different impact of the *Discourses* on the development of Wordsworth's poetics has not been stressed.[26] Yet, we must go through the *Discourses* and their understanding and valuation of art prepared to recognise a level of positive identification between them and Wordsworth if we are to reach an understanding of the significance of Wordsworth's ekphrastic turn. This was as much an effect of his (re)reading of the *Discourses* as the acquaintance with Beaumont, whose own understanding of art and taste had to a large extent been dictated by Reynolds.

In the letter to Beaumont, Wordsworth may be responding to a central passage in the Seventh Discourse, where Reynolds discussed wherein lays the 'true or just relish...of works of art'.[27] According to Reynolds, 'the same habit of mind which is acquired by our search for truth in the more serious duties of life, is only transferred to the pursuit of lighter amusements. The same disposition, the same desire to find something steady, substantial, and durable, on which the mind can lean as it were, and rest with safety, actuates us in both cases' (134). A passage such as this may be what Wordsworth alludes to when he praises Reynolds for fixing his attention on what is 'intrinsically interesting and permanent': what in the artwork itself is 'interesting' and therefore what makes it permanent ('steady, substantial, and durable').

How to secure the permanence of the artwork, its survivability, is indeed what Reynolds theorises in his *Discourses*, which emphasise tradition and the precept of classical models over individual talent and innovation. 'A man who thinks he is guarding himself against prejudices by resisting the authority of others, leaves open every avenue to singularity, vanity, self-conceit, obstinacy, and many other vices, all tending to warp judgment, and prevent the natural operation of his faculties', Reynolds said (132–133); and continued, 'submission to [the taste and authority of] others is a deference which we owe, and indeed

are forced involuntarily to pay' (133). Reynolds then professed his faith in perpetuating and upholding tradition:

> He...who is acquainted with the works which have pleased different ages and different countries, and has formed his opinion on them, has more materials, and more means of knowing what is analogous to the mind of man, than he who is conversant only with the works of his own age or country. What has pleased, and continues to please, is likely to please again: hence are derived the rules of art, and on this immoveable foundation they must ever stand. (133)

Asserting imitation of models and adherence to '*the* rules of art' against innovation and reliance on individual genius, Reynolds' aesthetics is profoundly classicist and conservative, something that earned him the spite of Blake in particular, but which Wordsworth to a certain extent was turning towards. We see this for instance in the 'Ode to Duty' or in the re-use of the couplet under inspiration from John Beaumont and Dryden. Holding that 'innovation always brings with it...evil and confusion' (139), Reynolds believed in a slow and gradual process of change, in reforming rather than revolutionising taste. 'Whoever would reform a nation', he said toward the end of the Seventh Discourse, 'supposing a bad taste to prevail in it, will not accomplish his purpose by going directly against the stream of their prejudices. Men's minds must be prepared to receive what is new to them. Reformation is a work of time' (140–141). Immediately before the comment on the 'work of time' needed to change a nation's taste, Reynolds had written something that would certainly have caught Wordsworth's attention due to his disposition to conflate rather than distinguish between writing and writing surface.

In his general discussion of ornamentation in art on the basis of his principle that 'As life would be imperfect without its highest ornaments, the Arts, so these arts themselves would be imperfect without *their* ornaments' (135), Reynolds writes that 'even the durability of the materials will often contribute to give a superiority to one object over another. Ornaments in buildings, with which taste is principally concerned, are composed of materials which last longer than those of which dress is composed; the former therefore make higher pretensions to our favour and prejudice' (139–140). To Reynolds, artistic value in part depends upon the durability of the artwork's basic matter, and architecture consequently is raised above fashion. We can now sum up a few points of what Wordsworth may have meant by Reynolds' 'general

philosophy': we have in our nature a 'desire to find something steady, substantial, and durable, on which the mind can lean as it were, and rest with safety', this desire finds fulfilment in our enjoyment of true works of art, which are works that are based on models that have stood the 'test of time' and, among other things, have value according to the durability, steadiness and substantiality of their material medium.

The first letter from 20 July 1804 gave voice to Wordsworth's response to the general aesthetics embedded in Reynolds' *Discourses*. The next letter of 25 December 1804 expresses a wish to get in touch with actual examples of the art of painting:

> I have...read the rest of his Discourses, with which I have been greatly pleased, and wish most heartily that I could have an opportunity of seeing in your company your own collection of pictures and some others in town, Mr. Angerstein's for instance, to have pointed out to me some of those finer and peculiar beauties of Painting which I am afraid I shall never have an occasion of becoming sufficiently familiar with pictures to discover myself. There is not a day in my life when I am at home in which that exquisite little drawing of yours of Applethwaite [gift from Beaumont to the Wordsworths ca. June, 1804] does not affect me with a sense of harmony and grace which I cannot describe. (*EY*, 517)

In this letter, we are witnesses to a crucial stage in the growth of the poet's mind. When Wordsworth criticism deals with the topic of 'Wordsworth and London', it is usually in the context of Book Seven of *The Prelude* and does not entail a consideration of visits to the private collections of aristocratic collectors such as Beaumont, Lord Stafford or John Julius Angerstein, whose collection of 38 masterpieces was purchased for £57,000 in 1824, and along with Beaumont's donation effectively served to found the National Gallery. However, after finishing *The Prelude*, and certainly in the years after those recorded in that poem, Wordsworth came to experience a London very different from that epitomised by Bartholomew Fair. With reference to the visit to London, Wordsworth mentions in the letter above—which did not occur until the spring of 1806 due to the death of Wordsworth's brother John in 1805—one of the poet's recent biographers evokes these experiences vividly:

> William met...a host of up-and-coming artists: James Northcote, the historical and portrait painter, who had been an assistant to Sir Joshua Reynolds; Henry Edridge, the brilliant society miniaturist, who had

called at Town End in the late summer of 1804 [and was commissioned by Beaumont to make a tinted pencil-drawing of Wordsworth in 1805]; Richard Duppa, Southey's friend, who had accompanied Edridge and to whom William had promised the translations of Michaelangelo; David Wilkie, the young Scottish artist and portrait painter; Joseph Farington, an artist-friend of Uncle William Cookson, now probably better known for his voluminous and splenetic diaries than his landscapes.[28]

Mark Reed also speculates that Wordsworth's visit to Nollekens' study occurred during this visit and notes that Wordsworth and Beaumont went to the Royal Academy exhibition on 2 May probably seeing one of Beaumont's two paintings of Peele Castle exhibited along with his painting based on 'The Thorn'.[29] During his visit to London, Wordsworth, as he later told a correspondent, was 'so much engaged that [he] did not read five minutes' (*MY* 1, 89), and surely the thirst for knowledge of the visual arts articulated in the December 1804 letter could begin to be quenched in such busy company, which, along with discussions with Beaumont, study of Reynolds' *Discourses*, and other treatises on aesthetics, among them Lessing's *Laocoön* (in 1802), enabled Wordsworth to develop a language with which to 'describe' how painting 'affect[s] [him] with a sense of harmony and grace'.[30] Coleridge's description of the impact of Beaumont also holds for Wordsworth, 'I have learnt as much fr[om] Sir George respecting Pictures & Painting and Painte[rs as] I ever learnt on any subject from any man.'[31]

Beaumont had not taken Wordsworth to see *Peel Castle in a Storm* whether at the exhibition or at home because he did not want to aggravate Wordsworth's grief over his brother by reminding him of shipwreck. Wordsworth acknowledges this when he writes to Beaumont on 1 August 1806: 'I am glad you liked the verses, I could not but write them with feeling with such a subject, and one that touched me so nearly: your delicacy in not leading me to the Picture did not escape me.... The Picture was to me a very moving one; it exists in my mind at this moment as if it were before my eyes' (*MY* 1, 63). The 'verses' Wordsworth refers to are of course the 'Elegiac Stanzas suggested by a Picture of Peele Castle in a Storm' whose first 'publication' was in the form of a gift to Beaumont in a preceding letter. On the evidence of the poem, what Wordsworth 'saw' in Beaumont's picture, among other things, was what he had been taught to see from reading Reynolds' *Discourses*. Reynolds gave him a language to describe how painting

'affect[s] [him] with a sense of harmony and grace'; at least Reynolds can be said to have legitimated Wordsworth's way of seeing painting in terms of something 'steady, substantial, and durable, on which the mind can lean as it were, and rest with safety', which is essentially how Wordsworth saw Beaumont's painting.

In writing 'Peele Castle' with Beaumont specifically in mind as addressee, Wordsworth—in however an unconscious manner—wished to demonstrate his newly acquired vocabulary, taste and sensibility. He wanted no doubt to thank his addressee for initiating him to the world of art even if Wordsworth wanted to be initiated on his own terms. This is demonstrated by his writing about this specific picture, which Beaumont did not show him, and by the fact that he essentially *projects* the value of permanence and stability into Beaumont's picture. As James Heffernan astutely points out, the actual painting does not itself suggest permanence and stability but rather the very opposite qualities of destruction, mutability and dissolution (see Figure 4). The painting's 'shattered walls show plainly that it is anything but impervious to assault', writes Heffernan, 'Instead of representing Beaumont's painting, then, Wordsworth constructs in words [an] imaginary picture of his own.'[32]

Even as he 'commends' Beaumont's painting, Wordsworth coats or varnishes it, first, in two 'pictures' of his own making, the memory image and the painting he would have painted had his been 'the Painter's hand', and, second, he recreates it to produce what is in effect a notional ekphrasis in the third verbal picture, which ostensibly represents the actual painting, but in fact recreates it in the image of Wordsworth's desire for permanence and stability.

The best example of the nature of the collaborative work between Wordsworth and Beaumont is probably the ekphrastic sonnet, 'Upon the Sight of a Beautiful Picture, Painted by Sir George Beaumont':

> PRAISED be the Art whose subtle power could stay
> Yon cloud, and fix it in that glorious shape;
> Nor would permit the thin smoke to escape,
> Nor those bright sunbeams to forsake the day;
> Which stopped that band of travellers on their way,
> Ere they were lost within the shady wood;
> And showed the Bark upon the glassy flood
> For ever anchored in her sheltering bay.
> Soul-soothing Art! whom Morning, Noontide, Even,
> Do serve with all their changeful pageantry;
> Thou, with ambition modest yet sublime,

> Here, for the sight of mortal man, hast given
> To one brief moment caught from fleeting time
> The appropriate calm of blest eternity.

<div align="center">

(*PW* 3, 6)

</div>

The octave describes the painting by singling out certain motifs in it: cloud, smoke, sunbeams, travellers, wood and a ship at anchor; and it praises the art of painting for having fixed them in the artwork. The sestet goes on to reflect upon this description and to present an evaluation of the artwork's capacity to perform a soul-soothing act by virtue of the fixity of the artwork, which may derive from the reading of Reynolds. This sonnet offers an example of the chiasmic turn from nature to art when it suggests that nature 'serve[s]' art even as art preserves nature's various apparitions, and it gives a compressed articulation of what Wordsworth valued most about painting: its power to catch, fix, frame and preserve evanescent phenomena, to give 'To one brief moment... / The appropriate calm of blest eternity'.

One must look carefully to locate what Geoffrey Hartman (as discussed in Chapter 1) calls the 'tyranny of sight' and 'fear of visual reality' in this sonnet, wherein Wordsworth offers painting as the place where 'eternity' for 'one moment' has found a finite form in which the intelligible and the sensible commingle to assume the contours of something indestructible. The sonnet represents a double representation of a ship at anchor, 'the Bark upon the glassy Flood / For ever anchored in her sheltering bay'. This clear instance of a return of the visible in its multiple reflection and representation (a ship reflected in water that is reflected in painting and again reflected in the poem) is often read as the end of Wordsworth's work of mourning John's death by shipwreck in 1805 insofar as it shows a tamed nature that soothes and lulls rather than agitates and threatens the mind with extinction. Yet, it also echoes with the apostrophe to Imagination in *The Prelude* (1805, VI, ll. 525–536) that Hartman has placed at the centre of his analysis of Wordsworth. The painting represented in the sonnet revises the sublime anti-visuality of the Alpine scenery as it represents in a visible, concrete form the 'invisible world' where 'greatness... harbours' (*Prelude*, 1805, VI, ll. 535–536). It shows Imagination as externalised and 'anchored' in Art for silent contemplation.

To complicate the idea of the immutability of art expressed in the poem, the actual art object to which the sonnet refers has been lost, consumed by what the poem calls 'fleeting time'. Yet, despite the fact that the painting and thus the ground for a literal comparison of text

and image has been lost, we can be fairly certain that there is something in the poem which is not in the painting by Beaumont. To see this, the sonnet needs to be restored to its original context of 'publication' in a long letter Wordsworth wrote to Beaumont on 28 August 1811. Read in the context of what Martha Hale Shackford has characterised as 'the most interesting letter Wordsworth wrote about painting', the poem means something quite different from what it means if approached in isolation.[33] In the letter, Wordsworth reports a conversation between an anonymous painter and the then fashionable watercolourist, John Glover (1767–1849): 'I heard the other day of two artists who thus expressed themselves upon the subject of a scene among our Lakes. "Plague upon those vile Enclosures!" said One; "they spoil everything". "O", said the Other, "I never *see* them". Glover was the name of this last' (*MY* 1, 506). 'Now, for my part', Wordsworth continues, 'I should not wish to be either of these Gentlemen, but to have in my own mind the power of turning to advantage, wherever it is possible, every object of Art and Nature as they appear before me' (*MY* 1, 506). Given the choice between realistic fidelity to a given particular in nature (the sense that the first painter cannot but paint the enclosures), and idealistic neglect of anything given (the sense that the second painter completely overlooks the enclosures), Wordsworth chooses both and neither; he chooses to depart from something given by 'turning [it] to advantage'. Wordsworth next mentions a practical example of an artwork that turns the given to advantage:

> What a noble instance, as you have often pointed out to me, has Reubens given of this in that picture in your possession, where he has brought, as it were, a whole Country into one Landscape, and made the most formal partitions of cultivation; hedge-rows of pollard willows conduct the eye into the depths and distances of this picture; and thus, more than by any other means, has given it that appearance of immensity which is so striking. (*MY* 1, 506)

In his famous painting, *The Château de Steen* (c. 1635), Rubens retains the accidental particular but uses it to give a non-accidental effect of wholeness that is the province of art rather than nature.[34] Such an exemplary analysis of the formal work of painting would have been unthinkable a few years earlier, when Wordsworth professed his ignorance of the language of art in the first letter to Beaumont. Yet, due to the influence of Beaumont (and Reynolds and Lessing), Wordsworth

can now perceive how Rubens converts the accidental features of nature into the formal permanence of art.

Wordsworth's growing knowledge of painting and skill in analysing it along with his reliance on Beaumont's judgement is brought out in his report of a visit with Coleridge to Angerstein's gallery in April 1808. Wordsworth thanks Beaumont for a letter of introduction to the famous portrait painter, Sir Thomas Lawrence, with which he and Coleridge were given access to Angerstein's gallery:

> the great picture of Michael Angelo's Sebastian pleased me more than ever, the new Rembrant has, I think, much, very much, to admire, but still more to *wonder at*, rather than admire; I have seen many pictures of Rembrant which I should prefer to it. The light in the *depth* of the Temple is far the finest part of it; indeed it is the only part of the picture which gives me any *high* pleasure; but that does highly please me.... I saw at my Friend's and your Neighbour, Mr Tuffin's, a collection of Cabinet pictures, which he would be proud to shew you, and which I think you would like to see. They pleased me very much.... When you have seen [William] Havill's drawing of Rydale pray tell me what you think of it. I have not much confidence in my judgment of Pictures except when it coincides with yours. (*MY* 1, 208–209)

Wordsworth reveals that it is not the first time he had visited the gallery and seen Michelangelo's work and that he is mentally storing pictures for comparison (making a *musée imaginaire*) in his discussion of the new Rembrandt in relation to others he has seen. Further, he indicates a growing vocabulary with which to conceptualise his response to artworks: he distinguishes between admiration and wonder, notes effects of light in depth, and speaks of high pleasure as opposed to being highly pleased, yet he still wants to confer with Beaumont's judgement.

After Wordsworth in the 1811 letter mentioned his own preferred aesthetics as a mixture of realism and idealism, and after he had mentioned Rubens as a model of this aesthetic principle, he went on to say that he had written a sonnet which one of Beaumont's paintings inspired. 'A few days after I had enjoyed the pleasure of seeing in different moods of mind your Coleorton Landscape from my fireside, it *suggested* to me the following Sonnet, which, having walked out to the side of Grasmere Brook, where it murmurs through the meadows near the Church, I composed immediately' (*MY* 1, 507; Wordsworth's emphasis). Wordsworth cites the sonnet, and reveals that some of the

details attributed to the painting are in fact supplemented by his own imagination: 'The images of the smoke and the Travellers are taken from your Picture; the rest were added, in order to place the thought in a clear point of view, and for the sake of variety' (*MY* 1, 507). In short, the letter tells us that in the poem Wordsworth creates as much as re-creates or describes the picture.

In the latter half of the letter, Wordsworth provides a remarkable prose description of a cloud formation worthy of and indeed probably made possible by virtue of the experiences with descriptive writing in the *Guide to the Lakes* (a 'line of clouds immoveably attached...to the Island, [which] manifestly took their shape from the influence of its mountains' [508]) and of a ship at sea, which he compares to Milton's description of Satan as a Fleet ('the visionary grandeur and beautiful form of this *single* vessel, could words have conveyed to the mind the picture which Nature presented to the eye, would have suited [Milton's] purpose as well as the largest company of Vessels that ever associated together with the help of a trade wind, in the wide Ocean. Yet not exactly so, and for this reason, that his image is a permanent one, not dependent upon accident' [508]). Wordsworth, in other words, ends the letter by evoking a permanent image of clouds and of a ship more permanently represented in Milton's language than in nature's painting. He describes these two phenomena as consonant with the values and qualities he tends to associate with the plastic arts which explains his motive for having transplanted the two images of cloud and ship into Beaumont's picture. The poet's hand has added the clouds that open the description in the octave as well as the ship anchored in the bay that closes the description, the two things Wordsworth ends the letter by describing. The poem is thus an instance of Wordsworth exercising what he calls 'the power of turning to advantage...every object of Art and Nature as they appear before me'. Wordsworth perfects Beaumont's Art by bringing in two things observed in Nature (and in one case mediated, rendered permanent and perfected in the art of Milton), and realised in his own artwork, which functions as a supplement to Beaumont's picture.

The implication of this supplementation is that when we get to the last tercet, which articulates the key Romantic idea of the transcendent powers of art and its capacity to reflect and perhaps even partake in the order of the eternal, the adverb that opens line 12, 'here', begins to perform differently than when we attend to the poem as a self-contained entity sealed off from its context of production. In other words, what might be taken as an instance of unambiguous reference

to the landscape painting is complicated because the painting to which 'here' refers exists only in the words for it. The only place we can observe all the phenomena the poem singles out as in the painting is in fact in the poem, which begins as an actual, straightforward ekphrastic *re*presentation of an actual painting, yet suddenly, without telling us directly, imperceptibly slips over into an ekphrastic *pre*sentation or creation through linguistic description. This is not to imply that the poem completely usurps the painting and appropriates the deictic 'here' solely for itself. It is to say that at the very least poetry wants to share the deictic with painting, to make it a double sign that shifts between painting and poetry and is equally capable of accommodating both art forms. To perceive in a moment's time a sonnet fixed on a page and a painting on a wall is a similar act in several ways. It depends on the material being of the artwork but also presupposes and entails a certain amount of time for the perceiver to make out what is represented, how it is represented, and the ways in which these two aspects of the artwork relate to each other. In the letter to Beaumont, Wordsworth tells us that he composed the sonnet only after he had been looking at the picture for several days and at different times of the day. As E. H. Gombrich has said, 'It takes more time to sort a painting out [than a mere moment]. We do it, it seems, more or less as we read a page, by scanning it with our eyes.'[35] A certain temporal process has preceded what in the poem may appear to be the staging of a moment's perception of the artwork. It takes time to see how an artwork may be said to capture and transcend time in a moment.

When we read Wordsworth's sonnet in a dialectical interplay with its immediate context defined by the letter and the absent painting, the deictic 'here', as said, doubles its reference and begins to oscillate between painting and poem. 'Here' points at once to the absent art object and to the poetic (re)construction of the painting that unfolds as we read. Thus, the wish of 'Peele Castle' ('if mine had been the Painter's hand / To express what then I saw; and add the gleam') is fulfilled in the sonnet 'when the poet's hand paints his own peace and reconciliation into Beaumont's benign scene', as John Hollander puts it.[36] The poem, in other words, claims to be able to paint with words; to verbally conjure a 'sight'. In the last tercet, the word 'sight' clearly means that something has been visualised before our eyes. Not surprisingly the central motif of the bark, which Wordsworth's imagination rather than Beaumont's has supplemented and which rounds off and unifies the poetic 'description', is the only motif whose visuality is mentioned explicitly ('PRAISED be the Art whose subtle power ... *showed* the Bark'). When Wordsworth praises

the art which can immortalise and visualise something he is praising his own art of poetry (we must in other words take him at his word when he says in the letter that he aims to 'place the thought in a clear point of view'). This means in effect that Wordsworth claims to have performed a verbal act, which he had forsworn a decade earlier when he departed from Neoclassical ideals of poetic representation based on the art of painting. This departure was articulated in 'Tintern Abbey', where Wordsworth, in saying 'I cannot paint what then I was', said that his verbal art was not modelled on the art of painting, but on music. 'Tintern Abbey' aims to express 'the still sad music of humanity', rather than to paint a faithful picture of the visible world. In a late sonnet from the *River Duddon* sequence (1820), which the next chapter will deal with in more detail, Wordsworth addresses the river and asks rhetorically, 'How shall I paint thee?'. This question presupposes a pictorialist aesthetics which is opposed to the aesthetics he professed in 'Tintern Abbey', where we are never actually given a sight of the River Wye, which is only present as sound, as a 'soft inland murmur'. When Wordsworth asks, 'How shall I paint thee?', he reveals one of the most significant changes between his earlier iconoclastic and iconophobic Great Decade aesthetics and his later pictorialist aesthetics.

If Wordsworth's ekphrastic poems tend to absorb and assimilate the paintings they ostensibly represent enabling him to imagine a permanent poetry destined for posterity, then Beaumont's pictures also make incursions into Wordsworth's textual territory in the form of illustration. Despite his problems with the illustrations to the *Guide to the Lakes* in 1810, by virtue of its frontispiece illustrations, Wordsworth's 1815 *Poems* participated, though in a modest manner, in the booming market for illustration. Basil Hunnisett notes that the Romantic period coincided with 'a great interest in art' and a 'desire to own pictures and *objets d'art* as a sign of culture and breeding'.[37] For the majority who could not afford the originals, a wide and rapidly expanding market arose for reproductions of various kinds and quality, mainly by the techniques of wood and copper plate engraving as already described in Chapter 1. Especially the works of Claude Lorraine, Nicolas Poussin and Salvator Rosa were popular in the latter half of the eighteenth century along with the illustrated editions of James Thomson's *The Seasons*, which 'was for more than one hundred and fifty years the most illustrated poem in the English language', as Ralph Cohen writes.[38] Picturesque landscapes and the many topographical books that featured them, such as the *Guide*, were indeed the most popular kind of illustrated works in the period, seconded by books of poetry.[39] Robert Southey knew that

illustrations could boost the sale of a book. Planning the second edition of *Poems* (1797) on 2 May 1797 he wrote to his publisher Joseph Cottle,

> Mr Peacock strenuously recommends two or three vignettes.... If you should think seriously of any ornaments of this kind, I would wish the frontispiece to be Gaspar Poussins exquisite landscape. I am inclined to think that prints help a book. That frontispiece and two vignettes—one from the Slave Trade Poems, one—'Elinor' would be enough. It is needless to add that I am indifferent concerning all this and merely suggest it as matter of consideration in the profit and loss way.[40]

Southey wanted an illustration to match one of the most important Romantic ekphrases to precede 'Peele Castle', his blank verse meditation 'On a Landscape by Gaspar Poussin', not to profit aesthetically but financially. Later in May Southey wrote again to Cottle,

> I write to you upon the subject of the vignettes again, because it has been recommended from many quarters, and by those who know how books sell. They tell me that ornaments of this kind accelerate the sale of a book; and as far as my own observations go—I may say my own feelings—they agree with the remarks.... The point is will it accelerate the sale? Think upon this, and let me speedily know the result of your thoughts, ... if they incline toward tickling the public eye.[41]

The 'public eye' responded to the kind of 'tickling' provided by illustrations and the proliferation and importance of illustration only increased in the first decades of the nineteenth century to peak momentarily in 1823 when Rudolf Ackermann published the first literary annual, the *Forget-Me-Not*. The extraordinary commercial success of the annuals was due to their use of steel-engraved illustrations as much as the prose and poetry that made up the bulk of their pages. The technique of steel engraving, which was developed in the 1820s, enabled both a better quality of the reproduction and many more copies to be made from the same plate than the alternative technique of copper plate engraving. Rapidly, the annuals made it evident that 'readers' were at least, if not in fact more, interested in graphic illustration than in text. As Hunnisett puts it, steel engraving 'encouraged the kind of book where the illustrations created the text, which merely became an extended caption to the pictures'.[42]

Despite the experiences with the *Guide*, the inclusion of frontispiece illustrations may in other words be seen as a commercial venture to assist the book's sales and increase its market value. As already seen in Chapter 2 in relation to *The White Doe of Rylstone*, Wordsworth was not above virtually soliciting illustration even as he was reluctant to write in commissioned illustration of a picture. Norma Davis has investigated the interchanges concerning the illustration of *The White Doe*. With reference to the letter to Beaumont where Wordsworth mentions 'one situation which, if the work should ever become familiarly known, would furnish as fine a subject for a picture as anything I remember in poetry, ancient or modern. I need not mention what it is, as when you read the poem you cannot miss it' (*MY* 1, 197–198), Davis writes, 'Such an oblique reference to a specific passage in a work of nearly two thousand lines is evidence of Wordsworth's confidence in Beaumont's perceptivity and sensitivity to his poetry. It also constitutes an understanding between the two men as to what constituted good art.'[43] However, we should also consider the significance of the fact that Wordsworth was not only actively, even if indirectly, leading 'the Painter's hand', he was also (in a manner reminiscent of Beaumont's not leading Wordsworth directly to *Peele Castle*) leaving it up to Beaumont to decide what to illustrate; Wordsworth will not explicitly commission an illustration nor propose its motive, but merely 'suggests' a pretext and leaves the artist free to choose and interpret: given Wordsworth's 'suggestion', Beaumont could hardly choose the wrong passage for illustration. As Davis writes with reference to *The White Doe* and the plans to publish it in an expensive quarto format, 'Longmans was hesitant to publish an expensive edition, but its value was thought at the time to be enhanced by the inclusion of an engraving of the painting by Beaumont' (195), which Wordsworth had all but commissioned.

Whether Wordsworth in 1815 was motivated by commercial interests matters less than the fact that he presents the illustrations, in the dedication to Beaumont, as somehow capable of ensuring the survival of the book as a 'memorial'. That the dedication ends with a wish and a hope that the illustrations in some sense will secure the book from destruction, that they will serve to immortalise it, however, was ironically undercut by the inclusion of another paratextual layer in collected works editions after 1820, in which a footnote in effect replaces or substitutes for the engravings by informing us that 'The state of the plates has, for some time, not allowed them to be repeated' (*PrW* 3, 17). Wordsworth's illustrations were made from copper plate engravings which, compared to the later technique of steel engraving, were much less durable and

allowed fewer print runs. Even though it makes good sense to include this footnote to explain the whereabouts of the dedication's missing referent, we have to ask ourselves whether we should not read more out of it and the irony that is generated by its inclusion; indeed, we may legitimately wonder whether we cannot detect some of Wordsworth's notorious iconoclasm in this frank admission of the mutability of visual artworks and the capacity of verbal artworks to outlast and to absorb them. The illustrations may have been included primarily as a token of friendship (and because Beaumont paid all expenses) rather than for aesthetic or commercial reasons. This much seems to be implied by Henry Crabb Robinson, who disliked the illustrations intensely. Crabb Robinson was surely no enemy of illustrations, but a bibliophile who knew a beautiful book when he saw one, and writing to Dorothy in 1825, he said with reference to the forthcoming third edition of *Poems* (1827), 'I shall be delighted in adding a third edition to those I have.... Of works that one really loves, one is glad to have varieties of shape and size—The landscapes [i.e. the engravings from Beaumont's landscapes] are, I hope, to be omitted in the new edition—And yet if the omission cast but a shade of mortification over the brow of your venerable friend for a moment I would not have them omitted—But if there are to be *gays* as we call them in Suffolk Why not *line* engravings[?]'.[44] Wordsworth seems to have wanted it both ways: to maintain the idea in the Dedication of offering illustrations from Beaumont even in their absence, where the technical argument may serve as a convenient excuse for leaving them out. The creative friendship and artistic dialogue between Wordsworth and Beaumont was founded on an organising principle of mutual 'suggestion' and indirect influence: it may be the most significant collaborative relationship in his later period, and it holds the key with which to reopen and reconsider the specific concerns, textual strategies, qualities and values of the later work; but it of course always pointed to Wordsworth getting the last word.

4
The Sonnet as Visual Poetry: *Italics* in 'After-Thought'

> It will easily be perceived that the only part of this Sonnet which is of any value is the lines printed in Italics.
>
> —Wordsworth on Gray in Preface to *Lyrical Ballads* (1800)

All in all Wordsworth wrote some 535 sonnets. In the years 1818–1822 alone, he composed nearly two hundred and, as Lee Johnson notes, the sonnet was indeed the 'principal form of utterance' in the later phase of the career.[1] To understand the difference and appreciate the specificity of Wordsworth's later work, we must understand both why he turned so emphatically to the sonnet and what he turned it into. What compelled this allegedly 'simple' poet of nature, who claimed to compose in 'a selection of the language really spoken by men' (Brett & Jones, 254), to invest so heavily in the stylised, artificial and conventional sonnet form he at one point thought of as 'egregiously absurd'? (*LY* 1, 125).

Readers divide over this question and by implication over the nature and quality of the sonnets from the later years. For Johnson, they 'often demonstrate a poetic achievement of undisputed distinction and thereby indicate a way of correcting our sense of a "decline" in his imaginative powers'.[2] Stuart Curran, to the contrary, reminds us that some of Wordsworth's last published poems were the fourteen arguments in favour of capital punishment, the 'Sonnets on the Punishment of Death' (1841). With these sonnets, Curran claims, Wordsworth 'leaves the perverse impression of having pursued across the arc of his career an almost undeviating course away from the internal debates and epiphanies by which he had refined the form for his culture' in the sonnets first published in *Poems, in Two Volumes* (1807), described by Curran as representing 'the most significant recasting of the form since

Milton'.[3] Distancing himself from these mutually exclusive positions, William Galperin has proposed that we bracket the question of quality and instead locate the significance of the later sonnets in the fact that they revise our view of what is central in Wordsworth. For, as Galperin puts it, they are conscious efforts in 'deflecting attention from imagination' and mark a 'repudiation of Wordsworth's earlier poetic forms—both the "personal epic" and "greater romantic lyric"—which are clearly expressions of personality'.[4] As Galperin puts it with reference to the *River Duddon* sonnets also singled out for attention in this chapter, they 'refer to something other than William Wordsworth' (ibid.).

Building on Galperin's suggestion that Wordsworth breaks new poetic ground in the later sonnets, I argue that the emphatic turn to the sonnet after the late 1810s was increasingly prompted by a desire for a complex of interrelated values and qualities not usually associated with the poet. When he turned to the sonnet Wordsworth turned to a form that could function as a vehicle for the 'extinction' more than the 'expression' of the poet's personality and self, and result in the creation of a palpable, concrete and above all visual poetry. Visual is meant both in the sense of being more about the visual, external world of matter as opposed to the hidden, internal world of self (as in poetry that renders sights seen on a tour, for instance, or poetry that describes works of visual art), and in the sense of calling attention to itself as a visual form on the page. In late Wordsworth's sonnets we see, in a double sense, how the 'return of the visible' in British Romanticism revises and decentres the 'visionary' Wordsworth who sought to transcend physical nature to attain a sense of 'something far more deeply interfused', and who—to realise this idealist project—called the eye 'the most despotic of our senses'.

Wordsworth apparently did not rank his sonnets as high as other parts of his *oeuvre*. As Henry Crabb Robinson reported in his diary for 17 August 1837, Wordsworth

> did not expect or desire from posterity any other fame than that which would be given him for the way in which his poems exhibit man in his essentially human character and relations—as child, parent, husband, the qualities which are common to all men as opposed to those which distinguish one man from another. His sonnets are not therefore the works that he esteems the most.... I had...spoken of the sonnets as [my] favourites. He said: 'You are...wrong'.[5]

However, inasmuch as Wordsworth by 1837 had composed more than 500 sonnets and was generally seen as its foremost practitioner at the time, Crabb Robinson's entry also registers the general impression we get from considering the subject of 'Wordsworth and the sonnet': that he always felt uneasy, even guilty for writing sonnets.

This seems to stem from two main causes. On the one hand, due to its artificiality and many set conventions the sonnet appears oddly out of place in the work of someone famous for promoting and exemplifying a plain, natural and simple poetry spoken in the 'real language of men' rather than that 'substituted for it by Poets, who think that they are conferring honour upon themselves and their art in proportion as they separate themselves from the sympathies of men, and indulge in arbitrary and capricious habits of expression', as he said in the Preface to *Lyrical Ballads* (Brett & Jones, 245–246). It is no coincidence that the only sonnet 'in' the *Lyrical Ballads* is Thomas Gray's 'Sonnet on the Death of Richard West' (1775), which is famously castigated in the Preface for employing artificial poetic diction. Wordsworth does not censure the form as such for being artificial, but he certainly associates it with artifice as a covert way of attacking the Della Cruscans for being artificial ('those who...have attempted to widen the space betwixt Prose and Metrical composition' [Brett & Jones, 252]).[6]

On the other hand, the sonnet came in the way of grander and what Wordsworth saw as more legitimate poetic labour that would secure his poetic immortality (i.e. *The Recluse*). If the sonnet, as Hazlitt puts it, 'is a sigh uttered from the fulness of the heart, an involuntary aspiration born and dying in the same moment', it may be said to be a bad formal choice for anyone aiming to erect a lasting monument.[7] Reviewing the *Memorials of a Tour on the Continent, 1820*, which consisted mainly of sonnets, a critic for the *British Review* points directly to the paradox:

> We wish...to see Mr. Wordsworth engaged in some more important and continuous exertion of his powers. It is rather too lounging for such a poet to dissipate his resources in short and sportive exercises, the neglect of all grand and adequate undertakings, in which the varied gifts of his mind might be collectively and momentously displayed. (Reiman, Vol. 1, p. 256)

Already in 1803 Coleridge hoped that Wordsworth had said 'farewell to all small poems' and devoted himself exclusively to 'his great work', *The Recluse*. As Coleridge put it, 'In those little poems, his own corrections [came] of necessity so often—at the end of every fourteen or twenty

lines... [that they] wore him out.'[8] However, by 1803 Wordsworth had initiated his troubled but persistent affair with this quintessential 'small' poem. As is well-known, the 'affair' got serious when Dorothy read Milton's sonnets to Wordsworth in 1802 and lasted for the rest of his career, ultimately resulting in the transformation of the 'small' form into great, even monumental proportions.

One of the less well-known aspects of Wordsworth's sonnetian invest-ment is its culmination in the publication in 1838 of all the sonnets in a single volume: *The Sonnets of William Wordsworth. Collected in One Volume, with A Few Additional Ones, now First Published*, which counts an extraordinary 477 pages of which 415 contained sonnets and the rest title pages and notes. If with his 1807 volumes Wordsworth had 'assured' 'the sonnet's revival', as Curran puts it, with his 1838 book he registered the culmination of Romantic 'sonnettomania' and anticipated the Victorian obsession with the form.[9] To consider this publication is to recognise the potential Wordsworth saw in the sonnet form even as he professed a certain indifference about the book project. In 1835, Edward Moxon had become Wordsworth's publisher and as Wordsworth noted in a February 1835 letter to Moxon, 'I am rather pleased that you approve of the Sonnets in a separate volume, not that I care much about it myself, except for the money that it would bring' (*LY* 3, 518). Despite his professed indifference, Wordsworth did invest some energy into the project by writing twelve new sonnets for the collection (advertised in the title) which suggests that the book was more than a merely acci-dental commercial venture to further refine and adapt his poems for the market.

The perhaps most interesting aspect of the book was revealed in a February 1838 letter to Crabb Robinson, where Wordsworth charac-terised 'the structure of the Sonnet' as 'so artificial' (*LY* 3, 522). This characterisation is, on the one hand, not surprising. As Ian Balfour has noted, 'This most artificial of genres, the sonnet, became in the Romantic era an oddly naturalized form of expression.'[10] Yet, it is still surprising given that Wordsworth makes the characterisation with perfect ease and without any signs of the anxiety we might expect from him on the topic of the artificial, which he elsewhere sees in negative terms prompting critics to suggest that 'The force of Wordsworth's aesthetic is directed...against artifice.'[11] The context in which Wordsworth made this surprising but apt characterisation of the sonnet's primary formal characteristic was a justification of Moxon's plan to publish the sonnets with only one sonnet per page. At first, Wordsworth had objected to this plan and had wished to print two sonnets per page in order to lower

the production costs and thus increase the circulation of the book (*LY* 3, 530). One sonnet per page, as he wrote to Moxon, 'would make it a book of luxury, and tho' I have no objection to that yet still my wish is, to be read as widely as is consistent with reasonable pecuniary return' (*LY* 3, 518). In the same letter he reported a letter from a clergyman who had expressed a wish that Wordsworth would publish his works 'in "brown paper", that was the word, meaning I suppose the cheapest form, for the benefit of readers in the humblest condition of life' (*LY* 3, 519). However, having said this, Wordsworth also said he would leave 'the mode of publication entirely to [Moxon's] superior judgement' (ibid.) knowing full well what the result would be.

Moxon had set up shop as independent publisher of poetry in the early 1830s at a time when most other publishers were opting for prose rather than poetry. He made his first appearances with lavishly illustrated editions of Samuel Rogers, while Tennyson was his great discovery and asset. In 1835, Robert Southey said that 'No one knows better how to get up a book' than Moxon, an evaluation shared by most other commentators at the time.[12] As Moxon's biographer puts it, 'The type in Moxon books was clear-cut and well spaced.... The title-pages were simple and dignified, usually without rulings or ornaments. The binding was simple but elegant.'[13] Clearly Wordsworth knew that Moxon would not compromise the aesthetic impression of the book to make it cheaper by cramming the page, using inexpensive brown paper and small, sparsely leaded type. The end result was indeed a 'luxury book' with one sonnet per page, which, as Wordsworth wrote to Crabb Robinson, 'may be better tolerated in this class of composition than others, as the structure of the Sonnet is so artificial' (*LY* 3, p. 522). It was not a *de luxe* edition however: there were no illustrations and other embellishments, no hot-pressed paper, gilded edges or fancy leather bindings, and at 6*s* it was neither more nor less expensive than other poetry books of the 1830s. The 'luxury' had to do only with the relation between the relatively large amount of pages and marginal space and the small amount of words.

Wordsworth here reveals a keen sense of the interrelation between the materiality of the book medium and the strictures of a fixed poetic form such as the sonnet. From one point of view, to print two sonnets per page, regardless of the quality and kind of paper, the typeface, size of margins or amount of leading, should not make a difference; the words and their formal arrangement within the sonnet surely give the same meanings irrespective of the context in which the reader confronts them. However, from another point of view, to print two sonnets per page is to signal that all that matters is the lexical, syntactic, rhetorical

and formal meanings of the words, which are aimed at the mind and the ear, rather than their visual and sensuous presence on the page before the eye. To print two sonnets per page on cheap brown paper would create a jarring mismatch between poetic form and the form and format of publication, while to print one sonnet on one page facilitates the concrete realisation of Wordsworth's idea of the sonnet form as expressed in an 1833 letter to Alexander Dyce, where he said that the enjambment of octave and sestet in Milton's sonnets

> is not done merely to gratify the ear by variety and freedom of sound, but also to aid in giving that pervading sense of intense Unity in which the excellence of the Sonnet has always seemed to me mainly to consist. Instead of looking at this composition as a piece of archi-tecture, making a whole out of three parts, I have been much in the habit of preferring the image of an orbicular body—a sphere—or a dew-drop. (*LY* 2, p. 604)

A sonnet suits a page perfectly and it is therefore proper to have one sonnet per page even though this leaves much white paper unprinted. When they were discussing one vs. two sonnets per page, Wordsworth and Moxon (himself a prolific sonneteer) recognised the aesthetic surplus value that would be generated by a sonnet standing alone on the page as a form of visual poetry, a black figure framed by wide white margins. To have one sonnet per page is to spell out its 'intense Unity' in textual space and to recognise that the blanks bear meaning.

The awareness Wordsworth reveals of the sonnet as a form of visual poetry ('Instead of *looking* at this composition', etc.) whose physical appearance makes a difference was set in relief in the early 1830s. In an 1830 letter, Wordsworth discussed plans to compress the 1827 edition of the collected works from five to four volumes (*The Excursion* had its own volume, so the issue was a compression of the shorter poems from four to three). The motivation behind this compression was to make the poetry cheaper and more competitive *vis-à-vis* the cheap single-volume 'pirate' edition issued by Galignani in Paris in 1828 and imported and sold illegally in England. 'My intention at present', wrote Wordsworth, 'is to reprint the whole pretty much in the same form; only I shall print *two* Sonnets in a page, a greater number of *lines* also; and exclude all blank paper (called I believe by Printers *fat*) and by this I hope to reduce the price of the Work' (*LY* 2, 225–226). This edition came out in 1832, but Wordsworth soon realised his sales did not depend on a crammed page, which in addition had become a source of displeasure. Writing

to Moxon in 1836, Wordsworth said that 'The three volumes...ought to be spread over 4, one Sonnet only being on a page.... The whole would then consist of 6 Volumes, and certainly would have a much better appearance. If you see Mr [Crabb] Robinson ask him about this; he complains of the present Edition having a shabby appearance from the crowded page' (*LY* 3, 149). More space was needed to enhance the aesthetic quality of the layout and make the page an adequate surface on which to exhibit the poetic text. This was particularly the case for the sonnets, which had suffered most from the compression and were consequently in need of more space. If he had not been fully aware of it before, Wordsworth (encouraged by his bibliophile and sonnet-loving friend Crabb Robinson) would have come to see the difference between printing one and two sonnets per page after the failed experiment with compression in 1832.

Moxon's decision to print one sonnet per page and Wordsworth's endorsement of this decision in light of the sonnet's 'artificiality' reveals that Wordsworth's awareness of the relation between material surface and poetic form extends beyond his epitaphic poetics. In the 1815 Preface, Wordsworth classified the sonnet among such subgenres of the Idyllium as Inscription, Epitaph and Verse Epistle that rely on the materiality of writing and use the surface of inscription as an important part of the totality of the meaning of the poem. This placement underscores that Wordsworth thought of the sonnet as a type of poem whose visual display matters. To the extent that the sonnet incorporates the surface of inscription as part of its meaning, like the poems with which it is classified, this surface is the page. Wordsworth's sonnets may in other words be seen as inscriptions which have been removed from the traditional inscriptional surface of stone and have found their proper 'room' in the book fixed on the page by the medium of print.

Wordsworth's and Moxon's sense of the relation between the sonnet and the page may also be illuminated by an 1835 review in *Blackwood's Edinburgh Magazine*, which elaborated an intriguing analogy between the single-page sonnet and works of painting:

> All write sonnets [and] you will seldom find a volume of poems in which some twenty or thirty, or more, do not each occupy its own page as the author's especial favourites. If they are, as we believe they are, the author's favourites, they ought to bear mostly the impress of genius—the concentrated essence of poetry in fourteen lines.... We look upon sonnets, when they are such as sonnets should be, as cabinet pictures, each one complete in itself.... [T]he sonnet is one

highly finished picture, richly framed, admitting, strictly speaking, but one prominent idea, one subject, every line tending to the point, as all within the frame would converge to the principal object. They are cabinet pictures, all of a size—the frames bespoken fourteen inches in the clear.[14]

When considering this review alongside the fact that most of Wordsworth's ekphrastic poems are sonnets, it should be more evident that he thought of the sonnet as a form of visual poetry.[15] Indeed, it brings us closer to an explanation not only of why it matters that Wordsworth and Moxon resolved to print one sonnet per page, but also why Wordsworth between 1820 and 1822 referred to the specific formal characteristics and representational possibilities of the sonnet in metaphors taken from the sister arts of painting and sculpture, as 'picture', 'frame' and 'monument'. In his ekphrastic work, Wordsworth certainly relied on the 'old' pictorialist poetics, which aimed to achieve *enargeia* through the stimulation of the inner eye of the reader. But he also relied on the 'modern' emphasis on what Wendy Steiner (although she excludes the Romantics from this characterisation) calls 'the materiality of art' where the effect of *enargeia* is achieved on the page and is thus available to the physical eye of the reader.[16]

Wordsworth refers to the sonnet as a 'picture' and posits the reader as a spectator in the headnote to *Ecclesiastical Sketches* (1822):

For the convenience of passing from one point of the subject to another without shocks of abruptness, this work has taken the shape of a series of Sonnets: but the Reader, it is hoped, will find that the pictures are often so closely connected as to have jointly the effects of passages of a poem in a form of stanza. (*PW* 3, 557)

This may be read as nothing more than an off-hand reference to the primary aim of the sonnets, to represent 'things as they are' with the utmost fidelity and achieve *enargeia* in the traditional sense. Yet, it may also be read in a stronger sense: Wordsworth may for instance be revising 'Upon the Sight of a Beautiful Picture' and no longer laying claim to 'just' writing descriptively about a picture, but to be explicitly writing the picture as such. Thus, he may be appropriating painting's representational power to visualise something 'for the sight of mortal man' (*PW* 3, 6) on the page in a gesture that anticipated the publication in 1850, in the fourth and last issue of *The Germ* (which had by then been titled

Art and Poetry), of Dante Gabriel Rossetti's six 'Sonnets for Pictures' ('for' suggesting the direct exchangeability of sonnet and picture).

Paradoxically, in the Postscript to the *River Duddon* sequence Wordsworth also presented the sonnet as what surrounds a picture, as a 'frame', when he distinguished between his own sequence and a poem Coleridge had told the readers of the *Biographia Literaria* he had planned to write in 1797. This poem, to be entitled *The Brook*, intended to tell a natural history of the evolution of mankind and the rise of civilisation on the analogy to the course of a river—essentially what Wordsworth had done in the Duddon sonnets. Having read the *Biographia* and knowing that he might be accused of a lack of originality, Wordsworth said in the Postscript that he started out by thinking about the sequence as arranged according to the passing of a day. The other main structural principle that ties the sonnets together and helps give them a sense of unity as a sequence, that they follow the course of a stream, added itself almost by accident, according to Wordsworth,

> upon occasional visits to the Stream, or as recollections of the scenes upon its banks awakened a wish to describe them. In this manner I had proceeded insensibly, without perceiving that I was trespassing upon ground preoccupied, at least as far as intention went, by Mr. Coleridge.... But a particular subject cannot, I think, much interfere with a general one; and I have been further kept from encroaching upon any right Mr. C. may still wish to exercise, by the restriction which the frame of the Sonnet imposed upon me, narrowing unavoidably the range of thought, and precluding, though not without its advantages, many graces to which a freer movement of verse would naturally have led. (*PW* 3, 503)

Wordsworth reveals a sophisticated formal thinking when he acknowledges that 'the frame of the Sonnet' is both restrictive and liberating: something that at once forbids and enables certain things. To conceptualise the sonnet as a 'frame' is to point both to its visuality and to emphasise its formal function as an ordering and shaping device that promises fixity and regularity. The sonnet, Wordsworth says in a typical litotic double negative, is 'not without its advantages' even though a Coleridgean 'freer movement of the verse' might be the more obvious choice in representing the flow of a river. Unlike the 'natural' running blank verse of 'Tintern Abbey', which embodies the free flow of the River Wye, the 'artificial' sonnet channels, controls and perhaps aims to contain the subject of the river. Whatever else it does, the presence of a

frame reminds us that we are engaging a representation of something, a picture that gives a mediated rather than an unmediated vision of something.

Wordsworth refers to the sonnet as a 'monument' in the third Duddon sonnet, which combines this sculptural metaphor with the painterly:

> How shall I paint thee?—Be this naked stone
> My seat, while I give way to such intent,
> Pleased could my verse, a speaking monument,
> Make to the eyes of men thy features known.

> *(PW* 3, 247)

This sonnet articulates the visual turn to pictorialism in the later career. Even if expressed in tentative terms in the form of a question that is qualified both by an 'intent' to be realised and by the modal 'could', there is not the disavowal of pictorialism we find in 'Tintern Abbey's', 'I cannot paint / What then I was' (Brett & Jones, 115, ll. 76–77), which suggests that a pictorialist poetics is incompatible with its subject matter (the growth and constitution of the speaker's inner self). In the Duddon sonnets, to the contrary, Wordsworth presupposed a pictorialist poetics by which he aimed to describe the observed object world in all its particularity of detail. To ask rhetorically, 'How shall I paint thee?', and to wish to 'Make to the eyes of men thy features known', is quite evidently to think of the sonnet as a 'picture' (and for the poet to fashion himself as a 'man painting to men').

For the first time, Wordsworth refers to his poetry as a 'speaking monument' in the indicative and as an accomplished fact rather than in an optative or subjunctive context as he had done on previous occasions. This use of the Horatian *exegi monumentum* trope is significant, not because it is the first time Wordsworth uses it, but because it is the first time it makes full sense in his usage. Since Ernest Bernhardt-Kabisch's essay, 'Wordsworth: The Monumental Poet', criticism has been aware of the monumental and the related inscriptional aspects in Wordsworth's poetry and poetics. As also noted in Chapter 2, in a reading of Wordsworth's *oeuvre*, Kabisch argued that there is no fundamental difference in Wordsworth's use of the monumental metaphor across his career. According to Kabisch, the monumental 'pinpoints an important element in [Wordsworth's] work as a whole' insofar as it serves as a 'conceptual metaphor expressive of what he felt poetry should be and do'.[17] This element of continuity, however, obscures one

of the central differences between the later and the earlier 'monumental poet': that it was not until 1804/1805 he for the first time referred to his poetry as a monument made of words. He did so both in *The Prelude* and in 'Fidelity' (*PW* 4, 83, l. 52), composed c.1805 and first published in 1807. Yet in both usages, he did not realise its full potential, either because he used it ironically and subversively as in 'Fidelity', or because he used it in a manuscript and not in print, and then only in the subjunctive as in *The Prelude* (1805, VI, l. 68).

The one characteristic shared by all Wordsworth's pre-1805 poems about actual monuments that pre-date their verbal description is the mutability of the monument; the fact that it is found in a ruinous state of decay. The *Lyrical Ballads*, especially the poems added in the second edition, are typically poems that take their occasion and meaning from the history of decay inscribed on the monuments the various speakers chance upon in nature. In 'Heart-Leap Well' for instance the speaker confronts a scenery of decaying monuments the meaning of which he can 'ill divine' (Brett & Jones, 131, l. 105). A shepherd arrives and provides at least two versions of what they mean (ll. 137–140). Arriving at the original, intentional meaning of the decayed monuments is not the ultimate point of the poem; in the end *what* the monuments commemorate does not matter, *that* they commemorate is what matters. The ultimate point is that the monuments have come to signify time passing. Thus the speaker asserts that Nature, 'in due course of time' (l. 171), erases all traces of 'the hand of man' (l. 112), and that 'at the coming of a milder day / These monuments shall all be overgrown' (ll. 175–176). The mutability of the monuments raised by 'the hand of man' is their ultimate significance and the meaning they have encoded in Wordsworth's poetry up to around 1804–1805.

In the topical tradition that begins with Horace, the verbal monument is seen to outlast any non-verbal monument raised by 'the hand of man'. The difference between these two understandings of the monument as mutable and immutable is crucial to understanding the difference between the earlier and the later Wordsworth and to seeing the impact of posterity as the cause that may explain the difference. In early Wordsworth, the poem stands as an indexical sign of the monument: a direct effect of the monument to which it points; in a sense we are asked to imagine that the poem participates in the same system of natural decay as the monument. Late Wordsworth fashions the poem itself as a monument: the poem comes to stand as an iconic sign of itself as monument, which is envisioned as of a different order than the decaying monument. The idea that a poem is or may be thought to be a

monument made of words indeed became second nature to Wordsworth in his later period. In an 1819 letter concerning the construction of a national monument for Robert Burns, Wordsworth wrote that Burns (or any other literary artist) was in no need of such a monument because he had 'raised for himself a Monument so conspicuous, and of such imperishable materials, as to render a local fabric of Stone superfluous, and therefore comparatively insignificant.... Let the Gallant Defenders of our Country be liberally rewarded with Monuments: their noble actions cannot speak for themselves as the Writings of Men of genius are able to do' (*MY* 2, 534–535; see also *LY* 3, 752).

Appearing around 1805, the trope of the self-sufficient verbal monument is the master trope in late Wordsworth. In the *River Duddon* volume, the trope finally makes full sense because the publication as such can be seen as the first to fully incorporate the issue of its having been conceived, written and published for posterity. The Duddon sonnets were published after Wordsworth had publicly theorised the necessarily delayed reception of works of genius in the 'Essay, Supplementary...' of 1815, and after the failures of *Poems* and the publications of 1816 and 1819 had affirmed his theory. It is therefore somewhat ironic that the Duddon sonnets, as Wordsworth recognised in 1849, became the most 'popular' poems published during his lifetime (see *PW* 3, 505) and, as Daniel Robinson points out, 'saved Wordsworth's career'.[18]

Wordsworth's understanding of the sonnet as a form of visual poetry as revealed in his attention to layout and his conceptualisation of it as 'picture', 'frame' and 'monument' was most fully articulated in one of the key sonnets from the later period, the very last poem in the Duddon sequence, 'After-Thought' (see Figure 5).

When first published in 1820, this poem was printed in roman typeface like the preceding sonnets in the sequence. Yet, as he revised the Duddon sequence for inclusion in the five-volume collected works edition of 1827, Wordsworth not only changed the title of this sonnet from 'Conclusion' to 'After-Thought', he also called attention to something often overlooked, not only in Wordsworth, but in poetry as such: typeface. 'After-Thought' was entirely reset in italics making its physical appearance, its *mise-èn-page*, a crucial aspect and an integral part of its full meaning.[19]

In Wordsworth's most intense sonnet period, both writers and readers were becoming increasingly aware of the visual pleasures of poetry. According to Jerome McGann, after c.1820 'artists and writers gradually developed a new and extraordinarily sophisticated understanding of the expressive character of physical text'.[20] As McGann notes, this

318 THE RIVER DUDDON.

XXXIV.

AFTER-THOUGHT.

I THOUGHT *of Thee, my partner and my guide,*
As being past away.—Vain sympathies !
For, backward, Duddon ! as I cast my eyes,
I see what was, and is, and will abide ;
Still glides the Stream, and shall not cease to glide ;
The Form remains, the Function never dies ;
While we, the brave, the mighty, and the wise,
We Men, who in our morn of youth defied
The elements, must vanish ;—be it so !
Enough, if something from our hands have power
To live, and act, and serve the future hour ;
And if, as toward the silent tomb we go,
Through love, through hope, and faith's transcendent dower,
We feel that we are greater than we know.

Figure 5 William Wordsworth, 'After-Thought', *The Sonnets of William Wordsworth. Collected in One Volume, with A Few Additional Ones, now First Published* (Edward Moxon: London, 1838). Private copy

was partly due to and partly reflected in the literary annuals. Their prolific use of illustrations and general foregrounding of bibliographic signs called attention to the book as a visual object meant to give pleasure by itself. The annuals, in which sonnets proliferated, in other words participated in producing a general awareness of the printed word as a visual entity in a concrete and literal sense.[21] James Montgomery's poem, 'The First Leaf of an Album', which introduced the reader to *Friendship's Offering* for 1829, should be understood in this respect:

> Here may each glowing Picture be
> The quintessence of Poesy,
> With skill so exquisitely wrought
> As if the colours were pure thought,
> Thought from the bosom's inmost cell,
> By magic traits made visible,
> That while the eye admires the mind
> Itself, as in a glass, may find.
> And may the poetic verse, alike,
> With all the power of painting strike.[22]

This poem interpellates the reader as a viewer and the poet as a painter in a manner that was typical of the annuals and their historical moment. It suggests how the presence of graphic illustrations was altering the sense of poetry by making it more visually oriented both in terms of having to produce *enargeia* and in terms of its typographic presence on the page. As Alaric Watts noted in the Preface to his annual, *The Literary Souvenir* for 1826, 'I would not have the beautiful typography of the present volume escape notice altogether. In order that the mechanical part of the work should not be thought unworthy [when compared with its words and images], it has been printed from an entirely new font of type.'[23]

Sensing the competitive challenge from the annuals, the already established journals of the 1820s worked hard to denounce the quality of their literary material. The criticism launched in the *London Magazine* was typical. In its 1825 review of the *Forget Me Not* and *Friendship's Offering*, it said: 'The verse and prose are equally uninteresting, unamusing, worthless; unless it be by the strength of the artists and printers' merits (for these two books are beautifully got up in all points).'[24] The following year we hear that the 'young ladies' who read the annuals

are often deluded by lines printed with a delightful regularity, each commencing from a margin beautifully straight, and each crossing the page to about the same point, and dropping off in similar terminations with a kind of uniform unevenness. Over these magic rows, the real magician being, in truth, Mr. Davison, or Mr. Maurice, (the printers of these...books, and the Didots of London) delicate glances wander with a strong faith in the charms of poetry—but the last line is done, and the last rhyme has ceased to jingle on the young ear, and the heart is all void.[25]

These observations reveal the increasing awareness of typography and the fact that a poem's physical appearance inflects its meaning and reception. If we disregard the possibility of heavy irony, this was recognised in the *London Magazine* in its 1828 review of *The Keepsake*. The only quotation given in the review is of P. B. Shelley's prose essay, 'On Love'. As the reviewer puts it, 'Any poetry of the volume would never be read, excellent as much of it is, in our business-like type.'[26] Although Wordsworth tried to distance himself from the annuals, he read them, recognised what they were about, and could not but register that in the 1820s and 1830s the visual language of typography mattered as never before (see e.g. *LY* 1, 476).[27]

According to Lee Johnson, Wordsworth was responsible for the typographic revision of 'After-Thought', yet we cannot exclude the possibility that he was encouraged to do so by, in fact, Alaric Watts, who assisted Wordsworth with the 1827 edition and acted as middle man between author and printer in London. As Wordsworth said in a May 1826 letter, Watts was 'master of all particulars,—as [to?] the materials of the Vols, proposed mode of printing etc etc' (*LY* 1, 450). Johnson is the only critic to have noted the use of italics in 'After-Thought', and for him it only reflects a wish to 'set [the poem] off from the sequence proper' and emphasise closure.[28] Such a structural use of typography appears elsewhere in the later Wordsworth, most significantly in the 1838 volume, where the dedication sonnet ('Happy the feeling from the bosom thrown'), and the concluding, 'Valedictory Sonnet', were both italicised to typographically indicate the unity of the book and the entire corpus of sonnets. Italics were introduced to England in 1528 and in coming centuries were frequently used for entire documents, especially classic works, and longer pieces of text meant to be distinguished from the main text such as prefaces, indexes, notes and citations—a usage that feeds into Wordsworth's usage in 'After-Thought', but which is not consistent with his many other sequences that conclude without

italics.[29] In addition to this structural usage to mark the poem as a kind of paratext, the typographic sign also seems to be used to instance, enact or perform the poem's meaning, appropriately by virtue of a revisionary after-thought.

Not everyone saw the increasing attention to the visual dimensions of poetic texts in late Romanticism as a salutary tendency. In *A Defence of Poetry*, Shelley put forth an argument that excludes the Romantics' uses of typography for expressive purposes. According to Shelley, 'when composition begins, inspiration is already on the decline, and the most glorious poetry that has ever been communicated to the world is probably a feeble shadow of the original conception of the poet'.[30] For the Neo-Platonic Shelley, the poem we as readers confront is a 'feeble shadow' of what was a much more beautiful and valuable mental object, intention or 'conception' before it had found external form through 'composition'. However, as McGann points out, Shelley's statement 'is not the whole truth about poetry ... and it should always be read ... both for and against itself'.[31] As McGann puts it, and as Wordsworth's sonnet illustrates, 'The "composition" of poetry is not completed ... when the writer scripts the words on a page' (112).

Shelley is typical of the Romantic idealism which held that 'the concrete material dimension of the inscribed text was ... alien and antithetical to literature's spiritual, ideal, and imaginative nature', as Richard Shusterman notes.[32] An earlier instance of this idealism, expressed specifically in relation to the sonnet form, can be found in Coleridge's Introduction to the *Sonnets from Various Authors* (1796). With this anthology, Coleridge would come almost 'to seize control of the burgeoning sonnet industry of the British Isles'.[33] Yet, in 1797, he abandoned the form by writing three satirical and extremely contrived 'Sonnets Attempted in the Manner of Contemporary Writers'. They were later republished in a footnote to Chapter 1 of *Biographia Literaria* in the course of a discussion of a period of Coleridge's literary life when he 'for a short time adopted a laborious and florid diction ... most likely to beset a young writer' (Bate & Engell 1, 25).

Although his aim was to legitimate the English sonnet of Charlotte Smith and William Lisle Bowles, already in the Introduction Coleridge objects to a form which seemed to counter his ideal of a spontaneous and orally performed poetry, what he first conceived of formally in terms of the 'effusion' (how he initially referred to his sonnets) and later theorised in terms of 'organic form' in opposition to a 'mechanical form' such as the sonnet. The Irish poet William Preston, whom Coleridge cites, had promoted the Italian sonnet and claimed that it ' "is peculiarly adapted

to the state of a man violently agitated by a real passion, and wanting composure and vigour of mind to methodize his thought. It is fitted to express a momentary burst of passion" '.[34] Against this, Coleridge writes:

> Now, if there be one species of composition more difficult and arti-
> ficial than another, it is an English Sonnet on the Italian Model.
> Adapted to the agitations of a real passion! Express momentary bursts
> of feeling in it! I should sooner expect to write pathetic *Axes* or *pour
> forth Extempore Eggs and Altars!* But the best confutation of such idle
> rules is to be found in the Sonnets of those who have observed them,
> in their inverted sentences, their quaint phrases, and incongruous
> mixture of obsolete and spenserian words: and when, at last, the
> thing is toiled and hammered into fit shape, it is in general racked
> and tortured Prose rather than any thing resembling Poetry. (49–50)

When Coleridge relates the artificiality of an Italian sonnet in English to shaped pattern poetry he points to the sonnet's tendency to stand out on the page as a visual shape irrespective of its specific rhyme scheme. This analogy to the one kind of poetry that has never attempted to render its medium transparent or laid claim to being the product of any spontaneous overflow of powerful emotion is intended to expose the ridiculousness of any claim to express true feeling directly in a form as conventionalised, artificial and *written* as the Italian sonnet.[35]

Coleridge associated the Italian sonnet's 'inverted sentences, ... quaint phrases, and incongruous mixture of obsolete and spenserian words' with italic typeface in the three parodic sonnets that signalled his final disavowal of the sonnet whether Italian or English. In a 1797 letter to Joseph Cottle, he wrote:

> I sent three mock Sonnets [to the *Monthly Magazine*] in ridicule of my
> own, & Charles Lloyd's, & Lamb's, &c &c—in ridicule of that affectation
> of unaffectedness, of jumping & misplaced accent on common-place
> epithets, flat lines forced into poetry by Italics (signifying how well &
> *mouthis[h]ly* the Author would read them) puny pathos &c &c.[36]

Coleridge here also aims to ridicule the Della Cruscan sonneteers, who made prolific use of italics as part of their foregrounding of the artifi-ciality of the poetic sign; as a reviewer for the *English Review* suggested with reference to Mary Robinson: 'In every poem many words, and those too of no importance, are printed some in *Italics* and some in Capitals,

without any apparent reason; except that, perhaps, the printer supposed that such variety adorned the page.'[37] Whether the poet or the printer was ultimately responsible (and Judith Pascoe suggests that Robinson herself was responsible), this reviewer notes that italics at this historical moment were not only an elocutionary means to serve vocalisation, as Coleridge indicated, but that they foregrounded the poem as a visual entity insofar as they 'adorned the page'.

Today, we have become used to decoding italics as a visual means of calling attention to the emphatic meaning of a given word or phrase. Yet, for most of the eighteenth-century italics had not yet been thus encoded for purposes of semantic emphasis and were used much more prolifically and variously even though the modern usage was coming into being. In 1712, Richard Steele referred to italics in the modern sense in *The Spectator*, 'I desire you would print this in *Italick*, so as it may be generally taken Notice of.'[38] Yet, in 1733, Swift wrote in 'On Poetry: A Rhapsody':

> To Statesman wou'd you give a Wipe,
> You print it in *Italick Type*.
> When Letters are in vulgar Shapes,
> 'Tis ten to one the Wit escapes.[39]

Swift saw italics as a means to conceal subversive meaning rather than to reveal it, both because italics had come to seem less readable to English eyes compared to roman type, and because italics had not yet been restricted and codified for a few special purposes. As we saw in relation to the Della Cruscans, in the 1790s italics still served multiple, sometimes impenetrable purposes and as late as 1824, the printer Joseph Johnson said, 'It would be a desirable object, if the use of *Italic* could be governed by some rules' (*OED* 'italic').

Talbot Baines Reed reflects a later age's impatience with italics when in 1887 he pointed out that 'The extensive, and sometimes indiscriminate, use of italic gradually corrected itself during the eighteenth century; and on the abandonment, both in roman and italic, of the long *f* and its combinations, English books were left less disfigured than they used to be.'[40] The long *f* was left behind in what Reed calls the 'general typographical revolution at the close of the eighteenth century' first registered by John Bell's *Shakespeare* in 1785 (47n). When William Caslon and John Baskerville had caused a modernisation in the form of a standardisation, purification and simplification of page layout in the course of the eighteenth century, which rendered the page more

efficient as a vehicle for the rapid processing of large quantities of text, with the coming of the Romantic period almost no texts were published entirely in italics. Only after this typographical revolution can we be certain that a poem set entirely in italics is using typography to make a point we are meant to attend to with special care.

Wordsworth most often used italics in a manner we would see as conventional today: to foreground single words, phrases or lines. He was highly conscious of their effect as we see for instance in an 1835 letter to Moxon regarding the proofs for the first printed version of the epitaph on Charles Lamb, 'Thanks for the printed Copy, which, tho' a line longer than I supposed, *looks* at least a good deal shorter than in M.S.—The *italics* at the close must all be struck out except in the word *her*—Mrs W accounts for the *if e'er* being in italics, by the supposition of her having made a stroke to signify the lines were finished—The rest she marked designedly' (*LY* 3, 143). This letter reveals Wordsworth's concern with even the minutest aspects of typography as well as the problems he was faced with using an amanuensis and communicating with printer and publisher in London while in the Lake District. Italics were typically used for citations (e.g. Milton in ' "*A little onwards lend thy guiding hand*" ' [*PW* 4, 92] or Cowper in '*There is pleasure in poetic pains*' [*PW* 3, 29]), to mark foreign or otherwise odd and strange words (e.g. the Latin '*MISSERIMUS*' in the sonnet 'A Gravestone Upon the Floor in the Cloisters of Worcester Cathedral' [*PW* 3, 48]) and for deictic emphasis (especially 'here', 'there' or 'that'). Whenever longer passages are set in italics, they tend to be used to indicate material inscription and citation. In one of the *Ecclesiastical Sketches* ('Cistertian Monastery'), italics are used to signal both material inscription and citation, and to point deictically to the italicised passage:

> '*HERE Man more purely lives, less oft doth fall,*
> *More promptly rises, walks with stricter heed,*
> *More safely rests, dies happier, is freed*
> *Earlier from cleansing fires, and gains withal*
> *A brighter crown*'.—On yon Cistertian wall
> *That* confident assurance may be read...

<div align="center">(PW 3, 363, ll. 1–6)</div>

In this example, italics are employed to represent an inscription that has been translated from Latin and signal (with inverted commas) that it does not actually 'belong' to the sonnet 'as such', but is a foreign graft.[41]

An exception to these uses appears in editions later than the first of *The White Doe of Rylstone*, where italics and small capitals are used to represent the emphatic but silent mental presence as well as the stern authority of an injunction made by Emily's brother not to follow himself and their father to war:

> *Her duty is to stand and wait;*
> In resignation to abide
> The shock, AND FINALLY SECURE
> O'ER PAIN AND GRIEF A TRIUMPH PURE.

> (*PW* 3, 315, ll. 1068–1072)

The small capitals signal graphically the eventual 'triumph' of Emily's 'wise passiveness' while the italics represent the interiority of authoritative thought; that the brother's injunction is no longer direct speech but present as a form of internalised, mental inscription, a *memento*.

Compared to these more typical and conventional usages, the italics in 'After-Thought' may explicitly function to foreground 'the poem in the eye'.[42] They bring the visibility of the text into the foreground and literally 'bare the device' in the Russian Formalist sense of reminding us that something is mediating the referential world.[43] Coming after thirty three sonnets all set in roman type, this sonnet 'deviates' from an automatised reading of them in which we may have begun to attend solely to the referential level and not to the message itself. Wordsworth may in other words be using italics to render his utterance 'palpable' and to demote what it is about. The use of italics for an entire text, in a textual corpus otherwise set in roman type, temporarily freezes the flow of discourse and increases the reader's awareness of the diagrammatical, spatial plasticity of the medium; the italics illuminate these letters, this writing.

But 'After-Thought' may simultaneously be using italics to achieve the illusion of an unmediated *pre*sentation of the referential world (this is indeed the effect of 'defamiliarization' in the Russian Formalist sense: it removes an automatised perception and gives a new and more vital and direct perception of the object world). 'After-Thought' rounds off a sequence which has stated its goal to be to 'Make to the eyes of men thy [the River Duddon] features known' and it has asked, 'How shall I paint thee?' In the very first sonnet, echoing John Denham, Wordsworth addressed the 'native Stream': 'Pure flow the verse, pure, vigorous, free, and bright, / For Duddon, long-loved Duddon, is my theme!' (*PW* 3, 246). In the enumeration and accumulation of 'pure, vigorous, free,

and bright', Wordsworth dissolved the antitheses Denham employed to represent the Thames in *Cooper's Hill*. Yet, like Denham, Wordsworth explicitly analogised the flow of his verse and the flow of the river. Thus, when the *'Stream'* is addressed in the final sonnet, it is both the actual river and the sonnet sequence which has taken its title from the object it had set out to represent *and* to emulate. One explanation of why the final poem is printed in italic type may thus be that in rendering the sonnet visible for the eye of the reader, Wordsworth renders its representational object visible as well; at least he reminds us that the poem is about seeing the visible world. The sonnet has finally made the 'features' of its object known to our eyes and it has thus also assumed the immutable state in which the river is positioned: that of remaining as Form despite the flow of time. The sonnet displaces thought by sight, the subject by the object, when it uses the stable, visual given as a counterforce to the unsettling thought of the river *'being past away'*: *'For, backward, Duddon! as I cast my eyes, / I see what was, and is, and will abide'*. In the same way, here at the end of the sonnet sequence, after the poem now titled 'Conclusion', we are graphically and sensuously reminded of the staying power of the 'speaking monument' that is Wordsworth's verse.

While Wordsworth used italics to represent the interiority of thought in *The White Doe*, in 'After-Thought' they seem to be used to represent the *exteriority* of what literally may be said to come 'after thought'. What comes 'after' thought is writing—what Wordsworth would call 'monumental writing' (*Prelude*, 1805, XI, l. 295). The earliest italic was cut in 1501 by Francesco Griffo da Bologna for the famous Venetian Renaissance printer Aldus Manutius' edition of Virgil. According to Lucien Alphonse Legros and John Cameron Grant, it 'is a form of type directly imitative of the art of the penman and is said to have been founded on the handwriting of Petrarch, which it closely resembles'.[44] It is a daunting thought that Wordsworth in 'After-Thought', which follows the Petrarchan mould, may be using typography as well as rhyme scheme to allude to one of the most famous sonneteers; yet it is probably safer to say that he used it to imitate or simulate the cursiveness of chiro- graphical writing. The italics produce, on the page, an effect of material inscription, of writing *as such*. As we saw in the case of the use of black letter typography in Chapter 2, the italics offer a literal instance of Wordsworth's curious fascination with all things visibly written and an example of typographic inscription where he uses the page of the book as the surface for material inscription in the same way that he often asks us to imagine his lines as inscribed on out-houses, monuments, trees

and benches—surfaces in relation to which the meaning of the text is produced.

If typography is used to foreground 'the art of the penman' in 'After-Thought', this corresponds to the thematic content of the poem, which is about what visibly remains, after thought, as the material effect of work carried out by *'our hands'*. According to the poem, a fear of death may be alleviated by the knowledge that something follows from death—something comes after to make death tolerable. The knowledge that we *'must vanish'* is bearable because we are able to leave something *'from our hands'* *'as toward the silent tomb we go'*. In other words, the knowledge of mortality is balanced by the knowledge that something remains by virtue of which *'We feel that we are greater than we know'*. What remains to make us *'greater than we know'* is writing or any other acts that have unforeseen material effects after death; effects that cannot be known, but only felt. If the italic letters are suggestive of handwriting, the *'something from our hands'* it is hoped has *'power / To live, and act, and serve the future hour'* and may be thought of as a manuscript: something written by hand (*manu* hand, *script* writing). If a fear of death is alleviated in 'Tintern Abbey' through speaking to another, who will or may remember 'these my exhortations' (Brett & Jones, 117, l. 147) after the death of the speaker, then writing has taken the place of speech in 'After-Thought'. With writing, the self-present listening addressee of the 'conversation poem' disappears and is replaced by what is called a *'future hour'*, the reading posterity that had become late Wordsworth's favoured audience.

In a manuscript variant, the *'thought'* of line one was 'spake' (*PW* 3, 261). From one point of view, this revision economically suggests the proximity and ideal interchangeability of thought and speech in Wordsworth's logocentric thinking and in the Western metaphysical tradition in which he stands. Yet, it is significant that speaking is erased and that in the process Wordsworth eclipses the medium on which his earlier 'conversational' poetics was grounded and which is usually taken to translate thought most directly and immediately. Wordsworth's choice of thought rather than speech should be understood in terms of the poem's title. It is a poem not only about what comes after speech, for example listening and the silence of thought, but about what comes after we have finished listening and, more disturbing, *after* the silence of thinking, what comes *after* thought even as it also comes after speech. 'After-Thought' of course can be taken to mean only *an* afterthought, that is a second thought, a thought that adds itself to a prior thought and suggests the occurrence of new thoughts and afterthoughts. But it

also has a more final and radical sense of a state *after* thinking, that is where there is no longer any thought, where thought and consciousness, personality and self, are absent and have been vacated. That is to say, the past tense of the verb in '*I thought of thee*' may inscribe a present moment of complete serenity in which thinking is over and something else has taken its place. That something else is the observed object world of the river mediated through the visible language of writing; framed, pictured and monumentalised in this sonnet standing alone on the printed page.

The poem both thematises and performatively enacts its message: it is something that lasts, a 'moment's monument'. Wordsworth moves beyond an understanding of poetic language as a form of *re*presentation (whether of the external world of the river or of the internal world of thought) towards an understanding of poetic language as a mode of *pre*sentation, where the medium becomes the message: written characters.[45] The poem does not ultimately seek to imitate or reflect an already given object in the world. Nor does it ultimately function as a means to express the personality of its speaker. Rather, and more than anything else, the sonnet calls attention to itself as an eminently visual form on the page. The italics foreground the artificiality of the poem; make it stand out as an object or indeed a 'picture' surrounded by the white marginal frame of the page. The visual presence of the poem argues against absence and death in the same way that the visual presence of the river belies the unsettling thought of its '*being past away*' that sparks the poem. As was the case with the change in the conventional inscriptions investigated in Chapter 2, this marks a step beyond the materiality of epitaph-inscriptional writing with a limited durability to the materiality of printing with a far more extended durability, which has been presented as the central change in the later Wordsworth's poetic thinking that can be said to stem from the redirection of his poetry towards a posterity whose mode of reception will be silent, visual reading.

Directed towards posterity, 'After-Thought' is at once a fixative 'frame' around the rest of the sonnets in the Duddon sequence and one that finally contains, fixes and provides closure to the subject of the river, a 'picture' as it presents itself visually to the eye of the reader and renders its subject matter concrete, and a 'monument' due to its imitation of the materiality of inscriptional writing in the more permanent medium of print. 'After-Thought' correlates form, meaning and layout to produce an impersonal word-thing which (like the epitaphic genre to which it bears striking resemblances) may remain after the death of the

author.[46] The sonnet's emphasis on sight as corrective of thought and corresponding use of the visual language of typography to instance its meaning and foreground the poem on the page as a spatial artwork show the later Wordsworth's decreasing interest in himself and his increasing concern with ways to mediate and articulate the tangible materiality of the wor(l)d.

5
The Book of Ekphrasis: *Yarrow Revisited, and Other Poems*

Wordsworth's turn to ekphrasis was fully realised in what is probably the most important publication from his later period, *Yarrow Revisited, and Other Poems* (1835). His first book containing new poetry since 1822, *Yarrow Revisited* reflects the turn in a number of ways.[1] The book signals a hesitant recuperation of a Neoclassical conception of poetic language in the motto inscribed on the title page: 'Poets...dwell on earth / To clothe whate'er the soul admires and loves / With language and with numbers'.[2] Taken from the end of Mark Akenside's *The Pleasures of the Imagination* (1772), this motto suggests a surprising return to an understanding of poetic language that Wordsworth had resisted in the *Essays upon Epitaphs*, where language as 'clothing' was presented as an artificial counter-spirit and opposed to an authentic poetic language, which incarnates thought in an organic manner (see *PrW* 2, 84–85). The clothes metaphor foregrounds exteriority and visuality in a manner which suggests a decentring of the idealist presuppositions of the earlier Wordsworth and signals that much of what *Yarrow Revisited* contains is an 'artificial' poetry of exteriors that responds to visual pleasures and is intended for the 'bodily eye'.

The book was dedicated to the banker poet Samuel Rogers (1763–1855), whom Wordsworth had known since 1801. The dedication is very sparse compared to other dedications, especially the one to Beaumont. It simply reads, 'To / Samuel Rogers, Esq. / As a testimony of friendship and acknowledgement of intellectual obligations' (*PW* 3, 262). Wordsworth appreciated the friendship with Rogers, which 'opened every door in London' due to Rogers' 'wealth, as much as his literary reputation' and it furthered Wordsworth's immersion in a number of important artists' circles.[3] Yet the dedication is more than a recognition of friendship

and a reflection that most other potential dedicatees had recently died (e.g. Coleridge and Scott). It is also Wordsworth's way of inscribing his book alongside Rogers' newly re-released *Italy* (1830, first published 1822) and especially his *Poetical Works* (1834). One 'intellectual obligation' Wordsworth would have felt *vis-à-vis* Rogers was the one that was put on him when he received no less than three complimentary copies of the illustrated edition of *Italy* in 1830, and when he received three copies of the profusely and brilliantly illustrated *Poetical Works* in 1834. With engravings after Thomas Lawrence, Thomas Strothard, J. M. W. Turner, Samuel Prout and others by some leading engravers such as William Finden and Edward Goodall, Rogers' *Poetical Works* surpassed *Italy* and stands as a highpoint in the bibliographic art of making an illustrated collected works edition.[4] Regarding *Italy*, Wordsworth reported Dorothy's opinion that 'the Books are charmingly *got up*, as the Phrase is The embellishments, my Sister says, are delicious, and reflect light upon the Poetry with which she was well acquainted before' (*LY* 2, 330). About the 1834 book, Wordsworth wrote to thank Rogers saying that 'Of the execution of the Plates, as compared with the former Vol, and the merit of the designs, we have not yet had time to judge. But I cannot forebear adding that as several of the Poems are among my oldest and dearest acquaintance in the Literature of our day, such an elegant Ed: of them, with their illustrations, must to me be peculiarly acceptable' (*LY* 2, 688). So much for the 'despotism' and 'tyranny' of the eye: Wordsworth knew quality work when he saw it and he and Dorothy were no strangers to the fact that graphic illustration may perform valuable interpretative work on already known poetry; that a new material integument to poetry, how it is 'got up', changes and may add significantly to its aesthetic value and impact.

While Wordsworth found Rogers' illustrations 'peculiarly acceptable', the same cannot be said of Charles Lamb. In December 1833, Lamb responded to Rogers' engraved poetry:

> thy gay book hath paid its proud devoirs,
> Poetic friend, and fed with luxury
> The eye of pampered aristocracy
> In flittering drawing-rooms and gilt boudoirs,
> O'erlaid with comments of pictorial art
> However rich or rare, yet not leaving
> Of healthful action to the soul-conceiving
> Of the true reader.[5]

Lamb both points to the intended reader segment of high quality, illus-
trated luxury books ('aristocracy'), and vents a typical High Romantic
opinion that illustrations pacify the reader who ought only to be
concerned with the words to qualify as a 'true reader' rather than a
'pampered' one.

Unlike Lamb, Dorothy and William responded to the books the way
they were meant to, because the illustrations were indeed intended
to make Rogers' poetry, which had been published since 1792, newly
attractive to readers. Such a strategy of re-publication with illustrations
was part of a more general trend by means of which publishers and poets
tried to make poetry attractive in these lean years still suffering from
the 1826 'crash'.[6] 'When Samuel Rogers complained that nobody read
his poems', Sybille Pantazzi writes, 'Turner exclaimed "Then they shall
read them, and no lady's boudoir shall be complete without a copy, for
I will make them attractive with illustrations". As is well known, the
illustrated editions . . . were best-sellers and their success was due to the
illustrations.'[7] Even if these works did not integrate text and image to
everyone's full satisfaction because of a certain disparity between the
engravings and the print work, we should recall the verdict of Rogers'
biographer Clayden, who in 1889 stated that 'There had been nothing
like them before' and 'There has been nothing like them since'; the
Poetical Works, Clayden claimed, was a 'marked event in the history of
art'.[8]

Yarrow Revisited was the first book by Wordsworth published by
Edward Moxon, who was also the publisher of *Poetical Works* and *Italy*.
In fact, *Italy* was Moxon's first really independent publication, and as
Moxon's biographer writes,

> It is hardly possible to exaggerate the importance of the book to the
> new publishing house. Rogers was influential among literary people;
> he enjoyed a long-established reputation for taste in art and liter-
> ature; he was the friend of men and women in high society Leigh
> Hunt caught the significance when he commented in the *Tatler*, in
> June, 1831: 'Mr. Moxon has begun his career as a bookseller in singu-
> larly high taste. He has no connection but with the select of the
> earth'.[9]

No wonder Wordsworth was eager to get Moxon's name on the title-
page to *Yarrow Revisited* (see *LY* 2, 724, 732, 746), and that when he saw
it in proof, he wrote to Moxon to say that it 'gives me great pleasure to
see your name there' (*LY* 3, 7).

For the first edition in 1835, Moxon shared the credit for publication with Longmans (who had published Wordsworth since 1800). There is contextual evidence to suggest that Wordsworth wanted the book to feature engraved illustrations like Rogers', but that Longmans declined, because it would be too costly compared to the number of copies Wordsworth could sell. In a letter to Moxon 17 July 1834, Wordsworth relates certain negotiations regarding the publication of *Yarrow Revisited*, partly about dividing the rights with Moxon, and partly about the use of illustrations. Although we do not have all the documents to reconstruct the exchange, it is not difficult to imagine its nature based on Longmans' statement that 'We think you have done right to abandon the Illustrations—to have them executed as those in Rogers' Works would be so very expensive, that we should doubt their ever answering' (*LY* 2, 724). Rogers himself paid the engraving and printing expenses of his books, and even though they sold well, they never turned in a profit.[10] Although he wished for an illustrated edition, Wordsworth did not have the economic means nor in any sense the will to pay the expenses for such an edition to increase readers' gain at the expense of the author's profits. And in March 1835 (right at the time *Yarrow Revisited* was being published), we find Crabb Robinson reporting Wordsworth's views of painters such as John Martin and Turner, both of whom were prolific illustrators and included in Rogers' books: 'We had a very pleasant chat on painting, a subject on which Wordsworth talks well. He spoke severely of Martin (not even sparing Turner) and of all the analogous artists in poetry.'[11] Whether this was petty envy aimed at those who could afford to publish illustrated volumes, a certain anxiety that the 'artists' were invading 'poetry' (as in John Martin's enormous narrative paintings), or whether it signals Wordsworth's deep ambivalence about painting and illustration, or all of these concerns, is hard to tell.

The proper names blazoned at the paratextual entrance to *Yarrow Revisted*, Samuel Rogers and Edward Moxon, carry special significance in the context of the 1830s. They signify quality books and 'good' 'aristocratic' taste, which in the 1830s meant the intersection of art and literature. Along with the motto from Akenside, these names are important clues to the decoding of the poetry published in *Yarrow Revisited*, which seems to be aimed at a refined audience informed, as Leigh Hunt saw, by 'high taste': an audience which would read the paratext as a sign that its preferences would be reflected by the contents of the volume. While Rogers' book could use engraved pictures to attract its readers, Wordsworth only alluded to this practice through his dedication, perhaps to attract the same segment of readers. Although most

of the poetry in Rogers' illustrated volumes was presented and may be read as ekphrastic, neither volume contained poetry that was originally written as ekphrastic poems in the narrow sense of descriptive of actual or notional works of plastic art; though art objects make frequent appearances especially in *Italy*. This, however, is characteristic of Wordsworth's unillustrated volume, whose 'unillustratedness' in fact attracts interest as making a statement by itself in the context of the proliferation of illustrated poetry in the 1830s.

When we look into the book and consider the nature of its poetic texts we see that it contains the largest number of ekphrases (strictly defined as poems about plastic art objects) of any new volume. The book contains Wordsworth's most complex ekphrastic poem, which is also one of his most important late poems, 'Lines Suggested by a Portrait from the Pencil of F. Stone'. This poem is surely among what Harold Bloom has called 'the handful of good poems that Wordsworth wrote in his last decades' even though it is not mentioned by Bloom in *The Visionary Company*, and would hardly be among the poems he had in mind.[12] This poem, along with the poetry of *Yarrow Revisited*, relies too much on the visual and the visible at the expense of the visionary and transcendent for it to be of value in Bloom's scheme of things. The ekphrases of *Yarrow Revisited* are written in a variety of different forms and concern a wide variety of plastic art objects both ancient and modern. They thus mark the consummation of Wordsworth's ekphrastic art and the volume may therefore be described as his 'book of ekphrasis'. Wordsworth and Rogers' volumes both respond to the pictorial turn in late Romanticism and they both register the 'return of the visible'. Yet, even if they thus complement each other, they respond very differently to the pictorial turn: Rogers with actual images engraved on the page, Wordsworth, as we shall see in more detail, with images verbally recreated on the page and in the mind of the reader.

As Stephen Gill points out, '*Yarrow Revisited* was the first of Wordsworth's publications to sell widely—new editions were called for in 1836 and 1839—and it certainly confirmed his own sense, as well as his readers', that at last his time had come.'[13] There are several explanations, some of them contradictory, to account for this popularity. As Gill writes, 'No doubt sheer survival was an important factor' behind Wordsworth's rise in popularity in the 1830s. Another reason, according to Gill, is that the volume showed Wordsworth as an engaged public and *political* poet whose views and positions, especially as articulated in the 'Postscript' on the Poor Laws, 'asserted quite freshly...that the living Wordsworth could contribute to contemporary

debate quite...trenchantly'.[14] The explanation should also include the possibility that the increase in the sheer number of late Romantic readers may be the reason for Wordsworth's sales. Wordsworth registered this increase for instance in April 1830 when he wrote to John Gardner that 'Readers, I am aware, have...increased much, and are daily increasing; Perhaps also my own Poems are gaining ground upon the Public' (*LY 2*, 225). Still another explanation is provided by Merriam, for whom the rise was due to the fact that 'A new generation had grown up, bred in the romantic tradition.'[15] This is just short of saying that Wordsworth had succeeded in creating his own audience, and along with Gill's points, it surely constitutes an important part of the explanation. However, the explanation is more complex and must include the possibility that Wordsworth had changed and that such a change had not only met with the approval of this new large generation of readers, but had in fact been prompted by a certain desire to accommodate his work to its taste.

Wordsworth's increasing popularity in the 1830s registers in contemporary reviews. *Yarrow Revisited* was heralded by the *Monthly Repository*: 'No poet has ever lived and written down, and that in the most quiet way, a greater host of difficulties than Wordsworth. The common consent which once denied him a place amongst the bards of his age and country, now seems to concede to him the highest rank....This is the course of greatness' (Reiman, Vol. II, p. 699). The *Monthly Repository* was generally in favour of Wordsworth, so the celebratory note should not come as a surprise. However, in June 1822, when reviewing the *Ecclesiastical Sketches* and *Memorials of a Tour of the Continent*, the exclusiveness of Wordsworth's appreciative audience was emphasised (see Reiman, Vol. II, p. 698).

What the reviewer for the *Monthly Repository* praised in 1835 was significantly not what either later generations of readers have found praiseworthy in Wordsworth, or what Wordsworth, according to Gill, had become known for among the readers who received *Yarrow Revisited* in 1835. Gill writes that 'by the late 1830s what were once derided as [Wordsworth's] follies are being identified as the true sources of his strength'.[16] However, the reviewer says that 'There is scarcely a trace in [*Yarrow Revisited*] of what used to be regarded as characteristic of Wordsworth. Nobody could ever imagine from it why he was ever laughed at' (Reiman, Vol. II, p. 701). Although Gill is not necessarily wrong it is important to remember that there are differences between the earlier and the later Wordsworth and that there are no idiot boys, mad mothers or Peter Bells in *Yarrow Revisited*. The

Monthly Repository reviewer finds that 'the charm of the volume is in the ballad and narrative poetry' and singles out the following poems as especially noteworthy, ' "The Egyptian Maid", "The Armenian Lady's Love", "The Russian Fugitive" &c. The first two of these are equal to anything of the kind which the author has ever written, and, therefore, by implication, any one else' (ibid.). The poems singled out for praise in 1835 have since disappeared from the Wordsworth canon, yet they are significant examples of late Wordsworth's interests and general creative strategies. These three verse romances are departures from Wordsworth's usual poetry and, as Brennan O'Donnell points out, they are 'clearly Wordsworth's attempts to answer Byron and Moore'.[17] As such, their appearance can surely to some extent be explained as Wordsworth's tentative accommodation to certain reader demands and tastes he himself had *not* 'created'. To some extent the later Wordsworth was in other words created in the image of his audience's desire. Surely, the full explanation of the change in his popularity between 1822 and 1835 would involve at least an account of the changes *both* in the taste, size and segmentation according to class, gender, education, profession, age and so on of the more and more stratified and diversified late Romantic reading public, *and* in the nature of Wordsworth's poetry; it would necessitate, in other words, accounting for the impact of the reading public on Wordsworth's work and vice versa.

As interesting as the relationship to the popular verse romances of Byron or Moore is the ekphrastic nature of the first poem mentioned by the reviewer, 'The Egyptian Maid; or the Romance of the Water-Lily'. That *Yarrow Revisited* turned out to be Wordsworth's most popular volume may have to do with the fact that the volume revealed a Wordsworth who had adapted to the popular taste for ekphrasis, especially of portraiture, which had been stimulated mainly by the literary annuals and giftbooks, to which Wordsworth himself had contributed a portrait ekphrasis in 1828 ('The Country Girl' in *The Keepsake* for 1829, later retitled 'The Gleaner. Suggested by a Picture').[18] Even as they promoted poetic 'servility' to painting, the annuals in fact seem to have been the medium Wordsworth had in mind when he composed much of the ekphrastic poetry that was published in *Yarrow Revisited*. Referring specifically to 'The Egyptian Maid', Mary told Edward Quillinan 28 November 1828 that William 'has within the last 8 days composed a Poem (for next Keepsake) of above 300 lines without let or hindrance from one uneasy feeling either of head or of stomach'.[19] Responding to and capitalising on the main trend in poetry, which went towards the visual and ekphrastic on the stimulus of the annuals and giftbooks,

Yarrow Revisited is more emphatically ekphrastic than any previous collection by Wordsworth. It includes such ekphrases as 'The Egyptian Maid', 'A Jewish Family (In a Small Valley opposite St. Goar, upon the Rhine)', the sonnet 'To the Author's Portrait', on the Pickersgill in St. John's College, a sonnet on a painting by Rubens, two sonnets on a monument by Nollekens, and 'Lines Suggested by a Portrait from the Pencil of F. Stone'.

The ekphrastic nature of the poetry of *Yarrow Revisited* is set in relief by the poem that concludes the sequence of mostly sonnets entitled 'Yarrow Revisited', 'Apology For the Foregoing Poems'. This poem posits an internal order to the poems in the sequence and by implication *Yarrow Revisited* (and perhaps all of the later Wordsworth's poetry) by means of an extended *ut pictura poesis* simile:

> No more: the end is sudden and abrupt,
> Abrupt—as without preconceived design
> Was the beginning; yet the several Lays
> Have moved in order, to each other bound
> By a continuous and acknowledged tie
> Though unapparent—like those Shapes distinct
> That yet survive ensculptured on the walls
> Of palaces or temples, 'mid the wreck
> Of famed Persepolis; each following each,
> As might beseem a stately embassy,
> In set array; these bearing in their hands
> Ensign of civil power, weapon of war,
> Or gift to be presented at the throne
> Of the Great King; and others, as they go
> In priestly vest, with holy offerings charged,
> Or leading victims drest for sacrifice.

(*PW* 3, 279, ll. 1–16)

The desire to achieve poetic permanence and posterior survival through the assimilation of poetry's 'other' in the form of visual, material and concrete works of plastic art here finds cogent articulation. In an 'orient-alised' version of the gothic church metaphor, Wordsworth's book becomes a 'palace' and a 'temple' upon whose walls his poems appear before our silent gaze. In this meta-poem, the 'foregoing' poems (and by implication the following ones as well) are presented as relief sculpture, as material vestiges or relics of the past that still survive as frozen spatial

images. The poem presents the later Wordsworth's envisioned reader as a spectator and his poetry as an ekphrastic poetry intended for posterior, silent and visual reading. Insofar as we are asked to imagine that the poems themselves are pictures there is no need for actual graphic illustrations in the book.[20]

The pervasiveness of the ekphrastic trope in *Yarrow Revisited* may be illustrated through some of its less important ekphrases. 'Picture of Daniel in the Lion's Den, at Hamilton Palace' is a sonnet from the 'Yarrow Revisited' group:

> Amid a fertile region green with wood
> And fresh with rivers, well did it become
> The ducal Owner, in his palace-home
> To naturalise this tawny Lion brood;
> Children of Art, that claim strange brotherhood
> (Couched in their den) with those that roam at large
> Over the burning wilderness, and charge
> The wind with terror while they roar for food.
> Satiate are *these*; and stilled to eye and ear;
> Hence, while we gaze, a more enduring fear!
> Yet is the Prophet calm, nor would the cave
> Daunt him—if his Companions, now bedrowsed
> Outstretched and listless, were by hunger roused;
> Man placed him here, and God, he knows, can save.

> (*PW* 3, 275–276)

The use of 'palace' in the title denotes a specific local referent (Hamilton Palace, erected in 1695 and levelled in 1920), but also connotes the usage in 'Apology...' and makes evident that Wordsworth not only says that we are reading these poems in a 'palace of art', but that he has been inspired by works in that palace, such as Rubens' painting from 1615.

The remarkable phrase, 'stilled to eye and ear', caused Wordsworth trouble. In 1835, it was 'a stillness drear', and between 1837 and 1845 it read 'still—to eye and ear'. Its final sense best captures the silencing and the fixation brought about by the art of painting as it transforms the real lions into representation. The phrase echoes with the relief figures on the walls of 'Apology...' and it distils what Wordsworth generally saw in painting and valued about the art and its objects—even when he was compelled to overlook a roaring lion in the picture next to the figure of Daniel and dubiously read Daniel as 'calm' when he seems to be

shivering with fear and desperately praying for his life. As Henry Crabb Robinson noted in his diary, 'all the muscles of his countenance [are] strained with extreme terror. He is without joy or hope; and though his doom is postponed, he has no faith in the miracle which is to reward his integrity' (cited in *PW* 3, 534).

The challenge of the poem is to explain in what sense the representation, the image of 'satiate' and 'couched' lions, can be said to generate a 'more enduring fear' in the beholder than what we normally would take to be their more fearful real life referents, who 'charge / The wind with terror as they roar for food'. In the octave, the sonnet posits a series of oppositions around the basic opposition between painted and real lion, which can be described as a difference between the green, moist and fertile region of the ducal palace, the home where the painted lions lie couched and cosy like children, and the burning wilderness where the real lions are at home to roam and roar and fill the wind with terror. This is a difference between here and there, artwork and nature, home and away, and safe and unsafe. Employing the sonnet's primary structural device, the sestet 'turns' this difference around: what was safe, the painted lion, now becomes that which produces what the poem calls 'a more enduring fear' in the beholder. The representation in other words becomes more terrifying and threatening than its real life referent. The poem seems to account for our increased fear with reference to the satiateness and the stillness of the painted lions. The represented lions are more fearful because, paradoxically, we do not have to fear an attack from them. The 'more enduring fear' produced by the picture issues from Wordsworth's absorption in its life-size figures, his identification with its main figure Daniel (the painting measures 224.3 cm × 330.4 cm). The picture may turn out to be so threatening because its very stillness gives time 'while we gaze' to recall the story of Daniel and replace a fear of nature with a fear of the god who holds nature in His power (who decides whether the lions will spare whoever is thrown into their den). The most important thing about this sonnet is that it ascribes more or at least as much affective force to the silent, static, stilled world of art as it does to the loud, dynamic, changing world of nature. This is another significant indication that the turn from earlier to later Wordsworth runs parallel with a turn from nature towards art as site of analysis and exploration, particularly a valorisation of the fixative powers of art to 'still' something.

Another reason for the popularity of *Yarrow Revisited* was that it combined the ekphrastic with travel poetry. In an age of burgeoning mass tourism when more and more people began to see themselves as real or

potential travellers, poems functioned both as real and imaginary travel guides to the most interesting places, and as means of instruction in the proper way of confronting the sights. According to Juliet Barker, the tour poems appealed 'to the age of steamboats and trains, and to a growing number of people able to travel faster and more easily to the very places William celebrated in his poetry'.[21] The sonnet from Hamilton Palace for instance emerged from the practice of the country-house tour and the making of guides to such tours, whose popularity rose during the war with France when the continent was closed to tourism. Wordsworth based his writings on travels and movement from the first (his first published poems were *An Evening Walk* and *Descriptive Sketches*, subtitled *Taken During a Pedestrian Tour*, both published in 1793 and already part of a poetic trend towards basing longer poems and sequences on travels). But as John Wyatt has shown, this motif came to assume ever greater importance in the later work, most of which is presented as 'memorials of a tour'. Indeed, according to Wyatt, 'for this poet ageing was expressed not in rest, but in movement, normally an attribute of youth'.[22] While this is certainly true, it must be held against the strong sense of fixity and stillness, which the ageing Wordsworth in part travelled to experience in works of art. Wordsworth was always, as Hartman has emphasised, the 'halted traveller'. Often he was halted by dancing daffodils, rainbows and other natural phenomena; yet, in his later years, he was increasingly halted and fixed by material artworks—whether paintings, architectural spaces or, as we shall see presently, sculpture.

In *Yarrow Revisited*, Wordsworth published a genuine 'memorial of a tour' sequence, the 'Poems Composed or Suggested During a Tour, In the Summer of 1833'. At the heart of the 1833 summer tour, which went to Staffa and Iona, are the important 'Stanzas Suggested in a Steamboat Off Saint Bee's Heads, on the Coast of Cumberland'. I shall pass by that poem as well as the intended climax in the sonnets at Staffa and Iona (XXVIII–XXXIV), to follow the itinerants on their way back towards England. On their way, they pass by, among other things worth the sight-seeing tourist's attention, a work by Joseph Nollekens (1737–1823) recorded in sonnet XXXIX, 'Monument of Mrs. Howard (by Nollekens), In Wetheral Church, Near Corby, on the Banks of the Eden':

> Stretched on the dying Mother's lap, lies dead
> Her new-born Babe; dire ending of bright hope!
> But Sculpture here, with the divinest scope

Of luminous faith, heavenward hath raised that head
So patiently; and through one hand has spread
A touch so tender for the insensate Child—
(Earth's lingering love to parting reconciled,
Brief parting, for the spirit is all but fled)—
That we, who contemplate the turn of life
Through this still medium, are consoled and cheered;
Feel with the Mother, think the severed Wife
Is less to be lamented than revered;
And own that Art, triumphant over strife
And pain, hath powers to Eternity endeared.

(*PW* 4, 45–46)

Wordsworth reveals a superb command of the sonnet's characteristic volta or 'turn' by at once enacting a formal turn of the argument around line 9 and by thematising processes of turning at the same time. In line 9, the poem turns from a description of the monument to a reflection on its effect upon the onlookers ('we'). In the octave, the sculpture is presented as capturing the new-born child's life that has already turned into death and the mother's life that is quickly turning into death: this is what the sonnet calls 'the turn of life' and says may be observed in the monument. Rather than turn the gazer into stone, like Shelley's Medusa, this artwork produces consolation and cheers the onlooker. Due to the intervention of sculpture's 'still medium' 'we, who contemplate the turn of life /... are consoled and cheered'. The poem suggests that Art or Sculpture in a sense compensates for and perfects a life ended too soon. The 'dire ending of bright hope' which is the essentialised lesson of life represented by the sculpture is not allowed to be hopeless. Sculpture gives new life to hope through its representational intervention, its capacity to turn or 'trope' death into something else: Art. Sculpture 'hath raised that head / So patiently; and through one hand has spread / A touch so tender for the insensate Child' and therefore we as viewers feel the way we feel. We feel this way because the sculptor's hand *is* in a sense the mother's hand, which has managed to instil belief that the parting represented in the artwork is merely another form of greeting that occurs in the beyond. The artwork, as it were, at once reflects a 'dire ending of bright hope' and posits the beginning of new hope, because 'Art, triumphant over strife / And pain, hath powers to Eternity endeared'. Recalling that Wordsworth in the third Duddon sonnet called the sonnet a 'speaking monument' in relation to the title

to this sonnet ('Monument of...'), and that he identifies the poems of 'Yarrow Revisited' as relief sculpture, we may begin to sense that the deictic in 'Sculpture *here*' begins to function in the double sense we observed in 'Upon the Sight of a Beautiful Picture', where it connoted the poem as much as the artwork, thus rendering '*this* still medium' at once sculpture and the sonnet through which 'we...contemplate the turn of life': the 'Art' referred to is at once the art of sculpture and the art of poetry, which aims to participate in the eternal by virtue of the 'word-preserving art' of the book.

'The Egyptian Maid; Or the Romance of the Water-Lily', one of the many 'other poems' in *Yarrow Revisited*, is more of an oddity when seen in terms of Wordsworth's *oeuvre* than in the context of the poetry market of the 1830s. With this poem, Wordsworth at once reflected and prefigured the growing pictorialism as well as the medievalism that was soon to become the full-fledged pictorial and Arthurian turn in Victorian verse, fully realised in Tennyson's *Idylls of the King*. He likewise participated in the growing popular and scientific interest in Egypt, which had been stimulated by the work of Napoleon's scientific team during his Egyptian Campaign (discovering, among other things, the Rossetta Stone that captivated popular imagination in the 1820s), 'and more locally by the transfer of their accumulated ancient objects to the British Museum after the 1798 Battle of the Nile' and after the 1801 liberation (or re-occupation) of Egypt from Napoleon's brief occupation.[23] Wordsworth's poem can be said to legitimate the movement of Egyptian art to Britain: in the fiction of the poem, an Egyptian king has promised his daughter to one of King Arthur's knights in thanks for Arthur's help against an invading force ('my prowess from invading Neighbours / Had freed his realm' [ll. 224–225]). The Egyptian king thanks Arthur by promising to become Christian and by giving away his daughter, who arrives on a ship and reaches Camelot after much hardship.

As mentioned above, this poem was among those inspired by Wordsworth's dealings with the annuals, especially *The Keepsake* in 1828. As Peter Manning points out, 'this invented Arthurian fable... would have been quite at home in the *Keepsake*. Wordsworth had evidently studied the style, and quickly matched it.... [T]he *Keepsake* rejuvenated Wordsworth, diversifying and lightening his repertory.'[24] It is not difficult to imagine 'The Egyptian Maid' accompanied by an engraving to match the ekphrastic description of the Lotus:

> ...a carved Lotus cast upon the beach
> By the fierce waves, a flower in marble graven.

> Sad relique, but how fair the while!
> For gently each from each retreating
> With backward curve, the leaves revealed
> The bosom half, and half concealed,
> Of a Divinity, that seemed to smile

<div align="center">(<i>PW</i> 3, 235, ll. 125–131)</div>

An engraved illustration of the sculpture would have complemented the play in these lines on 'leaves revealed'.[25] Its intended audience as well as context of publication perhaps explains why the poem is presented as an ekphrasis of a fashionable piece of classical sculpture, as its headnote informs us:

> For the names and persons in the following poem, see the 'History of the renowned Prince Arthur and his Knights of the Round Table'; for the rest the Author is answerable; only it may be proper to add that the Lotus, with the bust of the Goddess appearing to rise out of the full-blown flower, was suggested by the beautiful work of ancient art, once included among the Townley Marbles, and now in the British Museum. (*PW* 3, 232)

By now, it should come as no surprise that Wordsworth chooses to tell us that the poem's major symbol derives from (was 'suggested by') a modern 'palace of art'—the British Museum. The Townley collection was acquired in 1806 and exhibited in a special building erected for the purpose, featuring among other things the first instance of roof-lights in a museum building. This building was formally opened in June 1808 and was the first that was specifically constructed as an exhibition gallery made to look nothing like a private home, marking an important step in the development of the public museum out of the private collection.[26] That we are in what Heffernan calls 'the museum of words' as we read *Yarrow Revisited* is evident from this headnote and from the simile deployed in 'Apology...', which resonates with the use of 'palace' in the sonnet. 'The Egyptian Maid' was the first of the 'other' poems to follow the 'Yarrow Revisited' section, which was concluded by 'Apology...'. The reference to a work of art as its source of inspiration clearly shows that the 'Apology...' poem also points beyond itself to the 'other' poems of *Yarrow Revisited*.

The headnote to 'The Egyptian Maid' may be compared to the head-note to 'Hart-Leap Well':

> Hart-Leap Well is a small spring of water, about five miles from Richmond in Yorkshire, and near the side of the road that leads from Richmond to Askrigg. Its name is derived from a remarkable Chase, the memory of which is preserved by the monuments spoken of in the second Part of the following Poem, which monuments do now exist as I have there described them. (Brett & Jones, 127)

This headnote singles out the privileged referent of the majority of the *Lyrical Ballads*: monuments found in nature where they preserve and give access to various histories. From 'Hart-Leap Well' through 'Rural Architecture' to 'Michael', monuments are scattered everywhere in the *Lyrical Ballads* where they function as anchor points and building grounds for the poems. Thus, in 'Michael', Wordsworth singles out 'one object', 'a straggling heap of unhewn stones!', to which 'appertains / A story—' (Brett & Jones, 226). The headnote to 'The Egyptian Maid...' does the same for *Yarrow Revisited*, whose privileged referential object is an *objet d'art*, which serves the same function as something to which a story 'appertains' (belongs and fits). On the paratextual level singled out by the headnotes to these poems (both of which are narratives that contain legendary material and suggest the supernatural), the movement from earlier to later Wordsworth is a movement from Nature into the Museum; from the local objects of Richmond in Yorkshire to the international artworks in the British Museum; from objects found in a state of natural decay to objects confronted in an institution made to protect them from decay; from objects that are found where they 'belong' to objects that have been moved from the site where they were made and fulfilled a certain function to a site where they are contemplated in isolation.

The public art museum was an innovation of the Romantic period. Elizabeth Gilmore Holt points out that its 'exterior form... was that of a temple' and that

> The nineteenth-century museum was separated from the collections in princely or royal galleries by the impersonal nature both of the installations and the acquisition of the objects. In the museum the single art work or fragment existed for itself, available for contemplation and stimulation, free from any specific purpose. The art

museum was a treasury of objects that came to possess the quality of reliquaries.[27]

The museum reflects as well as produces the modern idea of the work of art as autonomous, as ideally contemplated in isolation from its context of production and practical use. The museum thus participates in giving the artworks a religious value. As Heffernan points out, the museum is 'the shrine where all poets worship in a secular age'.[28] In nature (where Wordsworth is typically thought to be worshipping), the object is subjected to the natural forces of decay and contingency that the modern museum exists to combat. Thus, a large part of the meaning of the monuments of 'Michael' or 'Hart-Leap Well', as suggested in Chapter 4, is that they are disappearing. The monuments of 'Hart-Leap Well' tell history directly: they enact it by decay; the monuments in a museum in a sense deny history by presenting themselves ultimately as objects of beauty rather than of knowledge, and by being preserved in a context that is dedicated to denying change and dissolution.

As the headnote to 'The Egyptian Maid' shows, Wordsworth in fact tended to see objects in the museum as beautiful works of art even if they were not originally intended as such. Henry Crabb Robinson for instance reports a visit to the British Museum with Wordsworth in 1815, 'Wordsworth beheld the antiquities with great interest and feeling as objects of beauty, but with no great historical knowledge.'[29] The museum's transformation of objects that formerly may have had a certain function and historical meaning into self-sufficient artworks could hardly be more cogently expressed. In this context, we may also note how Wordsworth registers a lack of knowledge of what the Persian relief sculptures in 'Apology...' actually mean (these he most likely saw at the British Museum after 1826 when Sir Gore Ouseley's collection was donated). 'The Egyptian Maid' in essence tells and *enacts* an allegory of the decontextualisation of classic art and its reinvention as an object of beauty for the modern museum goer's contemplative gaze. The Townley marble that inspired Wordsworth was in all likelihood Greek and not Egyptian, but in a museum it may appear like an Egyptian work or rather, it appears to lend itself to the interpretation that best suits the desires of the ignorant onlooker.

The museum caused a significant change in how poets saw and valued painting and sculpture in the Romantic period. Before the museum, paintings tended to be seen as perishable objects whereas after the invention of the museum and its attendant sacralisation of the singular artwork, the painted object was increasingly seen as

imperishable, permanent and immutable. When Lessing in *Laocoön* spoke of the 'immutable permanence' ('unveränderliche Dauer') of art, he was according to Heffernan 'the first notable figure to speak of visual art as a medium that perpetuates a pose'.[30] Wordsworth read Lessing in 1802 and would certainly have heard of his ideas from Coleridge, who for years spoke of translating and introducing Lessing. Yet, it was not until Thomas De Quincey's translations from the *Laocoön* in *Blackwood's Magazine* for November 1826 and January 1827 that Lessing's treatise was made available to a wider English-speaking audience.[31] His ideas, however, were in the air among painters, critics and poets.[32] Hazlitt, for instance, registered a Lessingesque belief in the eternity and immortality of art in his *Sketches of the Principal Picture-Galleries of England* (1824), where on the eve of the opening of the National Gallery he described a series of visits to private galleries in terms of being 'a cure (for the time at least) for low-thoughted cares and uneasy passions':

> We are abstracted to another sphere: we breathe empyrean air; we enter into the minds of Raphael, of Titian, of Poussin, of the Caracci, and look at nature with their eyes; we live in time past, and seem identified with the permanent forms of things. The business of the world at large, and even its pleasures, appear like a vanity and an impertinence. What signify the hubbub, the shifting scenery, the fantoccini figures, the folly, the idle fashions without, when compared with the solitude, the silence, the speaking looks, the unfading forms within? Here is the mind's true home. The contemplation of truth and beauty is the proper object for which we were created, which calls forth the most intense desires of the soul, and of which it never tires.[33]

In painting, 'Time stands still, and the dead re-appear' (19). Holbein's portraits are 'stamped on his canvass forever!' (23) while a landscape with cattle by Claude 'give[s] one the idea of sculptured cattle....They appear stamped on the canvas to remain there forever, as if nothing could root them from the spot. Truth with beauty suggests the feeling of immortality' (57). The invention of the museum presented the Romantics with a new conception of the plastic arts, which Heffernan characterises as 'the belief that visual art has the power to perpetuate a moment, to raise it above time, change, and contingency'.[34] Yet, no rule without exceptions: in his notes for a poem on Washington Allston's painting of *Diana and Her Nymphs in the Chase*, Coleridge says he planned to point to painting's 'perishability by accident as well as time, and the narrow Sphere of action of Pictures'.[35] In other words, his unwritten

ekphrasis of Allston's painting would be paragonal and emphasise the differences between poetry and painting by highlighting poetry's double mastery of time, its greater longevity and capacity to depict actions.

Like Coleridge, ekphrastic poets prior to the mid- to late eighteenth century tended to motivate their verbal representation of painting by reference to the impermanence of painting, for which poetry could make amends by securing the survival of painting in the verbal representation. In one of Martial's epigrams, he compares his book to painting,

> While my likeness is taking form for Caecilius Secundus, and the canvas breathes, painted by a cunning hand, go, book, to Getic Peuce and prostrate Hister—these regions with their conquered peoples he rules. Small, but welcome, shall be the gift you will make to my dear comrade: more truly in my song will my face been seen; this my song, which no chances, no lapse of years, can efface, shall live when the work of Apelles shall perish.[36]

To Martial, language was superior to painting both in terms of representational fidelity to nature and in terms of durability in time and mobility in space. The idea that a verbally mediated image was more durable than an actual one was reiterated in the Renaissance; for instance in Jacobo Mazzoni's 1587 defence of Dante when he wrote that images in a 'poetic narration' 'will be much more steadfast and will last a longer time' than images of visual artists.[37] One of the last pre-Romantic reiterations of this topos occurs in a poem by Thomas Morrison, *A Pindarick Ode on Painting. Addressed to Joshua Reynolds, Esq.* (1767). Towards the end of the poem, Morrison apostrophises Time and asks it to spare a work by Reynolds 'At least, for some few centuries space', after which 'every trace of beauty [must] melt away'. And he continues,

> Oh then—reject not with disdain,
> Great Artist, this unpolished strain—
>
> In the long course of rolling years,
> When all thy labour disappears,
> Yet shall this verse descend from age to age,
> And, breaking from oblivion's shade,
> Go on, to flourish while thy paintings fade.[38]

Here, the often devious logic of ekphrasis that Grant Scott describes is spelt out. As Scott puts it, the ekphrastic poet 'ensures the permanence

of [his] own composition at the expense of the art work', and 'at times even delights in the ephemerality of the painted or sculpted image'.[39]

When Romantic poets confronted a painting, however, they tended to see an immutable object that was fully capable of surviving on its own (helped by the museum as well as the newly invented arts of conservation, preservation and restoration) and of reaching a large audience through public display and various forms of reproduction. William Cowper's 'On the Receipt of My Mother's Picture out of Norfolk the Gift of My Cousin Ann Bodham' (1790) may represent the very first attribution of immortality to an *actual* painting in English literary history. Earlier, paintings that were deemed immortal in poems by Samuel Daniel, Edmund Waller or John Donne were explicitly works painted with the 'colours of rhetoric'.[40] The attribution of immortality appears in a parenthesis at the end of the remarkable opening passage,

> Oh that those lips had language! Life has pass'd
> With me but roughly since I heard thee last.
> Those lips are thine—thy own sweet smiles I see—
> The same that oft in childhood solaced me—
> Voice only fails, else, how distinct they say—
> Grieve not, my child, chase all thy fears away!
> The meek intelligence of those dear eyes
> (Blest be the Art that can immortalize,
> The Art that baffled Time's tyrannic claim
> To quench it) here shines on me still the same.[41]

Cowper's poem is an affirmation of the vicarious consolatory powers of visual representation in the face of death, absence and the ravages of time; powers which are due to the survivability and unchangeability of the portrait. Cowper thus registers what was to become the dominant Romantic response to painting, both in terms of its function as a kind of therapeutic object of hope and consolation, and in terms of the valuation of paintings as imperishable objects that partake in and reflect an order of 'eternity'. This valuation and function was reinforced but cannot be said to have been the sole effect of the appearance of the museum. The appearance of the museum was surely also to a certain extent the effect of these new ideas about the value of the artwork (articulated in the profuse eighteenth-century discourse on aesthetics as exemplified in the discussion in Chapter 3 of the impact of Reynolds' *Discourses*) and a reflection of a desire to provide the artwork with the best conditions for display and preservation. As Carol Duncan points

out, 'the rise of the art museum is a corollary to the philosophical invention of the aesthetic and moral power of art objects: if art objects are most properly used when contemplated as art, then the museum is the most proper setting for it, since it makes them useless for any other purpose'.[42] The museum was in other words both cause and effect of how the Romantics saw the objects of the plastic arts.

'Lines Suggested by a Portrait...' is the most important ekphrastic poem on display in the verbal museum of *Yarrow Revisited*. This poem is to late Wordsworth what 'Lines Written a Few Miles above Tintern Abbey, on Revisiting the Banks of the Wye, During a Tour, July 13, 1798' is to early Wordsworth: of such importance that it may be understood to possess synecdochal value with regard to the overall poetics held by Wordsworth at the time of writing. However, while 'Tintern Abbey' is firmly in place in the Wordsworthian canon as just such a synecdoche, 'Lines Suggested by a Portrait...' is virtually unknown. To the extent that it is at all noticed, David Perkins may be taken as representative of critical consensus when he says that 'no urgent concern animates the poem'.[43] However, the poem can be seen as animated by a certain sense of urgency, which stems from the fact that in this poem Wordsworth is particularly conscious of the problems, but also of the daunting potential, faced by the writer who has posterity as audience. The special interest of the poem is that it shows Wordsworth's perhaps most complex and subtle example of a verbal assimilation and absorption of a plastic artwork in the interest of imagining the survival of the poem.

In both 'Tintern Abbey' and 'Lines Suggested...', Wordsworth uses heavily enjambed blank verse to orchestrate subjective meditations that take off from a concrete scene or detail in the exterior environment, develop into an extended more general reflection on the meaning of this detail, and return through the device of the return-upon-itself, introduced by Coleridge in the 'conversation poems', to the point of departure with a new and enhanced recognition and understanding of the relation of the concrete detail to the observing and meditating mind. Both poems, in other words, adhere to the structure and style of what M. H. Abrams calls the 'greater Romantic lyric'.[44] However, there are two central differences between 'Tintern Abbey' and 'Lines Suggested...', which also clearly instance the difference between earlier and later Wordsworth. 'Tintern Abbey' is inspired by and generated from experiences of the natural world as well as reflections on these experiences once stored in the house of memory as mental representations in accord with the norm laid down by Abrams for the greater Romantic

lyric ('outdoor setting', 'The speaker begins with a description of the landscape', 'For several decades poets did not often talk about the great issues of life, death, love, joy, dejection, or God without talking at the same time about the landscape' [201, 202]). In contrast, 'Lines Suggested by a Portrait...' is inspired by and generated from the experience of a work of visual, plastic art as well as reflections on the art of painting as such. As Martha Hale Shackford points out, in this poem 'more attention [is] being paid to [the art and craft of painting] than in any other of Wordsworth's poems on pictures'.[45] This, however, does not disqualify the poem as a greater Romantic lyric, because it is not a necessary condition for generic participation that a poem must deal with nature in the sense of landscape; indeed, Abrams makes this concession when he includes 'Peele Castle' among his specimens.[46]

The relocation of the poem's setting and descriptive point of departure from the natural world to the world of art represents one of the most important changes in Wordsworth's poetry as we move from early to late, and one which becomes more pronounced. Where 'Peele Castle' typically goes through several layers of 'imaginary images' constructed by memory and wishfulness to finally apostrophise the actual painting only half way through the poem, 'Lines Suggested...' reaches the painting almost instantly and confronts it directly:

> BEGUILED into forgetfulness of care
> Due to the day's unfinished task; of pen
> Or book regardless, and of that fair scene
> In Nature's prodigality displayed
> Before my window, oftentimes and long
> I gaze upon a Portrait whose mild gleam
> Of beauty never ceases to enrich
> The common light; whose stillness charms the air,
> Or seems to charm it, into like repose;
> Whose silence, for the pleasure of the ear,
> Surpasses sweetest music.
>
> (*PW* 4, 120–121, ll. 1–11)

Shockingly, the 'poet of nature' states that he is 'regardless...of that fair scene / In Nature's prodigality displayed' and that he prefers to 'gaze upon a Portrait'. Nature is marginalised and excluded in order to place the portrait at the centre of attention for the meditating

consciousness observed in the act of aesthetic contemplation. Nowhere is late Wordsworth's pictorial turn away from nature to the world of the plastic arts articulated more decisively than in these opening lines, which state that plastic art not only 'enriches' and 'charms' the 'light' and 'air' of nature, but that painting 'Surpasses sweetest music'.

The main difference between the two poems has to do with representational object (landscape vs. art), but it can also be observed with reference to the addressee they each imagine. On this account, the later poem begins to decentre the norm of the greater Romantic lyric because it does not present an addressee who is present (or potentially present) as 'auditor' in the moment of enunciation. Instead, its addressee is envisioned as an absent reader who faces the written text rather than the speaking poet. The addressee of 'Tintern Abbey' is present at the moment of utterance, 'thou art with me *here*…my dearest friend', and is audible as a form of dialogue partner, 'in thy voice I catch / The language of my former heart' (Brett & Jones, 116–117, ll. 115–118). In contrast, the addressee of 'Lines Suggested…' is absent from the moment of enunciation and figures only as an anonymous 'thou' far distanced from the moment of utterance not only in space but potentially in time as well. At the end of the introductory verse paragraph, which responds to the portrait of a young girl (ll. 1–21), Wordsworth addresses his reader:

> Look at her, whoe'er
> Thou be that, kindling with a poet's soul,
> Hast loved the painter's true Promethean craft
> Intensely—from Imagination take
> The treasure,—what mine eyes behold see thou,
> Even though the Atlantic ocean roll between.

> (ll. 22–27)

This appeal to the reader not only reiterates Wordsworth's turn to a literary pictorialism which posits *enargeia* as an ideal, it also reveals the fundamental uncertainty of addressee which the Romantic poets were faced with and which to a large extent precipitated Wordsworth's turn to posterity.

'Tintern Abbey' was in a sense inspired by and aspired to imitate the sound of 'waters, rolling from their mountain-springs' (Brett & Jones, 113, l. 3). In 'Lines Suggested…', the 'rolling ocean' has become an obstruction to be overcome, a source of separation between sender and receiver. Water is no longer a source of rejuvenation and inspiration,

but a part of that mutable and changeable natural world which is being marginalised for the purpose of silent aesthetic contemplation and communication. Rather than the friends addressed in 'Tintern Abbey' and *The Prelude*, the addressee of this late poem is a stranger: 'Who'er thou be'. The addressee is no longer present in the same space as the poet-speaker, who now presumes that the eye of the reader will look through the poem to see what the 'I' of the poem contemplates in order to re-create the sight of the portrait through silent hallucinatory reading. The reader has become a spectator; in a literal sense, a member of the 'visionary company' of seers.

The poem begins in the mode of what W. J. T. Mitchell terms 'ekphrastic hope'—a mode in which it is believed that description is equivalent to depiction and 'we discover a "sense" in which language can do what so many writers have wanted it to do: "to make us see" '.[47] In the course of its first two verse paragraphs (ll. 1–40), the poem aspires to represent in words what the portrait represents in image. Gazing at the silent portrait, which is likened to sculpture to underline the poem's intermedial field ('marble neck' [l. 13] and the 'pillar of her throat' [l. 14]), the speaker tells us to 'look at her' (l. 22) and to behold what his 'eyes behold' (l. 24). After the initial representation of the girl's sculptural pose, the portrait is described in detail:

> A silver line, that runs from brow to crown
> And in the middle parts the braided hair,
> Just serves to show how delicate a soil
> The golden harvest grows in; and those eyes,
> Soft and capricious as a cloudless sky
> Whose azure depth their colour emulates,
> Must needs be conversant with upward looks,
> Prayer's voiceless service; but now, seeking nought
> And shunning nought, their own peculiar life
> Of motion they renounce, and with the head
> Partake its inclination towards earth
> In humble grace, and quiet pensiveness
> Caught at the point where it stops short of sadness.
>
> (ll. 28–40)

This description aims to pre-empt pictorial depiction through rhetorical *energeia*. Contained in a single sentence, the language of the lines freezes and stills movement and aspires to represent a single 'pregnant

moment'. This is especially evident in the last lines where the eyes 'partake' with the head in 'its inclination towards earth / In humble grace, and quiet pensiveness', yet are 'Caught at the point where it stops short of sadness' and suspended in this middle position through what is almost a rhyming couplet (pensiveness/sadness) that closes this sonnet-like *tableaux* description of the girl's pose by balancing temporal movement and spatial fixity to imitate verbally the 'pregnant moment' caught by the portrait.

If the poem's first movement articulates 'ekphrastic hope', then the next movement, which consists of one long verse paragraph (ll. 41–78), articulates what Mitchell calls 'ekphrastic fear'. Ekphrastic fear occurs almost as a natural consequence of any articulation of ekphrastic hope; it 'is the moment of resistance or counterdesire that occurs when we sense that the difference between the verbal and the visual represent-ation might collapse and the figurative, imaginary desire of ekphrasis might be realised literally and actually'.[48] The poem's second move-ment dramatises Wordsworth's iconoclasm by revealing his need to distinguish rigorously not only between the visual sign and its real life referent in order not to endorse fetishistic idolatry by giving the sign a status similar to that of its referent, but also between the visual sign and the verbal sign so as not to give the visual sign the power of speech thereby rendering the verbal redundant. Although framed by a recogni-tion that the address is to a piece of representational art and not the girl herself, idolatry is exactly what Wordsworth seems to submit to when he apparently confuses sign and referent and apostrophises the portrait imploring it to speak as if it were the girl and not her representation. The gazer-descriptor now becomes a Keatsian questioner-interpreter as he begs the silent representation to tell him what her facial expression really signifies, what its source or origin is, in other words, what the story behind it is:

> Offspring of soul-bewitching Art, make me
> Thy confidant! say, whence derived that air
> Of calm abstraction? Can the ruling thought
> Be with some lover far away, or one
> Crossed by misfortune, or of doubted faith?

> (ll. 41–45)

The silence that follows the unanswered first question and is marked by the caesura in line 43 represents the transition into 'ekphrastic fear'

when, as Mitchell puts it, 'the difference between verbal and visual mediation becomes a moral, aesthetic imperative rather than ... a natural fact that can be relied upon' (154). The silence prompts Wordsworth to go beyond what is visibly represented and offer his own conjecture of the meaning of her expression: the girl has a lover on her mind. However, this girl *is* still unravished and Wordsworth quickly proceeds to trope this brief instance of Keatsian indecency with Wordsworthian decency by abolishing the conjecture as an

> Inapt conjecture! Childhood here, a moon
> Crescent in simple loveliness serene,
> Has but approached the gates of womanhood,
> Not entered them; her heart is yet unpierced
> By the blind Archer-god; her fancy free:
> The fount of feeling, if unsought elsewhere,
> Will not be found.

(ll. 46–52)

To thus say that the expression on the girl's face has its source 'elsewhere' means both somewhere else than in erotic fantasies and somewhere else than in the portrait as such. The erotic questioning represents a decoding of the portrait anyone not knowing the sitter in person might have produced, but it is false, says Wordsworth. It does not disclose the truth of the painting. The portrait is presented as too suggestive, as giving too much room for the imagination and thus as dangerously unable to tell its own story.

Keats's questioning response to the Grecian Urn was the result of a fundamental alienation from and lack of knowledge of the world it represents. As Grant Scott has pointed out, it is paralleled by the alienation of the artwork from its original cultural context and its re-contextualisation in the modern museum: 'For the Romantics, the object [of ekphrastic attention] has ... been removed from its context ... and placed, many times haphazardly, alongside other decontextualized objects in a museum.'[49] 'The ekphrastic objects', Scott writes, 'are redolent of the past, and it is this historicity that lends them their mysterious sense of otherness' (16). This, however, is not the case in Wordsworth's poem, which departs from what Scott describes as the Romantic norm and is in fact consonant with what he elsewhere characterises as the typical mode of Felicia Hemans' ekphrases.[50] The power of the portrait represented in Wordsworth's poem derives to a large extent

from the fact that it represents, on the one hand, a known, familiar and domestic subject, and, on the other hand, a 'Creation, as it were, of yesterday' (*PW* 4, 124, l. 18), as he puts it in the sequel poem, 'The Foregoing Subject Resumed'. The portrait in 'Lines Suggested…' derives its force, its attraction, from the fact not that it *has* but that it *will* (so the speaker hopes) survive. Likewise, the challenge of this ekphrasis is not the challenge of Romantic ekphrasis as described by Scott, viz. 'somehow to overcome the remoteness, the otherness, of the objects and recover for them even a partial context' (16) that will account for their meaning and value. This may be said to be the project of for instance 'The Egyptian Maid' or 'The Pillar of Trajan', but not of 'Lines Suggested…'. Nor is it the project of 'Lines Suggested…', as Scott also suggests with regard to Romantic ekphrasis, to preserve the 'alterity of the artifacts' and thereby presume a license to imagine the object's provenance and turn a virtue out of a historical ignorance (16). This account also suits 'The Egyptian Maid' very well, but not 'Lines Suggested…'. Wordsworth's attraction to the portrait is not to be explained by a lack of context to account for its provenance and deeper meaning; this context is known by the poet and provided in the poem. Wordsworth, in other words, unlike an ignorant Keats (or Wordsworth in 1815 according to Crabb Robinson) faced with 'the rude / Wasting of old time', knows the truth about this painting 'of yesterday'; but it is a truth, Wordsworth goes on to suggest, that is determined by a knowledge that cannot be derived from the painting itself. The portrait is unable to give utterance to its own truth. The portrait itself 'says' that the girl has a lover on her mind, but this is not its truth, according to Wordsworth.

Because the portrait cannot speak for itself, it needs someone to speak on its behalf. Thus, revising the inadmissible conjecture of romantic love, Wordsworth tells the true story of the origin of the represented girl's facial expression in lines 53–63 in a skewed fashion rather than prosopopoeically: he speaks *for* her, not *through* her. By thus muting the visual representation, denying it a language of its own, the poem proposes that a true understanding of her facial expression is dependent upon the ability of words to construct a temporal narrative of cause and effect from which painting is debarred. The story Wordsworth delivers from the portrait's pregnant moment is a domestic tragedy: the girl's mother loved the flower which the girl holds in her hand; then the mother died, and because she is dead and because her mother loved the flower by which the girl remembers her mother, the girl is sad. Where the silent artwork in Keats is said not only to be able to express its 'flowery tale' on its own, using its own signs, but to be able to do so

sweeter than 'our rhyme', in Wordsworth the silent artwork is not only incapable of expressing its own sentimental 'tale', but dangerously so in the sense that its own signs lead the viewer astray.

Poetry thus gains the upper hand in this paragone because it can *both* paint the outside by mimicking painting's pregnant moment (ll. 28–40) *and* reveal the inside of the representation (ll. 53–63). The inside is revealed when the poem supplements the 'absent mind' (l. 55) of the represented girl with a mind, with consciousness, thought, memory, knowledge; even as this happens at the expense of erotic desire, which Wordsworth claims has not yet entered her heart and fancy (ll. 49–50). According to the poem, words can do as much as and more than the medium of painting. Wordsworth distinguishes between the arts of painting and poetry in terms of poetry's supreme grasp of truth in contrast to painting's deceitfulness. Motivated by 'ekphrastic fear', he is interested in drawing limits and erecting boundaries between poetry and painting rather than in exploring whether painting has a language of its own.

Painting, however, besides being deceitful and alluring, can do something which poetic speech seems to envy: it can confer permanence and fixity upon its representation. Rarely has the eternising powers which Wordsworth invests in painting been expressed more explicitly than in these lines:

> Words have something told
> More than the pencil can, and verily
> More than is needed, but the precious Art
> Forgives their interference—Art divine,
> That both creates and fixes, in despite
> Of Death and Time, the marvels it hath wrought.
>
> (ll. 73–78)

Although Wordsworth does imply that there are things images may tell, words can tell *more* than images. This more is the 'mind' of the represented girl that words have supplemented. 'The precious Art' of painting, however, can also do something more than spoken words although the *less* that speech entails in comparison with painting is not given explicit articulation, but must be inferred symptomatically. Painting can *fix* its 'marvels' and render them impervious to the levelling forces of Death and Time. Poetry may be able to visualise through *enargeia* and to tell the truth about what it visualises, but it seems to be denied the capacity of painting to fix its creation. Painting, then, is opposed to speech the

way fixity is opposed to Death and Time. This makes Death and Time equivalent to the *more* that words can tell. Death and Time are thus the equivalents of mind and consciousness. And indeed, what is on the girl's mind according to the more that words can tell, is Death and Time. Yet *because* it is spoken and even as it therefore reveals the truth in painting, poetry does so by implication in a way that is highly susceptible to the levelling forces of Death and Time.

'Lines Suggested...' seems to grant painting the apparently unique power of fixing its representation and thus to imply that words, because spoken and ephemeral (the poet calls his product a 'Song' in the last line), cannot provide this 'spatial fix' in Murray Krieger's sense.[51] In the third and final movement (ll. 79–131), however, the words of the poem also usurp this privilege of painting as Wordsworth conglomerates the meliorative aspects of song and painting: the ability to reveal mind truthfully and the ability to fix and perpetuate the representation of what is ephemeral:

> That posture, and the look of filial love
> Thinking of past and gone, with what is left
> Dearly united, might be swept away
> From this fair Portrait's fleshly Archetype,
> Even by an innocent fancy's slightest freak
> Banished, nor ever, haply, be restored
> To their lost place, or meet in harmony
> So exquisite; but *here* do they abide,
> Enshrined for ages.
>
> (ll. 80–88)

Wordsworth first points to the outside of the portrait, the girl's 'posture' and 'look'. He then points to the inside of the portrait, the 'elsewhere' (l. 51) mentioned earlier, her thoughts or 'flowery tale' of Death and Time, 'of past and gone', which the poem has supplemented (because 'Words have something told / More than the pencil can'). The outside and the inside are then said to be in 'exquisite' 'harmony'. This 'harmony' results from the interpretative and representational work of the poem, its supplementation of mind to the 'absentminded' portrait. In other words, the italicised adverb '*here*', which is deictic of where the girl's 'posture', 'look' *and* her 'Thinking' 'abide', is the verbal representation of the visual representation and not, as we might presume on a hasty reading, the painting itself. The same deictic play with 'here' that we

observed in 'Upon the Sight of a Beautiful Picture' in Chapter 3 is at
work in these lines, which suggest *both* text and image, at once. The
capitalised 'Art' in line 88 must therefore in its reiteration be seen to
signify not only the art of painting as in lines 75 and 76, but also
the ekphrastic art of verbally representing the visual. The ability to
transcend Death and Time, apparently the sole province of painting
and sculpture, is appropriated by the verbally re-created portrait, which
visibly partakes of the quest for immortality—just like painting itself.
Thus, something 'visible' intervenes between and conglomerates the
invisible and ephemeral song and the visible and permanent portrait.
This 'visible' 'something' is writing, captured and perpetuated by the
'word-preserving Arts' of printing and the book.

A single word serves as the locus of the conglomeration of the ephem-
erality and invisibility of song and the fixity and visibility of painting,
the seemingly inconspicuously common noun 'line'. The word 'line'
appears as the initial word in the poem's title as a kind of tautological
designation of what we are going to read: lines of poetry suggested by a
portrait. Here we might properly ask what the point may be of noting
that a poem consists of 'lines'. Upon reflection, the word seems close
to meaningless—as if doubt might arise concerning which kind of lines
this poem consists of. Which is the point, of course, that doubt *can* be
made to arise and perhaps inevitably does when we recall Coleridge's
insight that 'Wordsworths words always *mean* the whole of their possible
Meaning'.[52] In the poetic text itself, the word that reminds us of what
we are reading, lines of poetry, is used when Wordsworth begins to
describe the portrait in detail, noting 'A silver line, that runs from brow
to crown / And in the middle parts the braided hair' (ll. 28–29). Line
refers to poetic lines as well as to painted lines. The significance of this
double reference is that the poem claims at once to be able to express
the truth and deep meaning of painting by representing it in the 'Lines'
of verse of which the title notifies us that the poem consists, *and* that the
poem claims to be a fixed entity capable of defying the levelling forces
of Death and Time the way painting's 'silver line' does. The aspired-for
conglomeration of poetic song and painting, of fluidity and fixity, of
temporality and spatiality, the ephemeral-invisible and the permanent-
visible that may be said to be indicated by the pun on line, is further
indicated by the fact that the painted line is represented as running
'from brow to crown' in poetic lines that also run, which are run-on
lines. The lines run, yet they are caught, composed and arranged in paint
and poetry the way spoken discourse is framed and fixed by writing

and the way the head of the represented girl is 'caught' in suspended 'inclination towards earth' by the portrait.

The effect of the pun, of the repetition of the word 'line' in title and poem proper, is a confusion of the materiality of the sign, run-on lines of blank verse, with the materiality of what it represents, a line of paint that runs. In other words, this is an example of Wordsworth's poetic materialism, his tendency to present 'poetry as somehow infused with the materiality of the objects it so ostentatiously depends upon'.[53] Representation and represented, sign and referent, intersect and intermingle through the use of a pun, which suggests what Geoffrey Leech calls the 'superstition' 'that if two words are alike, what they stand for must also be alike'.[54] This reiteration with a difference mixes different ontological entities and deliberately confuses poetic lines with what they ostensibly represent. The poetic lines represent a permanent object, which they desire to assimilate as a means of ensuring the permanence of the text and preparing the ground for the possibility of its future vocalisation.

Like other paratextual phenomena, a title has what Anne Ferry calls an 'interpretative function'.[55] This function stems from the fact that while it meets the reader before the poem, it gives the impression of having been conceived after the poem was completed and thus to be summing it up for the reader. It therefore often, as in this poem, directs the reader toward the most significant details in the poem by conferring a kind of textualised perspective. In a manuscript version, 'Lines Suggested...' was entitled 'Poem by W. on Mima's portrait by Stone' (*PW* 4, 429). When we recall this working title, we see that the published title seems to have been given to the poem after it was written and that it is of some significance and importance to Wordsworth that the word 'lines' be included in the published version. 'Lines' is, in other words, not just a throw-away word used off-hand. It is deliberately put there, perhaps to suggest a certain similarity between poetic and painterly lines and to signify the plastic fixity conferred upon song by its representation in the materiality shared by printing and painting.

Wordsworth certainly also, upon rereading his own poem and deciding to use 'lines' in the title, came to see its striking relationship with his most famous 'lines', those 'Written a Few Miles above Tintern Abbey, upon Revisiting the Banks of the Wye, during a Tour, July 13, 1798'. Marjorie Levinson has called to our attention the significance of 'Wordsworth's snake of a title', as she puts it.[56] Levinson's point is that the title refers to the 'outside' of the poem, to the time and place of its composition which for her means the French Revolution and the Industrial Revolution. The French Revolution is inscribed in the date,

which resonates with the celebration of the Storming of the Bastille. The Industrial Revolution appears when we remember that in 1798 Tintern Abbey was crowded with beggars mostly suffering from the enclosure acts, which by decreasing the amount of common land had removed their condition of subsistence, and that the River Wye was polluted due to emergent industry and widespread deforestation that helped keep the war economy going. As Levinson notes, this context is not to be found in the poem itself. There is, as she points out, a certain discrepancy between the title and the poem whereby the poem suppresses its titular context. As Levinson's reading reveals with great insight, the relation between poem and title is often extremely significant in Wordsworth; yet, as her reading's central blindness discloses, the most significant details in Wordsworth often escape notice.

In 'Tintern Abbey', the exact same thing happens that we have been observing in 'Lines Suggested...' when we hear of 'these hedge-rows, hardly hedge-rows, little lines / Of sportive wood run wild' (Brett & Jones, 113, ll. 16–17). The effect of the repetition of the word 'lines' in title and poem proper is the same in both poems. This reiteration with a difference deliberately confuses poetic lines with what they ostensibly represent: nature or painting. Significantly, nature and painting are two major sources of inspiration in the earlier and the later poetry, respectively. In both cases, they represent a valuable resource which poetry desires to assimilate and absorb in order to ensure the permanence of the text and hence its possibility of yielding a pleasurable future response.

In his rich account of 'Lines Suggested...' in relation to Wordsworth's biographical circumstances as well as the painterly conventions alluded to by the poem, Matthew Brennan assumes that it represents an actual portrait taken by Frank Stone in 1833, which shows, like the poem, a young girl.[57] However, the portrait which Brennan takes the poem to represent may in fact not be the one represented in the poem. As Jared Curtis points out, Wordsworth may or may not refer to it when he told Isabella Fenwick in 1843 that 'This portrait has hung for many years in our principal sitting-room, and represents J. Q. [Jemima Quillinan] as she was when a girl. The picture, though it is somewhat thinly painted, has much merit in tone and general effect; it is chiefly valuable, however, from the sentiment that pervades it' (*PW* 4, 428–429).[58] What this note obviously *does* refer to is an actual portrait that Wordsworth claims to have represented in his poem. Yet, if the poem is supposed to be a representation of the portrait reproduced by Brennan, it is a rather conspicuous misrepresentation: as in many other portraits of young girls in the nineteenth century, the girl in the portrait is reading, whereas the

girl in the poem's representation of the portrait is holding a flower in her hand (also a typical motif). However, if the poem's portrait *is* 'accurate' in relation to the actual but evidently lost portrait mentioned in the Fenwick note, then it still arguably fails to answer to what Wordsworth refers to in the note as the 'somewhat thinly painted' portrait hanging in his sitting-room. The portrait in the poem is the result of 'the painter's true Promethean craft' (l. 24); it instances an 'Art divine, / That both creates and fixes, in despite / Of Death and Time, the marvels it hath wrought' (ll. 76–78). In fact, with its references to silver, gold and azure colours, it seems as far from a 'somewhat thinly painted' portrait as possible. On all counts, verbal and visual representation appear to be out of tune with one another.

In the printed title, Wordsworth identifies the significantly untitled portrait not with the sitter but with the artist; he speaks of the maker of the representation, not the object represented. If we disregard the manuscript title's pet name, 'Mima', the very point of portraiture, which seems to be the proper identification of the represented person, requires the help of the Fenwick note where Wordsworth gives away the identity of the represented girl as J. Q.—initials easily identified with Jemima Quillinan, a young girl whose mother actually did die in her early childhood, and a portrait of whom taken by Stone Wordsworth actually owned. These biographical facts thus substantiate the story Wordsworth narrates to account for the portrait's expression. Strict adherence to them, however, clouds our view of the poem. Not least does it divert attention from the fact that Wordsworth may be making a point in erasing the name in the published title, which may be the point also of not using an engraving as illustration, because the portrait he 'paints' and responds to 'here' fails to answer either to the one he mentions in the Fenwick note (which is 'thinly painted') or the one by Stone (where the girl reads a book). The fact that we ultimately should not look for the portrait in order to explain the poem is announced not only by the fact that the name of the sitter is erased from the published title, but also by the title's second word, 'suggested'. 'Suggested' implies subjective response and interpretation rather than verisimilar representation. It calls forth the typical Anacreontic conceit, which Wordsworth had used to great effect in the ekphrases relating to Beaumont, wherein the poet goes beyond the painter and produces an all but impossible painting.[59] The word 'suggested' in fact tells us that the claims Wordsworth makes on behalf of the painting neither correspond to the reality of the portrait, nor any other actual portrait. It tells us that Wordsworth's poem represents an *idea* and an *ideal* of visual representation that is probably only

realisable in the verbal re-creation of painting (the idea that it is immutable, can catch and perpetuate a single moment and elevate it above and beyond time and history), rather than the all too mutable representation presumably before his eyes as he 'speaks'.

The absence of the actual portrait thus ultimately 'says' what the absence of Beaumont's illustrations from the collected works after 1820 and of the 'beautiful picture' from 'Upon the Sight...' say: that the poem has survived while the picture seems to have perished. Thus, although the poem purports to represent an actual portrait, it is what John Hollander calls a 'notional ekphrasis', a poem in which 'the linguistic account invents a fictional object, the description of which constitutes its creation', which W. J. T. Mitchell in fact says is characteristic of all ekphrases regardless of how 'faithful' they claim to be *vis-à-vis* the artwork.[60] Wordsworth sneaks in through the back door the old ekphrastic topos that poetry outlasts painting (seen in the examples mentioned from Martial and Thomas Morrison), because this portrait only survives and exists in this poem's 'Lines'. Lines which usurp the 'immutable permanence' (Lessing) of painting's 'silver line[s]' and are produced by a poet writing to posterity.

6

'The Marble Index of a Mind': Frontispiece Portraiture and the Image of Late Wordsworth

You could tell fra the man's faace his potry would niver have no laugh in it.

—Westmoreland farmer interviewed by H. D. Rawnsley about Wordsworth after the poet's death.[1]

One of Wordsworth's very first poems is a juvenile imitation of one of Anacreon's odes. First published in 1940, dated Hawkshead, 7 August 1786, 'Anacreon (Imitation)' reveals his early fascination with *enargeia* and long-standing attraction to portraiture. The poem calls upon Joshua Reynolds and challenges him to paint a portrait the poem then describes in vivid detail ending with the Pygmalian and gothic fantasy of the portrait coming alive (*PW* 1, 261–262). It belongs to one of the most radical forms of 'notional ekphrasis': the so-called *advice-to-a-painter* poem where a poet describes a painting to a painter intending the painter to realise the description visually.[2] The advice-to-a-painter poem derives from three Hellenistic Anacreontea, two of which are instructions for a portrait. In the Renaissance, poems that instruct a painter to paint portraits resurfaced and became objects of imitation. After Waller and Marvell's famous examples from the 1660s, the genre decreased in importance but did not die out.[3] That Wordsworth came across it at the age of sixteen is both evidence that it was part of the stock of classical texts that was being preserved in the educational system, and that the subject of portraiture claimed a special attraction for him.

Critics of Wordsworth have long been familiar with the curious fact that a large number of portraits of the poet exist. According to Frances Blanshard, there are eighty-seven in all from the first by William Shuter in 1798 to the large number that stem from the last years of national and international fame in the 1830s and 1840s, when Wordsworth

was sought out by aspiring portraitists seeking to make a name for themselves by association with the famous poet.[4] In her seminal work, *Romantic Theatricality*, Judith Pascoe shows how these portraits implicate Wordsworth—to some extent despite himself and the image of sincere poet of nature he cultivated—in 'the all-encompassing theatricality of romantic era culture'.[5] However, the extent to which some of these portraits must be seen as an integral part of Wordsworth's aesthetic vocabulary due to their use as engraved frontispieces has not been considered. Yet, when we do so, we may see that one of the most creatively significant and surprisingly innovative aspects of Wordsworth's later work is his use of authorial frontispiece portraiture.

Kenneth Johnston opens *The Hidden Wordsworth* by discussing some of the portraits and by reminding his readers that Wordsworth 'was not an immediately attractive man, especially compared with his great literary contemporaries, almost all of whom *look* Romantic'.[6] As 'pictorial emblem' for his book, Johnston chose a portrait only discovered in 1950, allegedly taken by Hazlitt around 1800 and presumably representing Wordsworth. It is, Johnston says, 'an appropriate symbol for a young man who in many ways hid himself from the gaze of posterity, covering over or destroying aspects of his life he did not want us to see' (4). As Johnston puts it, 'I see Wordsworth's youthful face like the eyes in the unknown portrait: not calm but alert, the expression not pleasing but questioning, calculating, perhaps a bit startled—or a bit frightening' (5); 'By contrast',

> Wordsworth's uniformly calm gaze in all his other portraits matches the remarkable consistency with which he and his works have been perceived by the public. The young, unknown, unsettling Wordsworth has been replaced by the sedate, grave, and boring older poet. From twenty years before his death until a hundred years after it, he was, above all, *revered*. His youthful self has become to a large degree a prisoner of the later image that he himself created. (5–6)

While late Wordsworth indeed hid his earlier self from the gaze of encroaching posterity, we have not looked closely enough at the 'later image that he himself created' and sought to impose on us in the two frontispiece portraits he authorised to be published in the collected works editions of 1836 and 1845 (see Figures 6 and 7).

The first edition was the growing multivolume edition which was published from 1815 onwards, in often extensively revised editions, and in 1836, when Edward Moxon had become Wordsworth's publisher (and

Figure 6 Frontispiece to *The Poetical Works of William Wordsworth* (Edward Moxon: London, 1836) of H. W. Pickersgill's portrait of Wordsworth, engraved by W. H. Watt. Reproduced by permission. British Library shelf mark 11611.b.11–16

probably to a large extent because of Moxon), introduced the frontispiece portrait. The portrait was engraved by W. H. Watt from Henry William Pickersgill's 1832 portrait, which was commissioned to be hung in St John's College, Cambridge.[7]

WILLIAM WORDSWORTH.

Figure 7 Frontispiece to *The Poems of William Wordsworth* (Edward Moxon: London, 1845) of Frances Chantrey's bust of Wordsworth, engraved by W. Finden. Reproduced by permission. British Library shelf mark 11632.ee5 frontispiece

The second edition was a single volume, double columned, stereotyped volume, which was first planned in 1838, but which for a variety of reasons to do with the incompatibility of the aesthetics and the economics of print was not realised until 1845, when price and design combined to allow Wordsworth to get the desired layout at the price he aimed for.[8] In this edition, Watt's engraving was replaced by William Finden's engraving of the 1820 bust by Sir Frances Chantrey.[9]

I claim this latter frontispiece as the 'pictorial emblem' for *Wordsworth and Word-Preserving Arts* because it was the image of himself as the poet of his collected works that the later Wordsworth wished should portray him for posterity, and because—like the subject it bodies forth—it has been completely lost and forgotten even as it has important things to tell us about the later Wordsworth. As will become evident from this examination quite a lot of anxious energy went into the construction of this public image, energy that shows Johnston's 'boring' familiarity with it to be a product of the myth of Wordsworth's decline rather than an engagement with the material itself.

The practice of presenting a portrait of a text's author alongside the text itself dates back to the very first written papyrus scrolls, yet the use of portraits of the author became more common after the appearance of the codex book in the second and third centuries, which both protected the image and allowed it to take up more space on the page, and 'in medieval manuscripts [author portraits] outrank, numerically, any other type of miniature'.[10] The individualised and particularised engraved portrait of the single author appeared for the first time in a book printed in Milan in 1479, and as the arts of printing and engraving developed and enabled a more economic reproduction, frontispiece portraiture flourished with the portrait genre as such from the sixteenth century onwards reflecting the growing interest in the individual in post-Renaissance Western culture.[11] In the seventeenth century, frontispiece portraits had become so popular that Cervantes in 1613 felt the need to excuse himself for not providing his *Novelas ejemplares* with a specimen, and in the eighteenth century a writer like Swift had fully integrated them into his work as seen, for instance, in the various portraits of Gulliver in *Gulliver's Travels*.[12] Alexander Pope looked back to Dryden (1701) when he utilised the feature in his fold-out portrait to his *Works* of 1717: the portrait measured an extraordinary 37.5 cm × 27.5 cm and had to be folded twice to fit into the quarto volume. Unlike Dryden, Pope audaciously did this at the outset of his career rather than at the end as with Dryden's posthumous edition, and 'It is as though the representation of the author is grander than the book itself', as one critic has noted.[13]

The main attraction of frontispiece portraiture is the idea that we can reach a better and truer understanding of an author's text through knowledge of how he or she looks. As Joseph Addison said in the first issue of the *Spectator* in 1711, 'a Reader seldom peruses a Book with Pleasure 'till he knows whether the Writer of it be a black or a fair Man of a mild or cholerick Disposition, Married or a Bachelor, with other Particulars of the like nature, that conduce very much to the right Understanding of an Author'. Both textual pleasure and understanding are said to depend on reliable knowledge of the author's looks and personality, the desire for which, Addison goes on to say, 'is so natural in a Reader'.[14] The frontispiece portrait responds to readers' apparent need for a central human presence to ground and stabilise, unify and authenticate, the production of textual meaning. According to Roger Chartier, its function 'is to reinforce the notion that the writing is the expression of an individuality that gives authenticity to the work'.[15] For Steven Rendall, frontispiece portraits 'figure a subject that claims not only to have produced the work but also, through the immanence of an individual intention, to determine—that is, to limit—its *meaning*'.[16]

This was noted by William Bates when he edited a collection of 85 portraits of distinguished authors first published in the 1830s in *Fraser's Magazine*, and republished as *The Maclise Portrait Gallery of Illustrious Literary Characters with Memoirs* in 1898, at the end of the century that had seen an inundation of author portraits and a treatment of them as fetish objects. Portraits of authors, writes Bates, 'have naturally a special attraction for the lover of literature':

> That there is no faith to be put in faces is an old axiom; but one against which we instinctively act. We think that there must be a certain correspondence between the man and his book; and that, from either, we are able to predicate what the other will be. Thus the portraits of the learned may be studied with advantage, not only as matters of art and curiosity, but as enabling us to gain therefrom some further apprehension and elucidation of their minds and writings.[17]

Likewise, in one of the essays from *Table-Talk*, 'On the Knowledge of Character', Hazlitt writes:

> I had rather leave a good portrait of myself behind me than have a fine epitaph. The face, for the most part, tells what we have thought and felt—the rest is nothing. I have a higher idea of Donne from a rude, half-effaced outline of him prefixed to his poems than from

any thing he ever wrote.... I cannot convince myself that any one is a great man, who looks like a blockhead.[18]

Having detailed Wordsworth's looks and his 'manner of reading his own poetry' in *The Spirit of the Age*, Hazlitt speculates that 'Perhaps the comment of his face and voice is necessary to convey a full idea of his poetry'.[19] A frontispiece portrait is one way of indicating the presence of the speaker in order to facilitate the reader's comprehension of the 'full idea' of a poet's work. Hazlitt may be providing an ironic twist to this more general suggestion when he recalls, in 'My First Acquaintance With Poets', that

> Wordsworth read us the story of Peter Bell in the open air; and the comment upon it by his face and voice was very different from that of some later critics! Whatever might be thought of the poem, 'his face was as a book where men might read strange matters', and he announced the fate of his hero in prophetic tones. There is a *chaunt* in the recitation of...Wordsworth, which acts as a spell upon the hearer, and disarms judgment.[20]

Hazlitt here points to the fact that the presence of the author as performer makes a difference, even as he also points to the fact that the presence of the author is not a necessary condition for receiving his poetry and evaluating it. Yet in the absence of the author, as Hazlitt points out with exquisite irony, readers are prone to respond differently than when faced with the real thing. The frontispiece portrait may be a means to cast a 'spell' upon the *reader* and 'disarm judgment'. As Hartley Coleridge noted in an 1840 review of nine women poets, 'when we venture to lift a pen against women ... the weapon drops pointless on the marked passage; and whilst the mind is bent on praise or censure of the poem, the eye swims too deep in tears and mist over the poetess herself in the frontispiece, to let it see its way to either'.[21] Hartley went on to resist the inclination to judge a book by its covers and the quality of a poet's work by her disarming looks, yet he symptomatically expressed a strong desire to do so.

A portrait of the author is, in other words, not a necessary or sufficient condition for his or her understanding. That we are dealing with a complex issue is suggested, for instance, by the fact that Addison undermined his own statement by publishing anonymously and without revealing the looks of the Spectator. Yet even when authors have voiced their dislike of certain author portraits (as Milton did in 1645 when he

made the engraver of his portrait engrave lines in Latin that denounced the quality of the portrait in a language foreign to the engraver) or castigated superficial readers taken to think they gain privileged access to the author through his likeness (as Ben Jonson did in speaking of Shakespeare's portrait in the 1623 Folio), they have dealt with an audience that desired the figure of the author to help them figure out the author's meaning. When authors include a portrait of themselves as frontispiece they may therefore be expected to present images of themselves meant to be read as giving privileged access to their work or somehow casting significant light on it. To say this is of course to say that a frontispiece portrait is a representation, a sign that can be manipulated as well as any other; but it is also to say that it is one we are meant to attend to as carefully as the verbal text it prefaces.

The frontispiece portrait is a significant place for the construction of a writer's 'image' in the sense of his or her public identity as the author of a certain body of work. As is well known the role of author assumed new significance and increasing importance in the Romantic period when it was associated with strong concepts of originality and creative genius and when a literary work—and an *oeuvre*—was seen as fundamentally structured around the expression of the author's unique individuality.[22] According to Lee Erickson, this 'modern idea of an author' as someone who defines 'himself in terms of his oeuvre and identif[ies] his own ego with it...stems in no small part from Wordsworth's continuing attention to his work, from his careful revision of his earlier poems, and from his determination to control his final text. Although some may see this activity as obsessive behaviour', Erickson continues, 'it is ultimately the behaviour of all writers who understand that in the future's eyes they will be what they have written'.[23] This understanding caused the Romantics to reveal a great deal of anxiety over their visual appearance in front of their works, but also to display a great deal of ingenuity as they discovered frontispiece portraiture's potential for a poetics of self-expression; their use of it may, in other words, be understood in terms of what Charles Taylor describes in *The Sources of the Self* as 'the Romantic ideal of self-completion through art'.[24]

The Romantic age witnessed a 'mania' for collecting and owning portraits. In 1814, the notorious Shakespeare forger and literary entrepeneur, William Henry Ireland, under the pseudonym 'Satiricus Sculptor', published his long poem, *Chalcographimania; or the Portrait-Collector and Printseller's Chronicle*. Ireland evokes a mania for portraits of any kind, among them engraved frontispiece portraits, when the hero of the poem cries out, 'For prints...I burn, expire! / Ah give me portraits

good or bad, / To physic fancy running mad'; as he continues: 'Cost what they may, I must possess 'em, / They are my idols, good heav'n bless 'em'.[25] This desire for engraved portraits had been stimulated by Samuel Granger's collection of engraved heads, *A Biographical History of England* (1769). This book reflected the growth of a market for engraved portraits during the latter half of the century, which saw an urge to collect portraits among the gentry that could afford the highly priced books with pictures they could cut out to make their own 'grangerized' collections.[26] Granger's book included a variety of engraved portraits in a hierarchical system featuring twelve categories ranked according to social position—from Kings and royalty in the first, down through poets in the ninth, to women in the eleventh, ending in the twelfth with persons noted for deformities and convicts.[27]

Robert Southey points out in *Letters from England* (1807) that due to Granger's book 'you rarely or never meet an old book here with the author's head in it; all are mutilated by the collectors'.[28] In the Romantic period, *authors* became sufficiently interesting in themselves to figure as the subject of an expensive portfolio book. The first portfolio containing 140 engravings of portraits of British poets from Chaucer to Cowper and Beattie was published in 1824.[29] This and other similar publications had been preceded by many reproductions in popular journals such as the *New Monthly Magazine* and the *European Magazine*, where portraits of living authors along with short more or less fictional biographical memoirs were hugely popular. *Fraser's Magazine*, for instance, ran the series 'A Gallery of Illustrious Literary Characters' between 1830 and 1838 that was later republished as *The Maclise Portrait Galley* from which I quoted above. Poets had become celebrities and media icons in what Coleridge derogatively called the 'age of personality'.[30]

The late Romantic humorist, Thomas Hood, satirised the convention of the frontispiece portrait in his illustrated prose sketch, 'Fancy Portraits'. Caricaturing graphically among others Thomas Campbell and George Crabbe, Hood wrote, 'As soon as a gentleman has proved, in print, that he really has a head,—a score of artists begin to brush at it.... Sir Walter is eternally sitting like Theseus to some painter or other;—and the late Lord Byron threw out more heads before he died than Hydra'.[31] To be recognised as the true and original author of a book, a Romantic writer had to make his or her face available for the public; as Hood said,

A book without a portrait of the author, is worse than anonymous. As in a church-yard, you may look on any number of ribs and shin-bones, as so many sticks merely, without interest; but if there should

chance to be a scull near hand, it claims the relics at once,—so it is with the author's head-piece in front of his pages. The portrait claims the work.[32]

Hood knew that in the age of Romanticism few things were more likely to stir readers' interest than a portrait of the author.

Southey knew this as well. That Southey was one of the most professional and publicly exposed Romantic authors made him more deeply concerned with his image than most other writers at the time. Born for opposition and fiercely polemical in most of what he wrote, Southey had several bad but telling experiences with the Romantic fame industry.[33] In a fascinating long poem on portraiture, 'Epistle to Allan Cunningham', first published in Cunningham's ambitiously edited annual, the *Anniversary* for 1829, Southey treats publishers' commercially motivated use and abuse of frontispiece portraits as well as political caricaturists' 'graphic libels'.[34] He articulates a typical lack of interest in engaging verbal attacks on his performance, which he claims will be sentenced to oblivion in the court of Time: 'Injuries there are which Time redresseth best' (l. 109), Southey writes, 'Let then the dogs of Faction bark and bay' (l. 116),

> and for that viler swarm,
> The vermin of the press, both those that skip,
> And those that creep and crawl, I do not catch
> And pin them for exposure on the page,
> Their filth is their defence.
>
> (ll. 132–136)

It is quite another matter with visual attacks and misrepresentations. These have in a literal sense caught Southey and pinned him on the page for public exposure, and he fears that they will survive so that once the original has disappeared, there will be no standard against which to measure the truth of their representational quality. Representing in words a visual 'gallery / Of…mis-resemblances' (ll. 244–245), 'an array of villainous visages' (l. 247), in the guise of which he has been made to face audiences at home and abroad, Southey attacks those 'Who fix one's name for public sale beneath / A set of features slanderously unlike' (ll. 105–106). These are to be condemned because 'Against the wrong / Which they inflict Time hath no remedy' (ll. 107–108); thus Southey 'appeal[s] / Against the limner's and the graver's wrong; / Their evil works survive them' (ll. 136–138).

The poem tells of Southey's inability to control the construction of his image in the public sphere and how he continually finds it misconstrued and travestied by the forces of capital. One such instance evolves from his reflections on his participation in getting a portrait printed in 1814 in Henry Colburn's *New Monthly Magazine*. The unintended effects of this venture were that the portrait was distorted and falsified as it was reproduced and disseminated through the unauthorised German Schumann (1820) and French Galignani (1829) editions of his poems. The Schumann Brothers' pirate edition published in Zwickau in 1820 used a portrait which Southey says does not represent himself but the stereotype of what he calls a 'cut-throat face' (l. 289) that he wishes the publishers and the engraver might encounter 'In the Black Forest' (l. 291)!

In a letter 24 July 1824, he looks back on his business with Henry Colburn:

I have never had any communication with him but once, which was many years ago, when he wrote to request that I would lend him a portrait of myself to be engraved for his magazine.... It happened that a most methodistical mis-likeness of me had been exhibited some little time before in the *European Magazine*, and as I was willing enough to supersede it by something better, I told Colburn where he might borrow a bust, which was the only satisfactory resemblance that existed.... Mr Colburn however was not satisfied with this. He borrowed the bust, and got someone to attempt the impossible task of making a portrait from it, which he engraved as an original picture:— a miserable looking wretch it is—something in physiognomy between assassin and hangman.... Of course I thought myself ill used, but this sort of usage is too common to excite either surprize or anger.[35]

This letter and the poem register a dispersal of a sense of centered, stable selfhood whose elimination seems a possible consequence arising from the experience of seeing his image created in the likeness of, following the poem, a cut-throat, a Jew, and a barber, and, following the letter, an assassin and a hangman. This alienating dispersal of 'Southey' into a panopticon of various negatively valued physiognomic stereotypes made with no reference to or reverence for the original is, for Southey, 'too common to excite either surprize or anger' to someone operating in the Romantic public sphere, who must expect to be 'ill used'.

As we know from Chapter 3, Southey was more than prepared to 'tickle the public eye' with engravings, and he does not oppose the

practice of using visual portraiture for commercial marketing purposes. He takes this practice for granted: as well he might writing in a culture that feared it was witnessing the displacement of the word by the image and publishing his epistle in an annual giftbook, a medium symptomatic of the valuation of a book by its covers, looks and graphic illustrations—and not just any annual. In the year in which the market for annuals exploded in no less than seventeen different specimens, 1828, Allan Cunningham's *The Anniversary*, as Basil Hunnisett puts it, 'is of outstanding charm and beauty and by far the best produced of all the annuals'.[36] Southey merely laments the fact that his publishers apparently show little concern over the veracity of the portraits they employ to ensure that the book sells by staging him as a marketable commodity.

The immediate occasion for Southey's poem was that he had just had his bust taken by Frances Chantrey. Against the dispersal of a stable subject position propelled by commercial forces, Southey presents the bust made by Chantrey as the better portrait of what he calls 'the inner man' (l. 100), the singular image of the essential, interior self that he wishes to bequeath for posterity and believes has found expression, indeed been verbally 'portray'd' throughout his poetry (ll. 100–101). The premise of the poem is that if any of the portraits treated therein 'as a likeness could be proven upon me, / It were enough to make me in mere shame / Take up an alias, and forswear myself' (ll. 249–251). The question implicitly raised by the poem is whether any firm ground can be found upon which to recover such a private 'myself' behind all the masks Southey commanded and was commanded by in public, or whether Chantrey's representation of 'myself' is not just another 'misresemblance' (l. 245), 'unlikeness' (l. 380), or 'misrepresentation' (l. 388) no different from any of those treated in the poem. While the poem reveals a desire to possess a stable, unified, sovereign self adequately expressed in a unified perfect artwork, it also shows the difficulty if not impossibility of maintaining it as such in public due to the unsolicited proliferation of corrupt replicas of replicas of replicas of bad originals that decentre and deform it and alienate the poet from himself, his work and his audience.

Southey's obsessive and possessive concern with his image has much to do with simple personal vanity and with his professionalism and sense of business. Yet, it may also have to do with a deeper existential concern with personal identity and the nature of the self. In his essay, 'On Sitting for One's Portrait', William Hazlitt points out that, 'The fact is, that the having one's picture painted is like the creation of another

self; and that is an idea, of the repetition or reduplication of which no man is ever tired, to the thousandth reflection'.[37] While Hazlitt here surely points to one of the main attractions of portraiture for the self-obsessed culture of Romanticism, he also points to what partly caused Southey's anxiety. Southey experienced that to count as a 'portrait' an image did not necessarily have to have much reference to the original; indeed, the copied and distorted image might supersede the original and cause readers to mistake and misread the work as created by someone else than the real author. Southey's anxiety may thus also stem from the way in which a portrait can cause the subject to experience his essential selfhood being evacuated and exposed as constructed by prefabricated images, which could assume the scandalous state of being a catachresis. Even as a portrait may give the best expression to the self that underlies much Romantic art, a bad portrait may disarticulate this self and alienate the poet it represents from him or herself in effect exposing the work of the portrait as constructive rather than reflective of the poet's self.

Southey's specific concern with frontispiece portraiture also has to do with his participation in a literary movement which explicitly connected the poet to his poetry. In the *Biographia Literaria*, Coleridge famously said that the question,

> What is poetry? is so nearly the same question with, what is a poet? that the answer to the one is involved in the solution to the other.... The poet, described in ideal perfection, brings the whole soul of man into activity.... He diffuses a tone, and spirit of unity, that blends, and (as it were) fuses, each into each, by that synthetic and magical power, to which we have exclusively appropriated the name of imagination. This power...reveals itself in the balance or recon-ciliation of opposite or discordant qualities;...and while it blends and harmonizes the natural and the artificial, still subordinates art to nature; the manner to the matter; and our admiration of the poet to our sympathy with the poetry. (Bate & Engell 2, 15–17)

In a culture of writing where authors increasingly took their personal experience as the subject matter for their art, it seems inevitable that they, or their publishers, would begin to use frontispiece portraits to articulate this subject. Yet, they were not encouraged to do so by Coleridge and the idealist aesthetic he represents. For Coleridge, the poet and the poetry were not equally important but part of a hierarch-ical system where our 'admiration of the poet' must yield before 'our sympathy with the poetry'. A visual portrait would be too theatrical,

mannered and artificial; it would direct undue attention to the poet as a real historical rather than a perfect ideal being who dissolves before the creation of an autonomous, ultimately impersonal work that can stand on its own. Yet, Southey knew that readers resisted and would tend to reverse Coleridge's hierarchy and form their sense of the poetry on the basis of the appearance of the poet. He knew that the frontispiece portrait is an important and integral part of a book, which influences readers' sense of its total meaning.

That Wordsworth should choose to publish his last collected works editions under the sign of frontispiece portraiture is perhaps less surprising than his choice of two radically different images to stand as the material embodiments of his self. If the frontispiece of an author is meant to stabilise and unify the meaning of a certain body of work by showing us who is 'speaking' and what its subject and origin is, the presence of two very different portraits, which accordingly fashion 'Wordsworth' differently, raises as much as settles, that is to say, unsettles the question of who is speaking and threatens to split and disperse rather than complete the self.

Wordsworth's likeness had circulated in public since February 1819 when the *New Monthly Magazine* published Henry Meyer's engraving of Richard Carruthers' 1817 portrait of Wordsworth striking what had become, since Godfrey Kneller's famous 1722 portrait of Pope, the characteristic pose of pensive poetic melancholy: the right hand held to the forehead where according to physiognomy and phrenology, inspiration and imagination were situated.[38] While Henry Crabb Robinson found the Carruthers portrait to exhibit 'a languor approaching to disease', Wordsworth appears to have liked it.[39] So did Alaric Watts' wife, who reports that 'Of the various portraits which have been published of him, one painted by Mr. Carruthers, and engraved for Galignani's edition of his poems, issued in Paris in 1828, reminds me more of the poet, as I remember him, than any other'.[40] However, because the engraving of Carruthers was reproduced as the frontispiece portrait for Galignani's 'pirated' edition, Wordsworth's move to issue a different authorised portrait may have been motivated to counteract its dissemination and to provide readers with something new. Thus, in 1836, the collected works were published with the engraving from Pickersgill's portrait of the poet reclined on a rock with pen and paper at hand. Yet, quickly after its first publication Wordsworth expressed a vehement desire to replace Pickersgill's portrait and the new frontispiece was engraved from Chantrey's bust and published in 1845, to the poet's full satisfaction.

In publishing with a frontispiece portrait, Wordsworth made use of a genre of painting whose legitimacy he habitually seems to have questioned, even if his sitting for a large number of portraits in his later years raised it in his estimate. The friendship with Beaumont began with a discussion in which Wordsworth held that Joshua Reynolds had spent too much time on the 'lesser' genre of portrait painting. And, in 1846, Wordsworth wrote to William Boxall, whose very first portrait had been of Wordsworth (1831), expressing a wish that Boxall had 'found for [his] Pencil more interesting employment than mere Portraits,—but I am afraid', says Wordsworth, 'that little else is suitable to English demand' (*LY* 4, 780). Recognising a commercial demand and implicitly suggesting that portrait painting is the only economically profitable form of painting, Wordsworth reveals a certain scepticism regarding the aesthetic legitimacy of portraiture compared to the other main genres of history and landscape (a view Wordsworth shared with his age). Yet, portraits of Wordsworth proliferated and he chose to make use of them as frontispieces. 'How explain', asks Frances Blanshard, 'that Wordsworth could endure so often the tedium of sitting for an artist?... Was he willing to face it because he was particularly vain? The suspicion that this might be so vanishes when we consider how many of the artists for whom he sat were youngsters or amateurs.... He allowed them to practice on him, partly because he was genuinely kind, and hated to refuse beginners who hoped his face would make their fortune'.[41] However, that Wordsworth may have wanted to help aspiring artists by acting as a model for them, and that there was a public demand for likenesses of the poet who was becoming a national institution in the 1830s, which are the two reasons Blanshard gives to account for the presence of so many portraits, is only part of the explanation of what motivated Wordsworth's sitting and his use of portraits as frontispieces.

A large part of the explanation is surely that Wordsworth was aware of the need for exposure and promotion to secure the place of his poems on the contemporary marketplace and thus took an active part in disseminating his likeness to achieve this goal. The decision to publish with a frontispiece in fact seems to have been primarily motivated by commercial considerations. In 1832, Wordsworth planned to have an engraving made from Pickersgill's portrait to be sold as a kind of fan poster in multiple reproductions. To facilitate this, Wordsworth wrote to Moxon and asked him 'to recieve the names of such persons as it *might* suit [to buy the engraving], to write them down in your Shop' (*LY* 2, 555). This being Wordsworth, he cautions Moxon that 'I ought to have said that

it is not wished to have a *Board* or Advertisement of this intention in your Shop, but merely that you should receive such Names as might offer' (*LY* 2, 555) to buy the engraving.[42] This scheme appears never to have been realised although Wordsworth mentions it in a letter to Crabb Robinson in 1835 ('ask Moxon if the engraving from my Portrait has been begun—It is often enquired after' [*LY* 3, 122]), and refers to it again in the 1836 letter where for the first time he announces the plan to use the engraving as frontispiece or 'vignette' (*LY* 3, 262). As a frontispiece rather than an independent poster, Wordsworth's image could both answer the rising demand for a visual likeness of the poet and help increase the chronically low sales of his poetry.[43] One reason why the plan to make a poster was shelved may thus have been that Wordsworth wanted to avoid putting off those readers potentially more interested in 'grangerizing' his image than reading his poems from buying the new edition.[44]

As suggested in earlier chapters, Wordsworth knew the market value of illustrations. In a letter to Moxon concerning the 1836 edition he writes, 'I have heard such strong opinions given respecting the disadvantages the Ed: will labour under in not having one illustration at least for each Vol. that I regret much...that an arrangement was not made...to include this' (*LY* 3, 307). Earlier in the year, Wordsworth had asked for Moxon's advice 'as to any ornaments such as prefixed to Murray's Edit. of Crabbe and Boswell's Johnson. These were strongly recommended to me by a spirited Bookseller' (*LY* 3, 148–149). Like Samuel Rogers' *Poems* discussed in the previous chapter, both Crabbe's *Life and Poems* from 1833 and Boswell's *Life of Johnson* republished in 1835 were secondary commodities reproduced and lavishly illustrated in order to attract and cater to the visual imaginations of a reading public, whose desire for engravings may be gauged by the soaring popularity of the literary annuals and giftbooks. However, the annuals and other less expensive and less sumptuously illustrated printed ephemera such as the *Penny Magazine* sold, which could hardly be said about volumes of poetry by single authors at this time.[45] The market for such books—despite Wordsworth's modest success with *Yarrow Revisited* in 1835—was in a state of severe crisis and depression and needed the image to function at all. In 1842, for instance, Moxon accounted for Wordsworth's low sales on the grounds of the reading public's preference for 'the immense number of weekly and Monthly publications—chiefly illustrated'.[46] In 1836 and with a new publisher, Wordsworth wanted his share of this market. Yet, his first attempt harboured a warning to be more careful

about the visual medium, and about the process of engraving needed to facilitate reproduction.

Insofar as a frontispiece portrait has communicative and aesthetic dimensions that exceed its use as commercial advertisement, these were set in relief by the engraving, because in terms of public relations, the first authorised portrait was a disaster. An additional explanation of the appearance of the frontispiece portrait, besides Wordsworth's concern with marketing, has to do with his awareness of and resistance to the dislocation between poetry and poet caused by writing. By representing an embodied form of the poetic 'I', the frontispiece portrait becomes a way for Wordsworth to come as close as ever to being 'a man speaking to men' through the silent medium of the book. If it represents the author as a 'speaker', attention is naturally placed on the organ of speech and vocalisation: lips and mouth. Yet, Wordsworth felt that that there was something wrong with the mouth when he first saw the 1836 engraving. There was, he says in a letter to Moxon, 'a weakness of expression about the upper lip' (*LY* 3, 304), while in a letter from 1837 he refers to 'the maudlin expression about the upper lip' (*LY* 3, 344). Richard Brilliant points to what tends to be wrong with the mouth in portraiture, 'few portraits at any time, even so-called realistic portraits, ever show anyone smiling or talking.... One must remember', Brilliant continues, 'that the most human characteristic of all—the act of speaking—splits the face wide open, but portraits rarely show this because the genre operates within social and artistic limits', which prompt them to 'exhibit a formal stillness, a heightened degree of self-composure that responds to the portrait-making situation'.[47] When portraits transgress these limits and show for instance an open mouth, as happens in an extreme manner in the Laocoön statue, they tend to be censured and condemned. Indeed, Lessing takes great affront to the idea of an open mouth in a plastic artwork because, as he sees it, it is incompatible with the ideal of the pregnant moment and leaves too little 'unsaid' for the imagination to supplement in the act of contemplation.

The frontispiece portraits may also reflect Wordsworth's desire to secure a secular afterlife. As Nathaniel Hawthorne points out in 'Prophetic Pictures' (1837), 'Nothing in the whole circle of human vanities takes stronger hold of the imagination than this affair of having a portrait painted.... It is the idea of duration—or earthly immortality—that gives such a mysterious interest to our portraits' which are 'to be [our] representatives with posterity'.[48] Or as Brilliant puts it, 'Portraiture challenges the transiency or irrelevancy of human existence and the portrait artist must respond to the demands formulated

by the individual's wish to endure'.[49] In having himself rendered in permanent form through portraiture and in using it as frontispiece illustration, Wordsworth had his work, which in a sense was himself, rendered equally permanent. As James Elmes said of portrait figures in his *Dictionary of the Fine Arts* (1826),

> if the expression on their countenances is still and unchanging, it is at the same time perpetual, and subject neither to the accidental dimming of angry and unworthy passions, nor to the fading touch of time. It haply remains young while we grow old, and constitutes a charm whereby our earlier and later years are linked together.... [T]he painter by his 'so potent art' effectually bids defiance not only to time but mortality.[50]

However, in the process of transforming the original Pickersgill portrait into a reproducible portrait through engraving, the portrait was altered in significant ways that seem to have given Wordsworth certain intimations of mortality rather than of immortality.

In addition to giving the lips an undesired effeminate expression ('maudlin' 'weakness'), in the engraving of the original Pickersgill important parts were cut out: arms, legs, background, foreground, the ground on which the subject sits, as well as the poet's professional identity markers, pen and paper.[51] The bodily signs that remain in a truncated form in the picture thus assume new meaning. Upon receiving the first volume from the printer, Wordsworth complained to Moxon that the portrait's 'attitude has an air of decrepitude in consequence of the whole Person not being given' (*LY* 3, 307). In a letter to Henry Taylor, November 1836, this criticism was elaborated: 'partly owing...to its having preserved the inclination of the body (natural in a recumbent attitude) without an arm to explain it or account for it, the whole has an air of feebleness and decrepitude which I hope is not yet authorized by the subject. It was an unfortunate suggestion from Mr [Samuel] Rogers that the portrait should be given in this half sort of way' (*LY* 3, 319). However, Rogers may not have been giving bad advice because the presentation of the portrait in a 'half sort of way' can be said to be highly successful in Rogers' own frontispiece portrait, which was engraved by Finden for the *Poetical Works* in 1834 (assuming that Rogers' advice was to follow this model). While Rogers' facial features are engraved in a very fine line producing a certain 'photographic' sense of likeness, the rest of the body is represented so as to give the impression that the body fades to disappear and dissolve

into as it merges with the blank surrounding page, and from there becomes the body of the book. This effect is not accomplished in Wordsworth's portrait, because it applies almost the same line all the way to the edge of the picture, and because the portrait is cut off abruptly, giving the impression, as Wordsworth sees it, of feeble decrepitude in the reproduction, rather than recumbent relaxation as in the original.

By featuring the torso out of the context of the rest of the body, and by not either integrating it into the page as may be observed in Rogers, whose legs fade into and merge with the surrounding white paper, or displaying it for instance in a frame, the engraving fashions an amputated, auraless Wordsworthian poet somehow alienated from his book that did not match his idea of what the author of his works and speaker of his poems should look like in public. If a good portrait challenges 'the transiency and irrelevancy of human existence', as Brilliant suggests, a bad portrait is doubly bad. Rather than challenge death, a bad portrait can be said to articulate and exemplify 'the transiency and irrelevancy of human existence'. What in Pickersgill's original portrait signifies 'recumbent'—a neutral, descriptive term here—gets interpreted by Wordsworth as 'feebleness' and 'decrepitude' in the reproduction. Feebleness and decrepitude are of course highly evaluative terms that describe how Wordsworth did not want his public poet-persona fashioned. If the visual representation of the author according to Addison is conducive to 'the right Understanding of an Author', then surely the opposite can also be the case. Thus, Robert P. Graves concluded in 1869 about the first authorised frontispiece portrait: 'I can have little doubt that that frontispiece, conveying a false impression of the poet, has even conduced with many to a misinterpretation of his poetry.'[52] This portrait is in many ways a fitting representation and evaluation of the later Wordsworth as he has been received by criticism since Matthew Arnold; it visualises even as it seems to enact his 'decline' and disenchantment and matches Johnston's characterisation of its subject as 'sedate, grave, and boring'.

Whether it should be called a 'misinterpretation', the 1836 frontispiece portrait inflects our reading of Wordsworth's poems that represent portraiture of various kinds. These poems tend to represent their portraits along the lines of the ekphrasis of the portrait by Stone considered in the previous chapter: as a bulwark against time and change, as a defense against death and decay. Wordsworth's sonnet on Pickersgill's original portrait, 'To the Author's Portrait', first published

in *Yarrow Revisited*, for instance, imagines it to be hung in its proper place in St John's College, Cambridge:

> Go, faithful Portrait! and where long hath knelt
> Margaret, the Saintly Foundress, take thy place;
> And, if Time spare the colours for the grace
> Which to the work surpassing skill hath dealt,
> Thou, on thy rock reclined, though kingdoms melt
> And states be torn up by the roots, wilt seem
> To breathe in rural peace, to hear the stream,
> And think and feel as once the Poet felt.
>
> (*PW* 3, 50, ll. 1–8)

The function of the portrait as a 'double' or reinvention of the self as other, in this case as a permanent and unchangeable other, is here cogently articulated. This sonnet seems to promote an idea of the portrait as of a different world than the historical world ruled by uncontrollable forces of nature, where 'kingdoms melt' and states are 'torn up by the roots'. Yet, the actual fate of the portrait in 1836 belies this idea, casts a certain ironic 'gleam that never was' on the original Pickersgill portrait, and undermines the investment in the portrait's capacity to withstand and resist time and history. In the Pickersgill 'double' (the engraving where the rock that gives stability and permanence to the portrait and its subject had been excised), the very opposite of what Wordsworth valued about portraiture and understood this specific portrait to portray is made manifest; it carries death and decay rather than immortality and permanence and raises the question of why he used a frontispiece portrait at all with renewed force.[53]

Almost as soon as the 'feeble' and 'decrepit' portrait was published, Wordsworth began to plan its substitution. However, rather than either give up the practice or reproduce the Pickersgill portrait in full or in a better 'half sort of way' as in Rogers, Wordsworth chose another way, which reveals at least as much concern with making an aesthetic and properly 'last impression' as with furthering sales. The decision to change frontispiece was already made by January 1837 when Wordsworth wrote to his nephew Christopher at Cambridge, 'If we live to see another Ed: an engraving from Chantrey's Bust shall replace it' (*LY* 3, 343–344). In a June 1845 letter to Moxon, Wordsworth writes that 'I think I mentioned to you that I had an utter dislike of the Print from Pickersgill prefixed to the Poems. It does me and him also great injustice.

Pray what would be the lowest expense of a respectable engraving from Chantrey's Bust? That I should like infinitely better' (*LY* 4, 676).[54]

Taught by experience, this time Wordsworth insisted on seeing a copy of the engraving before publication and he, of course, enforced certain corrections to be made in the area of the mouth. On 19 November 1845, he wrote Moxon,

> [the engraving] ought.... To be altered...both on the eyes and the nose, neither is the upper lip what it ought to be.—There is both in my face and in the bust a swelling or projection rather, above the upper lip where as in the bust [i.e. the engraved bust] it sinks. The Engraver if he works carefully must at once recognise that—I am sorry to give so much work, but really my Friends here are so dissatisfied that I could not but dwell on these particulars. (*LY* 4, 725; see also 723)

Having seen these alterations carried out, Wordsworth wrote back 25 November, 'I think...the Engraving of the Bust...considerably improved, and hope [it] will do credit to the Publication' (726).

Chantrey's bust was the representation of himself that Wordsworth preferred to have multiplied both through engraving and through multiple plaster casts distributed to friends and family.[55] Yet, he never explicitly motivated his choice of it as frontispiece over for example Haydon's *Wordsworth on Helvellyn*, which Wordsworth found the 'best likeness, that is the most characteristic, which had been done of [him]',[56] and which Wordsworth's posterity has preferred as its image of the Poet. As Elizabeth Barrett Browning wrote in 1842, 'No portrait this with academic air! / This is the poet and his poetry'.[57] Indeed, Matthew Arnold's 1879 selection from Wordsworth's poetry, which largely produced the twentieth century's impression of the poet, used an engraving based on Haydon's portrait as frontispiece. Robert Graves, who found Chantrey's bust to be 'a work of thought and elevation, but...not a striking likeness', likewise preferred Haydon's portrait. In 'Recollections of Wordsworth', Graves said that Haydon's 'alone deserves to be the historic portrait of Wordsworth. Nothing can be truer to the original than the droop of the head weighed down by the thoughts and feelings over which the active imagination is pleasurably brooding'.[58]

Henry Crabb Robinson probably comes as close as any to explaining why Wordsworth preferred the bust as frontispiece. Upon first seeing it in 1821, Robinson wrote to Dorothy that

I have heard the opinion of several who do not know [Wordsworth], and who consider it (as I do) as the *idea of a poet*. It matters little who, perhaps—It might be Pindar! Or Dante or Calderon—or any other individual characterised by profound thought and exquisite sensibility.—But I think too that it is a good likeness—and there is a delicacy & grace in the muscles of the cheek which I do not recollect in the Original.[59]

It is a good likeness, but everything Crabb Robinson says about it has nothing to do with the particular subject it ostensibly represents. It is and remains the likeness of the Platonic 'idea of a poet'. On this, Crabb Robinson concurred with Graves ('not a striking likeness') and the subject himself, who in 1822 wrote to Chantrey's secretary, Allan Cunningham, that the bust 'can be of little value as to the likeness, but as a work of fine Art I may be excused if I say that it seems to me fully entitled to that praise which is universally given to Mr Chantry's Labours' (*LY* 1, 138). The bust is in other words more artwork than likeness, by which Wordsworth means that the bust provides an ideal representation rather than a realistic depiction.

Crabb Robinson called attention to the work of idealisation in the bust when he noted the absence of Wordsworth's characteristic scars on his left cheek, saying, 'there is a delicacy & grace in the muscles of the cheek which I do not recollect in the Original'. The removal of this 'accidental' feature was noted by others. In 'My First Acquaintance With Poets', Hazlitt writes of Wordsworth's

intense high narrow forehead, [his] Roman nose, cheeks furrowed by strong purpose and feeling, and a convulsive inclination to laughter about the mouth, a good deal at variance with the solemn, stately expression of the rest of his face. Chantrey's bust wants the marking traits; but he was teazed into making it regular and heavy: Haydon's head of him, introduced into the *Entrance of Christ into Jerusalem*, is the most like his drooping weight of thought and expression.[60]

Hazlitt hints at a rumour of Wordsworthian vanity that could be potentially fatal to the image he had been establishing of the antitheatrical and sincere poet safely centered in what Judith Pascoe calls a 'bastion of strong selfhood'.[61]

When John Gibson Lockhart published his biography of Sir Walter Scott in 1838, the idealisation evident in the bust—the signs of Wordsworth 'advising' the sculptor and thus somehow acting out the

Anacreontic conceit—was again mentioned and this time in such an explicit manner in a widely circulated text that Wordsworth could no longer maintain silence. Lockhart printed an incriminating letter from Scott to Allan Cunningham,

> I am happy my effigy is to go with that of Wordsworth [to the Royal Academy Exhibition in 1821], for (differing from him in very many points of taste) I do not know a man more to be venerated for uprightness of heart and loftiness of genius. Why he will sometimes choose to crawl upon all fours when God has given him so noble a countenance to lift to heaven I am as little able to account for as for his quarrelling (as you tell me) with the wrinkles which time and meditation have stamped his brow withal. (*LY* 3, 561n)

Wordsworth could not allow this representation of himself as vain and potentially corruptive of the 'high calling' of art to stand uncontested, and he promptly wrote Lockhart adding 'One more word on the story of the Bust', as he refers to it. Wordsworth, almost totally immersed in thinking about the mechanisms of self-representation, writes:

> I have a crow to pick with 'honest Allan [Cunningham]', as he has misled Sir W. by misrepresenting me. I had not a single wrinkle on my *forehead* at the time when this bust was executed, and therefore none could be represented by the Artist (a fact I should have barely been able to speak to, but that it was noticed by a Painter while drawing a Portrait of me a little while before) but deep wrinkles I had in my cheeks and the side of my mouth even from my boyhood— and my Wife, who was present while the Bust was in progress, and remembered them, from the days of her youth, was naturally wishful to have those peculiarities preserved for the sake of likeness, in all their force. Chantrey objected, saying those lines if given with shut mouth, would sacrifice the spirit to the letter, and by attracting undue attention, would greatly injure instead of strengthening the resemblance to the living Man. My own knowledge of Art led me to the same conclusion. I supported the Sculptor's judgement in opposition to my Wife's desire: this is the plain story, and it is told merely that I may not pass down to posterity as a Man, whose personal vanity urged him to importune a first-rate Artist to tell a lie in marble, without good reason; but in reality the sacrifice of truth would have been much greater, if the principles of legitimate art had been departed

from. Excuse so many words upon what may be thought, but I hope not by yourself, an insignificant subject. (*LY* 3, 561)

The performance of 'Wordsworth' has rarely been more explicitly staged than in this passage, which provides aesthetic rationale for the idealisation, the 'lie [told] in marble', in Chantrey's bust registered by most observers, as it takes us behind the scenes of the construction of the author-image he imagined would 'pass down to posterity' to hear of his anxious sense of self-completion through Art. Of course, by the same token, Wordsworth 'explains' why Chantrey's bust was used as the pretext for the last frontispiece.

The motive behind using the bust as frontispiece was hinted at by Crabb Robinson when in 1825 he first suggested to Dorothy that it ought to be engraved for a frontispiece. Making suggestions for future editions of Wordsworth's poems, and misquoting 'Upon the Sight of a Beautiful Picture', Crabb Robinson asked, 'why not by a first rate hand, a print of the bust? I am aware that busts do not engrave well generally: But certainly this is the least unsatisfactory of the attempts to "snatch from fleeting time" an image of your brother's countenance'.[62] As Kenneth Gross writes, 'we recognize in the statue an image of the fate of bodies, a fate elected out of desire to deny our vulnerable, penetrable, wasting, and dying physical persons, to provide ourselves with idealized stone mirrors.... The lure of the statue is that it becomes a shield, a wedge between myself and my death'.[63] Or as Byron put it in 1821 or 1822, 'everybody sits for their picture—but a bust looks like putting up pretensions to permanency—and smacks something of a hankering for *public* fame rather than private remembrance'.[64] Despite (if not indeed because of) the failed attempt to project a sense of permanence through the Pickersgill frontispiece and the inadvertent projection of a certain effeminate 'weakness' and 'maudlin expression', Wordsworth's use of frontispiece portraiture lends itself to being considered in terms of his self-fashioning for posterity; it 'smacks' of an attempt to assume permanent form in order to survive his own death and be received into a Yeatsian 'artifice of eternity'. That Wordsworth should want to correct the realistic image of himself as 'decrepit' and effeminate with an idealised image of himself as erectly masculine and as rescued and preserved from time in statuesque perfection is in other words understandable as a means to overcoming the bodily decay inadvertently articulated by the engraving from Pickersgill.[65] It also sets in relief Wordsworth's apparent delight when Haydon measured him in 1842 'to ascertain his real height, and found him, to my wonder, eight heads high, or 5 ft. 9 7/8 in., and of

very fine, heroic proportions. He made me write them down, in order, he said, to show Mrs Wordsworth my opinion of his proportions'.[66] Whether a sign of a sense of humour or of vanity (probably both), this anecdote shows Wordsworth's deep concern with the meaning of his bodily appearance.

Ultimately, the concern with finding the appropriate frontispiece portrait and the fact that the final choice seems to have been made on grounds of Art rather than likeness reflects Wordsworth's consciousness of the book as a visual form of expression in its own right. A frontispiece portrait is surely also an aesthetic sign which does not point beyond itself, but is its own 'end'. This is particularly the case when it does not aim to produce 'photographic realism', as in the case of an engraving from a bust, which so evidently signals 'art' (in the second or third degree) rather than 'nature'. Seeing an engraved bust we see the representation before we see the represented author, the medium more than the referent is foregrounded. As a work of art rather than a 'mere' portrait, like the engraving from Pickersgill or Haydon's portrait, Wordsworth's second frontispiece portrait contributes to making the collected works, the book itself, into a work of art rather than a mere anthology of poems by the same author. The final frontispiece, finally, best captures the later Wordsworth's desire and ambition to produce a poetic work that might endure and reach posterity as a 'speaking monument'. Yet, no readers since have taken this Neoclassical, artificial and idealised image seriously as representing Wordsworth's self. Instead, like Arnold and many others readers refer to Haydon's more Romantic Wordsworth brooding in sublime natural surroundings, or like Stephen Gill, who used it for his Oxford edition and later for his biography, to Richard Carruthers' stereotypical Wordsworth with his hand to his forehead, or like Johnston to one of the early portraits. That we thus disobey Wordsworth's final intention and make our own choice of his image reveals, if nothing else, that the sovereign authorial and authoritative, masculine and dominant self often associated with Wordsworth is in fact a malleable and changeable social construction that accommodates the past in the interest of the present.

In the last 40-odd years accounts of what was significantly new and revolutionary in Romanticism have often been based on Wordsworth's discovery of himself as poetic subject matter. As Harold Bloom once said, and still maintains, Wordsworth 'was the inventor of modern poetry, and he found no subject but himself'.[67] However, until we have considered Wordsworth's use of frontispiece portraiture, then we have barely begun to understand the ways in which he was articulated in his

literary work. Attention to the frontispiece portrait is, on the one hand, nothing more than a supplementary way of pointing to the central tenet of Romantic poetics, its emphasis on authorial self-expression. Yet on the other hand, the sense of self we get to hear about as we look at and behind these portraits is different, new and even subversive of traditional accounts. The self of the Romantic and Wordsworthian frontispiece portrait is fashioned through a collaborative effort between poet, portraitist, engraver, publisher and reader. It is staged and theatrical, a performative self that is public rather than private; it is exterior, material and concrete rather than interior, transcendent and abstract.

To study late Wordsworth's image seemed a logical way to end a study of the return of the visible in his career insofar as it provides a privileged way to get a firmer sense both of the trajectory of the career and of its complexity. The career that 'began' with the imitation of Anacreon's advice-to-a-painter poem that verbally hallucinates a portrait somehow had to 'end' with the graphic realisation of a portrait, even as much of what stands between these two bookends to the career contradict and complicate them. If the Wordsworth of 'Tintern Abbey' could not 'paint / What then I was', his later self (like his earliest self) knew how to instruct others to paint him, not as he once really was or is deep down, but as he wanted others to see and imagine him in the spectacular 'hand-held theatre of the book'.[68] The frontispiece portrait—especially the last—indicates, on the one hand, Wordsworth's turn away from the world of nature towards the world of art as the privileged mirror to reflect, interpret, articulate, complete and ultimately construct or compose his self; on the other hand, in a condensed manner the presence of two author portraits (and several unauthorised likenesses) frames the kind of complexity that has been traced throughout this book and that arises when we recognise that 'Wordsworth' is not either the poet of nature and simplicity or the poet of art and artifice, but that he is both and neither. What is attractive about the 'visible company' of Wordsworths as they appear (or disappear) in these frontispiece portraits is that while the portraits signal a central aspiration to express and complete the self in and through art, they compel the reconfiguration of Wordsworth's self-identity and show that it remains, like the *oeuvre*, incomplete and always potentially subject to critical reconstruction.

Notes

Introduction

1. Stuart Curran opened his seminal essay, 'Romantic Poetry: The I Altered', in *Romanticism and Feminism*, ed. Anne K. Mellor (Bloomington and Indianapolis: Indiana UP, 1988): 'Let us suppose they all died young: not just Keats at twenty-five, Shelley at twenty-nine, and Byron at thirty-six, but Coleridge in 1802, Wordsworth in 1807, and Southey on the day in 1813 he became poet laureate' (185). Marilyn Butler likewise entertained the idea of killing Wordsworth prematurely, as early as 1793, in 'Plotting the Revolution: The Political Narratives of Romantic Poetry and Criticism', in *Romantic Revolutions: Criticism and Theory*, ed. Kenneth Johnston *et al.* (Bloomington and Indianapolis: Indiana UP, 1990), pp. 133–157. In the process of telling the story of how he was cured from depression by reading Wordsworth in 1828, John Stuart Mill parenthesises the later Wordsworth with extraordinary authority: 'the miscellaneous poems, in the two-volume edition of 1815 (to which little of value was added in the latter part of the author's life), proved to be the precise thing for my mental wants at that particular juncture'. *Autobiography and Other Writings*, ed. Jack Stillinger (Boston: Houghton Mifflin Company, 1969), p. 88. In 1879, Matthew Arnold, more famously and influentially, originated the notion of Wordsworth's Great Decade when he said that 'within one single decade..., between 1798 and 1808, almost all his really first rate work was produced'. *Poems of Wordsworth* (London and New York: Macmillan, 1888, 1st ed. 1879), p. xii. In the early 1980s, the most influential Romanticist of the last two decades, Jerome McGann, in the most casual manner remarked that in 1807 Wordsworth 'fell asleep'. *Romantic Ideology: A Critical Investigation* (Chicago: The U of Chicago P, 1983), p. 116; elsewhere McGann concluded that the later work consists of 'verse we are spared from having to remember'. *The Beauty of Inflections: Literary Investigations in Historical Method and Theory* (Oxford: Clarendon P, 1985), p. 313. Similarly, for Harold Bloom, 'Wordsworth's dreadful poetic dotage...went on drearily from 1807 to 1850' signifying 'the longest dying of a major poetic genius in history'. *The Western Canon: The Books and School of the Ages* (New York: Harcourt Brace, 1994), pp. 249–250.
2. H. W. Garrod once described the Anti-Climax as 'the most dismal...of which the history of literature holds record'. *Wordsworth* (Oxford: Clarendon P, 1927, 1st ed. 1923), p. 138. See also Willard Sperry, *Wordsworth's Anti-Climax* (Cambridge, MA: Harvard UP, 1935).
3. For such unified constructions of Wordsworth's *oeuvre*, see Abbie Findlay Potts, *The Ecclesiastical Sonnets of William Wordsworth: A Critical Edition* (New Haven: Yale UP, 1922); and Bernard Groom, *The Unity of Wordsworth's Poetry* (London: Macmillan, 1966). René Wellek gives the most important construction of a unified Romanticism in 'The Concept of Romanticism in Literary

History' and 'Romanticism Re-examined', *Concepts of Criticism* (New Haven and London: Yale UP, 1963), pp. 128–221.

4. See Marilyn Butler, *Romantics, Rebels, and Reactionaries: English Literature and Its Background 1760–1830* (Oxford and New York: Oxford UP, 1981); McGann, *Romantic Ideology*; Anne Mellor, *Romanticism and Gender* (New York and London: Routledge, 1993); William Galperin, *The Return of the Visible in British Romanticism* (Baltimore: The Johns Hopkins UP, 1993); Paul Hamilton, *Metaromanticism: Aesthetics, Literature, Theory* (Chicago and London: The U of Chicago P, 2003).

5. Geoffrey Hartman, *Wordsworth's Poetry 1787–1814* (Cambridge, MA and London: Harvard UP, 1987, rev. ed. 1971, 1st ed. 1964), p. 331. Hartman addresses the later poetry in two essays in *The Unremarkable Wordsworth*, foreword by Donald G. Marshall (Minneapolis: The U of Minnesota P, 1987): 'Blessing the Torrent' and 'Words, Wish, Worth', pp. 75–119. See Jared Curtis, ed., *Last Poems, 1821–1850* (Ithaca and London: Cornell UP, 1999); and Geoffrey Jackson, ed., *Sonnet Series and Itinerary Poems, 1820–1845* (Ithaca and London: Cornell UP, 2004).

6. See Peter Manning, 'Wordsworth at St. Bees: Scandals, Sisterhoods, and Wordsworth's Later Poetry', *Reading Romantics: Texts and Contexts* (New York and Oxford: Oxford UP, 1990), pp. 273–299; 'Cleansing the Images: Wordsworth, Rome, and the Rise of Historicism', *Texas Studies in Literature and Language* 33:2 (Summer 1991), pp. 271–326; 'The Other Scene of Travel: Wordsworth's "Musings Near Aquapendente" ', in *The Wordsworthian Enlightenment: Romantic Poetry and the Ecology of Reading*, ed. Helen Regueiro Elam and Frances Ferguson (Baltimore: The Johns Hopkins UP, 2005), pp. 191–211; and 'The Persian Wordsworth', *ERR* 17:2 (April 2006), pp. 189–196.

7. John Wyatt, *Wordsworth's Poems of Travel, 1819–42: 'Such Sweet Wayfaring'* (Basingstoke: Macmillan, 1999).

8. Alison Hickey, *Impure Conceits: Rhetoric and Ideology in Wordsworth's 'Excursion'* (Stanford: Stanford UP, 1997), p. 8; Sally Bushell, *Re-reading The Excursion: Narrative, Response and the Wordsworthian Dramatic Voice* (Aldershot: Ashgate, 2002).

9. William Galperin, *Revision and Authority in Wordsworth: The Interpretation of a Career* (Philadelphia: U of Pennsylvania P, 1989), p. 56.

10. Harold Bloom and Lionel Trilling, eds, *The Oxford Anthology of English Literature*, 2 vols (New York and London: Oxford UP, 1973), 2, p. 125.

11. Duncan Wu, *Wordsworth: An Inner Life* (Oxford: Blackwell, 2002), p. 13. When Wu addresses a later poem such as 'Composed when a probability existed of our being obliged to quit Rydal Mount as a Residence' (1826), he emphasises its continuity with the earlier work (see 195–196).

12. David Perkins, *Is Literary History Possible?* (Baltimore and London: The Johns Hopkins UP, 1992), p. 65.

13. According to Potts in *Ecclesiastical Sonnets*, a ' "continuous stream of identity" ' (as Christopher Wordsworth said in the 1851 *Memoirs*) 'flow[s] from the poet's earliest to his latest poems'; for Potts, who adapts the term from Coleridge, Wordsworth's *oeuvre* was 'homogeneous' (3). Alluding to critics who dismiss the later Wordsworth, Groom asked in *The Unity Wordsworth's Poetry*: 'if Wordsworth's poetry is really of such merit, are his readers to consent, for all time, to the dismissal of the greater part of what he wrote

during more than half his life? The tendency to isolate a limited number of poems from the rest shows few signs of weakening, yet it is certain that a strong element of consistency runs through the poet's work from first to last. It deserves, indeed, to be viewed as a whole' (xi).

14. This study gives almost no attention to the topic of Wordsworth's politics and his later public role as national figure, a subject dealt with by Michael Friedman in *The Making of a Tory Humanist* (New York: Columbia UP, 1979), but whose force as interpretive key for understanding the later poetry in terms other than of failure and decline has seemed scant. The generally accepted explanation of the so-called 'decline' links a gradual change in Wordsworth's political commitment from an early republican radicalism towards a more liberal conservatism to a qualitative decline in his poetic output. From Emile Légouis' first modern critical biography, *The Early Life of William Wordsworth* (1896), which was republished with a new foreword by Nicholas Roe in 1988, to Marjorie Levinson's significantly titled *Wordsworth's Great Period Poems: Four Essays* (Cambridge: Cambridge UP, 1986); Alan Liu's *Wordsworth: The Sense of History* (Stanford: Stanford UP, 1989); and Kenneth Johnston's *The Hidden Wordsworth: Poet, Lover, Rebel, Spy* (New York and London: W. W. Norton & Co., 1998), modern scholarship has been obsessed with the youthful Wordsworth, who in a deeply fascinating ten-year span both embraced, rejected and transformed the meaning of revolutionary France. This critical tradition's interest in what came after is expressed in one of Johnston's closing remarks, 'Anyone who teaches Wordsworth for very long will occasionally toy with the idea of what his image in literary history would be had he died young—at age thirty-six, for example,...when he read *The Prelude* to Coleridge. In essence, he did die: the story of his youth ends there' (835).

15. Angus Easson, *The Lapidary Wordsworth: Epitaphs and Inscriptions* (Winchester: King Alfred's College, 1981), p. 4. See also Hoyt Hopewell, *The Epigram in the English Renaissance* (Princeton: Princeton UP, 1947); and John Sparrow, *Visible Words: A Study of Inscriptions in and as Books and Works of Art* (Cambridge: Cambridge UP, 1969).

16. The two seminal works in this field are Geoffrey Hartman, 'Inscriptions and Romantic Nature Poetry', *The Unremarkable Wordsworth*, pp. 31–47; and Ernest Bernhardt-Kabisch, 'Wordsworth: The Monumental Poet', *Philological Quarterly* 44 (1965), pp. 503–518.

17. Roger Chartier, *Forms and Meanings: Texts, Performances, and Audiences from Codex to Computer* (Philadelphia: U of Pennsylvania P, 1995), p. 5.

18. With significant early studies by R. W. Lee, *Ut Pictura Poesis* (1947); Jean Hagstrum, *The Sister Arts: The Tradition of Literary Pictorialism and English Poetry from Dryden to Gray* (Chicago and London: The U of Chicago P, 1958); Gispert Krantz, *Das Bildgedicht in Europa* (1981); and Wendy Steiner, *The Colours of Rhetoric* (1982), a number of monographs on ekphrasis have been published since the early 1990s that testify to a general academic interest in media, multi- and intermedia. Prominent examples of the recent wave of studies in ekphrasis are Murray Krieger, *Ekphrasis: The Illusion of the Natural Sign* (Baltimore and London: The Johns Hopkins UP, 1992); James Heffernan, *The Museum of Words: The Poetics of Ekphrasis from Homer to Ashbery* (Chicago and London: The U of Chicago P, 1993); W. J. T. Mitchell, *Picture*

Theory: Essays on Verbal and Visual Representation (Chicago and London: The U of Chicago P, 1994); Grant F. Scott, *The Sculpted Word: Keats, Ekphrasis, and the Visual Arts* (Hanover: UP of New England, 1994); and John Hollander, *The Gazer's Spirit: Poems Speaking to Silent Works of Art* (Chicago and London: The U of Chicago P, 1995).

19. Jared Curtis prints this poem alongside three other short poems at the end of *Last Poems*, p. 405. According to Curtis, it dates from 11 February 1846.

20. On Wordsworth and ekphrasis, see Heffernan, *Museum of Words*, pp. 91–107; Matthew C. Brennan, 'Wordsworth and "Art's Bold Privilege": His Iconic Poems as "Spots of Time"', *Yearbook of Interdisciplinary Studies in the Fine Arts* 2 (1990), pp. 487–499; Brennan, 'Wordsworth's "Lines Suggested by a Portrait from the Pencil of F. Stone": "Visible Quest of Immortality"?', *English Language Notes* 35:2 (December 1997), pp. 33–44; Eric Gidal, *Poetic Exhibitions: Romantic Aesthetics and the Pleasures of the British Museum* (Lewisburg: Bucknell UP, 2001), pp. 163–207; and Christopher Rovee, *Imagining the Gallery: The Social Body of British Romanticism* (Stanford: Stanford UP, 2006), pp. 150–181. The total number of Wordsworthian ekphrases depends on the definition of ekphrasis followed. According to Martha Hale Shackford, *Wordsworth's Interest in Painters and Paintings* (Wellesley: The Wellesley P, 1945), Wordsworth wrote twenty poems about works of art (3), whereas Heffernan, in *Museum of Words*, counts twenty-four (94).

21. On *ekphrazein*, see Jean Hagstrum, *The Sister Arts*, p. 18, n34; on the 'reproduction in words of a spatial art object', see Leo Spitzer, 'The "Ode on a Grecian Urn", Or Content vs. Metagrammar', in *Essays on English and American Literature*, ed. Hannah Hatcher (Princeton: Princeton UP, 1962), p. 72; for the 'verbal representation of visual representation', see Mitchell, *Picture Theory*, p. 152, and Heffernan, *Museum of Words*, p. 3; for ekphrasis as vivid description and the production of *enargeia*, see Ruth Webb, 'Ekphrasis Ancient and Modern: The Invention of a Genre', *Word & Image* 15:1 (January–March 1999), pp. 11–12.

22. Claus Clüver discusses the problems with the dominant understanding of ekphrasis represented by Mitchell and Heffernan in 'Ekphrasis Reconsidered: On Verbal Representations of Non-Verbal Texts', in *Interart Poetics: Essays on the Interrelations of the Arts and Media*, ed. Ulla-Britta Lagerroth, Hans Lund and Erik Hedling (Amsterdam: Rodopi, 1997), pp. 19–33. For Clüver, the idea that the visual work must be representational is unnecessarily limiting insofar as it for instance excludes architecture or non-figurative painting. Instead, he champions the use of the term *Bildgedicht* as advocated by Gispert Kranz. I agree with Clüver's criticism and use the term in his extended sense. My focus on literature's explicit reference to, and thematisation of, the plastic arts, however, excludes one of the traditional enterprises of interart studies: the comparison of a given poet and painter from the same period, for instance Wordsworth and Turner or Wordsworth and Constable. On the perspectives of such comparisons, see for example Karl Kroeber, 'Beyond the Imaginable: Wordsworth and Turner', in *The Age of William Wordsworth: Critical Essays on the Romantic Tradition*, ed. Kenneth R. Johnston and Gene W. Ruoff (New Brunswick and London: Rutgers UP, 1987), pp. 196–213; James Heffernan, 'The Temporalization of Space in Wordsworth, Turner, and Constable', in *Space, Time, Image, Sign: Essays on Literature and the Visual Arts*,

ed. Heffernan (New York: Peter Lang, 1987), pp. 63–82; and Wilhelmina L. Hotchkiss, 'Grounds for Change: Wordsworth, Constable and the Uses of Place', in *The Romantic Imagination: Literature and Art in England and Germany*, ed. Frederick Burwick and Jürgen Klein (Amsterdam and Atlanta, G: Rodopi, 1996), pp. 177–190.

23. Cf. Richard Lanham's discussion of the difference between 'looking at' and 'looking through' a textual surface in *The Electronic Word: Democracy, Technology, and the Arts* (Chicago and London: The U of Chicago P, 1993), p. 5.

24. Galperin, *The Return of the Visible in British Romanticism*, p. 19. In 'Romantic Poetry: The I Altered', Curran noted how 'We are so accustomed to referring to English Romantic poetry as a poetry of vision that we have numbed ourselves to the paradox that what the word signifies is exactly the opposite of what we mean by it' (189). For Curran, 'We mean that it is visionary... and obsessed... with imaginative projection as an end in itself. The actual vision', Curran continues, 'might be said to be the province... of women poets, whose fine eyes are occupied continually in discriminating minute objects or assembling a world out of its disjointed particulars' (189). Galperin's seminal monograph has been followed by a number of studies which emphasise the importance of women writers in a Romantic material culture that is seen as primarily visual. See Judith Pascoe, *Romantic Theatricality: Gender, Poetry, and Spectatorship* (Ithaca and London: Cornell UP, 1997); Jacqueline M. Labbe, *Romantic Visualities: Landscape, Gender and Romanticism* (Basingstoke: Macmillan, 1998); Richard Sha, *The Visual and the Verbal Sketch in British Romanticism* (Philadelphia: U of Pennsylvania P, 1998); Gidal, *Poetic Exhibitions*; Gillen D'Arcy Wood, *The Shock of the Real: Romanticism and Visual Culture, 1760–1860* (Basingstoke: Palgrave, 2001); and Rovee, *Imagining the Gallery*.

25. See, for example, such anthologies of criticism as *Beyond Romanticism: New Approaches to Texts and Contexts 1780–1832*, ed. Stephen Copley and John Whale (London and New York: Routledge, 1992); *At the Limits of Romanticism: Essays in Cultural, Feminist, and Materialist Criticism*, ed. Mary A. Favret and Nicola J. Watson (Bloomington and Indianapolis: Indiana UP, 1994); *Re-Visioning Romanticism: British Women Writers, 1776–1837*, ed. Carol Shiner Wilson and Joel Haefner (Philadelphia: U of Pennsylvania P, 1994); and *Questioning Romanticism*, ed. John Beer (Baltimore and London: The Johns Hopkins UP, 1995).

26. Andrew Bennett first called attention to the importance of posterity for the Romantics in *Romantic Poets and the Culture of Posterity* (Cambridge: Cambridge UP, 1999).

27. Alan G. Hill, ed., *The Letters of William and Dorothy Wordsworth. VIII. A Supplement of New Letters* (Oxford: Clarendon P, 1993), p. 11.

28. On this context, see Lucy Newlyn, *Reading, Writing, and Romanticism: The Anxiety of Reception* (Oxford: Oxford UP, 2000).

29. Jean Hagstrum, 'The Sister Arts: From Neoclassic to Romantic', in *Comparatists at Work: Studies in Comparative Literature*, ed. Stephen G. Nichols and Richard Vowels (London: Blaisdell, 1968), p. 176.

30. Susan D. Eilenberg, *Strange Power of Speech: Wordsworth, Coleridge and Literary Possession* (New York and Oxford: Oxford UP, 1992), p. 201.

31. Hagstrum, 'The Sister Arts', p. 176.
32. Shackford, *Wordsworth's Interest*, p. 8. See also Russel Noyes, *Wordsworth and the Art of Landscape* (Bloomington: Indiana UP, 1968), p. 63; and Lee Johnson, *Wordsworth and the Sonnet* (Copenhagen: Rosenkilde and Bagger, 1973), pp. 107–108.
33. In *English Bards and Grecian Marbles: The Relationship Between Sculpture and Poetry Especially in the Romantic Period* (New York: Columbia UP, 1943), Stephen A. Larrabee notes that 'the Antique seems to have interested [Wordsworth] more on the printed page than in the gallery and more in theory than in actual representational examples' (131). This also holds for his interest in paintings: Wordsworth is more interested in the idea of visual representation as a form of representation which employs a medium different from his own than he is in what is represented in this or that particular painting.
34. Krieger, *Ekphrasis*, p. 10.

1 The return of the visible and Romantic ekphrasis: Wordsworth in the visual art culture of romanticism

1. Mitchell, *Picture Theory*, p. 115.
2. See Edith C. Batho, *The Later Wordsworth* (New York: Russell and Russell, 1963, 1st ed. 1933), pp. 318–319.
3. Liu, *Wordsworth: The Sense of History*, p. 458.
4. Herbert Lindenberger, 'Literature and the Other Arts', in *The Cambridge History of Literary Criticism. Volume 5: Romanticism*, ed. Marshall Brown (Cambridge: Cambridge UP, 2000), p. 377.
5. On Blake, see W. J. T. Mitchell, *Blake's Composite Art: A Study of the Illuminated Poetry* (Princeton: Princeton UP, 1978); and Morris Eaves, *The Counter-Arts Conspiracy: Art and Industry in the Age of Blake* (Ithaca: Cornell UP, 1992). On Keats, see Ian Jack, *Keats and the Mirror of Art* (Oxford: Clarendon P, 1967); Scott, *The Sculpted Word*; and Theresa Kelley, 'Keats, Ekphrasis, and History', in *Keats and History*, ed. Nicholas Roe (Cambridge: Cambridge UP, 1995), pp. 212–237.
6. Jacqueline Labbe points to Charlotte Smith and Anna Seward as participating in the *ut pictura poesis* tradition in 'Every Poet Her Own Drawing Master: Charlotte Smith, Anna Seward and *ut pictura poesis*', in *Early Romantics: Perspectives in British Poetry from Pope to Wordsworth*, ed. Thomas Woodman (Basingstoke: Macmillan, 1998), pp. 200–214. Grant Scott deals with Felicia Hemans in 'The Fragile Image: Felicia Hemans and Romantic Ekphrasis', in *Felicia Hemans: Reimagining Poetry in the Nineteenth Century*, ed. Nanora Sweet and Julie Melnyk (Houndmills: Palgrave, 2001), pp. 36–54.
7. As Andrew Wilton writes in *Painting and Poetry: Turner's Verse Book and his Work, 1804–1812* (Millbank: Tate Galley Publications, 1990), 'Turner availed himself of the new dispensation. It was an affirmation of an evidently strongly held belief that poetry and painting are complementary arts' (11).
8. On this context, see Jonah Siegel, *Desire & Excess: The Nineteenth-Century Culture of Art* (Princeton and Oxford: Princeton UP, 2000).

9. Quoted from Jack, *Keats and the Mirror of Art*, p. 248. On this context, see also Peter Fullerton, 'Patronage and Pedagogy: The British Institution in the Early Nineteenth Century', *Art History* 5:1 (March 1982), pp. 59–72; and Maryanne C. Ward, 'Preparing for the National Galley: The Art Criticism of William Hazlitt and P. G. Patmore', *Victorian Periodicals Review* (Fall 1990), pp. 104–110.

10. Eleanor Jamieson, *English Embossed Bindings 1825–1850* (Cambridge: Cambridge UP, 1972), p. 5. Much criticism has been devoted to the annual phenomenon; see Peter Manning, 'Wordsworth in the *Keepsake*, 1829', in *Literature in the Marketplace: Nineteenth-Century Publishing and Reading Practices*, ed. John Jordan and Robert L. Patten (Cambridge: Cambridge UP, 1995), pp. 44–73; Lee Erickson, *The Economy of Literary Form: English Literature and the Industrialization of Publishing, 1800–1850* (Baltimore and London: The Johns Hopkins UP, 1996), pp. 40–47; Margaret Linley, 'A Centre that Would not Hold: Annuals and Cultural Democracy', in *Nineteenth-Century Media and the Construction of Identities*, ed. Laurel Brake, Bill Bell and David Finkelstein (Basingstoke and New York: Palgrave, 2000), pp. 54–74; Sara Lodge, 'Romantic Reliquaries: Memory and Irony in The Literary Annuals', *Romanticism* 10:1 (2004), pp. 23–40; and Terence Allan Hoagwood and Kathryn Ledbetter, *'Colour'd Shadows': Contexts of Publishing, Printing, and Reading Nineteenth-Century British Women Writers* (New York and Basingstoke: Palgrave Macmillan, 2005), pp. 47–124.

11. *The Keepsake for 1828* (London: Hurst, Chance & Co., 1827), no page, ll. 19–27.

12. See G. E. Lessing, *Laocoön: An Essay on the Limits of Painting and Poetry*, translated and introduced by Edward Allen McCormick with a foreword by Michael Fried (Baltimore and London: The Johns Hopkins UP, 1984), pp. 78–79. Cf. David Scott, *Pictorialist Poetics: Poetry and the Visual Arts in Nineteenth-Century France* (Cambridge: Cambridge UP, 1988), pp. 1–19.

13. M. H. Abrams, *The Mirror and the Lamp: Romantic Theory and the Critical Tradition* (London, Oxford, New York: Oxford UP, 1953), p. 50.

14. R. A. Foakes, ed., *Lectures 1808–1819 On Literature*, 2 vols (Princeton: Princeton UP, 1987), 2, p. 447.

15. Hartman, *Wordsworth's Poetry*, p. 5.

16. Hagstrum, 'The Sister Arts', p. 171. See also Roy Park, ' "Ut Pictura Poesis": The Nineteenth-Century Aftermath', *The Journal of Aesthetics and Art Criticism* 28:2 (Winter 1969), pp. 155–164; and Lawrence Starzyk, ' "Ut Pictura Poesis": The Nineteenth-Century Perspective', *The Victorian Newsletter* 102 (Fall 2002), pp. 1–9.

17. Galperin, *The Return of the Visible*, p. 208.

18. William Wordsworth, *Guide to the Lakes*, ed. Ernest de Selincourt with preface by Stephen Gill (London: Frances Lincoln, 2004, 1st ed. 1906), pp. vii–viii.

19. Quoted in Jonathan Bate, *Romantic Ecology: Wordsworth and the Environmental Tradition* (London and New York: Routledge, 1991), p. 42.

20. Beth Darlington, ed., *The Love Letters of William and Mary Wordsworth* (London: Chatto & Windus, 1982), p. 42.

21. Stephen Gill, *William Wordsworth: A Life* (Oxford and New York: Oxford UP, 1989), p. 285.

22. In *Romantic Ecology*, Bate reads it in terms of Wordsworth's role in the beginnings of present-day ecological awareness (36–61). The *Guide* has also attracted commentary because it offers insights into Wordsworth's special understanding of the aesthetic categories of the picturesque, sublime and beautiful and into his incorporation of geography into his poetics. See John R. Nabholz, 'Wordsworth's *Guide to the Lakes* and the Picturesque Tradition', *Modern Philology* 61:4 (May 1964), pp. 288–297; Theresa Kelley, *Wordsworth's Revisionary Aesthetics* (Cambridge: Cambridge UP, 1988); and Michael Wiley, *Romantic Geography: Wordsworth and Anglo-American Spaces* (Basingstoke: Macmillan, 1998), pp. 149–160. In a reading reminiscent of Marjorie Levinson's reading of 'Tintern Abbey', Jacqueline Labbe, in *Romantic Visualities*, argues that Wordsworth throughout the *Guide* shows an 'abhorrence of detail' (147). Labbe substantiates this argument with a number of examples where 'Wordsworth's eye, in the act of settling on one sight, blurs that sight into a representative vision, thereby necessarily generic, and ends his description with an impression of invisibility: our last view is of nothing at all' (144). As Labbe's reading shows Wordsworth did to some extent maintain his earlier idealising strategies in the *Guide*. Yet as I hope the following reading points out, there is a significant difference of degree in his allowance of detail into his descriptions which suggests that the difference in degree verges on a difference in kind that revises his earlier poetics of invisibility and signals the return of the visible.

23. See Heffernan, *Museum of Words*, pp. 94–95; Mitchell, *Picture Theory*, p. 120; and D'Arcy Wood, *The Shock of the Real*, p. 173.

24. Foakes, ed., *Lectures 1808–1819*, 1, 311–312.

25. Martin Meisel, *Realizations: Narrative, Pictorial, and Theatrical Arts in Nineteenth-Century England* (Princeton: Princeton UP, 1983), p. 31.

26. Marilyn Gaull, *English Romanticism: The Human Context* (New York and London: Norton, 1988), p. 335.

27. Charles Lamb, *The Complete Works and Letters* (New York: The Modern Library, 1935), p. 1019.

28. On the sublime and gender, see Mellor, *Romanticism and Gender*, pp. 85–106.

29. See Juliet Barker, *Wordsworth: A Life* (London: Viking Penguin Books, 2000), p. 392. Green had also published engravings of the Lakes in 1795 and 1796.

30. William Hazlitt, *The Complete Works of William Hazlitt*, 21 vols, ed. P. P. Howe (London: J. M. Dent, 1930–1934), 17, p. 117.

31. Galperin, *Return of the Visible*, p. 208.

32. Hartman, 'The Romance of Nature and the Negative Way', in *Romanticism and Consciousness*, ed. Harold Bloom (New York: Norton, 1970), p. 289.

33. Dale Townshend considers High Romantic anti-visuality as emerging in opposition to the gothic in 'Gothic Technologies: Visuality in the Romantic Era', *Romantic Circles Praxis Series* (December 2005) [19-12-05]. http://www.rc.umd.edu/praxis/gothic/townshend/townshend.html

34. Harold Bloom, 'The Visionary Cinema of Romantic Poetry', in *William Blake: Essays for S. Foster Damon*, ed. Alvin H. Rosenfeld (Providence: Brown UP, 1969), p. 20.

35. Quoted in William Knight, *The Life of William Wordsworth*, 3 vols (Edinburgh: William Paterson, 1889), 3, p. 296.

36. Derek Hudson, ed., *The Diary of Henry Crabb Robinson. An Abridgement* (London: Oxford UP, 1967), p. 66.
37. Knight, *Life*, 3, p. 296.
38. See Edward Miller, *That Noble Cabinet: A History of the British Museum* (London: André Deutsch, 1973), p. 199.
39. David M. Wilson, *The British Museum: A History* (London: The British Museum P, 2002), pp. 74–75. The problematic nature of these transactions is described in Miller, *Noble Cabinet*, pp. 198–202.
40. Richard Altick, *The English Common Reader: A Social History of the Mass Reading Public, 1800–1900*, foreword by Jonathan Rose (Columbus: Ohio State UP, 1998, 1st ed. 1957), p. 344.
41. Mark L. Reed notes that Wordsworth's experiences in 1843 with the making of an illustrated selection from his poetry may have prompted the sonnet. See 'Wordsworth's Surprisingly Pictured Page: *Select Pieces*', *The Book Collector* 46:1 (Spring 1997), pp. 69–92.
42. D'Arcy Wood, *Shock of the Real*, p. 173.
43. Hudson, ed., *Diary of Henry Crabb Robinson*, p. 98.
44. In Knight, *Life*, 2, 328. An example of this may be observed in an 1812 letter to Mary relating a visit to Washington Allston's studio, where Wordsworth responds to Allston's *Cupid & Psyche* and reports that he 'did not presume to give an *opinion* to Alston upon this Picture, but I begged he would permit me to mention the impression it made upon me'. Darlington, ed., *Love Letters*, p. 137.
45. Hazlitt, *Complete Works*, 11, p. 93.
46. Robert Woof, 'Haydon, Writer, and the Friend of Writers', in *Benjamin Robert Haydon 1786–1846: Painter and Writer, Friend of Wordsworth and Keats*, ed. David Blaney Brown, Robert Woof and Stephen Hebron (Grasmere: The Wordsworth Trust, 1996), p. 31.
47. Quoted in ibid.
48. Benjamin Robert Haydon, *The Autobiography and Memoirs*, ed. Tom Taylor (London: Peter Davies, 1926), pp. 730–731.
49. Cf. Scott, *Sculpted Word*, p. xi.
50. Manning, 'Cleansing the Images', p. 293.
51. Cf. Groom, *The Unity of Wordsworth's Poetry*, p. 188.
52. Cited in William Knight, ed., *The Poetical Works of William Wordsworth*, 8 vols (London: Macmillan, 1896), 7, p. 138.
53. A. W. Phinney, 'Keats in the Museum: Between Aesthetics and History', *Journal of English and Germanic Philology* 90 (1991), pp. 217–218.

2 Typographic inscription: The art of 'word-preserving' in Wordsworth's later inscriptions

1. Bernhardt-Kabisch, 'Wordsworth: The Monumental Poet'; Hartman, 'Inscriptions and Romantic Nature Poetry'; Easson, *The Lapidary Wordsworth*; J. Hillis Miller, *The Linguistic Moment: From Wordsworth to Stevens* (Princeton: Princeton UP, 1985), pp. 78–113; Cynthia Chase, 'Monument and Inscription: Wordsworth's "Lines"', *Diacritics* 11:4 (Winter 1987), pp. 66–77; J. Douglas Kneale, *Monumental Writing: Aspects of Rhetoric in Wordsworth's*

Poetry (Lincoln and London: U of Nebraska P, 1988); Karen Mills-Court, *Poetry as Epitaph: Representation and Poetic Language* (Baton Rouge and London: Louisiana State UP, 1990); Joshua Scodel, *The English Poetic Epitaph: Commemoration and Conflict from Jonson to Wordsworth* (Ithaca and London: Cornell UP, 1991), pp. 384–407. On Wordsworth's participation in the 'bibliomania' of the 1810s, see Brian Robert Bates, 'Wordsworth's "Library of Babel": Bibliomania, the 1814 *Excursion*, and the 1815 *Poems*', *Cardiff Corvey: Reading the Romantic Text* 14 (Summer 2005) [04-09-05] http://www.cf.ac.uk/encap/corvey/articles/cc14_n01.html.

2. Bernhardt-Kabisch, 'Wordsworth: The Monumental Poet', p. 504.
3. A facsimile of the fragments can be found in Stephen Gill, ed., *The Prelude, 1798–99* (Ithaca: Cornell UP, 1977), p. 163, where it seems that Wordsworth accentuates the word 'doth' by writing it several times producing a kind of boldface: as if to further convince himself of the possibility of what he is saying by giving the word a material substance, making it stand out in the manuscript.
4. Kneale, *Monumental Writing*, p. 84.
5. David Simpson, *Wordsworth's Historical Imagination: The Poetry of Displacement* (London: Methuen, 1987), p. 215.
6. As outlined by, for example, M. H. Abrams in 'The Correspondent Breeze: A Romantic Metaphor', in *English Romantic Poets: Essays in Criticism*, ed. Abrams (New York: Oxford UP, 1960), p. 38.
7. Miller, *Linguistic Moment*, p. 81.
8. On the generic trait of extended titles, see Hudson, *The Epigram in the English Renaissance* (Princeton: Princeton UP, 1947), pp. 11–12.
9. Though without reference to this inscription, Anne Wallace discusses Wordsworth's compositional technique in relation to pacing, in *Walking, Literature, and English Culture: The Origins and Uses of Peripatetic in the Nineteenth Century* (Oxford: Clarendon P, 1993).
10. Curtis, ed., *Last Poems*, p. 515.
11. Russell Noyes provides the evidence for the existence of this poem's referent: photographs of the terrace walk at Rydal Mount, in *Wordsworth and the Art of Landscape*, pp. 126–135.
12. See Mary Moorman, *William Wordsworth: A Biography*, 2 vols (Oxford: Clarendon P, 1966–1967), 2, pp. 421–422.
13. Cynthia Chase, 'Monument and Inscription'; and Linda Brigham, 'Beautiful Conceptions and Tourist Kitsch: Wordsworth's "Written With a Slate Pencil…"', *SiR* 40:2 (Summer 2001), pp. 199–214.
14. Jane P. Tompkins, 'The Reader in History', in *Reader-Response Criticism: From Formalism to Post-Structuralism*, ed. Tompkins (Baltimore and London: The Johns Hopkins UP, 1980), p. 214.
15. In *Visible Words*, John Sparrow locates the historical moment of the inscription's transition from stone to paper, which Wordsworth's *oeuvre* recapitulates. Sparrow identifies this migration in the frontispiece to the folio edition of Count Emanuele Tesauro's (1592–1675) *Inscriptiones* published in 1670. In this frontispiece (reproduced as plate 51, facing p. 121 in *Visible Words*), the Lapidary Muse is carving an inscription in stone while Mercury, the Messenger of the Gods, stands next to her and points his finger at a blank page in a book. As Sparrow writes, Mercury is 'saying' ' "not *there*, upon

the stone, but *here*, upon paper, is the proper place for the effusions of the epigraphic Muse"—the engraving is, in fact, a pictorial record of the transformation of the lapidary inscription into the text of a printed book—its migration from stone to paper' (119).

16. Easson, *The Lapidary Wordsworth*, p. 15.
17. See the Fenwick Note in *PW* 4, pp. 441–442. Inscription number II ('In a Garden of the Same') was not actually inscribed whereas numbers I, III and IV were.
18. William Knight, 'Preface', in *Memorials of Coleorton Being Letters from Coleridge, Wordsworth and His Sister, Southey and Sir Walter Scott to Sir George and Lady Beaumont of Coleorton, Leicestershire, 1803 to 1834*, ed. Knight (Edinburgh: David Douglas, 1887), pp. xx–xxi.
19. On these terms, see Gérard Genette, *The Work of Art: Immanence and Transcendence*, translated by G. M. Goshgarian (Ithaca and London: Cornell UP, 1997).
20. See, for example, Eilenberg, *Strange Power of Speech*, p. 201; and William Keach, ' "Words Are Things": Romantic Ideology and the Matter of Poetic Language', in *Aesthetics and Ideology*, ed. George Levine (New Brunswick, New Jersey: Rutgers UP, 1995), pp. 219–239.
21. In the note to 'The Thorn', Wordsworth says that repetition and near tautology will render words into things and thus suggests that this reification also occurs in the ephemeral medium of speech (Brett & Jones, 289).
22. Walter J. Ong, *Orality and Literacy: The Technologizing of the Word* (London: Methuen, 1982), p. 11.
23. See J. W. Saunders, 'The Stigma of Print: A Note on the Social Bases of Tudor Poetry', *Essays in Criticism* 1 (1951), pp. 139–164; and Alvin B. Kernan, *Printing Technology, Letters & Samuel Johnson* (New Jersey: Princeton UP, 1987), pp. 41–43.
24. Elisabeth Eisenstein, *The Printing Press as an Agent of Change*, 2 vols (Cambridge: Cambridge UP, 1979), 1, p. 118.
25. Charles Lamb, 'Oxford in the Vacation', *London Magazine* 3, October 1820. Reprinted in *The Essays of Elia*, introduction and notes by Alfred Ainger (London and New York: Macmillan, 1906), p. 380.
26. Kernan, *Printing Technology*, pp. 48–49. See also Terry Belanger, 'Publishers and Writers in Eighteenth-Century England', in *Books and Their Readers in Eighteenth-Century England*, ed. Isabel Rivers (London: St. Martin's P, 1982), pp. 5–25. In *The Nature of the Book* (Chicago and London: The U of Chicago P, 1998), Adrian Johns critiques the tendency (of Eisenstein in particular) to assign the qualities of permanence and fixity to the object of the printed book (technological determinism) rather than the cultural labour that was invested in making the book into an object with a fixed aura. Yet, Johns seems to confirm Kernan's identification of the eighteenth century as the moment of the naturalisation of an idea of the printed book as a fixed object, reflected by the fact that in 1760 the first book was published which reputedly was printed without errors. This, Johns points out, is not in the nature of print but is the effect of human agency reflecting a need for authenticity and stability. What is important to recognise, on the one hand, is that fixity is not inherent to print, but something that is historically variable, and, on the other hand, that print in fact assumed

the impression of possessing a high degree of fixity during the Romantic period.

27. Kernan, *Printing Technology*, p. 52. Kernan cites Marshall McLuhan, *The Gutenberg Galaxy* (Toronto: U of Toronto P, 1962), p. 144.

28. Bradley, 'Poetry for Poetry's Sake' (1901), cited in M. H. Abrams, 'From Addison to Kant: Modern Aesthetics and the Exemplary Art', in *Doing Things With Texts: Essays in Criticism and Critical Theory*, ed. Abrams (New York: Norton, 1989), p. 163.

29. Walter J. Ong, *Interfaces of the Word: Studies in the Evolution and Consciousness of Culture* (Ithaca: Cornell UP, 1977), p. 283.

30. Both quoted in Alan D. Boehm, 'The 1798 *Lyrical Ballads* and the Poetics of Late Eighteenth-Century Book Production', *ELH* 63:2 (1996), p. 467.

31. Elizabeth Barrett Browning, *The Poetical Works*, 6 vols (London: Smith, Elder & Co., 1890), 5, p. 285.

32. Bertrand Harris Bronson, *Facets of Enlightenment: Studies in English Literature and Its Contexts* (Berkeley and Los Angeles: U of California P, 1968), p. 326.

33. See, for example, James McLaverty, *Pope, Print and Meaning* (Oxford: Oxford UP, 2001); Janine Barchas, *Graphic Design, Print Culture, and the Eighteenth-Century Novel* (Cambridge: Cambridge UP, 2003); Jerome McGann, *Dante Gabriel Rossetti and the Game that Must be Lost* (New Haven and London: Harvard UP, 2000); and McGann, *Black Riders: The Visible Language of Modernism* (Princeton: Princeton UP, 1993).

34. Mario Praz, *The Romantic Agony* (Oxford and New York: Oxford UP, 1970, orig. 1933), pp. 14–15.

35. See W. J. T. Mitchell, 'Spatial Form in Literature: Toward a General Theory', in *The Language of Images*, ed. Mitchell (Chicago: The U of Chicago P, 1981), pp. 271–299.

36. Mitchell, *Picture Theory*, pp. 115, 116–117.

37. Earl Leslie Griggs, ed., *The Collected Letters of Samuel Taylor Coleridge*, 5 vols (Oxford: Clarendon P, 1956–1971), 1, p. 412.

38. See John Hollander, *Vision and Resonance* (New York: Oxford UP, 1975), pp. 245–287.

39. Jared Curtis, ed., *Poems in Two Volumes and Other Poems* (Ithaca: Cornell UP, 1983), p. 56.

40. Ibid., p. 375.

41. Jerome McGann, *Radiant Textuality: Literature After the World Wide Web* (Basingstoke and New York: Palgrave Macmillan, 2001), p. 183.

42. Sigfrid Steinberg, *Five Hundred Years of Printing*, rev. ed. John Trevitt (London: Oak Knoll Press and The British Library, 1996, orig. 1955), p. 80. For a problematisation of such an ultimately ideological view of black letters, which are of course perfectly and rapidly readable for the trained eye, see the essays in Peter Bain and Paul Shaw, eds, *Blackletter: Type and National Identity* (New York: Princeton Architectural P, 1998).

43. In a discussion of Giambattista Bodoni's revolution of typecasting between c.1768 and 1813, where there was a move from imitating a calligrapher's hand ('old style') to making types according to geometrical and rational principles ('modern'), Martin Antonetti writes in 'Typographic *ekphrasis*: The Description of Typographic Forms in the Nineteenth Century', *Word & Image* 15:1 (January–March 1999): 'For an early typographer, indeed for most type

designers until the end of the eighteenth century, type was simply the repro-
duction of the best calligraphic hand available locally.... By contrast, what is
now called "modern" refers to types that are *not* based on pen-written letter-
forms.... Structurally, "modern" types are characterized by a very dramatic
and abrupt contrast between the thick and thin parts of the letter and the
absence of the oblique cant. They are absolutely vertical in their stress and
have perfectly perpendicular, unbracketed, hairline serifs. These letters can,
of course, be drawn, but they cannot be written naturally with a pen' (45).

44. Cited in Wu, *Wordsworth: An Inner Life*, p. 273.
45. Lamb, *Complete Works*, p. 797. Though Lamb knew better than most
 Romantics that the printed look of poetry matters, he was sometimes equi-
 vocal about the effect of print on poetry. In an 1816 letter to Wordsworth,
 he expressed fear that Coleridge's 'Kubla Khan' 'should be discovered by
 the lantern of typography and clear reducting to letters no better than
 nonsense or no sense' (807).
46. See Peter Manning's important work on *The White Doe* in *Reading Romantics*,
 pp. 165–215.
47. See John Williams, '*The White Doe of Rylstone*: An Exercise in Autobiograph-
 ical Displacement', in *Writing the Lives of Writers*, ed. Warwick Gould and
 Thomas F. Staley (New York: St. Martin's P, 1998), pp. 125–134.
48. Mitchell, *Picture Theory*, p. 127.
49. Bennett, *Romantic Poets and the Culture of Posterity*, pp. 22–23.
50. Allan Grossman and Mark Halliday, *The Sighted Singer: Two Works on Poetry
 for Readers and Writers* (Baltimore and London: The Johns Hopkins UP,
 1992), p. 210.
51. Bennett, *Romantic Poets and the Culture of Posterity*, p. 23.

3 'If mine had been the Painter's hand': Wordsworth's collaboration with Sir George Beaumont

1. Hazlitt, *Complete Works*, 5, p. 161.
2. Ibid., 11, p. 89.
3. Shackford prints a catalogue of Beaumont's collection in *Wordsworth's
 Interest*, p. 13.
4. James K. Chandler points to Hazlitt's identification of contradiction as 'the
 spirit of the age' in 'Representative Men, Spirits of the Age, and Other
 Romantic Types', in *Romantic Revolutions*, ed. Johnston *et al.*, p. 111.
5. John Purkis, *A Preface to Wordsworth* (London: Longman, 1986), p. 140.
6. On the Beaumont connection, see Norma S. Davis, 'Wordsworth, Haydon,
 and Beaumont: A Change in the Role of Artistic Patronage', *Charles Lamb
 Bulletin* 55 (1986), pp. 210–224; Wilhelmina L. Hotchkiss, 'Coleridge,
 Beaumont, and the Wordsworthian Claims for Place', *TWC* 21:1 (1990),
 pp. 51–55; Thomas Pearson, 'Coleorton's "Classic Ground": Wordsworth,
 the Beaumonts, and the Politics of Place', *Charles Lamb Bulletin* 89 (1995),
 pp. 9–14; and Norma S. Davis, 'Poet and Painter: Beaumont's Illustrations
 in the Poetry of William Wordsworth', in *The Romantic Imagination*, ed.
 Burwick and Klein, pp. 191–201. Wordsworth's reliance on the creative
 assistance of others and his engagement in forms of artistic collaboration

is usually explored through his joint venture with Coleridge in the latter half of the 1790s, which resulted in the co-authored *Lyrical Ballads*. This is only the most famous of a number of Romantic collaborations and couplings that have received attention in recent criticism, which however has neglected collaborative efforts between poets and painters. As the work of Jack Stillinger, Alison Hickey and others suggests, the relevance of such an exploration is that it enables a timely critique of what Stillinger calls 'the myth of solitary genius'. This myth holds that creation is a radically solitary process and that such qualities as the originality and singularity of the artwork are to be measured by the extent of the artist's independence from the help and explicit influence of others. However, only when we qualify this myth will we be in a position to begin to reach a more complete and adequate understanding of the actual conditions and processes of artistic labour during the Romantic period, and thus also bring ourselves to a better understanding of the actual artworks produced during the period. See Jack Stillinger, *Multiple Authorship and the Myth of Solitary Genius* (New York: Oxford UP, 1991); Alison Hickey, 'Double Bonds: Charles Lamb's Romantic Collaborations', *ELH* 63:3 (1996), pp. 735–771; Hickey, 'Coleridge, Southey, "and Co.": Collaboration and Authority', *SiR* 37:3 (Fall 1998), pp. 305–349; and Jacqueline M. Labbe, 'Romantic Couplings—A Special Issue of Romanticism On the Net', *Romanticism On the Net* 8 (May 2000) [29-11-2006] http://users.ox.ac.uk/~scat0385/guest9.html.

7. Gill, *Wordsworth*, p. 291.
8. These poems are: 'In the Grounds of Coleorton, the Seat of Sir George Beaumont, Bart., Leicestershire', 'In the Garden of the Same', 'Written at the Request of Sir George Beaumont, Bart., and in His Name, for an Urn, Placed by Him at the Termination of a Newly-Planted Avenue, in the Same Grounds' and 'For a Seat in the Groves of Coleorton' (all in *PW* 4, 195–197).
9. J. Paul Hunter, 'Formalism and History: Binarism and the Anglophone Couplet', *MLQ* 61:1 (March 2000), pp. 115–116.
10. On 'blending' and blank verse vs. 'contrast' and couplets, see Hartman, *Wordsworth's Poetry*, pp. 104–115.
11. See *New Princeton Encyclopedia to Poetry and Poetics*, ed. Premiger and Brogan (Princeton: Princeton UP, 1993), p. 1308.
12. George McLean Harper, *William Wordsworth: His Life, Works and Influence*, 2 vols (London: John Murray, 1916), 2, p. 197.
13. See Curran, 'Romantic Poetry: The I Altered', p. 190.
14. As Dustin Griffin argues in his revisionary study of this narrative, *Literary Patronage in England, 1650–1800* (Cambridge: Cambridge UP, 1996), 'to most writers on the subject, the patronage system was by definition oppressive and demeaning. For them the only *proper* relationship between a writer and society is proud independence' (1).
15. The poet who, in a letter from 1837, held patronage in 'little esteem for helping genius forward in the fine arts, especially those whose medium is words', and argued that 'Genius in Poetry...is more likely to be cramped than fostered by [patronage]' (*LY* 3, 500), must, almost by necessity, be seen to have become the victim of his own analysis.
16. Knight, 'Preface', in *Memorials of Coleorton*, pp. xvi–xvii.
17. Davis, 'Wordsworth, Haydon, and Beaumont', p. 211.

18. See Felicity Owen and David Blayney Brown, *Collector of Genius: A Life of Sir George Beaumont* (New Haven and London: Yale UP, 1988), pp. 212–217.

19. Haydon, *Autobiography and Memoirs*, p. 96.

20. Griffin, *Literary Patronage in England*, p. 13.

21. As Joseph Farington reported in his *Diary* for March 1804, Beaumont said: 'He was infinitely indebted to Wordsworth for the good He had received from His poetry which had benefitted Him more, had purified His mind, than any sermons had done.' *The Farington Diary*, 8 vols, ed. James Greig (London: Hutchinson & Co., 1922–1928), 2, p. 207. In 1814, Beaumont wrote to Wordsworth, 'I have ... perceive[d] that the film which has so long blinded the public & prevented their being sensible of your excellence is gradually dissolving—& I have no doubt you will soon have "created the taste by which you are to be relished["]'. *William Wordsworth: The Critical Heritage. Volume I 1793–1820*, ed. Robert Woof (London and New York: Routledge, 2001), p. 256.

22. Edith J. Morley, ed., *The Correspondence of Crabb Robinson with the Wordsworth Circle*, 2 vols (Oxford: Clarendon P, 1927), 1, p. 459.

23. Cited in Owen and Brown, *Collector of Genius*, p. 142.

24. Gérard Genette, *Paratexts: Thresholds of Interpretation*, translated by Jane E. Lewin (Cambridge: Cambridge UP, 1997), p. 1.

25. L. J. Swingle, 'Wordsworth's "Picture of the Mind" ', in *Images of Romanticism: Verbal and Visual Affinities*, ed. Karl Kroeber and William Walling (New Haven and London: Yale UP, 1978), p. 78.

26. See Frederick W. Hilles, 'Reynolds among the Romantics', in *Literary Theory and Structure: Essays in Honour of William K. Wimsatt*, ed. Frank Brady, John Palmer and Martin Price (New Haven and London: Yale UP, 1973), pp. 267–283.

27. Sir Joshua Reynolds, *Discourses on Art*, ed. Robert R. Wark (New Haven and London: Yale UP, 1997), p. 134.

28. Barker, *Wordsworth*, p. 342.

29. Mark Reed, *The Chronology of the Middle Years 1800–1815* (Cambridge, Mass.: Harvard UP, 1975), pp. 318, 321.

30. On Wordsworth's reading of Lessing in February 1802, see Duncan Wu, *Wordsworth's Reading 1800–1815* (Cambridge: Cambridge UP, 1995), p. 134.

31. Coleridge's letter to John Rickman, February 1804, is cited in Carl Woodring, 'What Coleridge Thought of Pictures', in *Images of Romanticism*, p. 91.

32. Heffernan, *Museum of Words*, p. 107.

33. Shackford, *Wordsworth's Interest*, p. 30.

34. Cf. William Lisle Bowles' poem on this painting, 'Landscape With the Castle of Steen' (1807). Bowles praises Beaumont's ability to 'view the assemblage of the finished piece / As with his skill who formed it'. Cited in Shackford, *Wordsworth's Interest*, p. 13.

35. E. H. Gombrich, 'Moment and Movement in Art' (1964). Cited in Meisel, *Realization*, p. 27.

36. John Hollander, 'The Gazer's Spirit: Romantic and Later Poetry on Painting and Sculpture', in *The Romantics and Us: Essays on Literature and Culture*, ed. Gene Ruoff (New Brunswick, NJ: Rutgers UP, 1990), p. 136.

37. Basil Hunnisett, *Steel-engraved Book Illustration in England* (London: Scolar P, 1980), p. 2.

38. Ralph Cohen, *The Art of Discrimination: Thomson's* The Seasons *and the Language of Criticism* (London: Routledge & Kegan Paul, 1964), p. 250.
39. See Hunnisett, *Steel-engraved Book Illustration*, p. 135.
40. Kenneth Curry, ed., *New Letters of Robert Southey*, 2 vols (New York and London: Columbia UP, 1965), 1, pp. 125–126.
41. Ibid., pp. 129–130.
42. Hunnisett, *Steel-engraved Book Illustration*, p. 3.
43. Davis, 'Poet and Painter', p. 196.
44. Morley, ed., *Correspondence of Henry Crabb Robinson*, 1, pp. 138–139.

4 The sonnet as visual poetry: *Italics* in 'After-Thought'

1. Johnson, *Wordsworth and the Sonnet*, p. 10. The upsurge of critical interest in the Romantic sonnet revival, though mainly centred on prolific women sonneteers such as Charlotte Smith and Mary Robinson, has in recent years led to renewed efforts to establish the significance of the form in Wordsworth's *oeuvre*. On the Romantic sonnet revival, see Paula R. Feldman and Daniel Robinson, eds, *A Century of Sonnets: The Romantic-Era Revival* (Oxford: Oxford UP, 1999). On Wordsworth, see John Kerrigan, 'Wordsworth and the Sonnet: Building, Dwelling, Thinking', *Essays in Criticism* 35:1 (January 1985), pp. 59–65; Jerome Mazzaro, 'Tapping God's Other Books: Wordsworth at Sonnets', *SiR* 33:3 (Fall 1994), pp. 337–354; Jennifer Ann Wagner, *A Moment's Monument: Revisionary Poetics and the Nineteenth-Century English Sonnet* (Madison: Fairleigh Dickinson UP, 1996), pp. 27–63; Frederick Burwick, 'Wordsworth and the Sonnet Revival', *Colloquium Helveticum* 25 (1997), pp. 119–143; Daniel Robinson, ' "Still Glides the Stream": Form and Function in Wordsworth's *River Duddon* Sonnets', *ERR* 13 (2002), pp. 449–464; and Joseph Phelan, *The Nineteenth-Century Sonnet* (Basingstoke: Palgrave Macmillan, 2005), pp. 9–33. The reassessment of Wordsworth's sonnet writing has been greatly assisted by the publication of Geoffrey Jackson, ed., *Sonnet Series and Itinerary Poems, 1820–1845*.
2. Johnson, *Wordsworth and the Sonnet*, p. 9.
3. Stuart Curran, *Poetic Form and British Romanticism* (New York and Oxford: Oxford UP, 1986), pp. 49, 39.
4. Galperin, *The Return of the Visible*, p. 237. See also Galperin, *Revision and Authority in Wordsworth*, p. 217.
5. Hudson, ed., *Diary of Henry Crabb Robinson*, p. 182.
6. Jerome McGann suggests that the Della Cruscans (who were prolific sonneteers) were the real target of Wordsworth and Coleridge's critique of the contemporary poetry market, in *The Poetics of Sensibility: A Revolution in Style* (Oxford: Clarendon P, 1996), pp. 74–93. The Preface, writes McGann, 'is a conscious critique of the Della Cruscans and the kind of writing inspired by their work'; a work in which 'knowledge (moral or otherwise) generally lies closer to a surface of textual "letters" than to a sub-surface of deeper "Truth" ' (75).
7. Hazlitt, *Complete Works*, 8, p. 174.
8. Ernest Hartley Coleridge, ed., *Anima Poetae from the Unpublished Note-Books of Samuel Taylor Coleridge* (New York and Boston: Houghton, Mifflin & Co., 1895), p. 30.

9. Curran, *Poetic Form and British Romanticism*, p. 49. On the phenomenon of 'sonnettomania', see the article by that title in the *New Monthly Magazine* (1821), pp. 652–656.

10. Ian Balfour, 'The Sublime Sonnet in European Romanticism', in *Romantic Poetry*, ed. Angela Esterhammer (Amsterdam and Philadelphia: John Benjamins Publishing Company, 2002), p. 183.

11. Juliet Sychrava, *From Schiller to Derrida: Idealism in Aesthetics* (Cambridge: Cambridge UP, 1989), p. 60.

12. Quoted in Harold G. Merriam, *Edward Moxon: Publisher of Poets* (New York: Columbia UP, 1939), p. 76.

13. Ibid.

14. Anon., 'On Strong's Sonnets', *Blackwood's Edinburgh Magazine* (November 1835), p. 587. See Nathalie M. Huston, 'Valuable by Design: Material Features and Cultural Value in Nineteenth-Century Sonnet Anthologies', *Victorian Poetry* 37:2 (1999), pp. 243–272. John Clare also thought of the sonnet as a kind of picture, as he said in a letter dated 5 January 1824: 'I have made up my mind to write one hundred Sonnets as a set of pictures on the scenes of objects that appear in the different seasons.' Cited in Phelan, *The Nineteenth-Century Sonnet*, p. 39.

15. For instance, 'The Last Supper by Leonardo Da Vinci, in the Refectory of the Convent of Maria Della Graze—Milan' (1821), 'Recollection of the Portrait of King Henry the Eighth, Trinity Lodge, Cambridge' (1827), 'To B. R. Haydon, on Seeing His Picture of Napoleon on the Island of St. Helena' (1831), 'To the Author's Portrait. Painted at Rydal Mount, by H. W. Pickersgill, Esq., for St. John's College, Cambridge' (1832), 'On a Portrait of the Duke of Wellington Upon the Field of Waterloo, by Haydon' (1840), 'To a Painter' (1840), 'On the Same Subject' (1840).

16. Wendy Steiner, *The Colours of Rhetoric: Problems in the Relation Between Modern Literature and Painting* (Chicago and London: The U of Chicago P, 1982), p. xiii.

17. Bernhardt-Kabisch, 'Wordsworth: The Monumental Poet', pp. 511, 509.

18. Robinson, ' "Still Glides the Stream" ', p. 451.

19. In the first published version of 'After-Thought' as 'Conclusion', 'backward' in line 3 and 'we' in line 7 were italicised for emphasis. After 1827, they kept their italics and were not converted into roman type for distinction. This shows that it was important for the *entire* text to be printed in italics.

20. McGann, *Dante Gabriel Rossetti and the Game That Must be Lost*, p. 82.

21. This is most evident in Leigh Hunt's 'An Evening Landscape', first published in *The Keepsake* for 1828 and reprinted in *Essays by Leigh Hunt*, ed. Arthur Symons (London: Walter Scott, 1887), pp. 5–6. On Hunt's iconic text in relation to the annuals, see Peter Simonsen, 'Late Romantic Ekphrasis: Felicia Hemans, Leigh Hunt and the Return of the Visible', *Orbis Litterarum* 60:5 (2005), pp. 317–343.

22. *Friendship's Offering: A Literary Album, and Christmas and New Year's Eve Present, for MDCCCXXIX* (London: Smith, Elder, 1828), p. 1.

23. Alaric A. Watts, Preface, *The Literary Souvenir* (London: Hurst, Robinson & Co., 1825), p. viii.

24. Anon., 'Annual Souvenir Books', *London Magazine* (December 1825), p. 562.

25. Anon., 'Souvenir Books, Or Joint-Stock Literature', *London Magazine* (December 1826), p. 480.

26. Anon., 'The Editor's Room No. IX', *London Magazine* (December 1828), p. 696.

27. On Wordsworth's knowledge of and experiences with publishing in the annuals, see Manning, 'Wordsworth in the *Keepsake*, 1829'.

28. Johnson, *Wordsworth and the Sonnet*, p. 125.

29. On the history of italics, see Stanley Morison, *Selected Essays on the History of Letter-Forms in Manuscript and Print*, 2 vols, ed. David McKitterick (Cambridge: Cambridge UP, 1981), 1, pp. 23–113.

30. David Lee Clark, ed., *Shelley's Prose: Or the Trumpet of a Prophecy* (Albuquerque: The U of New Mexico P, 1966), p. 294.

31. McGann, *Black Riders*, p. 114.

32. Richard Shusterman, *Surface and Depth: Dialectics of Criticism and Culture* (Ithaca: Cornell UP, 2002), p. 163.

33. Curran, *Poetic Form and British Romanticism*, p. 38.

34. Samuel Taylor Coleridge, *Coleridge's Poetry and Prose*, ed. Nicholas Halmi, Paul Magnuson and Raimonda Modiano (New York: Norton, 2004), p. 49.

35. On the sonnet's relation to writing, see Paul Oppenheimer, *The Birth of the Modern Mind: Self, Consciousness, and the Invention of the Sonnet* (New York and Oxford: Oxford UP, 1989).

36. Griggs, ed., *Collected Letters of Samuel Taylor Coleridge*, 1, p. 357.

37. The review is cited in Judith Pascoe, ed., *Mary Robinson: Selected Poems* (Ontario: Broadview, 2000), pp. 15–16.

38. Joseph Addison, Richard Steele *et al.*, *The Spectator*, 4 vols, ed. G. Gregory Smith (London and Toronto: J. M. Dent, 1907), 3, p. 217. As E. A. Levenston remarks in *The Stuff of Literature: Physical Aspects of Texts and Their Relation to Literary Meaning* (New York: State U of New York P, 1992), 'the gradual development of the use of italics is an uncharted aspect of the history of printed literature' (93). For italic typeface in Samuel Richardson as well as a valuable overview of eighteenth-century usages of italics, see Joe Bray, ' "Attending to the *minute*": Richardson's Revisions of Italics in *Pamela*', in *Ma(r)king the Text: The Presentation of Meaning on the Literary Page*, ed. Joe Bray, Miriam Handley and Anne C. Henry (Aldershot: Ashgate, 2000), pp. 105–119.

39. Jonathan Swift, *The Poems*, 2 vols, ed. Harold Williams (Oxford: At the Clarendon P, 1958), 2, p. 643, ll. 95–98.

40. Talbot Baines Reed, *A History of The Old English Letter Foundries*, rev. and enlarged ed., A. F. Johnson (London: Faber & Faber, 1952, 1st ed. 1887), pp. 46–47.

41. A comparable example may be found in *The Excursion* (*PW* 5, 202–203, ll. 510–521), where Wordsworth uses italics to imitate, on his page, the effect of material inscription.

42. Hollander, *Vision and Resonance*, pp. 245–287.

43. See Victor Shklovsky, 'Art as Technique', in *Russian Formalist Criticism: Four Essays*, translated and introduced by Lee T. Lemon and Marion J. Reis (Lincoln: U of Nebraska P, 1956), pp. 3–24.

44. Lucien Alphonse Legros and John Cameron Grant, *Typographical Printing-Surfaces: The Technology and Mechanism of their Production* (London: Longman, 1916), pp. 95–96.

45. Jennifer Ann Wagner describes along similar lines (though without mentioning 'After-Thought') how the sonnet form for Wordsworth was characterised by 'an awareness of itself as a spatialization of a moment of self-conscious presence' (15) which places it at the centre of efforts through the nineteenth century culminating in the *art for art's sake* movement of British Aestheticism to 'make representation *presentation*' and give the illusion that there is no 'temporal interval between vision and form' (16). My reading of 'After-Thought' suggests just how literal this project sometimes seemed to Wordsworth even as he in 'After-Thought' may be using the sonnet to articulate a moment of self-conscious *absence*.

46. On the Romantics' ideas about the relationship between words and things, see Keach, ' "Words Are Things": Romantic Ideology and the Matter of Poetic Language'. Keach's essay is one possible entry into the recent interest in thing theory as developed and promoted especially by Bill Brown in *A Sense of Things: The Object Matter of American Literature* (Chicago: The U of Chicago P, 2003).

5 The book of ekphrasis: *yarrow revisited, and other Poems*

1. Eric Gidal explores *Yarrow Revisited* with an eye to ekphrasis in *Poetic Exhibitions*, pp. 163–207. In *Reading Romantics*, pp. 290–294, Peter Manning discusses the volume in the context of Wordsworth's *oeuvre* as well as in terms of the transitional period into which it was published and with which it engaged.

2. On the Neoclassical use of the trope of language as the dress of thought, see P. W. K. Stone, *The Art of Poetry 1750–1820: Theories of Poetic Composition and Style in the late Neo-Classical and Early Romantic Periods* (London: Routledge & Kegan Paul, 1967), pp. 47–57. Mark Akenside, *The Pleasures of the Imagination: Book The Fifth*, in *The Poetical Works of Mark Akenside*, ed. Robin Dix (Madison and London: Fairleigh Dickinson UP and Associated UP, 1996), p. 232, ll. 102–104.

3. Barker, *Wordsworth*, p. 344. Morchard Bishop writes in the introduction to *Recollections of the Table-Talk of Samuel Rogers* (London: The Richards P, 1952), 'From 1803, when he moved into his celebrated house at No. 22, St. James's Place, up to the day of his death, Rogers was the self-appointed dictator of English letters, the "Oracle of Holland House" in Macauley's phrase' (xvi).

4. See David E. Latané, 'Samuel Rogers' *The Voyage of Columbus* and Turner's Illustrations to the Edition of 1834', *TWC* 14:2 (Spring 1983), pp. 108–112.

5. Lamb, *Complete Works*, p. 1098.

6. On the depression and crises of the literary market between 1826 and 1848, and publishers' attempts to stimulate the market through aggressive advertisements and attempts to 'rejuvenate famous works with illustrated editions', see Henri-Jean Martin, *The History and Power of Writing*, translated by Lydia G. Cochrane (Chicago and London: The U of Chicago P, 1994), p. 440.

7. Sybille Pantazzi, 'Author and Illustrator: Images in Confrontation', in *A History of Book Illustration: 29 Points of View*, ed. Bill Katz (New Jersey and London: The Scarecrow P, 1994), p. 588. Pantazzi cites Turner's statement

from Mordechai Omer, *Turner and the Poets*...[Catalogue of an exhibition held at] Marble Hill House, Twickenham 12 April–1 June (London: Greater London Council, 1975), p. 19. As Bishop points out in *Recollections of the Table-Talk of Samuel Rogers*, 'It must not...be forgotten that *Italy*, in the sumptuous Turner-illustrated edition which the author produced at a cost to himself of some £7.335 after the earlier, unillustrated (and anonymous) editions had proved a total failure ("It would have been dished", said Luttrell "but for the plates"), was the work that first directed the juvenile Ruskin's lively mind towards the scenery and architecture of Italy' (xv).

8. P. W. Clayden, *Rogers and His Contemporaries*, 2 vols (London: Smith, Elder & Co., 1889), 2, p. 4. Cited in Merriam, *Edward Moxon*, p. 28. For the critical comments on the relation between image and text in Rogers' volumes, see Hunnisett, *Steel-engraved Book Illustration*: the 'delicate approach' in steel-engraving 'is at variance with the heavy and clumsy type-face which accompanies them. The reader tends to see either the engraving or the text.... The French recognized this very well in the eighteenth century, when they engraved both illustrations and text in order to achieve harmony on the page' (7–8).

9. Merriam, *Edward Moxon*, p. 29.

10. See ibid., pp. 27–28.

11. Hudson, ed., *Diary of Henry Crabb Robinson*, p. 140.

12. Harold Bloom, *The Visionary Company: A Reading of English Romantic Poetry* (Ithaca and London: Cornell UP, 1st ed. 1961, rev. ed. 1971), p. 196.

13. Stephen Gill, *Wordsworth and the Victorians* (Oxford: Clarendon P, 1998), p. 19. See also Gill, *Wordsworth*, p. 382.

14. Gill, *Wordsworth and the Victorians*, pp. 18, 19.

15. Merriam, *Edward Moxon*, p. 137.

16. Gill, *Wordsworth and the Victorians*, p. 20.

17. Brennan O'Donnell, 'Jared Curtis ed., *William Wordsworth's Last Poems, 1821–1850*', *Romanticism on the Net* 24 (November 2001) [29-11-2006] http://users.ox.ac.uk/~scat0385/24curtis.html.

18. See Jerome McGann, 'The Rationale of Hypertext', in *Electronic Text: Investigations in Method and Theory*, ed. Kathryn Sutherland (Oxford: Clarendon P, 1997), pp. 31–37.

19. Mary E. Burton, ed., *The Letters of Mary Wordsworth, 1800–1855* (Oxford: At the Clarendon P, 1958), p. 128.

20. See Manning, 'The Persian Wordsworth'.

21. Barker, *Wordsworth*, p. 666.

22. Wyatt, *Wordsworth's Poems of Travel, 1819–42*, p. 2.

23. Elizabeth Fay, 'The Egyptian Court and Victorian Appropriations of Ancient History', *TWC* 32:1 (Winter 2001), p. 24.

24. Manning, 'Wordsworth in the *Keepsake*, 1829', pp. 61–62. Only what Wordsworth perceived as mistreatment by the publishers Heath and Reynolds kept him from publishing new poetry in *The Keepsake* (Heath and Reynolds did not publish everything Wordsworth was contracted to write in 1828, and when he inquired for his manuscripts, they did not return them).

25. An image of the bust is reproduced in Gidal, *Poetic Exhibitions*, p. 164.

26. Miller, *That Noble Cabinet*, p. 99; and David M. Wilson, *The British Museum*, pp. 66–68.

27. Elizabeth Gilmore Holt, ed., *From the Classicists to the Impressionists: Art and Architecture in the Nineteenth Century. Volume III of A Documentary History of Art* (New York: Anchor Books, 1966), p. 272.

28. Heffernan, *Museum of Words*, p. 138.

29. Hudson, ed., *Diary of Henry Crabb Robinson*, p. 42.

30. Lessing, *Laocoön*, p. 20. Heffernan, *Museum of Words*, p. 92.

31. De Quincey translated Lessing's phrase as 'steadfastness of eternity' (echoing 'Peele Castle') and annotated it with reference to Wordsworth's 'Upon the Sight of a Beautiful Picture'. Thomas De Quincey, *The Collected Writings of Thomas De Quincey*, 14 vols, ed. David Masson (London: A. & C. Black, 1897), 14, p. 178.

32. See Frederick Burwick, 'Lessing's *Laocoön* and the Rise of Visual Hermenutics', *Poetics Today* 20:2 (Summer 1999), pp. 219–272.

33. Hazlitt, *Complete Works*, 10, p. 7.

34. Heffernan, *Museum of Words*, p. 93. Even when an artwork was demonstrably deteriorating, Wordsworth responded to its permanence. In his sonnet on 'The Last Supper, By Leonardo da Vinci, in the Refectory of the Convent of Maria Della Graze—Milan' (1820), Wordsworth notes how 'searching damps and many an envious flaw / Have marred this Work', yet he ends by saying that it 'still bespeak[s] / A labour worthy of eternal youth' (*PW* 3, 184).

35. Kathleen Coburn, ed., *Inquiring Spirit: A Coleridge Reader* (Minerva P, 1968), p. 215.

36. Martial, *Epigrams*, 2 vols, translated by Walter C. A. Ker. The Loeb Classical Library (London and Cambridge: Harvard UP, 1919), 1, p. 481.

37. Jacobo Mazzoni, *On the Defence of the Comedy of Dante: Introduction and Summary*, edited and translated by Robert L. Montgomery (Tallahassee: UP of Florida, 1983), pp. 50–51. Cited from Krieger, *Ekphrasis*, p. 120.

38. Thomas Morrison, *A Pindarick Ode on Painting: Addressed to Joshua Reynolds, Esq.*, preface by Frederick W. Hilles and biographical introduction by J. T. Kirkwood. The Augustan Reprint Society. Publication Number 37 (Los Angeles, William Andrews Clark Memorial Library: U of California, 1952), pp. 13–15.

39. Grant F. Scott, 'Ekphrasis as Ideology', *Yearbook of Interdisciplinary Studies in the Fine Arts* 2 (1990), p. 95.

40. See Claire Pace, ' "Delineated lives": Themes and Variations in Seventeenth-Century Poems and Portraits', *Word & Image* 2:1 (January–March 1986), pp. 1–17.

41. William Cowper, *The Poems*, 3 vols, ed. John Baird and Charles Ryskamp (Oxford: Clarendon P, 1993), 3, p. 56. On Cowper, ekphrasis and parenthesis, see Charles Lock, 'Those Lips: On Cowper (*Ekphrasis* in Parenthesis)', *Angles on the English-Speaking World* 3 (2003), pp. 27–45, which includes a colour reproduction of Dietrich Heins, *Ann Cowper, née Donne* (c. 1723).

42. Carol Duncan, 'The Art Museum as Ritual', in *The Art of Art History: A Critical Anthology*, ed. Donald Preziosi (Oxford: Oxford UP, 1998), pp. 479–480.

43. David Perkins, *Wordsworth and the Poetry of Sincerity* (Cambridge, Mass.: Harvard UP, 1964), p. 258.

44. M. H. Abrams, 'Structure and Style in the Greater Romantic Lyric', in *Romanticism and Consciousness*, ed. Bloom, p. 201.

45. Shackford, *Wordsworth's Interest*, p. 62.

46. Abrams writes that '"Peele Castle" adheres to the norm (with a change in initial reference from scene to painting)' (201). It should be pointed out, though, that the initial reference is not to the picture but to the memory of the Castle.
47. Mitchell, *Picture Theory*, p. 152.
48. Ibid., p. 154.
49. Scott, *The Sculpted Word*, p. 15.
50. See Grant Scott, 'The Fragile Image: Felicia Hemans and Romantic Ekphrasis'.
51. Krieger, *Ekphrasis*, p. 10.
52. Coleridge to Robert Southey 14 August 1803. Griggs ed., *Collected Letters of Samuel Taylor Coleridge*, 2, p. 977.
53. Eilenberg, *Strange Power of Speech*, p. 201.
54. Geoffrey N. Leech, *A Linguistic Guide to English Poetry* (London and New York: Longman, 1994), p. 214.
55. Anne Ferry, *The Title to the Poem* (Stanford: Stanford UP, 1996), p. 2.
56. Levinson, *Wordsworth's Great Period Poems*, p. 47.
57. See Brennan, 'Wordsworth's "Lines Suggested by a Portrait from the Pencil of F. Stone": "Visible Quest of Immortality"?'. The portrait by Stone is reproduced in Brennan's article, p. 43.
58. See Curtis, ed., *Last Poems*, pp. 269–270.
59. See Heffernan, *Museum of Words*, p. 100.
60. Hollander, 'The Gazer's Spirit', p. 131. 'I want to suggest', writes Mitchell in *Picture Theory*, 'that in a certain sense all ekphrasis is notional, and seeks to create a specific image that is to be found only 'in the text as its "resident alien", and is to be found' nowhere else. Even those forms of ekphrasis that occur in the presence of the described image disclose a tendency to alienate or displace the object, to make it disappear in favour of the textual image being produced by the ekphrasis' (157, n19).

6 'The marble index of a mind': Frontispiece portraiture and the image of late Wordsworth

1. H. D. Rawnsley, 'Reminiscences of Wordsworth Among the Peasantry of Westmoreland', in *Lives of the Great Romantics by Their Contemporaries: Wordsworth*, ed. Peter Swabb (London: William Pickering, 1996), p. 451.
2. Hollander, *Gazer's Spirit*, p. 23.
3. See Mary Tom Osborne, *Advice-To-A-Painter Poems 1633–1856* (The U of Texas, 1949).
4. See Frances Blanshard's seminal study, *Portraits of Wordsworth* (Ithaca: Cornell UP, 1959). Blanshard notes that these are three times as many portraits as were taken of Southey, Coleridge or Lamb, and four times as many as of Byron. The most popular subject for portraiture among the Romantics was Walter Scott.
5. Pascoe, *Romantic Theatricality*, p. 189.
6. Johnston, *Hidden Wordsworth*, p. 3.
7. The engraving was a steel engraving which enabled the portrait to be reprinted in 1840, 1841, 1843, 1846 and 1849. For bibliographical information on the multivolume *Poetical Works*, see Thomas J. Wise's problematic

A Bibliography of the Writings in Prose and Verse of William Wordsworth (Folkstone and London: Dawsons of Pall Mall, 1971, 1st ed. 1916), pp. 223–225.

8. The edition was not a cheap edition, see *LY* 4, 716.
9. See Wise, *Bibliography*, pp. 225–226.
10. Kurt Weitzmann, *Ancient Book Illumination* (Cambridge, Mass.: Harvard UP, 1959), p. 116.
11. The 1479 portrait was of Paulus Attavanti Florentinus and was used for the frontispiece to his *Brevarium totius juris canonici* printed in Milan by L. Pachel and U. Scinzenzeller. It is reproduced in Rudolf Hirsch, *Printing, Selling and Reading, 1450–1550* (Weisbaden: Otto Harrassowitz, 1974), p. 60, and discussed, p. 49. On authorial portraiture, see David Piper, *The Image of the Poet: British Poets and Their Portraits* (Oxford: Oxford UP, 1982).
12. Steven Rendall notes Cervantes' comment in *Distinguo: Reading Montaigne Differently* (Oxford: Oxford UP, 1995), p. 95. On Swift, see Barchas, *Graphic Design, Print Culture, and the Eighteenth-Century Novel*, pp. 19–59.
13. McLaverty, *Pope, Print and Meaning*, p. 63.
14. Addison, Steele *et al.*, *The Spectator*, 1, p. 3.
15. Roger Chartier, *The Order of Books: Readers, Authors, and Libraries in Europe Between the Fourteenth and Eighteenth Centuries*, translated by Lydia G. Cochrane (Cambridge: Polity P, 1994), p. 52.
16. Steven Rendall, 'The Portrait of the Author', *French Forum* 13:2 (1988), p. 144. In *Visual Words: Art and the Material Book in Victorian England* (Aldershot: Ashgate, 2002), pp. 103–202, Gerard Curtis discusses frontispiece portraiture at length with special emphasis on Charles Dickens.
17. William Bates, *The Maclise Portrait Gallery of Illustrious Literary Characters with Memoirs* (London: Chatto & Windus, 1898), p. viii.
18. Hazlitt, *Complete Works*, 8, pp. 303–304.
19. Ibid., 11, p. 91.
20. Ibid., 17, p. 118.
21. Hartley Coleridge, 'Modern English Poetesses', *Quarterly Review* 132 (September 1840), pp. 374–375.
22. See Andrew Bennett, *The Author* (London and New York: Routledge, 2005), p. 55.
23. Erickson, *The Economy of Literary Form*, p. 69.
24. Charles Taylor, *Sources of the Self: The Making of the Modern Identity* (Cambridge, Mass.: Harvard UP, 1989), p. 409.
25. [W. H. Ireland], *Chalcographimania; Or, the Portrait-Collector and Printseller's Chronicle* (London: R. S. Kirby, 1814), p. 79.
26. Marcia Pointon, *Hanging the Head: Portraiture and Social Formation in Eighteenth-Century England* (New Haven and London: Yale UP, 1993), p. 59.
27. Ibid., p. 56.
28. Robert Southey, *Letters from England by Robert Southey*, ed. Jack Simmons (London: The Cresset P, 1961), p. 117.
29. Bryan Waller Proctor, *Effigies Poeticæ; or Portraits of the British Poets* (London: James Carpenter & Son, 1824).
30. See David Higgins, *Romantic Genius and the Literary Magazine: Biography, Celebrity and Politics* (London and New York: Routledge, 2005).
31. Thomas Hood, *Whims and Oddities in Prose and Verse. A New Edition* (London: Charles Tilt, 1836), p. 188.

32. Ibid., p. 194.
33. Cf. W. A. Speck, *Robert Southey: Entire Man of Letters* (New Haven and London: Yale UP, 2006).
34. Robert Southey, *Poetical Works*, 10 vols (London: Longmans, 1838–1840), 3, pp. 305–318, l. 140.
35. Curry, ed., *New Letters*, 2, p. 266.
36. Hunnisett, *Steel-engraved Book Illustration*, p. 145.
37. Hazlitt, *Complete Works*, 12, p. 108.
38. See Blanshard, *Portraits*, pp. 35–36, 56. According to Haydon, 'In phrenological development [Wordsworth] is without constructiveness while imagination is as big as an egg'. *Autobiography and Memoirs*, p. 210.
39. Cited in Blanshard, *Portraits*, p. 56.
40. Alaric Alfred Watts, *A Narrative of His Life* (1884), in *Lives of the Great Romantics*, ed. Swabb, pp. 463–464.
41. Blanshard, *Portraits*, p. 30.
42. Other such posters apparently existed, see *LY* 4, 231, 742.
43. On the demand for a likeness, cf. also the letter dated 8 February 1830 to an anonymous correspondent who had asked for one (*LY* 2, 200–201).
44. A full-length engraving by R. C. Rolls from Pickersgill's portrait eventually appeared in the coffee-table giftbook edited by S. C. Hall, *The Book of Gems: The Modern Poets and Artists of Great Britain* (London, 1838). See *LY* 3, 262 n7, and Blanshard, *Portraits*, pp. 78ff.
45. See Erickson, *The Economy of Literary Form*, 'by 1830 almost all publishers refused to publish poetry' (26).
46. Quoted from Merriam, *Edward Moxon*, p. 138.
47. Richard Brilliant, *Portraiture* (Cambridge, Mass.: Harvard UP, 1991), p. 10.
48. Nathaniel Hawthorne, 'The Prophetic Pictures', from *Twice-Told Tales*, in *The Centenary Edition of The Works of Nathaniel Hawthorne. Volume IX*, ed. Charvat, Pearce, Simpson *et al.* (Columbus: Ohio State UP, 1974), p. 173.
49. Brilliant, *Portraiture*, p. 14.
50. Cited from Bruce Haley, *Living Forms: Romantics and the Monumental Figure* (Albany: State U of New York P, 2003), pp. 101–102.
51. On the pen and paper as 'mere stage properties', see Blanshard, *Portraits*, p. 76.
52. Robert Perceval Graves, 'Recollections of Wordsworth and the Lake Country', in *Lives of the Great Romantics*, ed. Swabb, p. 279.
53. On the relations between the sonnet and the painting, see Rovee, *Imagining the Gallery*, pp. 156–158.
54. Pickersgill always had the odds against him. In a letter to Beaumont 27 August 1832, Wordsworth writes that Pickersgill 'is coming down to paint my Portrait for St John's Coll. Cam.... Whatever success Mr P. may have, he will not, I fear, come near the bust' (*LY* 2, 553–554).
55. Beaumont wrote of Chantrey's bust in August 1820, 'it is admired by all, and especially by judges—of art or countenance; it does high honour to Chauntry' (*LY* 1, 69). On Wordsworth's desire to spread the bust, see for example letter to Chantrey October 1821 (*LY* 1, 86–87), and to Allan Cunningham 12 June 1822 (*LY* 1, 137–138). Chantrey's bust was engraved before 1845 by Achille Collas 'as a medallic portrait from a relief by Henry Weekes...and published in his *Authors of England*, 1838' (*LY* 2, 201 n1). In

The Image of the Poet, Piper describes Chantrey's bust as 'in the persistent neoclassic idiom, the stray lock of hair on the forehead providing perhaps the sole specific romantic accent' (124).

56. Wordsworth comments on Haydon's portrait in a letter to Haydon 24 January 1846 (*LY* 4, 753). In a letter to Henry Reed 23 January 1846, Wordsworth comments on the American painter Henry Inman's portrait (reproduced in Blanshard, *Portraits*, plate 27), that in it Inman 'has performed a striking resemblance...to his subject' (*LY* 4, 750–751). About Haydon's portrait, Wordsworth says in the same letter, 'There is great merit in this work and the sight of it will shew my meaning on the subject of *expression*. This I think is attained, but then, I am stooping and the inclination of the head necessarily causes a foreshortening of the features below the nose which takes from the likeness accordingly' (751).

57. Elizabeth Barrett Browning, 'Sonnet on Mr Haydon's Portrait of Mr Wordsworth'. Cited from the first published version in *Atheneum*, 29 October 1842. On the ekphrastic complexities of Haydon's representation, see Christopher Rovee, 'Solitude and Sociability: *Wordsworth on Helvellyn*', *Literature Compass* 1 (2004), pp. 1–14.

58. Graves, 'Recollections of Wordsworth', in *Lives of the Great Romantics*, ed. Swabb, p. 280.

59. Morley, ed., *Correspondence of Crabb Robinson*, 1, p. 102.

60. Hazlitt, *Complete Works*, 17, p. 118.

61. Pascoe, *Romantic Theatricality*, p. 187.

62. Morley, ed., *Correspondence of Crabb Robinson*, 1, p. 139.

63. Kenneth Gross, *The Dream of the Moving Statue* (Ithaca and London: Cornell UP, 1992), pp. 17–19.

64. Byron, 'Detached Thoughts' no. 25, *Letters and Journals*, 12 vols, ed. Leslie A. Marchand (London: John Murray, 1973–1982), 9, p. 20.

65. See Haydon's recreation of seeing Wordsworth having his plaster cast taken in April 1815: 'I had a cast made yesterday of Wordsworth's face. He bore it like a philosopher. John Scott was to meet him at breakfast, and just as he came in the plaster was put on. Wordsworth was sitting in the other room in my dressing-gown, with his hands folded, sedate, solemn and still. I stepped in to Scott and told him as a curiosity to take a peep, that he might say the first sight he ever had of so great a poet was in this stage towards immortality'. *Autobiography*, p. 209.

66. Haydon, *Autobiography*, p. 731.

67. Bloom, *Visionary Company*, p. 461.

68. D. F. McKenzie, 'Typography and Meaning: The Case of William Congreve', in *Buch und Buchhandel in Europa im achtzehnten Jahrhundert/The Book and the Book Trade in Eighteenth-Century Europe*. Fünftes Wolfenbütteler Symposium, ed. Giles Barber and Bernhard Fabian (Hamburg: Dr. Ernst Hauswedell & Co., 1977), p. 83.

Select Bibliography

Batho, Edith C. *The Later Wordsworth* (New York: Russell and Russell, 1963, 1st ed. 1933).

Bennett, Andrew. *Romantic Poets and the Culture of Posterity* (Cambridge: Cambridge UP, 1999).

Bernhardt-Kabisch, Ernest. 'Wordsworth: The Monumental Poet'. *Philological Quarterly* 44 (1965), pp. 503–518.

Blanshard, Frances. *Portraits of Wordsworth* (Ithaca: Cornell UP, 1959).

Bloom, Harold. *The Visionary Company: A Reading of English Romantic Poetry* (Ithaca: Cornell UP, 1971).

Boehm, Alan D. 'The 1798 *Lyrical Ballads* and the Poetics of Late Eighteenth-Century Book Production'. *ELH* 63:2 (1996), pp. 453–487.

Brennan, Matthew C. 'Wordsworth's "Lines Suggested by a Portrait from the Pencil of F. Stone": "Visible Quest of Immortality"?'. *English Language Notes* 35:2 (December 1997), pp. 33–44.

Bushell, Sally. *Re-reading The Excursion: Narrative, Response and the Wordsworthian Dramatic Voice* (Aldershot: Ashgate, 2002).

Chartier, Roger. *The Order of Books: Readers, Authors, and Libraries in Europe Between the Fourteenth and Eighteenth Centuries*. Translated by Lydia G. Cochrane (Cambridge: Polity P, 1994).

Curtis, Gerard. *Visual Words: Art and the Material Book in Victorian England* (Aldershot: Ashgate, 2002).

Easson, Angus. *The Lapidary Wordsworth: Epitaphs and Inscriptions* (Winchester: King Alfred's College, 1981).

Erickson, Lee. *The Economy of Literary Form: English Literature and the Industrialization of Publishing, 1800–1850* (Baltimore: The Johns Hopkins UP, 1996).

Galperin, William. *Revision and Authority in Wordsworth: The Interpretation of a Career* (Philadelphia: U of Pennsylvania P, 1989).

——. *The Return of the Visible in British Romanticism* (Baltimore: The Johns Hopkins UP, 1993).

Genette, Gérard. *Paratexts: Thresholds of Interpretation*. Translated by Jane E. Lewin (Cambridge: Cambridge UP, 1997).

Gidal, Eric. *Poetic Exhibitions: Romantic Aesthetics and the Pleasures of the British Museum* (Lewisburg: Bucknell UP, 2001).

Gill, Stephen. *William Wordsworth: A Life* (Oxford: Oxford UP, 1989).

——. *Wordsworth and the Victorians* (Oxford: Clarendon P, 1998).

Harper, George McLean. *William Wordsworth: His Life, Works and Influence*, 2 vols (London: John Murray, 1916).

Hartman, Geoffrey. *Wordsworth's Poetry 1787–1814* (Cambridge: Harvard UP, 1987).

——. *The Unremarkable Wordsworth*. Foreword by Donald G. Marshall (Minneapolis: The U of Minnesota P, 1987).

Heffernan, James. *The Museum of Words: The Poetics of Ekphrasis from Homer to Ashbery* (Chicago: The U of Chicago P, 1993).

Hickey, Alison. *Impure Conceits: Rhetoric and Ideology in Wordsworth's 'Excursion'* (Stanford: Stanford UP, 1997).

Hopewell, Hoyt D. *The Epigram in the English Renaissance* (Princeton: Princeton UP, 1947).

Hudson, Derek, ed. *The Diary of Henry Crabb Robinson. An Abridgement* (London: Oxford UP, 1967).

Hunnisett, Basil. *Steel-engraved Book Illustration in England* (London: Scolar P, 1980).

Johnson, Lee M. *Wordsworth and the Sonnet* (Copenhagen: Rosenkilde and Bagger, 1973).

Johnston, Kenneth. *The Hidden Wordsworth: Poet, Lover, Rebel, Spy* (New York: Norton, 1998).

Knight, William, ed. *Memorials of Coleorton* (Edinburgh: David Douglas, 1887).

——. *The Life of William Wordsworth*, 3 vols (Edinburgh: William Paterson, 1889).

Krieger, Murray. *Ekphrasis: The Illusion of the Natural Sign* (Baltimore: The Johns Hopkins UP, 1992).

Manning, Peter. *Reading Romantics: Texts and Contexts* (New York: Oxford UP, 1990).

——. 'Cleansing the Images: Wordsworth, Rome, and the Rise of Historicism'. *Texas Studies in Literature and Language* 33:2 (Summer 1991), pp. 271–326.

——. 'Wordsworth in the *Keepsake*, 1829'. *Literature in the Marketplace: Nineteenth-Century Publishing and Reading Practices*, ed. John Jordan and Robert L. Patten (Cambridge: Cambridge UP, 1995), pp. 44–73.

——. 'The Other Scene of Travel: Wordsworth's "Musings Near Aquapendente" '. *The Wordsworthian Enlightenment: Romantic Poetry and the Ecology of Reading*, ed. Helen Regueiro Elam and Frances Ferguson (Baltimore: The Johns Hopkins UP, 2005), pp. 191–211.

McGann, Jerome. *Black Riders: The Visible Language of Modernism* (Princeton: Princeton UP, 1993).

——. *Radiant Textuality: Literature After the World Wide Web* (Basingstoke: Palgrave, 2001).

Merriam, Harold G. *Edward Moxon: Publisher of Poets* (New York: Columbia UP, 1939).

Mitchell, W. J. T. *Picture Theory: Essays on Verbal and Visual Representation* (Chicago: The U of Chicago P, 1994).

Moorman, Mary. *William Wordsworth: A Biography*, 2 vols (Oxford: Clarendon P, 1966–1967).

Pascoe, Judith. *Romantic Theatricality: Gender, Poetry, and Spectatorship* (Ithaca: Cornell UP, 1997).

Reed, Mark L. 'Wordsworth's Surprisingly Pictured Page: *Select Pieces*'. *The Book Collector* 46:1 (Spring 1997), pp. 69–92.

Rovee, Christopher. *Imagining the Gallery: The Social Body of British Romanticism* (Stanford: Stanford UP, 2006).

Scott, Grant F. *The Sculpted Word: Keats, Ekphrasis, and the Visual Arts* (Hanover: UP of New England, 1994).

Shackford, Martha Hale. *Wordsworth's Interest in Painters and Paintings* (Wellesley: The Wellesley P, 1945).

Sparrow, John. *Visible Words: A Study of Inscriptions in and as Books and Works of Art* (Cambridge: Cambridge UP, 1969).

Wood, Gillen D'Arcy. *The Shock of the Real: Romanticism and Visual Culture, 1760–1860* (Basingstoke: Palgrave, 2001).

Wu, Duncan. *Wordsworth: An Inner Life* (Oxford: Blackwell, 2002).

Wyatt, John. *Wordsworth's Poems of Travel, 1819–42: 'Such Sweet Wayfaring'* (Basingstoke: Macmillan, 1999).

Index